AMERICAN *Art*

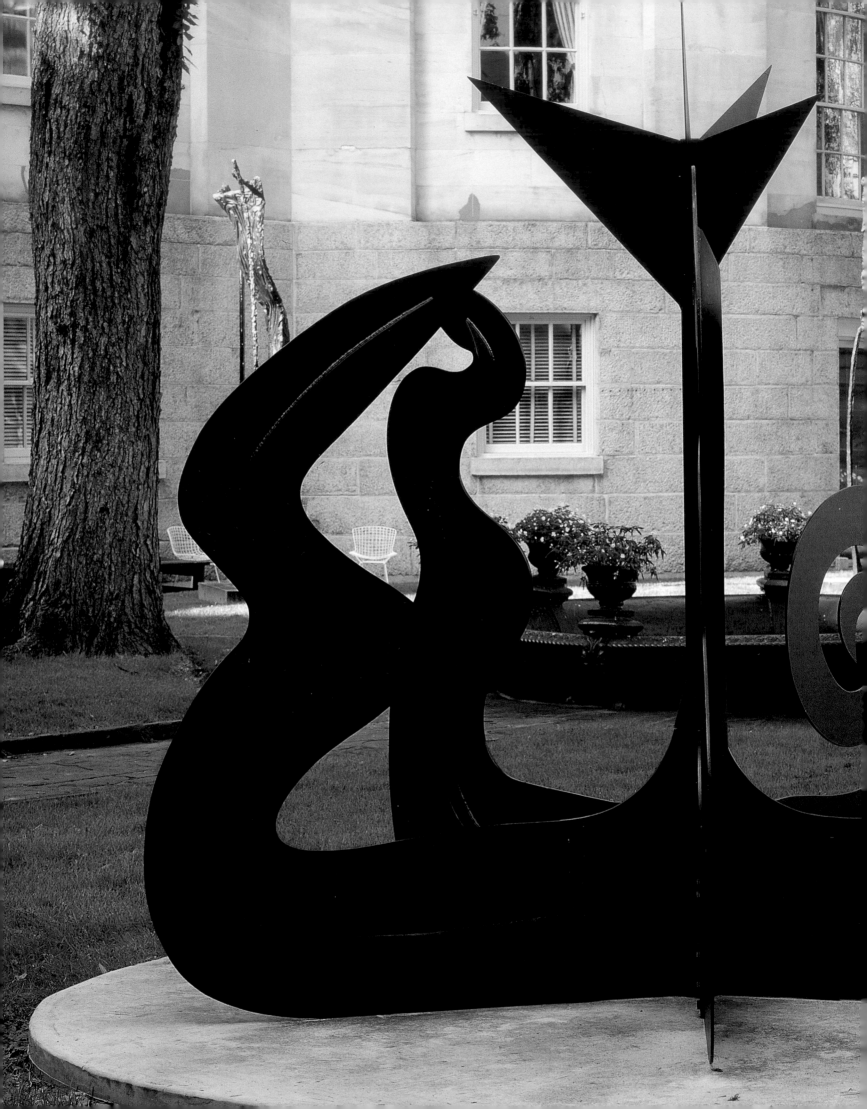

NATIONAL MUSEUM OF
AMERICAN Art

National Museum of American Art
Smithsonian Institution

CONTENTS

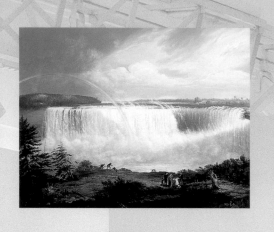

EARLY AMERICA

TRADITION

20TH CENTURY LIFE

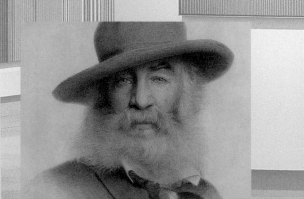

PEOPLE

OREWORD

The National Museum of American Art, dedicated to the art and artists who have contributed to our cultural heritage, provides insight into who we are as a people. Originating in 1829 when the first objects were acquired for the future national collection, the extensive holdings now constitute an invaluable record of our creativity, hopes, and concerns.

A measure of the size of the collections is the fact that this book can include only one percent of the museum's holdings. Even on the companion CD-ROM, with its much greater capacity for both images and text, the number increases to only approximately three percent. These figures begin to suggest the richness of the museum's collections, while at the same time implicitly cautioning against concluding that the works seen here provide a definitive overview of American art.

When the last survey of the collections was published in 1985, eighty-one works, ranging from colonial portraits to modern abstractions, were selected to represent the museum's holdings. All were paintings or sculptures, and all were based on European forms and traditions, with some inflection of native experience. American art was presented, in effect, as a steadily unfolding story of progress, from the time of the English settlers' arrival on the East Coast to the present day.

A decade after the publication of that book, the path of American art now appears not only more complicated but also more interesting—a journey with detours and switchbacks, byways and alternate routes paralleling and intersecting the long-accepted "mainstream" pathways. In recent years academic study has shifted from traditional art history and stylistic development to larger ideas about visual culture and material objects. Similarly, the museum's collections have notably broadened in the past decade, with new programs in photography, folk art, and crafts. Each of these areas was once considered marginal, "not really art," but each is now recog-

nized as necessary for an understanding of our visual culture.

The photography collections originated in 1983 with the transfer from the National Endowment for the Arts of approximately eighteen hundred images dating from the 1960s to the 1980s. Greatly expanded to encompass the entire history of the medium since the mid-nineteenth century, these collections now reveal visual traditions that were both independent of painting and a complement to the portraits, landscapes, and scenes of daily life presented in other media.

The museum's craft exhibitions began in 1972 with the opening of the Renwick Gallery in a historic building at 17th Street and Pennsylvania Avenue, across from the White House. It was not until the mid-1980s, however, that the idea took shape to build a permanent collection of modern American crafts, with the support of the James Renwick Alliance, the Smithsonian Institution Collections Acquisition Program, and other donors. The enduring attraction of hand-crafted objects made of fiber, metal, wood, glass, and clay is one of the hidden stories of American art, neglected far too long as peripheral to the fine arts. Not simply representing the oldest art traditions, crafts have renewed significance in a world shaped increasingly by technology and mass culture.

In 1986 the museum made the decision to collect works by untrained artists—conventionally called "folk art," although often not based in true community folk traditions. As we contemplated acquiring a major collection from Herbert W. Hemphill, Jr. of New York, the question arose as to whether these wonderful objects are really "art" or merely intriguing eccentricities. This debate now seems beside the point, as we clearly realize that most "makers" in America, from colonial days to the present, have lacked formal training. By improvising materials, borrowing ideas from many sources, and delving into

personal experience, self-taught artists have tapped vast reservoirs of creativity. How could a museum devoted to American art *not* include such riches?

The major issues faced by American society in the recent past have also shaped our collecting. Fair and equal representation of the finest accomplishments of all groups and people became a major concern in both public life and museums. The National Museum of American Art has made a concerted effort during the past decade to acquire important works by African-American, Latino, and Asian-American artists. (Native American art is the province of two other Smithsonian museums.) Recognizing the extent to which the early collections emphasized work by East Coast artists, we sought outstanding examples from other regions in order to fulfill the museum's mandate as a truly national collection.

Today, when we ask what American art means within this larger context, we know there is not one answer but many. Each answer bears the imprint of the speaker. This book, then, does not concentrate on a formal discussion of individual works, but instead offers diverse comments, anecdotes, and opinions.

This focus on the collections is also implicit testimony to the museum's strong commitment to research. The sampling of comments accompanying each object is intended to arouse the reader's curiosity rather than to satisfy it. As the nation's premier study center for American art, this museum offers a major library, seven automated research databases, a journal for the publication of new scholarship in the field, a program of fellowships and internships, as well as specialized curatorial research.

Each artwork is many things at once: a nonverbal communication in the formal language of design and color, the personal expression of an individual artist, a distillation of social and historical currents, and more. In this book the objects are organized in sections that invite comparisons and relationships. By keeping the organizational structure loose and the categories broad, not defined chronologically or stylistically, we encourage the reader to discover connections across the full range of works.

While this book was being prepared, we were also in the process of reinstalling the collections in our historic building. Many of the discussions about which works to install, their relationships in the galleries, and the information needed on the wall labels have informed the selections for this book. It serves, then, as a kind of tour by printed page, retaining some of the sense of discovery that makes visiting a museum such a special kind of experience.

Acknowledgments

This overview of the National Museum of American Art is, above all, a tribute to the ingenuity of the artists and the generosity of our donors. To each of the artists who created these remarkable works, and to the many individuals who were inspired to collect and contribute them, we give our heartfelt thanks.

The need for a new publication celebrating the collections was discussed for several years. The project became a reality when a collaboration was arranged with the Smithsonian Associates, Mara Mayor, director. The opportunity to share these great national collections with such a distinguished group of people across the country was a further stimulus to this project.

Merry A. Foresta, curator of photography, agreed to coordinate her colleagues in the curatorial office to select the objects that would be included. She worked closely with Publications Department editor Janet Wilson and project assistant Julie Strubel, who researched the historical and contemporary quotations that accompany each object. The resources of the museum's library, under the leadership of Cecilia Chin, and of the Smithsonian's Archives of American Art, ably directed by Richard Wattenmaker, proved invaluable in searching out the most insightful material for each work.

Our goal was to create a book that would delight the reader's eye while inspiring curiosity about the extraordinary range of our works produced over more than two centuries. Steve Bell, NMAA graphic designer, created the lively appearance of this book, with its flexible presentation of objects. Courtney DeAngelis orchestrated the major photography effort necessary to showcase each work to greatest advantage, working closely with staff photographers Gene Young, Mildred Baldwin, and Michael Fischer. Debbie Thomas ably coordinated the digitizing of all the images in the book. Lenore Fein in the registrar's office undertook the difficult task of checking permissions and copyrights.

The book is also a tribute to the curatorial staff of the museum, past and present. Their deep knowledge of the many traditions of American art and keen connoisseurship are the true foundations of excellence in the museum collections and in this book.

Elizabeth Broun
Director
National Museum of American Art

National MUSEUM OF AMERICAN ART

William Kloss

Although the National Museum of American Art is a long-established institution, both its name and location have changed over the years. The museum moved into its current home in 1968, when the collections were elegantly installed in an architectural landmark—the Old Patent Office Building. Ironically, it was in this building that some of the first paintings in this oldest of national art collections were displayed in the mid-nineteenth century.

The City of Washington, District of Columbia, was scarcely thirty years old in 1829 when an optimistic citizen named John Varden took it upon himself to amass a collection that would lend a patina of culture to the still-raw capital. By 1836 he had opened a public gallery in his home, where visitors could see a mélange of historical, natural, and artistic curiosities altogether typical of the age. His efforts were seconded between 1816 and 1838 by the Columbian Institute for the Promotion of Arts and Sciences, which acquired a few works for exhibition. Then in 1840 a more ambitious organization was created. First called the National Institution for the Promotion of Science, it was incorporated in 1842 as the National Institute. Those objects not already dispersed from the defunct Columbian Institute were combined with the holdings of John Varden, who became "curator" of the new collection. In 1841 it was installed on the top floor of the first completed wing of the new Patent Office Building rising grandly from the new city's mud. Reinforcing the quasi-official status suggested by the name of the new society and its location was the appointment of Secretary of War Joel R. Poinsett as its first president. Moreover, the act of incorporation provided that when the charter expired, the collection would become federal property.

The bequest of the Englishman James Smithson led Congress to pass legislation in 1846 establishing the Smithsonian Institution. Its building, the now familiar "Castle on the Mall," included two galleries for exhibiting art; and in 1858 the paintings, sculpture,

and other art objects in the National Institute were transferred to the Smithsonian building, followed by the rest of the collections when the National Institute was disbanded in 1862. In addition to carved and painted portraits of important persons, there were a number of European "old master" paintings, optimistically attributed to those artists most admired at that time. These included gifts and loans from generous citizens.

The largest and most significant early addition to this random accumulation was a group of more than three hundred paintings of Native Americans and related subjects by Charles Bird King and John Mix Stanley. Commissioned by the Department of War, King's works thus belonged to the government. Those by Stanley were on loan pending the government's authorization to purchase them. Tragically, virtually all of Stanley's and King's works were destroyed in a fire that swept through the second floor of the Castle on January 24, 1865.

Following this disaster, in 1874 and 1879 the Smithsonian regents deposited many of the artworks in William Wilson Corcoran's new public gallery, causing the national art collection to become dormant. The strongly scientific bent of the young Smithsonian tacitly buttressed this neglect, and despite intermittent urgings to recall and exhibit the art, only the legacy of a well-connected patron succeeded in effecting a change of policy. Harriet Lane Johnston, the niece of James Buchanan, had served as the bachelor president's official hostess in the White House during his incumbency (1857–61). Mrs. Johnston's small art collection would not have attracted much attention had she not bequeathed it in 1903 to a "national gallery of art," which did not yet exist.

This posthumous prodding came on the heels of a remarkable proliferation of museums in the three decades after 1870. In addition to the Corcoran Gallery of Art in Washington, those years saw the

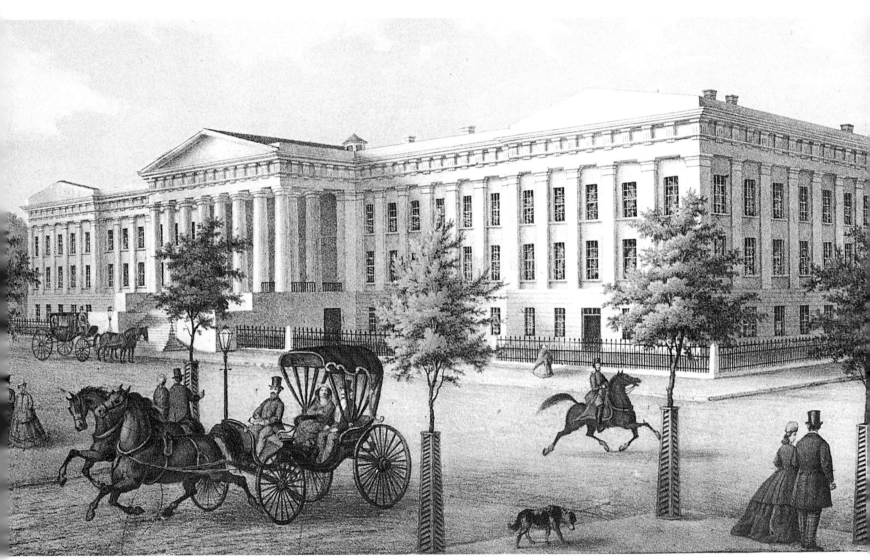

Old Patent Office Building, ca. 1855, lithograph, 22.5 x 40.6 cm (8 7/8 x 16 in.)

founding of the Metropolitan Museum of Art in New York, the Museum of Fine Arts in Boston, the Pennsylvania Museum (now called the Philadelphia Museum of Art), the Art Institute of Chicago, and the M. H. de Young Museum in San Francisco. Spurred by the ambition to emulate and rival European culture, and possessing vast fortunes made in industry and finance, Americans began to form private collections that were ultimately destined to enrich (or become) the new public museums of the nation.

The Johnston bequest reawakened the Smithsonian Institution's interest in art, and in 1906 a federal court ruled that the 1846 legislation establishing the institution also conferred upon it the status of a National Gallery of Art. Under this name the art collections were now officially gathered. The appellation held for thirty-one years, during which the collections were greatly increased. Understandably, donors were attracted by the prestigious name, as well as the prospect of being able to shape the character of the collection through their gifts. Thus, beginning in 1919, Ralph Cross Johnson and his daughter, Mabel Johnson Langhorne, bequeathed a considerable number of works, primarily European paintings. This reflected the prevailing devotion to European art among American patrons.

In contrast, the lifetime gifts of William T. Evans, beginning in 1917, constituted an extraordinary legacy of late-nineteenth and early-twentieth-century American art. A second source of American art, established in 1916, was the Henry Ward Ranger Fund, administered by the National Academy of Design. Ranger, a landscape artist whose works were collected by Evans, intended that the fund be used to purchase paintings by American artists through the National Academy, which would then distribute these works to public museums throughout the country. They would remain in these institutions until and unless the National Gallery of Art exercised its option to recall them during a five-year period beginning ten years after the artist's death. This advocacy of contemporary American art was shared by John Gellatly, the most important of the museum's early patrons. With his generous gift in 1929, Gellatly put his indelible stamp on the collection through the range and perspicacity of his taste.

Unlike Evans, Gellatly also bought European, Oriental, and ancient art, with the intention of demonstrating the high level of our native art by comparing it with the work of other cultures and periods. The non-American art in his collection, however, was heavily weighted toward *objets d'art*,

whereas paintings dominated the American portion. Like Evans, Gellatly for the most part was buying with the knowledge that his collection would reside in the National Gallery.

Gellatly's admiration for certain artists led him to purchase large amounts of their work. Abbott Thayer, Thomas Dewing, Childe Hassam, and John Twachtman were favored, but the palm went to Albert Pinkham Ryder. Seventeen of his haunting paintings came to the museum through the agency of Gellatly and remain one of the most unusual and important features of the museum.

During this period, the problem of a suitable home for the rapidly growing collection remained unsolved. In 1906 space for the works was allocated in the second Smithsonian museum to be built, the 1881 Arts and Industries Building (then called the U.S. National Museum Building). Four years later the collection was moved to a long skylit hall in the Natural History Building, quickly outgrowing the space but nonetheless remaining there for fifty-eight years.

During that time, two independent structures were designed for the art collection but remained unbuilt due to insufficient funds. The 1920 designation of the National Gallery as a separately administered bureau of the Smithsonian precipitated the first design, which was planned for the space between the Natural History Building and Seventh Street. The plans were submitted in 1925 by Charles A. Platt, whose much-admired Freer Gallery of Art had recently opened.

The second design was the result of radically changed circumstances in the museum's identity. In 1937 former Secretary of the Treasury Andrew Mellon gave the nation his collection, primarily composed of old masters, and the money to build a vast museum on the Mall, provided that it be named the National Gallery of Art, in emulation of the London institution. With no perceptible hesitation, Congress accepted his gift and stipulation; once again, the Smithsonian's art collection was renamed. Called the National Collection of Fine Arts, it had lost neither purpose nor supporters. Whereas the *new* National Gallery of Art then explicitly excluded the work of living artists, the Smithsonian collection was especially rich in this area. In 1847 a Smithsonian regents' committee had expressed the desire to cooperate with artists' associations in exhibiting "the best results of talent" among living artists, and that desire was particularly strong among supporters of the New Deal art projects of the 1930s. A redefinition of the goals of the National Collection of Fine Arts in the

aftermath of events of the late thirties resulted in an increased emphasis on the acquisition and exhibition of American art. Little or no increase would henceforth be seen in the collection of European works.

Congress proposed that the National Collection of Fine Arts be enlarged and its programs expanded as a Smithsonian Gallery of Art. In an architectural competition for the long-desired, independent museum building, the winner was the team of Eliel and Eero Saarinen and Robert Swanson. Their 1939 design would unquestionably have resulted in one of the most modern and functional museum structures in the United States. A conservative Fine Arts Commission rejected the design, and thus the newly christened National Collection of Fine Arts remained in its long hall in the Natural History Museum until 1968.

The critical shortage of exhibition and storage space discouraged an active acquisition program, so that relatively little of importance entered the collection between 1940 and 1960. In 1957 a congressional bill was introduced to demolish the Old Patent Office Building, occupied by the Civil Service Commission, in order to erect a parking garage. However, the winds of historic preservation were blowing, and the Eisenhower administration joined the chorus of opposition to this proposal. Instead, in 1958 the great Greek Revival structure was turned over to the Smithsonian Institution for the National Collection of Fine Arts. Although four years passed before the building was vacated, and six more before it could be restored and refurbished, a permanent home for the collection was at last in view. In 1962 the decision was made to create a new National Portrait Gallery, which, though a separate entity, would also be housed in the Old Patent Office Building.

It is appropriate to pause here and examine the history of this remarkable building, which first opened its doors in 1840. In Pierre L'Enfant's capital city plan, the site of the Patent Office was reserved for a national church or, alternatively, a national mausoleum or pantheon for the country's heroes. Instead, it was destined to receive a fireproof replacement for the patent office destroyed by fire in 1836. This substitution says something about the nature of the American republic during its first century. As Mark Twain wrote in *The Innocents Abroad* (1869),

The popes have long been the patron and preservers of art, just as our new, practical republic is the encourager and upholder of mechanics. In their

Vatican is stored up all that is curious and beautiful in art; in our Patent Office is hoarded all that is curious or useful in mechanics.... We can make something of a guess at a man's character by the style of nose he carries on his face. The Vatican and the Patent Office are governmental noses, and they bear a deal of character about them.

On the other hand, the fact that a portion of the Patent Office Building served from the outset as an exhibition hall for art, and that it is today entirely devoted to that purpose, attests to the complexities of national character and the ironies of history.

The erection of the massive structure involved several architects and consumed thirty years. William Parker Elliott was the young architect whose design was approved on the Fourth of July 1836. Robert Mills, the supervising architect on the project, was a very busy man in Washington at that time, also involved in either a design or supervisory capacity on the U.S. Capitol and the Treasury Building (and a few years later the Post Office). Mills's primary engineering contribution to the building was his introduction of masonry vaults (in the south wing) to shield the wooden roofs in the event of fire. His primary aesthetic contributions were the cantilevered, curving double staircase leading to the top floor and, above all, the elegant elevation of the magnificently proportioned hall (now the Lincoln Gallery) on the top floor of the east wing. Thomas U. Walter, who was soon to undertake the new dome and the House and Senate wings of the Capitol, oversaw the construction of this great hall; he introduced iron tie rods to reinforce the masonry vaults and replaced the wooden roofs with fireproof materials. Although this wing was not begun until 1849, it was completed by 1852.

Next came the west wing, where Walter introduced iron vaults and trusses and an iron ceiling in an ongoing attempt to prevent destruction by fire. (The disastrous burning of the Library of Congress in 1851 gave his effort new urgency.) This wing was completed by 1856, and work on the north wing began immediately. A new architect, Edward Clark, was employed, and he capped the rush to iron construction by devising floors made of iron beams with segmental brick arches between them. The Civil War delayed final completion of the north wing (the entrance steps) until 1867. Despite the intense preoccupation with fire prevention, a great conflagration did occur in 1877, destroying the roofs and interiors of the iron west and north wings, but sparing the masonry and wood construction of the south wing.

Native sandstone, granite, and marble were used in the construction, mostly obtained from Virginia and Maryland quarries. The building's variation on the Greek Revival style—pedimented colonnades of Doric temples centered as porticoes on the long wings—had already been introduced into American architecture, notably in Philadelphia, but never before on such a mammoth scale. The almost simultaneous appearance of the Patent Office, the Treasury, and the Post Office in an unpopulous and unpaved city provoked some bemused responses. "Public buildings that need but a public to be complete" was Charles Dickens's summation, while to Henry Adams's freer fancy they were "like white Greek temples in the abandoned gravel-pits of a deserted Syrian City."

Throughout the Civil War, the city of Washington served as headquarters and hospital. At times the Union wounded were billeted even in the Capitol, and the Patent Office Building also became a hospital. In this "noblest of Washington buildings" Walt Whitman described "a curious scene, especially at night when lit up. The glass cases, the beds, the forms lying there, the gallery above, and the marble pavement under foot—the suffering and the fortitude to bear it in various degrees—occasionally, from some, the groan that could not be repress'd." There, among the symbols of creativity, Whitman witnessed frightful suffering and death, as he spent uncounted hours comforting the soldiers.

In 1865 Whitman revisited the building on the occasion of Lincoln's second inaugural ball, a splendid spectacle. The guests entered by way of the monumental steps, through the south portico, and from there climbed up the curving staircase to the top floor, where they promenaded through the vaulted east wing, danced in the north wing, then dined in the west wing. Whitman recalled:

> I could not help thinking, what a different scene they presented to my view a while since, fill'd with a crowded mass of the worst wounded of the war, brought in from second Bull Run, Antietam, and Fredericksburgh. Tonight, beautiful women, perfumes, the violins' sweetness, the polka and the waltz; then the amputation, the blue face, the groan, the glassy eye of the dying, the clotted rag, the odor of wounds and blood.

In the 1960s, assured that a large and permanent museum building was in the offing, the administration of the National Collection of Fine Arts turned its attention to the conservation and cataloguing of the collection and an active program of acquisitions. From its establishment as a separate Smithsonian bureau in 1920 until shortly after the end of World War II, the museum had two directors, William Henry Holmes (1920–32) and Ruel P. Tolman (1932–48). They had administered the heterogeneous collections as best they could with limited space and money during a period of varying congressional expectations and a change of name. Holmes, an accomplished painter as well as an anthropologist, made a distinguished contribution as illustrator with the Hayden expeditions to the Colorado Territory, and with the watercolors that filled the journals in which he kept a record of his own later expeditions. Tolman, also an artist, was responsible for acquiring most of the more than three hundred American miniatures owned by the museum.

The next director, Thomas M. Beggs (1948–64), was instrumental in arranging the distinctive gift to the institution of the Alice Pike Barney Collection and Barney Studio House by her daughters. David Scott, who had overseen planning for the museum's eventual move to the Patent Office Building, was director (1964–70) during the strenuous and critical period of renovation of the building and preparation of the collections for transfer and reinstallation. A vigorous effort to expand the collections began during these years, and the list of works officially accessioned in 1968, when the museum reopened, is imposing.

The emphasis on American art that had long been implicit in the museum's collections had steadily increased, becoming further clarified and focused by the need to distinguish it from the new National Gallery of Art. Now, with the move to its own home, the National Collection of Fine Arts was specifically defined as a museum of American art, although a selection of the finest non-American works in the collection was also to be exhibited.

Under the direction of Joshua C. Taylor (1970–81), an enlarged curatorial staff was able to devote scholarly attention to the permanent collection and to special exhibitions documented by accompanying publications. Taylor, a noted scholar and educator, drew wider attention to the museum. As its goals and identity became evident, a final change of name was decided upon, which would unequivocally convey its role to the public. Thus in 1980, by act of Congress, the museum was rechristened the National Museum of American Art.

Harry Lowe, formerly assistant director, became acting director after Taylor's death in 1981. From 1982 to 1988, Charles C. Eldredge served as director,

confirming the identity of the National Museum of American Art through its acquisitions and exhibitions. Elizabeth Broun, director since 1989, has maintained a strong commitment to these programs while moving the museum into new areas of collecting.

The accelerated growth of the collection that began in the 1960s has included major donations, notably more than one hundred twentieth-century paintings from S. C. Johnson & Son, Inc.; more than one hundred fifty sculptures by Paul Manship, given by the artist; an equal number of sculptures by William Zorach, from the artist's children; a sizable collection of paintings and drawings by Romaine Brooks, given by the artist; the complete works of Lyman Säyen, from his daughter, Ann Säyen; one hundred seventy paintings by William H. Johnson, from the Harmon Foundation; ninety-six objects and studio effects of Joseph Cornell; the Martha Jackson Memorial Collection, consisting of more than one hundred works by twentieth-century artists associated with her New York gallery, from Mr. and Mrs. David K. Anderson; the Sara Roby Foundation Collection of twentieth-century art, totaling one hundred sixty-nine works; and more than three hundred works commissioned for the collection of the Container Corporation of America.

In 1968 the museum acquired the sculptural contents of Hiram Powers's nineteenth-century studio in Florence, Italy, which had been preserved largely intact. Transfer arrangements have also enriched the collection. Hundreds of works created under the auspices of various New Deal programs have been assigned to the museum, and beginning in 1972 the General Services Administration has transferred sculpture studies, paintings, and other preparatory works from its Art-in-Architecture program for federal buildings. In 1983 the museum received a major group of photographs related to projects in the Visual Arts Program, funded by the National Endowment for the Arts. In addition, the National Museum of African Art transferred to this museum more than two hundred works by African-American artists. The transfer of these works has inspired major new purchases and gifts of African-American art.

In 1985 the National Museum of Natural History transferred to this museum more than a thousand paintings devoted to Native American subjects, the majority by George Catlin from his Indian gallery of the early 1830s, as well as many by Joseph Henry Sharp. The museum's holdings of work by folk artists and self-taught artists were significantly augmented by three hundred eighty-five objects, acquired in 1986 by gift and purchase, from the renowned collection of Herbert Waide Hemphill, Jr. of New York City. Mr. Hemphill's donations of additional works in each succeeding year have further enriched the collection. American abstract art between the wars was the focus of collecting for Patricia and Phillip Frost of Miami, who donated their collection of one hundred fourteen works in 1986. Contemporary American landscape photography is now well represented in the museum's collection, thanks to the generous support of the Consolidated Natural Gas Company Foundation, which made possible the acquisition of approximately two hundred images by more than fifty photographers. Another important addition to the photography collection is a group of sixty works by Irving Penn, the gift of the artist in 1988, complemented by an additional gift of sixty of Penn's portraits to the National Portrait Gallery. The museum's holdings of work by members of the Washington Color School have been enhanced by a sizable group of paintings by Gene Davis, recently bequeathed by Florence Davis.

Although housed in its own nineteenth-century building near the White House, the Renwick Gallery is part of the National Museum of American Art. Erected as the first Corcoran Gallery of Art, the building was designed by James Renwick, architect of the Smithsonian Castle. Reborn in 1972 as a museum of American crafts, the Renwick Gallery presents a range of exhibitions and educational programs while actively pursuing the acquisition of the finest American craft objects.

The historic heart of Washington's downtown has become a vital center of art in the capital, just as it was in the early nineteenth century. There the National Museum of American Art, its purpose and its name unequivocal, stands in confident affirmation of its once-and-future role in the history of American art and museums.

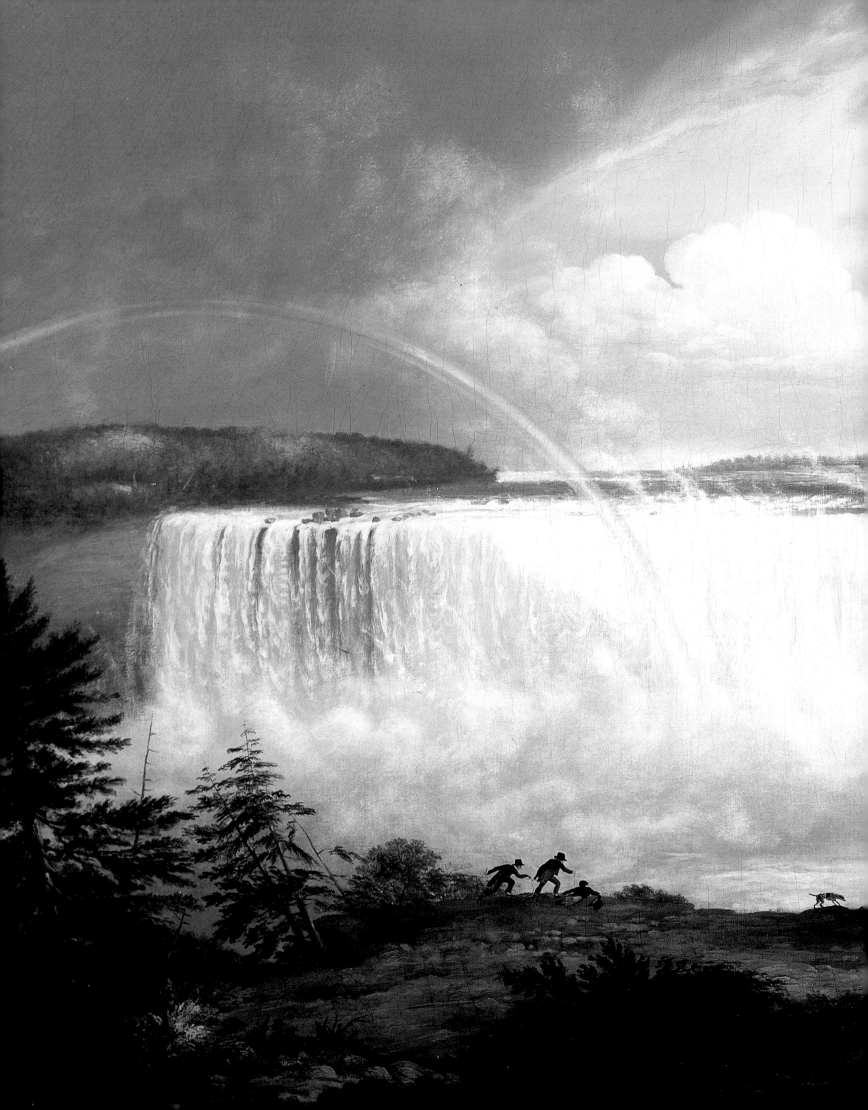

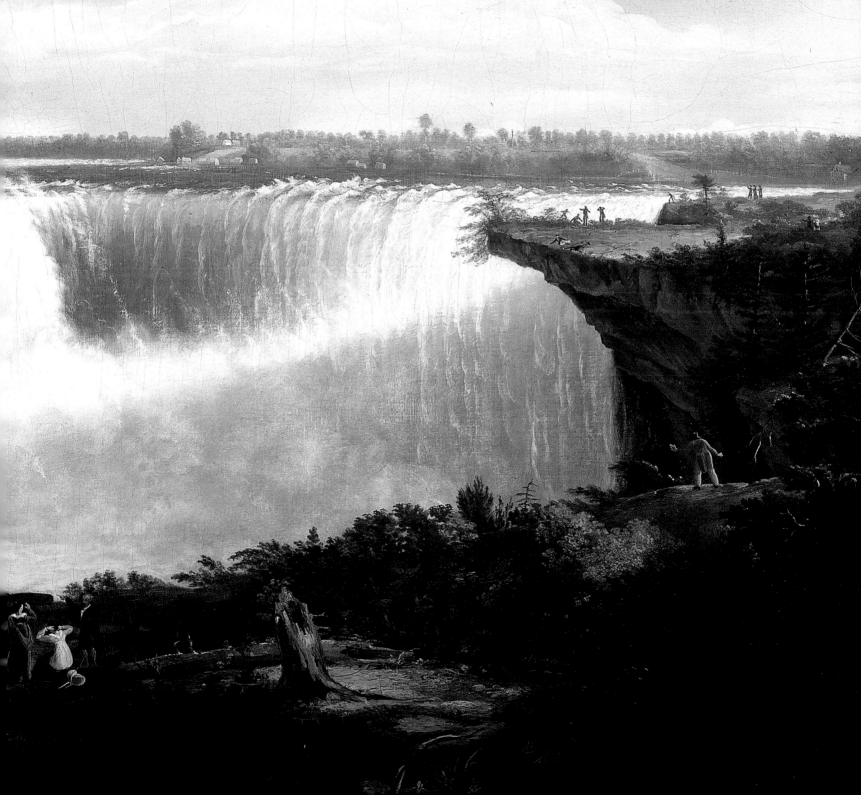

EARLY·AMERICA

Was it not for preserving the resemblance of particular persons, painting would not be known in [America]. The people generally regard it no more than any other useful trade...not as one of the most noble arts in the world.

John Singleton Copley

1738–1815

Mrs. George Watson, 1765, oil on canvas, 126.7 x 101.6 cm (49 7/8 x 40 in.). Partial gift of Henderson Inches, Jr., in honor of his parents, Mr. and Mrs. Henderson Inches, and museum purchase made possible in part by Mr. and Mrs. R. Crosby Kemper through the Crosby Kemper Foundations, the American Art Forum, and the Luisita L. and Franz H. Denghausen Endowment

You may perhaps be surprised that so remote a corner of the Globe as New England should have any d[e]mand for the necessary eutensils for practiceing the fine Arts but I assure You Sir however feeble our efforts may be, it is not for want of inclination that they are not better, but the want of opportunity to improve ourselves. [H]owever America which has been the seat of war and desolation, I would fain hope will one Day become the school of fine Arts.
—John Singleton Copley, 1762

A number of surprising details distinguish this portrait from Copley's other mature American works completed between 1760 and his departure for England in 1774. Crimson was an unusual color for Copley in this period, and Elizabeth's dress, with fine lace assuredly displayed by pearl clasps, is especially noteworthy. A delicate and rare blue and white vase holds equally rare orange parrot tulips and two guinea hen flowers. The tulip appears in only one other Copley painting and may have a special significance in the life of Mrs. Watson, perhaps as an exotic imported flower symbolizing the sitter's affluence and sophistication.

—Richard N. Murray, 1993

His talent shows itself particularly in the character portraits brought out in bold strokes.

—Johann Wolfgang von Goethe

John Trumbull
1756–1843

[In his youth, John Trumbull pondered the choice of a career.] "So far as I understood the question, law was rendered necessary by the vices of mankind,—that I had seen too much of them. In short, I pined for the arts, and again entered into an elaborate defence of my predilection, dwelling on the honors paid to artists in the glorious days of Greece and Athens. 'Give me leave to say,' replies my father, 'that you appear to have overlooked, or forgotten, one very important point in your case.' 'Pray, sir,' I rejoined, 'what is that?' 'You appear to forget, sir, that Connecticut is not Athens,'—and with this pithy remark he bowed and withdrew, and nevermore opened his lips on the subject."

—John Trumbull

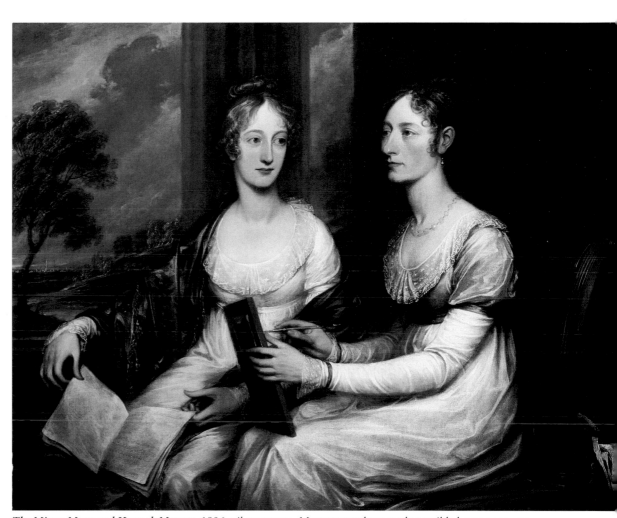

The Misses Mary and Hannah Murray, 1806, oil on canvas. Museum purchase made possible by an anonymous donor and Miss Emily Tuckerman

John Trumbull—son of a distinguished Connecticut family and graduate of Harvard who had served the young nation as an officer in the Continental Army and as a diplomat—was one of America's most versatile and accomplished artists…. In addition to his portrait work, he memorialized dramatic battle scenes from the Revolutionary War—eventually producing several historic pieces for the United States Capitol Rotunda—and painted admirable views of the American landscape….

Trumbull…enjoyed great success as a portraitist during his four-year residence in New York, counting among his patrons the municipal government as well as the city's most prominent Federalist families.

—Karol Ann Lawson, 1988

With their rolling lawns and natural settings, these estates of free men in a free society spoke to the success of the American experiment: commodious and tasteful, they were, by English standards, modest in scale as befitted the citizenry of a temperate republic.

—Edward Nygren, 1986

Thomas Birch
1779–1851

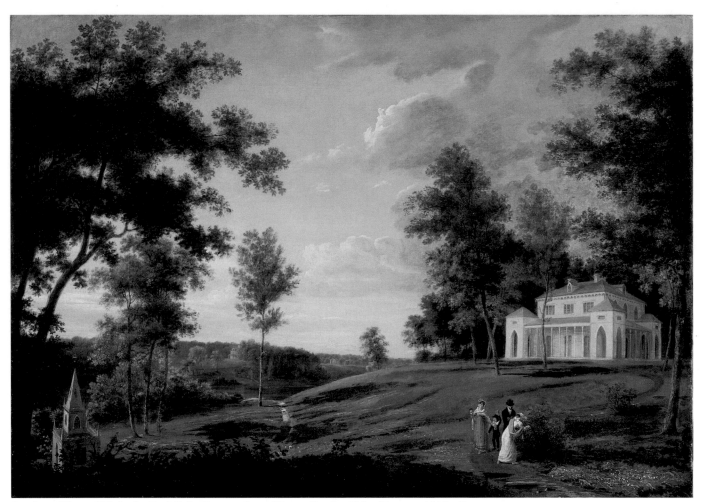

Southeast View of "Sedgeley Park," the Country Seat of James Cowles Fisher Esq., ca. 1819, oil on canvas, 87 x 122.9 cm (34 1/4 x 48 3/8 in.). Museum purchase made possible by the Luisita L. and Franz H. Denghausen Endowment

Coming to Philadelphia in 1794 with his father, Birch started his career drawing topographical cityscapes. Several of his designs were engraved by his father [William Birch] and published as *The City of Philadelphia in the State of Pennsylvania as it Appeared in 1800*, views of which depict a prosperous community. It is this theme of a civilized country which is integral to Birch's art.... With the houses at the apex of the compositions, an air of cultural confidence pervades these tranquil views of cultivated nature.

—Edward Nygren, 1986

Sedgeley Park, built in 1799 on the banks of the Schuylkill River, was the first private home in America designed in the Gothic Revival style. It was the first domestic commission for architect Benjamin Henry Latrobe, a designer of the U.S. Capitol in Washington. Birch painted *Sedgeley Park* for its second owner, James Cowles Fisher, who served as acting president of the Second Bank of the United States.

From long experience I know that resemblance in a portrait is essential, but no fault will be found with the artist, (at least by the sitter), if he improves the appearance.

Thomas Sully
1783–1872

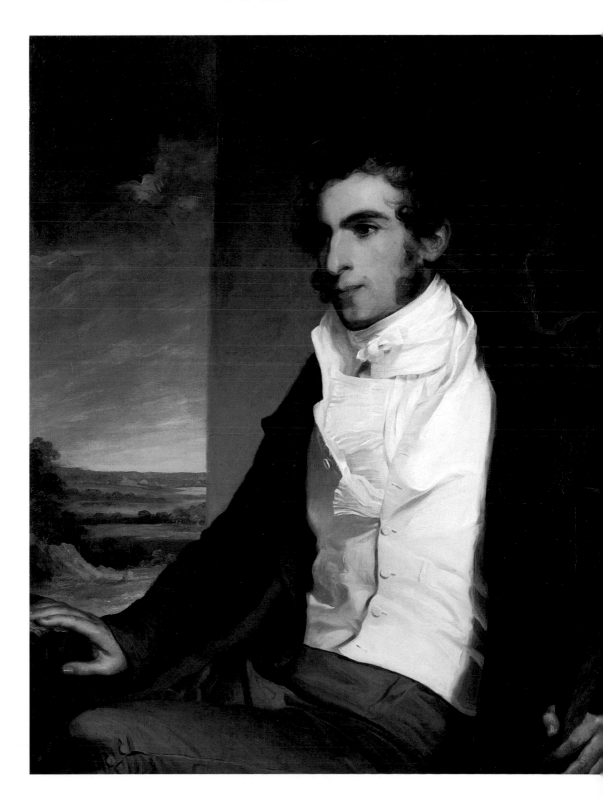

The casual elegance of Thomas Sully's portrait of *Daniel LaMotte* [a large landowner and Baltimore merchant] reflects his close study of the eighteenth-century English portrait tradition, in which aristocratic ladies and gentlemen were posed before landscape vistas suggestive of their vast estates.... The portrait, painted two years after Sully's English sojourn [in 1809-10], borrows Sir Thomas Lawrence's opalescent colors, layered translucent glazes, brilliant brushwork, and nonchalant charm, earning him the moniker "The American Lawrence."

—William H. Truettner, 1983

Daniel LaMotte, 1812/13, oil on canvas mounted on wood, 92.3 x 73.8 cm (36 3/8 x 29 in.). Gift of Mr. and Mrs. Ferdinand LaMotte III

To study Nature was to ramble through her domains late and early, and if I observe all as I should, that the memory of what I saw would at least be of service to me.

John James Audubon
1785–1851

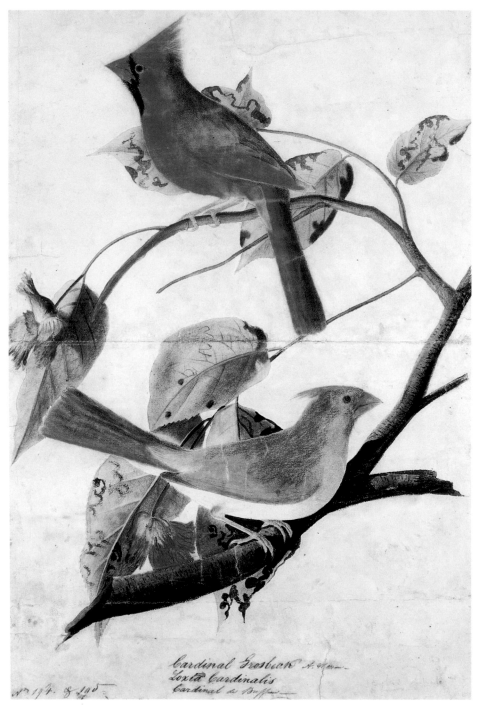

Cardinal Grosbeak, 1811, chalk, pencil, watercolor, and ink on paper, 42.6 x 29 cm (16 13/16 x 11 5/16 in.). Transfer from Smithsonian Institution, National Museum of Natural History, Division of Birds

In the swamps we met with warblers of various kinds, lively and beautiful, waiting in these their winter retreats for the moment when Boreas should retire to his icy home, and the gentle gales of the South should waft them toward their breeding-places in the North. Thousands of Swallows flew about us, the Cat-birds mewed in answer to their chatterings, the Cardinal Grosbeak elevated his glowing crest as he stood perched on the magnolia branch, the soft notes of the Doves echoed among the woods, nature smiled upon us, and we were happy.

—John James Audubon, 1830s

One of the most extraordinary things among all these adverse circumstances was that I never for a day gave up listening to the songs of our birds, or watching their peculiar habits, or delineating them in the best way that I could; nay, during my deepest troubles I frequently would wrench myself from the persons around me, and retire to some secluded part of our noble forests; and many a time, at the sound of the wood-thrush's melodies have I fallen on my knees, and there prayed earnestly to our God.

—John James Audubon, 1833

My life has been...what I apprehend to have been the life of most of the American artists, a life of toil, seeking the realization of a dream—of hope and disappointment—so that it is difficult, perhaps, to say whether I was wise or foolish in choosing a profession.

Alvan Fisher
1792–1863

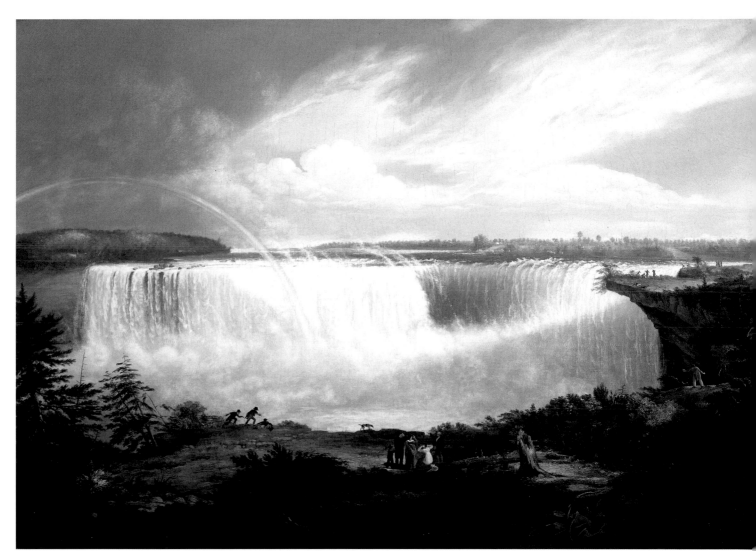

The Great Horseshoe Fall, Niagara, 1820, oil on canvas, 87.2 x 122 cm (34 3/8 x 48 1/8 in.). Museum purchase

Niagara Falls was the most frequently described and depicted natural wonder in North America. No other site in the New World was represented so many times by so many artists in so many ways.... The most prominent American painter to visit the Falls in the period from 1815 to 1825 was Alvan Fisher. *The Great Horseshoe Fall, Niagara*...captures the cataract's awesome grandeur by introducing storm clouds, astonished visitors, and a great rainbow.

 An unprecedented number of visitors populate Fisher's...view of the Horseshoe Fall [indicating] that by 1820 the once-remote spot had become a popular attraction.

—Jeremy Adamson, 1985

EARLY *A*MERICA

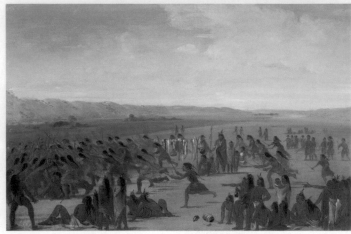

Ball Play of the Women, Prairie du Chien, 1835–36, oil on canvas, 49.7 x 70 cm (19 1/2 x 27 5/8 in.). Gift of Mrs. Joseph Harrison, Jr.

While rarely revealing the ideas that formed their attitudes, painters drew on well-established European intellectual constructs regarding primitivism and the Noble Savage. First developed in the late sixteenth century, the concept of the Noble Savage was used by eighteenth-century writers and philosophers such as Rousseau, Voltaire, and Diderot to criticize contemporary French morals and practices.... By the end of the eighteenth century the Noble Savage suggested other meanings. Previously viewed as an enlightened savage, he could now also be pictured as a "primitive," a man of intuition and emotion. At the beginning of the nineteenth century American painters suggested both concepts in their paintings of Indians.

—Julie Schimmel, 1991

Catlin's

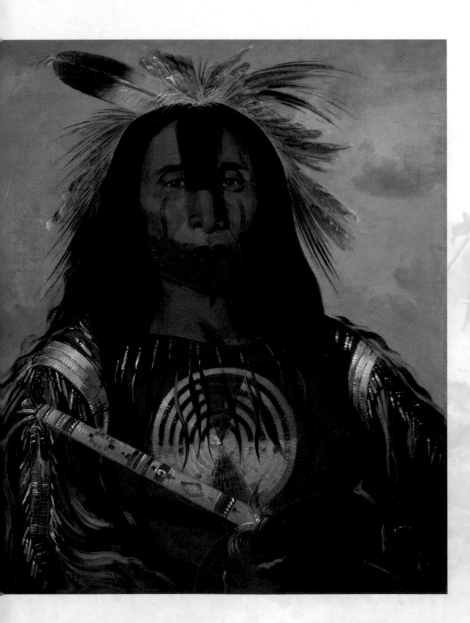

Catlin abandoned a law career to pursue his interest in art. In the early 1820s he achieved some success as a portrait miniaturist in Philadelphia. His real goal, however, was to depict American Indians and preserve their fast-disappearing culture. In 1830 he met explorer William Clark in Saint Louis and with him visited tribes living near the Mississippi River. In 1832 he traveled up the Missouri River to Fort Union, North Dakota. His portraits of the Mandans, with whom he stayed in 1832 before smallpox reduced the tribe in 1837, are today among his best-known works. By 1834, after crossing the southern plains to paint the Comanche, Catlin had visited more western tribes than had any other artist of his day. In 1841 he published his experiences and research in a two-volume work. His Indian Gallery (including artifacts and live Indian performers as well as nearly six hundred paintings) was exhibited throughout the East Coast and in Europe.

—Joni Louise Kinsey, 1991

Buffalo Bull's Back Fat, head chief, Blood Tribe, 1832, oil on canvas, 73.7 x 60.9 cm (29 x 24 in.). Gift of Mrs. Joseph Harrison, Jr.

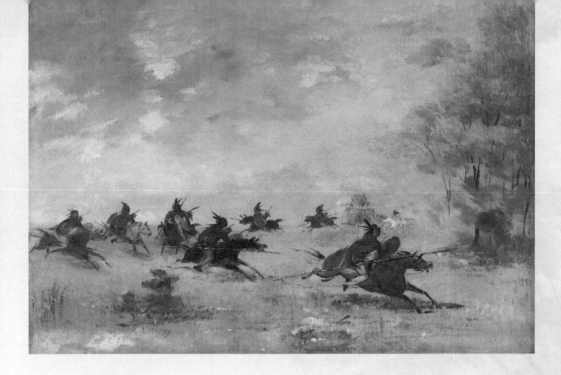

Comanche War Party, Mounted on Wild Comanche Horses, 1834–37, oil on fabric, 49.7 x 70 cm (19 5/8 x 27 5/8 in.). Gift of Mrs. Joseph Harrison, Jr.

Indian Gallery

Red, the color of blood, the color of life, flowed so abundantly in his gloomy Museum that it was like an intoxication; and the landscapes— wooded mountains, vast savannas, deserted rivers—were monotonously, eternally green. Once again I find Red (so inscrutable and dense a color, and harder to penetrate than a serpent's eye)—and Green (the color of Nature, calm, gay and smiling)—singing their melodic antiphon in the very faces of these two heroes.— There is no doubt that all their tattooing and pigmentations had been done in accordance with the harmonious modes of nature.

—Charles Baudelaire, 1846

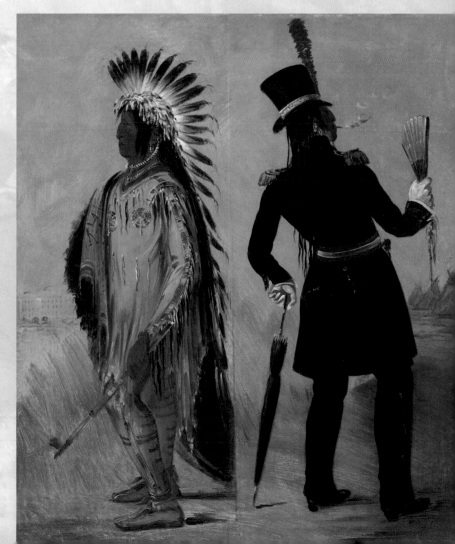

Pigeon's Egg Head (The Light) going to and returning from Washington, 1837–39, oil on canvas, 73.6 x 60.9 cm (29 x 24 in.). Gift of Mrs. Joseph Harrison, Jr.

But for this gallery [of King's portraits], our posterity would ask in vain—'what sort of a looking being was the red man of this country?'

—Jonathan Elliot, 1830

Charles Bird King
1785–1862

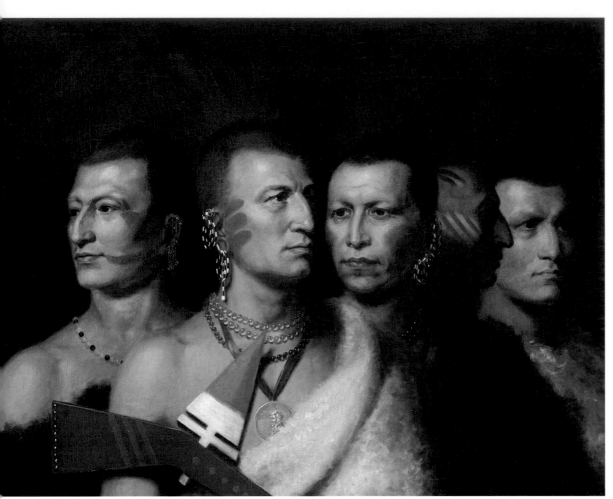

Young Omahaw, War Eagle, Little Missouri, and Pawnees, 1821,
oil on canvas, 91.8 x 71.1 cm (36 1/8 x 28 in.). Gift of Miss Helen Barlow

The first Indians known to have been painted by King were members of a delegation of 16 leaders from the Pawnee, Omaha, Kansa, Oto, and Missouri Tribes of the Great Plains who arrived in Washington on November 29, 1821.... *The National Intelligencer* of November 30, 1821, heralded their arrival: "Their object is to...learn something of that civilization of which they have hitherto remained in total ignorance. They are from the most remote tribes with which we have intercourse, and they are believed to be the first of those tribes that have ever been in the midst of the settlements."

—John C. Ewers, 1953

"My Great Father, I have traveled a great distance to see you—I have seen you and my heart rejoices. I have heard your words...and I will carry them to my people as pure as they came from your mouth....[I] have seen your people, your homes, your vessels on the big lake, and a great many wonderful things far beyond my comprehension, which appears to have been made by the Great Spirit and placed in your hands.... [But] it is too soon to send those good men [the missionaries] among us—we are not starving yet— we wish you to permit us to enjoy the chase until the game of our country is exhausted— until the wild animals become extinct.... I have grown up and lived this long without work. I am in hopes you will suffer me to die without it. We have everything we want—we have plenty of land, if you will keep your people off it.

—Sharitarish, Pawnee leader, 1822

The painter of American scenery has indeed privileges superior to any other;

all nature here is new to Art.

Thomas Cole
1801–1848

To me it seems that he is certain to take a higher rank after his death than was yielded to him in life. When I visit the collection of his pictures lately made for exhibition; when I see how many great works are before me...when I consider with what mastery, yet with what reverence he copied the forms of nature, and how he blended with them the profoundest human sympathies, and made them the vehicle, as God has made them, of great truths and great lessons...I say within myself, this man will be reverenced in future years as a great master in art.

—William Cullen Bryant, 1848

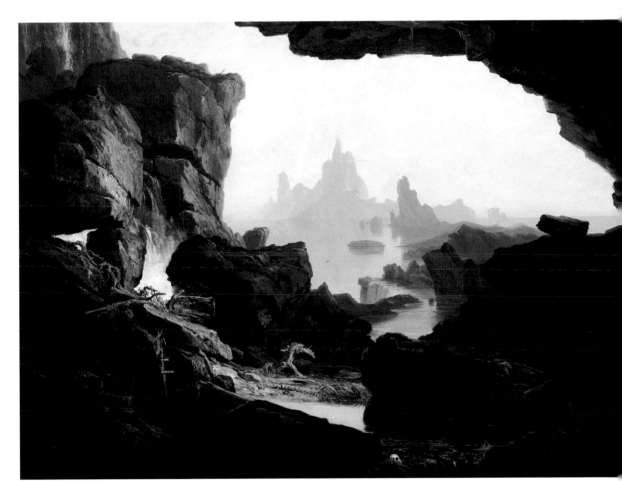

Subsiding of the Waters of the Deluge, 1829, oil on canvas, 90.8 x 121.4 cm (35 3/4 x 47 5/8 in.). Gift of Mrs. Katie Dean in memory of Minnibel S. and James Wallace Dean and museum purchase through the Smithsonian Institution Collections Acquisition Program

Confronting a nature "new to Art," Cole and other early landscapists engaged in what might be usefully thought of as aesthetic pioneering.... Nature had to be seized, tamed, brought under the dominion of artistic law. Stripped of its unfamiliarity and otherness, the land became "ours," the material out of which artist or writer shaped a cultural artifact.

—Alan Wallach, 1994

EARLY *A*MERICA

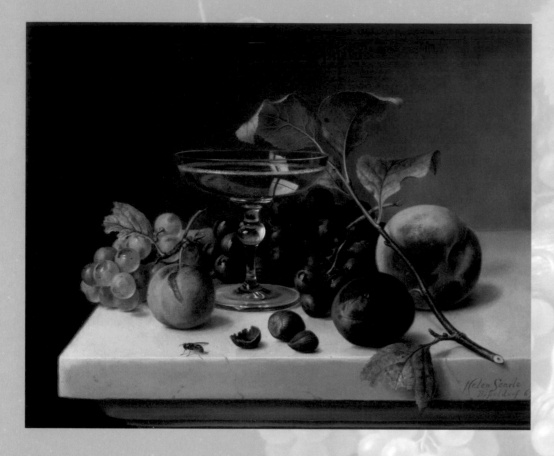

Helen Searle (1830–1884), *Still Life*, 1869, oil on canvas mounted on canvas, 28.4 x 36 cm (11 1/8 x 14 1/8 in.). Museum purchase

Raphaelle Peale's still lifes are overwhelmingly food still lifes.... They are not, however, about actual eating, or the sheer, unabashed enjoyment of food and drink.... [I]n the impeccably careful, sensitively balanced, and measured placement of their objects and the geometric purity of their form—[they] are almost more metaphysical than physical. In that respect they have something of the stringency and austerity of seventeenth-century Spanish still lifes such as those particularly by Zurbarán, van der Hamen, and Sánchez Cotán, two of which we know were exhibited at the Pennsylvania Academy in 1818.
—Nicolai Cikovsky, Jr., 1988

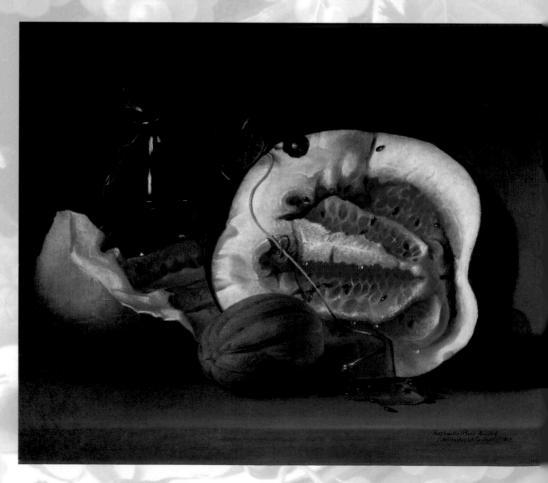

Raphaelle Peale (1774–1825), *Melons and Morning Glories*, 1813, oil on canvas, 52.6 x 65.4 cm (20 3/4 x 25 3/4 in.). Gift of Paul Mellon

Abbott Handerson Thayer (1849–1921), *Roses*, ca. 1896, oil on canvas, 56.6 x 79.7 cm (22 3/8 x 31 3/8 in.). Gift of John Gellatly

John Singer Sargent (1856–1925), *Pomegranates, Majorca*, ca. 1908, oil on canvas, 57.2 x 72.4 cm (22 1/2 x 28 1/2 in.). Partial and promised gift of Davis S. Purvis

Nature's Bounty

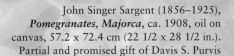

Roesen's methodology is an extremely synthetic one. While he may have worked, in part at least, from actual objects, the size of so many of his works would preclude his dependence upon the "living models," which would spoil and perish before he could complete such works. It seems that he may have had templates that he rearranged from painting to painting, for almost every element in a Roesen still life is repeated in other works, occasionally many times over.

—William H. Gerdts, 1981

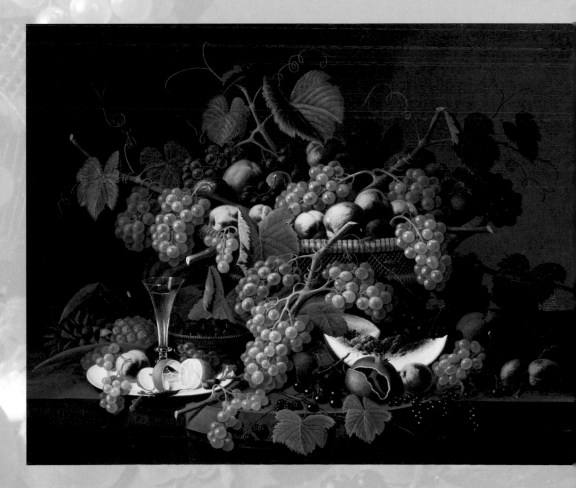

Severin Roesen(1815–after 1872), *Still Life*, 1852, oil on canvas, 86.5 x 111.5 cm (34 x 44 in.). Museum purchase and gift of Maria Alice Murphy in memory of her brother, Col. Edward J. Murphy, Jr.

EARLY \mathscr{A} MERICA

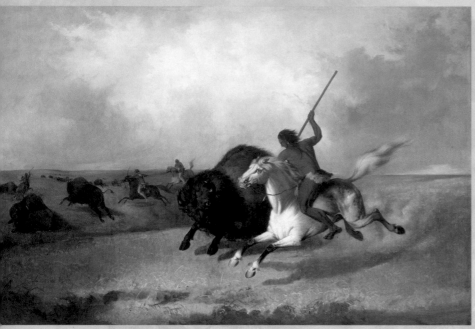

Most artists who painted western scenes...relied on a stylistic vocabulary drawn from the same sources used by those who painted more conventional subjects. But subjects representing westward expansion, whether painted by artists residing in the East or the West, more commonly (and more vigorously) extol the idea of progress, a concept mid nineteenth-century boosters of the West took very seriously. It was a religion, in a way, a belief in democracy and free enterprise as key factors in creating a superior civilization. And it presupposed industrial growth and territorial expansion as the means to accomplish that end.

—William H. Truettner, 1991

John Mix Stanley (1814–1872), *Buffalo Hunt on the Southwestern Prairies*, 1895, oil on canvas, 154.3 x 102.8 cm (60 3/4 x 40 1/2 in.). Gift of the Misses Henry, 1908

Had Charles Christian Nahl struck it rich in 1851 at Rough and Ready (a notorious mining camp near Sacramento), the gold-rush era in California might never have been portrayed in such detailed and lively terms. For Nahl subsequently became the painter laureate of San Francisco, famed not only for his views of life among the '49ers in the gold fields, but for his elaborate portraits and scenes of California history.

Miners in the Sierra was one of the first paintings produced by Charles Nahl and August Wenderoth after the two opened a studio in Sacramento in 1851. The subject comes as no surprise, an authentic placer mining operation probably composed and finished by Nahl, to which Wenderoth added the distant landscape.... For all his recent disappointment, Nahl here seems no less intrigued by the commitment of those who continued to search for gold, and by the unyielding character of the strange new environment to which he had come.

—William H. Truettner, 1983

William Henry Holmes (1846–1933), *Folded Strata, a Great Geological Arch, Colorado*, 1874, watercolor and pencil on paper, 17.7 x 24.2 cm (7 x 9 9/16 in.). Gift of Dr. William Henry Holmes

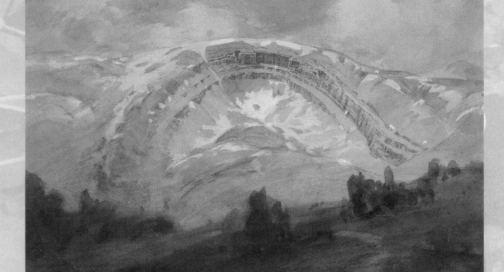

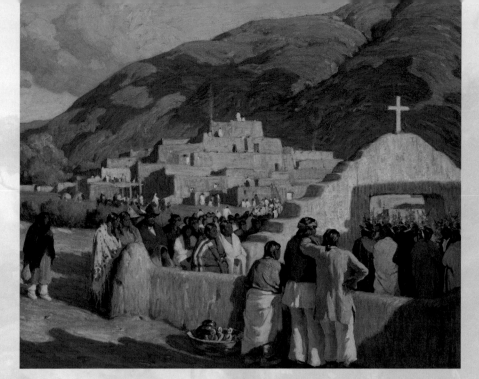

Joseph Henry Sharp (1859–1953), *Sunset Dance—Ceremony to the Evening Sun*, 1924, oil on canvas, 63.8 x 76.2 cm (25 1/8 x 30 in.). Gift of Arvin Gottlieb

Western Vistas

Lewis and Clark had shown the West to be immense in size and possibilities. They had also, in wading into the Pacific surf, shown it to be finite.... The frontier was necessarily temporary, and westering timebound. Thus the commanding theme, the *understood* theme, of nineteenth-century western art was change. But when change played itself out in traditional terms, when the last Indian tribes were defeated and confined on reservations, the vacant lands occupied, and Frederick Jackson Turner had rung down the curtain on pioneering, positive that America was entering a new and unknown period in its history, western art simply stopped time.

—Brian W. Dippie, 1992

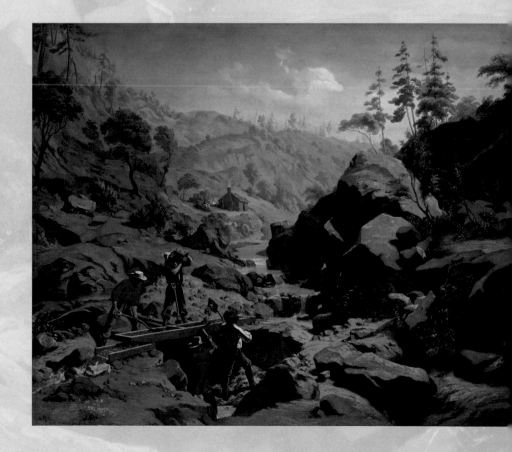

Charles Nahl (1818–1878) and August Wenderoth (1819-1884), *Miners in the Sierra*, 1851-52, oil on canvas, 137.7 x 169.8 cm (54 1/4 x 67 in.). Gift of the Fred Heilbron Collection

Our lives are in the hands of the Great Spirit. We are determined to defend our lands, and if it be his will, we wish to leave our bones upon them.

—Tecumseh

Ferdinand Pettrich
1798–1872

Tecumseh and his party overtook the main army near the Moravian towns, situated on the north side of the Thames. Here he resolved that he would retreat no further..... After the Indians were posted in the swamp, in the position occupied by them during the battle, Tecumseh remarked to the chiefs by whom he was surrounded, "brother warriors! we are now about to enter into an engagement from which I shall never come out—my body will remain on the field of battle." He then unbuckled his sword, and placing it in the hands of one of them, said, "when my son becomes a noted warrior, and able to wield a sword, give this to him." He then laid aside his British military dress, and took his place in the line, clothed only in the ordinary deer-skin hunting shirt.
—Benjamin Drake, 1841

The Dying Tecumseh, 1856, marble, length 197.2 cm (77 5/8 in.). Transfer from the U.S. Capitol

Tecumseh died at the Battle of the Thames, the American victory signaling the end of combined British and Indian resistance in the Old Northwest.... By the 1850s Tecumseh probably symbolized Indian opposition to westward expansion as effectively as had any Indian in United States history. The Shawnee chief had organized a formidable Indian confederacy in the Old Northwest between 1805 and his death eight years later. He urged local tribes to resist white purchase of Indian land and to continue communal ownership of property—ideas that made him an Indian nationalist and leader of enduring fame. Even whites recognized his greatness, but his death, tragic as they made it out to be, signaled the inevitability of white advance. Pettrich's marble, which creates for Tecumseh the role of a dying Roman general, passes judgment on all Indian "heroes" who died in battle against whites. Their courage and skill, Pettrich maintains, were devoted to the wrong cause. Their deaths argued not for Indian rights but for the triumph of expansionism.

—Julie Schimmel, 1991

His art, as he saw it, was a public art, and it was finally to the American public

that he wished his art to speak.

—Joshua Taylor, 1975

Emanuel Leutze
1816–1868

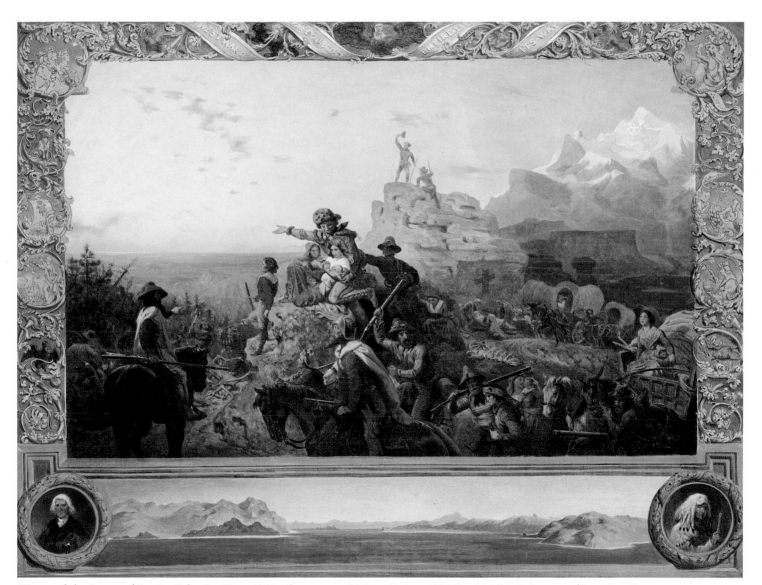

Westward the Course of Empire Takes Its Way , 1861, oil on canvas, 84.5 x 110.1 cm (33 1/4 x 43 3/8 in.). Bequest of Sara Carr Upton

It was delightful to see [Leutze] so calmly elaborating his design to go on the walls of the Capitol, while other men doubted and feared, or hoped treacherously, and whispered to one another that the nation would exist only a little longer, or that, if a remnant still held together, its centre and seat of government would be far northward and westward of Washing-ton. But the artist keeps right on [despite the Civil War], firm of heart and hand, drawing his outlines with an unwavering pencil, beautifying and idealizing our rude, material life, and thus manifesting that we have an indefeasible claim to a more enduring national existence.

—Nathaniel Hawthorne, 1862

Go first to Nature to learn to paint landscape, and when you shall have learnt to imitate her, you may then study the pictures of great artists with benefit.

Asher B. Durand
1796–1886

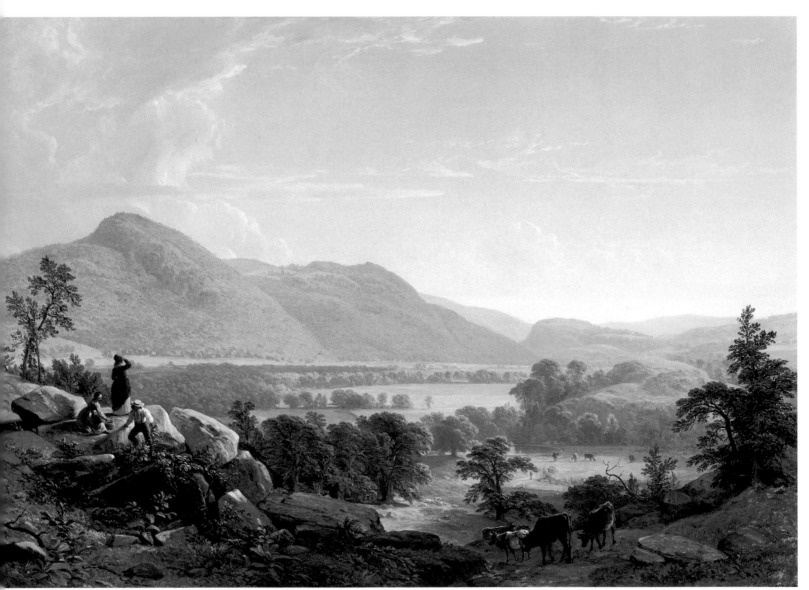

Dover Plain, Dutchess County, New York, 1848, oil on canvas, 107.9 x 153.7 cm (42 1/2 x 60 1/2 in.). Gift of Thomas M. Evans and museum purchase through the Smithsonian Institution Collections Acquisition Program

Durand was no less a moralist [than Thomas Cole], but he constructed a more docile form of nature. In the simple design and patient detail of *Dover Plain*, his message is not of judgment or doom but of peace and order, the sustaining virtue of rural America.
—William H. Truettner, 1980

Although much has been done, and well done, by the gifted Cole and others, much more remains to do. Go not abroad then in search of material for the exercise of your pencil, while the virgin charms of our native land have claims on your deepest affections.
—Asher B. Durand, 1855

My trip to Europe has to some extent enabled me to judge of my own talent. Of all the landscapes I saw in Europe (and I saw thousands) I do not feel discouraged.

Robert Scott Duncanson
1821/1822–1872

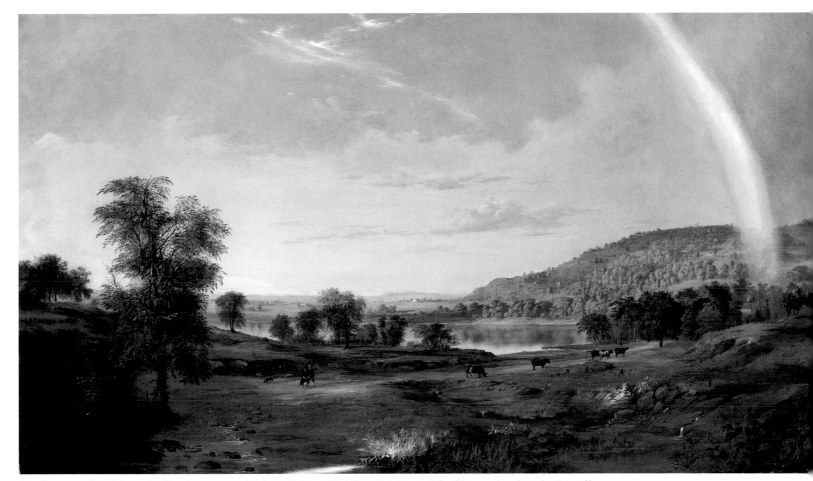

Landscape with Rainbow, 1859, oil on canvas, 76.3 x 132.7 cm (30 1/8 x 52 1/4 in.). Gift of Leonard and Paula Granoff

Duncanson's biography is meager and often contradictory in details.... The artist was born in Seneca County, New York in 1821 or 1822. The son of a free black or mulatto mother and a Scottish-Canadian father, young Duncanson moved to Canada, perhaps to Wilberforce, Ontario....

In 1853 Duncanson made his first documented trip to Europe, perhaps financed by the Anti-Slavery League. Accompanied by fellow landscapists William Louis Sonntag and John Robinson Tait, he visited England, France, and Italy.

—Lynda Roscoe Hartigan, 1985

This letter will be handed to you by Mr. Duncanson, a self-taught artist of our city [Cincinnati]. He is a man of integrity and gentlemanly deportment, and when you shall see the first landscape he shall paint in Italy, advise me the name of the artist in Italy that, with the same experience, can paint so fine a picture.
—Nicholas Longworth, 1852

A hundred years from now those pictures [of blacks] alone will have kept him famous.

—*New York Evening Post*, 1879

Winslow Homer

1836–1910

A Visit from the Old Mistress, 1876, oil on canvas, 45.7 x 61.3 cm (18 x 24 1/8 in.). Gift of William T. Evans

[Homer] is almost barbarously simple, and, to our eye, he is horribly ugly; but there is nevertheless something I like about him. What is it? For ourselves, it is not his subjects.... He has chosen the least pictorial features of the least pictorial range of scenery and civilisation; he has resolutely treated them as if they were pictorial, as if they were every inch as good as Capri or Tangiers; and, to reward his audacity, he has incontestably succeeded.

—**Henry James, 1875**

A *Visit from the Old Mistress* crystallizes into a single moment the staggering realization faced by all Southerners after the Civil War—both black and white— that things will never again be the same, that American society had been irrevocably changed by the abolition of slavery.... No longer did a black woman feel obliged to rise from her seat when a white woman entered the room.

—**Peter H. Wood and Karen C. C. Dalton, 1989**

"Squire Jack" is the obvious master of his abode, a self-reliant man not to be trifled with,

a man who symbolizes the independent spirit.

—Jean Jepson Page

Frank Blackwell Mayer
1827–1899

Independence (Squire Jack Porter), 1858, oil on paperboard, 30.4 x 40.3 cm (12 x 15 7/8 in.). Harriet Lane Johnston Collection

These years before the Civil War seem to have been by far the most rewarding ones for the painter.... Some of Mayer's most appealing works were painted at this time. Among them [is] *Independence, Squire Jack Porter*...executed in 1858 with rather fluid brushwork, and...demonstrating an interest, modern for its time, in the play of light and the juxtaposition of color values....

A summer trip to Annapolis in 1873 was an inspiration. He loved the "old mansions and gardens, and the beautiful Bay" and noted that they gave him "locality and surrounding...the History of Maryland certainly presents a great number of 'situations' for the painter with my knowledge of costume, etc." In December 1876 he bought his first house in Annapolis, calling it the Mare's Nest, and more or less retired to the town for the rest of his life. Over the door he inscribed the motto "He lives best who lives well in obscurity."

—Jean Jepson Page, 1976

My highest ambition lies in excelling in the art. I pursue it not as a source of gain or merely as an amusement, I trust I have higher aims than these.

Frederic Edwin Church
1826–1900

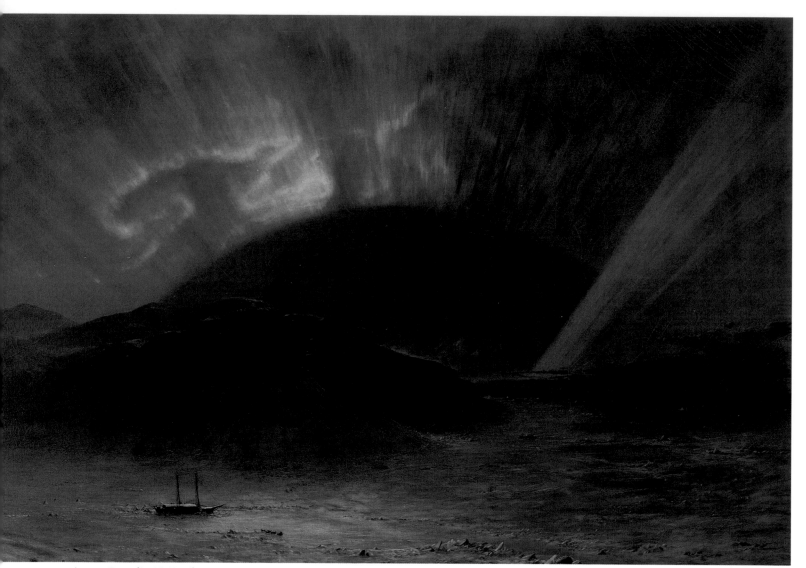

Aurora Borealis, 1865, oil on canvas, 142.3 x 212.2 cm (56 1/8 x 83 1/2 in.). Gift of Eleanor Blodgett

The light grew by degrees more and more intense, and from irregular bursts it settled into an almost steady sheet of brightness...The color of the light was chiefly red, but this was not constant, and every hue mingled in the fierce display. Blue and yellow streamers were playing in the lurid fire...they melt into each other, and throw a ghostly glare of green into the face and over the landscape.... Upon the mountain tops, along the white surface of the frozen waters, upon the lofty cliffs, the light glowed and grew dim and glowed again, as if the air was filled with charnel meteors, pulsating with wild inconstancy over some vast illimitable city of the dead. The scene was noiseless, yet the senses were deceived, for unearthly sounds seemed to follow the rapid flashes, and fall upon the ear.

—Isaac L. Hayes, 1867

This living out of doors, night and day, I find of great benefit. I do not know what some of your Eastern folks would say, who call night air injurious, if they could see us wake up in the morning with the dew on our faces!

Albert Bierstadt
1830–1902

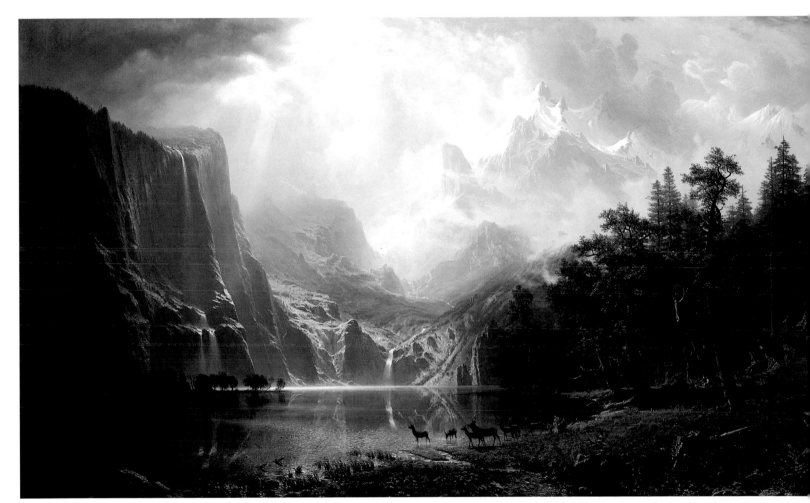

Among the Sierra Nevada Mountains, California, 1868, oil on canvas, 183 x 305 cm (72 x 120 in.). Bequest of Helen Huntington Hull, granddaughter of William Brown Dinsmore, who acquired the painting in 1873 for "The Locusts," the family estate in Dutchess County, New York

By the time Albert Bierstadt painted *Among the Sierra Nevada Mountains, California*, he had been traveling in the West, on and off, for about ten years, and his largest landscapes were not so much views of actual places as distillations of scenic wonders.... Whatever was grand and imposing about the West Bierstadt had learned to sum up in an exuberant, dramatic fashion, both to convey his response to the magnificent scenery and to capture the imagination of audiences back East, who were soon paying record prices for every major painting he produced.... He was the first major landscape painter to observe the Rockies and to make the difficult journey to the West Coast.

—William H. Truettner, 1980

EARLY *A*MERICA

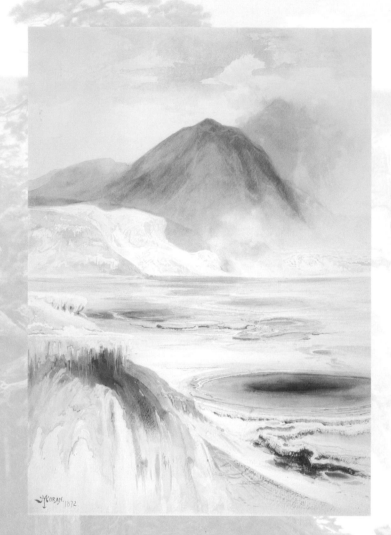

Mammoth Hot Springs, Yellowstone, 1872, watercolor and pencil on paper, 36.3 x 26.4 cm (14 5/16 x 10 3/8 in.). Gift of Mrs. Armistead Peter III

The motive or incentive of my "Grand Canyon of the Yellowstones" [sic] was the gorgeous display of color that impressed itself upon me.... I did not wish to re-alize the scene literally, but to preserve and convey its true impression....

The precipitous rocks on the right were really at my back when I stood at that point, yet...every member of the expedition with which I was connected de-clared, when he saw the painting, that he knew the exact spot which had been reproduced.

—Thomas Moran

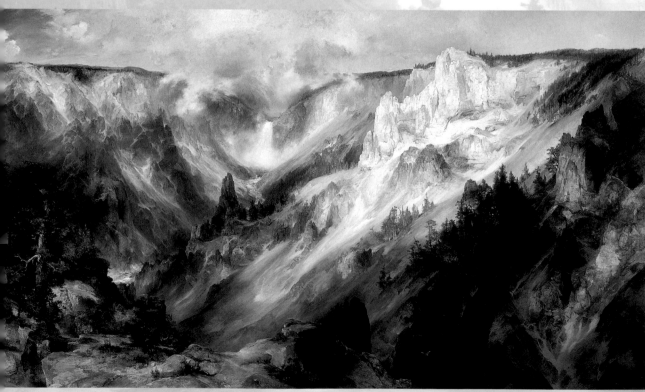

The Grand Canyon of the Yellowstone, 1893-1901, oil on canvas, 245.1 x 427.8 cm (96 1/2 x 168 3/8 in.). Gift of George D. Pratt

Moran was always seeing imaginative compositions. When talking of his subjects it was fascinating to watch his eyes. Clear, blue and sparkling, they looked at you but they looked far beyond. He saw what he was talking about. Frederick [sic] Church could close his eyes and see his picture as vividly as if real. Moran did not have to close his eyes.

—Howard Russell Butler, 1926

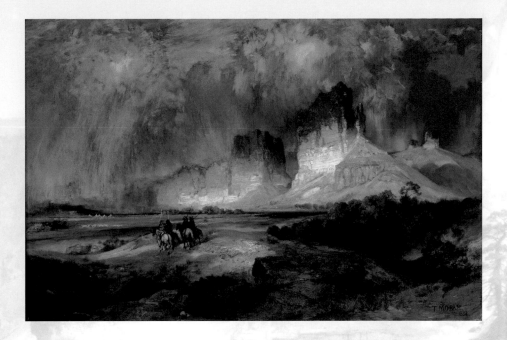

Cliffs of the Upper Colorado River, 1893-1901, oil on canvas, 40.5 x 61 cm (16 x 24 in.). Bequest of Henry Ward Ranger through the National Academy of Design

Thomas Moran

1837–1927

Excelsior Geyser, Yellowstone Park, 1873, watercolor and pencil on paper, 31.9 x 24.8 cm (12 9/16 x 9 13/16 in.). Gift of Mrs. Armistead Peter III

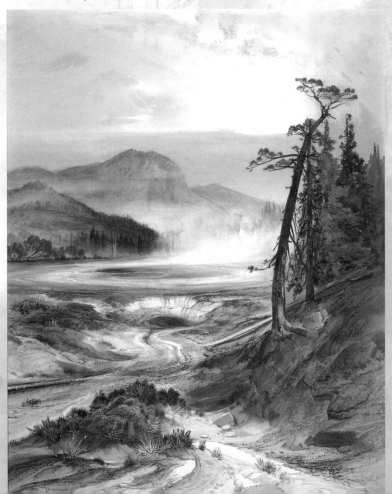

The majestic array of cliffs that line the banks of the Green River, in southwestern Wyoming, ranked high on Thomas Moran's list of favorite western subjects. To this formation he returned time and again, sketching it from different angles and under changing skies, staging it finally as a symbol of the breadth and grandeur of the western landscape. The most immediate source for *Cliffs of the Upper Colorado* seems to have been several Green River sketches done by the artist in 1879, [although] elements of these have been rearranged, and several topographical features added....

By the time Moran painted *Cliffs of the Upper Colorado*, he was at the height of his powers; indeed, some of his greatest triumphs were already behind him. Eleven years earlier, as a member of the Hayden expedition, he had made his first trip west, following the geological survey through the wonders of the Yellowstone. He returned with an assortment of pencil sketches and watercolors (and photographs by W. H. Jackson) that remained a source of inspiration for the rest of his career, and that were immediately translated into his first monumental western landscape, *The Grand Canyon of the Yellowstone*.

—William H. Truettner, 1980

Martin's landscapes look as if no one but God and himself had ever seen the place.

—Comment of unknown contemporary

Homer Dodge Martin

1836–1897

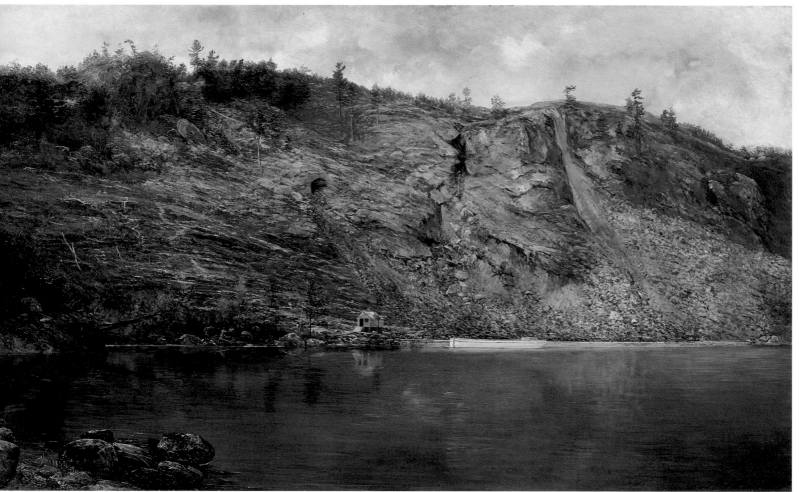

The Iron Mine, Port Henry, New York, ca. 1862, oil on canvas mounted on fiberboard, 76.5 x 127 cm (30 1/8 x 50 in.). Gift of William T. Evans

Close to the work of John Frederick Kensett in its handling, [*The Iron Mine*] is typically Martin in its subject and approach. Out of simple elements, Martin constructs a solemn scene, with the massive, richly textured cliff rising imposingly from the bay. The serenity of the water's surface is in contrast to the varied brushwork and impasto of the cliff....

Although a miner's shack, a dock strewn with ore, and a low-lying transport barge lie at the water's edge, there is no life or activity here. In the absence of humanity, the shoreline itself...is the mediator between the rock and the water....

Martin probes his cliff diligently for its quirky details and ponders its watery reflections, but in the end he subordinates naturalism to invention. His friend Elihu Vedder reported that on one occasion Martin "was found very busy painting some plants in the foreground of a picture; on being asked what the plant was, he said, 'Why don't you know that plant?—that's the foreground plant; I use lots of it.' "

—William Kloss, 1985

[Colman's] rendering of smoke would delight Ruskin; coal-smoke heavily but gracefully uncoiling itself before a light breeze, as it slowly mounts the sky, letting the eye through its dark masses into the clear light beyond.

—J. J. Jarves, 1863

Samuel Colman
1832–1920

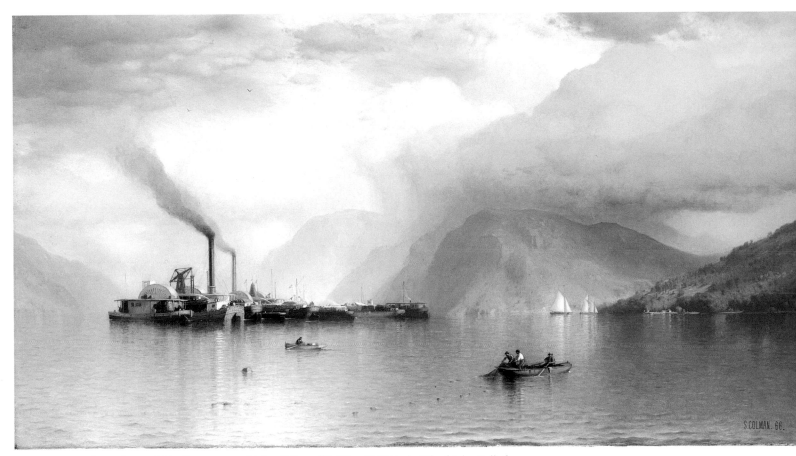

Storm King on the Hudson, 1866, oil on canvas, 81.6 x 152 cm (32 1/8 x 59 7/8 in.). Gift of John Gellatly

Colman has just finished a fine landscape...full of rich color and great truthfulness. The 'noble Hudson' is represented in its best aspect, a stormy sky is covering the tops of the Highlands, while here and there a gleam of sunlight shines out and is reflected on the surface of the stream, the tow boats are coming down, heavily burdened.

— Paletta, 1867

...When the Storm King smites his thunderous gong
Thy hills reply from many a bellowing wave;
And when with smiles, the sun o'erlooks their brow,
He sees no stream more beautiful than thou.
—Untitled poem by unknown nineteenth-century poet

EARLY AMERICA

Her garden [Cecilia Thaxter's on the Isle of Shoals]...was unlike any other garden, although more beautiful, perhaps, than the more conventional gardens I have seen lately; for it was planted all helter-skelter, just bursts of color here and there,— and what color! I have been told the sea-air makes the color of the flowers more vivid than they appear in inland gardens. Certainly it was so in this garden.

—Maud Appleton McDowell, 1935

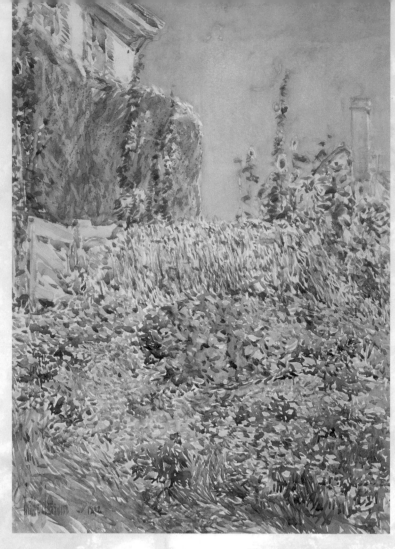

Childe Hassam (1859–1935), *Dexter's Garden*, 1892, watercolor on paper, 50.2 x 35.8 cm (19 13/16 x 14 1/8 in.). Gift of John Gellatly

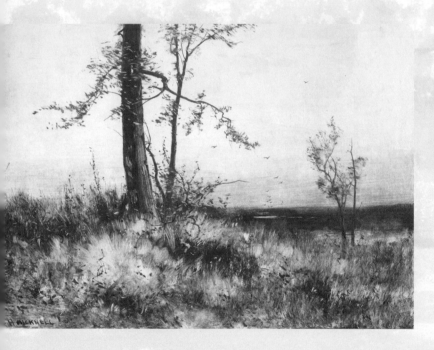

Albion Harris Bicknell (1837–1915), *Mill Pond*, n.d., monotype, 35.4 x 50.8 cm (13 15/16 x 20 in.). Gift of Brian A. Higgins and Jane Edgington Higgins

Mary Nimmo Moran (1842–1899), *The Old Homestead*, 1880, etching and chine collé on paper, 19.4 x 29.8 cm (7 3/4 x 11 15/16 in.). Transfer from Smithsonian Institution, National Museum of American History, Division of Graphic Arts

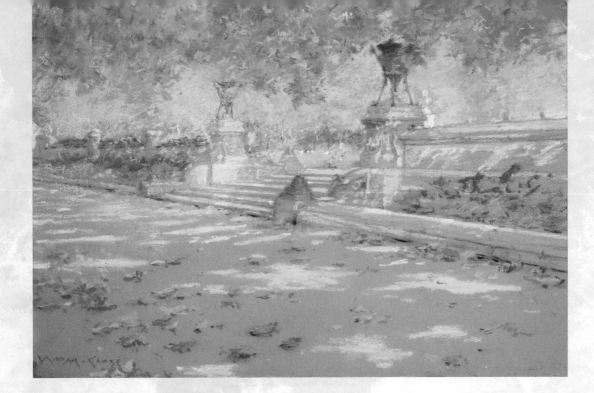

William Merritt Chase (1849–1916), *Terrace, Prospect Park*, n.d., pastel, 23.2 x 34.5 cm (9 5/16 x 13 13/16 in.). Gift of John Gellatly

Eastern Prospects

I prefer every time a picture composed and painted out-doors. The thing is done without your knowing it. Very much of the work now being done in studios should be done in the open air. This making studies and then taking them home to use them is only half right. You get composition, but you lose freshness; you miss the subtle, and to the artist, the finer characteristics of the scene itself.

—Winslow Homer, 1882

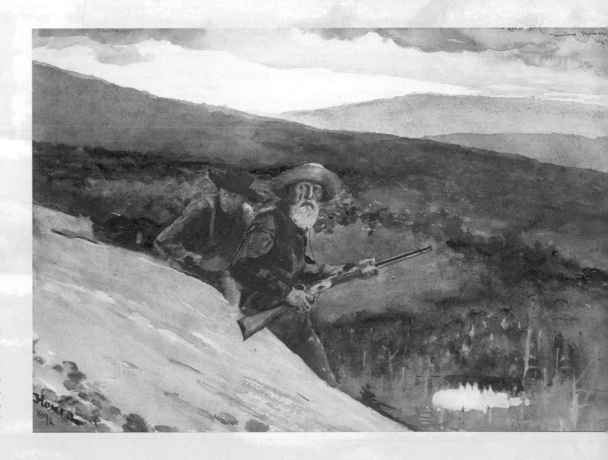

Winslow Homer (1836–1910), *Bear Hunting, Prospect Rock*, 1892, watercolor, ink, and pencil on paper, 35.3 x 50.8 cm (13 15/16 x 20 1/16 in.). Gift of John Gellatly

TRADITION

The art of painting has powers to dignify man, by transmitting to posterity his

noble actions, and his mental powers, to be viewed in those invaluable lessons of religion,

love of country, and morality.

Benjamin West
1738–1820

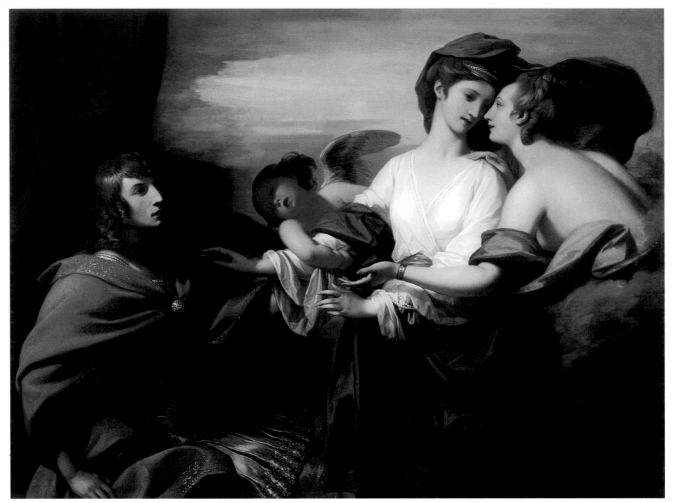

Helen Brought to Paris, 1776, oil on canvas, 143.3 x 198.3 cm (56 1/2 x 75 3/8 in.). Museum purchase

Paris, bribed by Venus to select her as most beautiful of goddesses, awaits entranced as his prize, Helen of Troy, is led in by Venus and Cupid. Venus whispers encouragingly to Helen, as she gently pushes her toward her intended. Cupid on the other hand tugs at her arm with open-mouthed urgency. West neatly places three hands on the central vertical axis of the painting—those of Cupid, Venus, and Helen—in an expressive conjoining of gestures....

The wonderful shadow falling across [Cupid's] eyes is a deeply symbolic passage: this union will result in the Trojan War. One wonders if it was a coincidence

that [*Helen Brought to Paris*] was painted the year the American Revolution erupted. Despite his close friendship with George III, West remained a partisan of the rebel cause.

—William Kloss, 1985

West with his own great soul the canvass warms,
Creates, inspires, impassions human forms,
Spurns critic rules, and seizing safe the heart,
Breaks down the former frightful bounds of Art.

—Joel Barlow, 1807

If an Artist loves his Art for its own sake, he will delight in excellence wherever he meets it,

as well in the work of another as in his own.

Washington Allston
1779–1843

Allston portrays Hermia and Helena, from *A Midsummer Night's Dream*, who represent perfect, intimate friendship.

We, Hermia, like two
* artificial gods*
Have with our needles created
* both one flower,*
Both on one sampler, sitting
* on one cushion,*
Both warbling of one song,
* both in one key,*
As if our hands, our sides,
* voices, and minds*
Had been incorporate. So we
* grew together,*
Like to a double cherry:
* seeming parted,*
But yet a union in partition,
* Two lovely berries moulded*
* on one stem*
 —William Shakespeare

Hermia and Helena, before 1818, oil on canvas, 72.5 x 62.5 cm (29 x 25 in.). Museum purchase through the Smithsonian Institution Collections Acquisition Program and made possible by Ralph Cross Johnson, Catherine W. Myer, and the National Institute Gift

A story told by a painter must obey the laws of pictorial art. The painter tells his story with the delicacies of his chiaroscuro, with the suggestions of his form.

George Inness
1825–1894

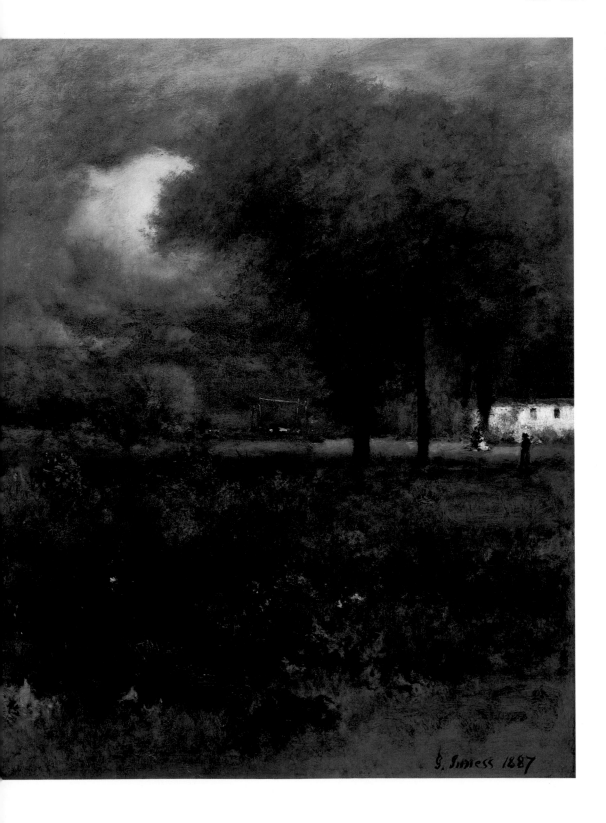

Inness felt no great desire to depict particular places, and when asked where a landscape was painted, he replied, "Nowhere in particular. Do you think I illustrate guide books? That's a picture." Moreover, he felt free to manipulate, even to ignore, the colors, forms, and arrangements of nature for his own ends. "My forms," he said, "are at my finger tips as the alphabet is on the tongue of a schoolboy." It was also said of him that he "painted within the four walls of the room, away from and without reference to any particular nature; for he himself was nature".... His primary dedication was to the mechanism of color and shape itself, and only secondarily to what it could depict or express.
— Nicolai Cikovsky, Jr., 1971

September Afternoon, 1887, oil on canvas, 95.1 x 73.6 cm (37 1/2 x 29 in.). Gift of William T. Evans

A great value in a work of art is that we may read the man in his work, nay, more — we may read the man and his time, and art which is immortal renders a people immortal.

Elliott Daingerfield

1859–1932

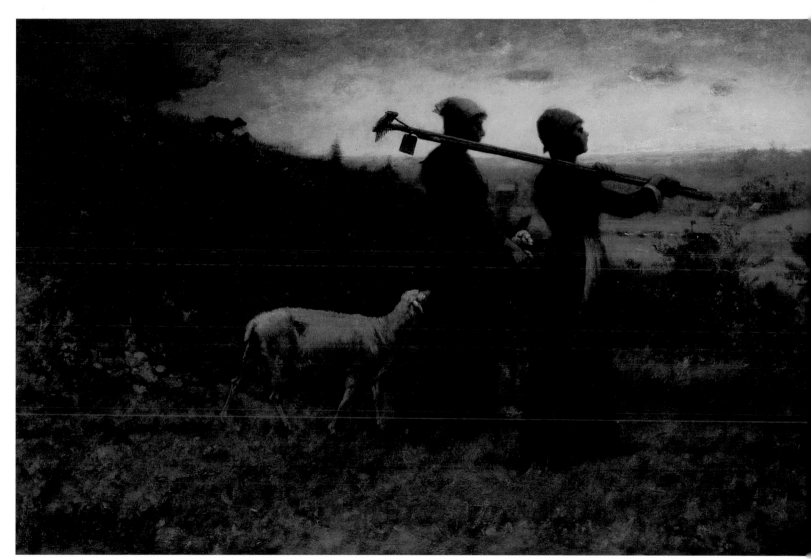

Bringing Home the Newborn Lamb, 1890, oil on canvas, 76.8 x 114.3 cm (30 1/4 x 45 in.). Museum purchase

No complete estimate of [his paintings] can be made without the recognition of certain dominating forces always at work behind Mr. Daingerfield's brush, namely the spiritual approach he brought to all of his creative effort, and his firm belief in a union existent between man, the elements in which he lives and moves, and the God who created all these. He could not, therefore, observe even the simplest manifestation of nature except as an outward and visible sign of the inner meaning of life upon the earth; and a tree upon the hillside with its decorative branches against the sky existed for him, not only as a beautiful pattern, but one which became a symbol of Life itself in the entire cycle of its growth, maturity and final absorption into the elements surrounding it.

— Lucile Howard, 1934

*T*RADITION

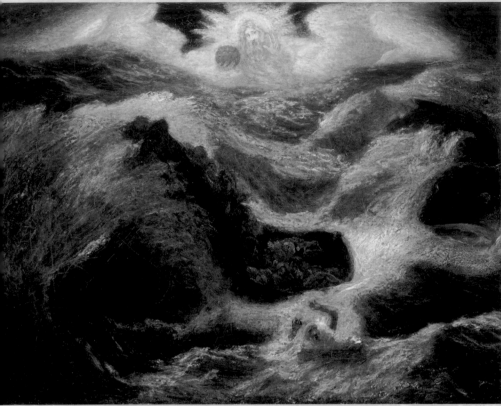

When my father placed a box of colors and brushes in my hands, and I stood before my easel with its square of stretched canvas, I realized that I had in my possession the wherewith to create a masterpiece that would live through the coming ages. The great masters had no more. I at once proceeded to study the works of the great to discover how best to achieve immortality with a square of canvas and a box of colors.

—Albert Pinkham Ryder, 1905

Albert

Jonah, ca. 1885, oil on canvas, 69.2 x 87.3 cm (27 1/4 x 34 3/8 in.). Gift of John Gellatly

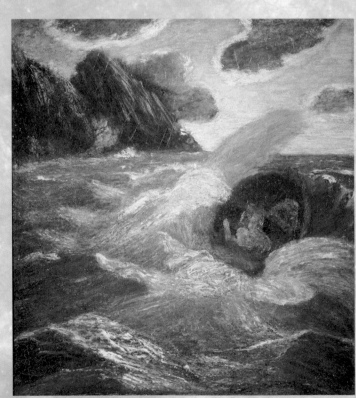

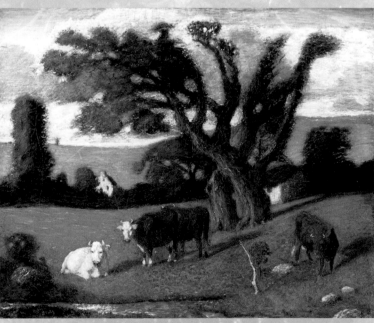

Pastoral Study, before 1904, oil on canvas, 60.9 x 74.6 cm (24 x 29 3/8 in.). Gift of John Gellatly

Lord Ullin's Daughter, before 1907, oil on canvas, 52 x 46.7 cm (20 1/2 x 18 3/8 in.). Gift of John Gellatly

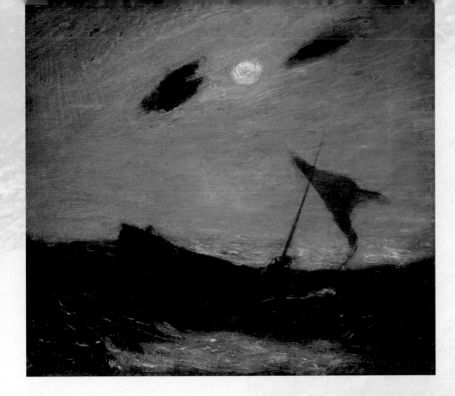

"Old man Ryder," he is apt to be called by the young generation of painters, yet in the quality of his work he is much nearer to the modern expression of intellectualized emotion than all but a few of the young men. In his unobtrusive sincerity he, in fact, anticipated that abstract expression toward which painting is returning and may almost be said to take his place as an old master in the modern movement.

Charles Caffin, 1913

Moonlight, 1880–85, oil on wood, 40.4 x 45 cm (15 7/8 x 17 3/4 in.). Gift of John Gellatly

Pinkham Ryder
1847–1917

Traditionalists saw him as the last romantic, using literary and narrative themes that were honored staples of romanticism since the 1830s. The avant-garde championed his tendencies toward abstraction and his unconventional stance as an artist. Everyone made political capital from the idea that Ryder was naive, a "visionary," for this was tantamount to saying that his achievement was natural and true, dredged from some deep current of character that was part of the American patrimony....

The legends that began to appear even before Ryder's death are like the thick varnishes that often cover his paintings. Once they added a touch of mystery, but they have grown cloudy with age, making the man and his work seem remote. By going back to the facts and looking closely at Ryder's world, we can penetrate the opacity a bit and perceive the remarkable composition and color of his career.

—Elizabeth Broun, 1989

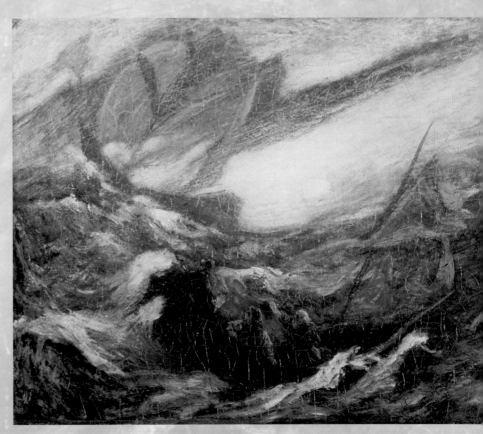

Flying Dutchman, ca. 1887, oil on canvas, 36.1 x 43.8 cm (14 1/4 x 17 1/4 in.). Gift of John Gellatly

All that I would do I cannot—that is, all I could say in art — simply from lack of training,

but with God's help I hope to be able to deliver the message he entrusted to me.

Edward Mitchell Bannister
1828–1901

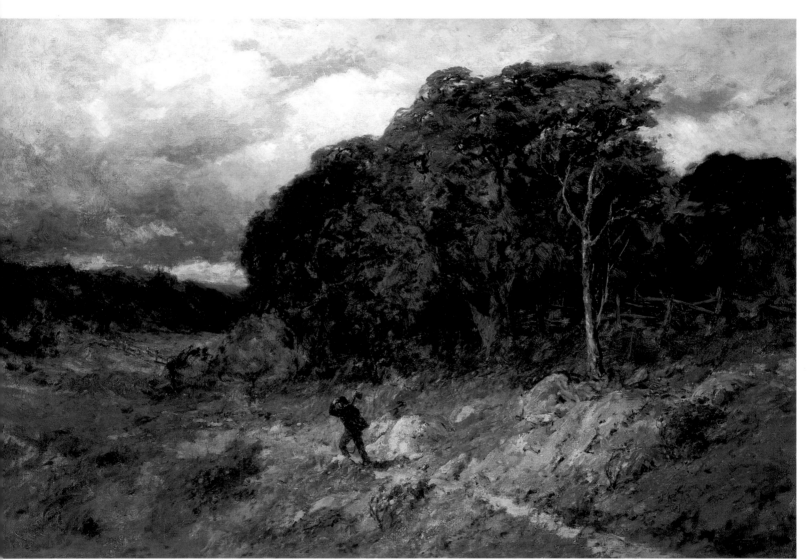

Approaching Storm, 1886, oil on canvas, 102 x 152.4 cm (40 1/4 x 60 in.). Gift of G. William Miller

Bannister's contemporaries frequently described him as a poetic painter whose style was shaped more by his sensitivity to nature than by the example of other artists. In their friendly appraisals of a well-liked man, many artists overlooked his awareness of French Barbizon painting and its American legacy in the works of William Morris Hunt, George Inness, Homer Dodge Martin, Alexander Helwig Wyant, and others. Bannister's appreciation of the Barbizon style enhanced his inherently spiritual approach to nature.

—Lynda Roscoe Hartigan, 1985

To say of a picture "It is like a Blakelock" is high praise and suggests color,

quality, tone and complete unity.

—Elliott Daingerfield, 1913

Ralph Albert Blakelock
1847–1919

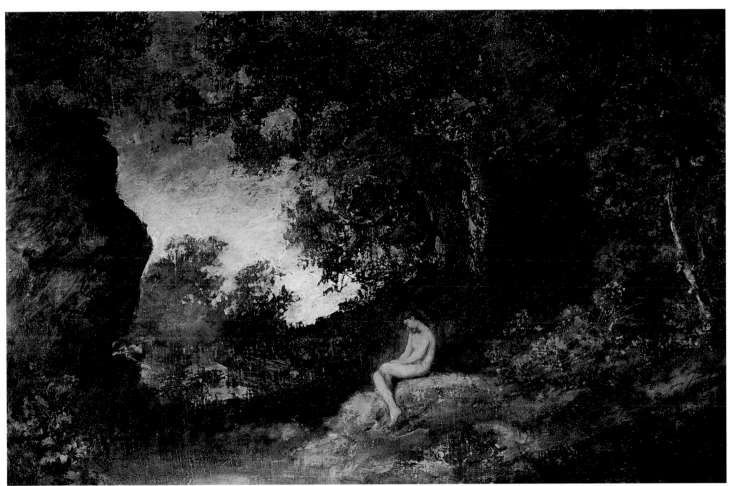

At Nature's Mirror, n.d., oil on canvas, 40.9 x 61 cm (16 1/8 x 24 in.). Gift of William T. Evans

His process was slow and laborious; sometimes years would elapse from the beginning to the end of his pictures, and many years at that. He piled on pigment and he scraped, he varnished and he re-painted, and he was likely at the last to completely change his theme once he had the proper foundation of paint on the canvas or panel.... It was something he could never by any means repeat once the work ˙ was finished, for he least of all knew how the effect was secured. It was feeling, pure and simple, like the improvisations of some gifted musicians.

—Frederick W. Morton, 1902

No American artist, except A. P. Ryder, has ever been able to get so much magic into a small space as Blakelock does in many of his tiny canvases. A pool and trees, a bit of meadow and woodland, become a wonderland under his hands, and the vague little figures with which he loves to people his landscapes have a wild, sweet strangeness—a fantastic delicacy and grace.... Blakelock's are creatures of the wilderness, as free of all human tradition and convention as those wild birds that dip in cataracts, the water ouzels of the Sierras.

—Harriet Monroe, 1913

ᴛRADITION

It was in the ideal pieces that the aesthetic goals of the neoclassic sculptor could be most clearly seen, for the form of his portraits was naturally conditioned, in part at least, by the subject and patron, while the artist could indulge his own concepts in the ideal works. The classical world, the world of ancient Greece, provided America with inspiration, from its democratic political goals to the classical temples that America turned into her homes, her colleges, her churches, and her government buildings. If classical forms were considered the symbol of an ideal way of life reborn, then a classical renaissance in sculptural terms is not surprising. The neoclassic sculptors reiterated the classical concept of the human body as the ultimate artistic ideal, an ideal of beauty rather than expressiveness.

—William H. Gerdts, 1973

Neoclassical

Chauncey Bradley Ives (1810–1894), *Undine*, ca. 1880/carved 1884, marble, 197.2 x 49.2 x 58.4 cm (77 5/8 x 19 3/8 x 23 in.). Museum purchase made possible in part by the Luisita L. and Franz H. Denghausen Endowment

Horatio Greenough (1805–1852), *George Washington*, 1840, marble, 345.4 x 259.1 x 209.6 cm (136 x 102 x 82 1/2 in.). Transfer from the U.S. Capitol

Henry Kirke Brown
(1814–1886), *La Grazia*,
modeled ca. 1844, bronze,
47.2 x 24.6 x 25.9 cm
(18 7/8 x 9 3/4 x 10 1/4 in.).
Museum purchase

Hiram Powers (1805–1873),
Last of the Tribe, modeled
1867–72, marble, 167.9 x
57.7 x 81.3 cm (66 1/8 x
22 3/4 x 32 in.). Museum
purchase in memory of
Ralph Cross Johnson

Sculpture

*Then this last winter I finished what I consider as my
best work—it is so considered by all, I believe—the
Libyan Sibyl.... It is a very massive figure, big shoul-
dered, large-bosomed, with nothing of the Venus in
it, but as far as I could make it, luxuriant and heroic.
She is looking out of her black eyes into futurity and
sees the terrible fate of her race. This is the theme of
the figure—Slavery on the horizon, and I made her
head as melancholy and severe as possible, not at all
shirking the real African type. On the contrary, it is
thoroughly African.*

—William Wetmore Story, 1861

William Wetmore Story (1819–1895),
The Libyan Sibyl, 1868, marble, 144.8
x 78.4 x 111.1 cm (57 x 30 7/8 x 43 3/4
in.). Bequest of Henry Cabot Lodge
through John Ellerton Lodge

The nude statue should be an unveiled soul.

Hiram Powers
1805–1873

[Hiram Powers'] nude female figures represented philosophical and spiritual concepts. From his regular reading of Swedenborg's writings, he was convinced that the human body is in the image of heaven and that heaven is in the image of God, the Divine Human. His knowledge of these correspondences also gave him a profound respect for the female form. He undoubtedly was familiar with teachings such as, "woman has a twofold beauty, one natural being the beauty of her face and body, and the other spiritual being the beauty of her love and manners"....

In comments about the passing phase of tinting sculpture to make it look more lifelike, he writes: "...an uncolored marble statue is, so to speak, a sentiment clothed in a spiritual body; colored, it becomes material and sensual."

—Martha Gyllenhaal, 1988

Eve Tempted
A faultless being from the marble sprung,
 She stands in beauty there!
And when the grace of Eden 'round her clung—
 Fairest, where all was fair!
Pure, as when first from God's creating hand,
 She came, on man to shine;
So seems she now in living stone to stand—
 A mortal, yet divine!...

—Bayard Taylor, 1845

Eve Tempted, 1842, marble, 174.9 x 75.8 x 52 cm (68 7/8 x 29 7/8 x 20 1/2 in.). Museum purchase in memory of Ralph Cross Johnson

I never knew but one artist, and that's Tom Eakins, who could resist the temptation to see what they thought ought to be rather than what is.

—Walt Whitman

Thomas Eakins
1844–1916

William Rush's Model, 1908, oil on canvas, 90 x 120 cm (36 x 48 in.). Gift of Mr. and Mrs. R. Crosby Kemper

Thomas Eakins, America's greatest portrait and figure painter, rarely used nude figures in major compositions, although his work was based almost entirely on study of the nude form. *William Rush's Model* provides haunting evidence of this lifelong preoccupation; it is the final version of a subject the artist had painted many years earlier, memorializing William Rush, the early Philadelphia carver who was the first American artist known to have worked directly from a nude model. Anatomical studies and training abroad under the French academic master Jean-Léon Gérôme had convinced Eakins that the nude was the touchstone of art. He later taught this principle to students at the Pennsylvania Academy of the Fine Arts despite objections from school authorities.

—William H. Truettner, 1986

If America is to produce great painters and if young art students wish to assume a place in the history of the art of their country, their first desire should be to remain in America to peer deeper into the heart of American life.

—Thomas Eakins, 1914

ᴛRADITION

Until the beginning of the nineteenth century, American artists portrayed children as miniature adults in both pose and costume. This grew out of the widespread belief that children were unredeemed and naturally sinful, having to be trained from cradle to assume moral and social responsibilities. Enlightenment philosophy, the advent of Romanticism, and shifts in Protestant theology, however, brought a general change in the perception of children in the early 1800s and artists began to portray childhood as a unique phase of life distinct from the cares of maturity.... In keeping with this growing appreciation of childhood's inherent simplicity and zest, artists often indulgently depicted children's inevitable mischief, finding amusement and relief from adult worries in their innocent antics and games.

—Karol Ann Lawson, 1990

Thomas Crawford (1813–1857),
Boy with Broken Tambourine, 1854,
marble, 108.6 x 39.7 x 38.4 cm
(42 3/4 x 15 5/8 x 15 1/8 in.).
Museum purchase

Images of

Harriet Hosmer (1830–1908), ***Puck***,
1856, marble, 77.5 x 42.1 x 49.9 cm
(30 1/2 x 16 5/8 x 19 3/4 in.). Gift of
Mrs. George Merrill

Samuel F. B. Morse (1791–1872),
The Goldfish Bowl, ca. 1835, oil on wood,
198.8 x 300.4 cm (29 5/8 x 24 7/8 in.). Gift
of Mrs. J. Wright Rumbough in loving
memory of her father Gilbert Colgate

Julian Alden Weir (1852–1919),
Children Burying a Bird, 1878,
oil on canvas mounted on fiber-
glass, 56.3 x 46.1 cm (22 1/4
x 18 1/8 in.). Museum purchase

Innocence

Untouched by worldly experience, the child
was identified with moral innocence and
believed to be in harmony with God and
nature. Although this concept was to change
before the end of the century, it enjoyed a
popularity of epidemic proportions during
the mid-century decades and was often
expressed in poetry and prose, painting,
prints and sculptures.

—Lois Marie Fink, 1977

David Gilmour Blythe (1815–1865),
Boy Playing Marbles, ca. 1858,
oil on canvas, 55.6 x 67.4 cm
(22 x 26 1/2 in.). Museum purchase

TRADITION

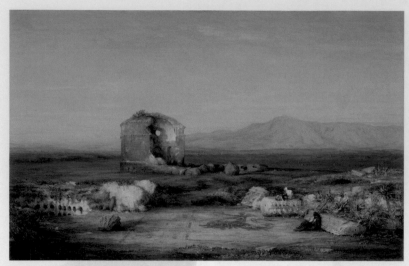

Thomas Hiram Hotchkiss (ca. 1834–1869), *Torre di Schiavi*, 1865, oil on canvas, 56.9 x 88.1 cm (22 3/8 x 34 3/4 in.). Museum purchase

The way in which the Italian scene on such occasions as this seems to purify itself to the transcendent and perfect *idea* alone—the idea of beauty, of dignity, of comprehensive grace, with all accidents merged, all defects disowned, all experience outlived, and to gather itself up into the mere mute eloquence of what has just incalculably *been*, remains forever the secret and the lesson of the subtlest daughter of History.... Seen thus in great comprehensive iridescent stretches, it is the incomparable wrought *fusion*, fusion of human history and mortal passion with the elements of earth and air, of colour, composition and form, that constitutes her appeal and gives it the supreme heroic grace.

—Henry James, 1909

Americans

A visit to Italy is perhaps more of an epoch in the life of an American artist than in that of any other. The contrast between the new and old civilization, the diversity in modes of life, and especially the more kindling associations which the enchantment of distance and long anticipation occasion, makes his sojourn there an episode in life.

—Henry T. Tuckerman, 1867

Sanford Robinson Gifford (1823–1880), *Villa Malta, Rome*, 1879, oil on canvas, 33.6 x 69.5 cm (13 1/4 x 27 3/8 in.). Gift of William T. Evans

Thomas Worthington Whittredge (1820–1910), *The Amphitheatre of Tusculum and Albano Mountains, Rome*, 1860, oil on canvas, 61 x 101.6 cm (24 x 40 in.). Museum purchase

in Italy

Daniel Huntington (1816–1906), *Italy*, 1843, oil on canvas, 98.1 x 74 cm (38 5/8 x 29 1/8 in.). Museum purchase

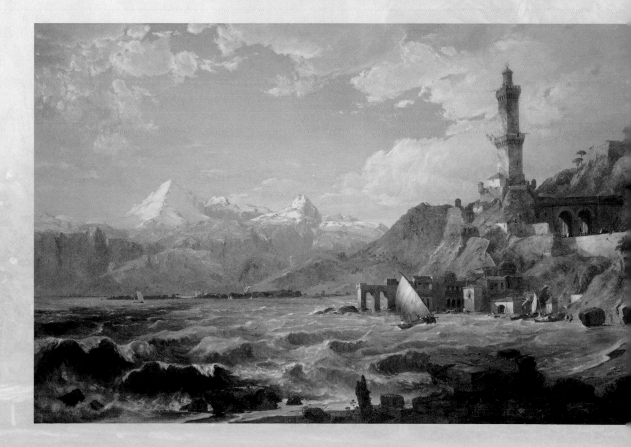

Jasper Francis Cropsey (1823–1900), *The Coast of Genoa*, 1854, oil on canvas, 122.4 x 184.2 cm (48 1/8 x 72 1/2 in.). Gift of Mrs. Aileen B. Train and promised gift of Mrs. Helen B. Spaulding and Mrs. Julia B. Key

I have a strong sympathy for all women who have struggled and suffered.

Edmonia Lewis
1843/1845–after 1911

For some critics, Lewis's work seemed to hold the promise of a meaningful change. By the 1860s American sculpture followed the classical tradition so closely that an anonymous writer remarked, "Has sculpture no new domains to occupy, no new worlds to conquer?" Lewis, who dealt with the human-rights issues of her time and pursued a more emotional and naturalistic vein than many of her contemporaries, represented a fresh approach. Visiting her Roman studio, the writer who criticized neoclassical sculptors wondered if "the youthful Indian girl" would forge a "distinctive if not original style in sculpture."

—Lynda Roscoe Hartigan, 1985

[Edmonia Lewis's] father was a free African-American and her mother a Chippewa Indian. Orphaned before she was five, Lewis lived with her mother's nomadic tribe until she was twelve years old. [After attending Oberlin College and briefly studying sculpture in Boston], Lewis decided to settle in Rome.... Lewis was unique among sculptors of her generation..., as she rarely employed Italian workmen and completed most of her work without assistance. Her motivation was probably twofold: lack of money and fear of the loss of originality in her work....

The sensitively carved *Hagar*...is probably the masterpiece among her known surviving works. In the Old Testament, Hagar—Egyptian maidservant to Abraham's wife, Sarah—was the mother of Abraham's first son, Ishmael. The jealous Sarah cast Hagar into the wilderness after the birth of Sarah's son Isaac. In Lewis's sculpture Egypt represents black Africa, and Hagar is a symbol of courage and the mother of a long line of African kings. That Lewis depicted ethnic and humanitarian subject matter greatly distinguished her from other neoclassical sculptors.

—Regenia A. Perry, 1992

Hagar, 1875, marble, 133.6 x 38.8 x 43.4 cm (52 5/8 x 15 1/4 x 17 in.). Gift of Delta Sigma Theta Sorority, Inc.

At midnight the Lord smote all the first-born in the land of Egypt, from the first-born of Pharaoh who sat on his throne to the first-born of the captive who was in the dungeon.... And there was a great cry in Egypt, for there was not a house where one was not dead.

—Exodus 12: 29-30

Charles Sprague Pearce
1851–1914

Lamentations over the Death of the First-Born of Egypt, 1877, oil on canvas, 97.8 x 130.8 cm (38 1/2 x 51 1/2 in.). Museum purchase

For all the archaeological perfection of this historicizing work, it speaks subtly of contemporary issues. The truncated child's sarcophagus and broken doll are pure Victorian sentiments, revealing the nineteenth-century preoccupation with infant death. And the fascination with exotic lands and people thinly veils France's powerful colonialist ambitions.

Such "orientalist," or Near Eastern subjects were popularized first by Delacroix and Gros, who were inspired by Napoleon's campaigns. Even as Pearce was studying Napoleon's booty in the Louvre, expansionist urges were beginning to be felt in America.

—Elizabeth Broun, 1994

The objective and the subjective must be married and intimately blended by the subtlest employment of color, as the composer employs the moods of music.

Louis Comfort Tiffany
1848–1933

Market Day Outside the Walls of Tangier, 1873, oil on canvas, 81.6 x 142.3 cm (32 1/2 x 56 in.). Gift of the American Art Forum

Based on photographs of Tangier that Tiffany collected, as well as his own exhaustive life studies of North Africa people and scenery, *Market Day Outside the Walls of Tangier* sets the exciting motif of a caravan preparing to cross the desert and the curious cacophony of a milling crowd of traders against the crenelated walls and peaked archways of an ancient city.... The broad, sweeping brushwork apparent in walls, distant buildings, and surrounding hills—suggestive of the work of French Romantics such as Delacroix and anticipating by several years a general movement by American artists toward this fresher, more spontaneous style—marks Tiffany as an innovative and daring painter.

—Elizabeth Broun, 1989

When first I had a chance to travel in the East and to paint where the people and the buildings also are clad in beautiful hues, the pre-eminence of color in the world was brought forcibly to my attention. I returned to New York wondering why we made so little use of our eyes, why we refrained so obstinately from taking advantage of color in our architecture and clothing when Nature indicates its mastership.
—Louis Comfort Tiffany, 1917

No sooner had I set foot on land than I began with joy to sniff the odors so peculiar to Oriental towns — perfumes of musk, tobacco, orange-blossoms, coffee, hashish — a subtle combination which impregnates Algerine clothing and hovers about the shops and bazars.

Frederick Arthur Bridgman
1843–1927

Oriental Interior (Cafe at Biskra, Algeria), 1884, oil on canvas, 70.2 x 111.8 cm (27 5/8 x 44 in.). Museum purchase made possible by the Pauline Edwards Bequest

Of the paintings in the 1880s, *Interior of a Biskra Cafe* is among the most important. Ilene Fort, the expert on Bridgman, considers this painting to be an especially fine example; apparently Bridgman thought so, too, for he selected it to represent his work in George Sheldon's important and lavishly illustrated *Recent Ideals of American Art*, published in 1888 as a record of American accomplishments in the world of international contemporary art. Richard Muther in his comprehensive and authoritative *History of Modern Painting* also illustrated the painting to represent Bridgman's work and that of the American Orientalists in Paris. Hence, this painting defined Bridgman's work for the public.

The scene is set inside a cafe in the town of Biskra, the farthest interior settlement of French emigres after the Franco-Prussian War. The town was the last point of safe travel in a climate inhospitable to Europeans. According to Ilene Fort, only women of pleasure were found in cafes; the couple on the central platform are engaging in a game of cards, a prelude to more serious sexual engagement.

—Richard N. Murray, 1993

TRADITION

[La Farge] was commissioned to provide stained-glass windows for a baronial hall in the house of the railroad magnate Frederick Lothrop Ames, in Boston (1882). The immense hall, measuring sixty-nine by seventeen feet, paneled in carved oak under a beamed ceiling eighteen feet above the floor, was illuminated on the west by La Farge's two *Peacocks and Peonies* windows.... The inner panels of these windows perpetuate in a mosaic of deep-toned glass the classic bird and flower theme of Ming dynasty painting.

—Henry La Farge, 1987

Frederick William MacMonnies (1863–1937), *Venus and Adonis*, 1895, bronze, 71.8 x 49.8 x 25.4 cm (28 1/4 x 19 5/8 x 10 in.). Museum purchase made possible in part by the Luisita L. and Franz H. Denghausen Endowment

John La Farge (1835–1910), *Peacocks and Peonies I & II*, 1893, stained glass and lead, 142.6 x 66.1 cm (56 1/8 x 26 in.). Gift of Senator Stuart Symington and Congressman J. W. Symington

Adolph Alexander Weinman (1870–1952), *Rising Sun*, 1914, bronze, 144.1 x 134 x 50.8 cm (56 3/4 x 52 3/4 x 20 in.). *Descending Night*, ca. 1915, bronze, 143.5 x 117.5 x 61.6 cm (56 1/2 x 46 1/4 x 24 1/4 in.). Gift of Mrs. Adolph A. Weinman

The Gilded Age

Wealthy American collectors had discovered Europe with a hungry appetite—not contemporary Europe but the Europe of the safe and glittering past—and the dealers who traded in masterpieces were enjoying a boom such as the art market had never seen before.... They, too, were contributing to the future of American taste as they embellished the houses of American millionaires with great pictures and sculptures of the past and lined their own pockets with gold. The public taste was the least of their worries, and the plight of the American artist was none of their business.

—Russell Lynes, 1954

Irving Ramsay Wiles (1861–1948), *Russian Tea*, ca. 1896, oil on canvas, 122 x 91.6 cm (48 1/8 x 36 1/8 in.). Gift of William T. Evans

Although I give perhaps but poor proof of a proper remembrance in the way of writing letters

I still think of the girls over the "way" a thousand times when they do not think of me.

Eastman Johnson
1824–1906

The Girl I Left Behind Me, ca. 1870–75, oil on canvas, 106.7 x 88.7 cm (42 x 34 7/8 in.). Museum purchase made possible by Mrs. Alexander Hamilton Rice in memory of her husband and by Ralph Cross Johnson

The title of the painting refers to an old Irish song that became a popular regimental ballad during the Civil War. Johnson had witnessed the battle of Manassas in 1862 and later made paintings that drew obliquely on his experiences at the front. Whether *The Girl I left Behind Me* might also be a reflection on the war is unclear, but some have seen in the distant landscape below her feet the smoke of cannon and rifle fire. The painting may also have had a more personal meaning for Johnson, as he kept it in his studio until his death in 1906.

—Andrew Connors, 1992

The eye in the telescope might have glimpsed a skirt of almost daring narrowness—and shortness, since two white ankles could be seen beneath the rich green coat and above the black boots that delicately trod the revetment.... There was no artifice [in her face], no hypocrisy, no hysteria, no mask, and above all, no sign of madness. The madness was in the empty sea, the empty horizon, the lack of reason for such sorrow.... [H]er bonnet was in her hand. Her hair, he noticed, was loose, as if she had been in wind.... It gave her a kind of wildness, which the fixity of her stare at him aggravated.... [A]n oblique shaft of wan sunlight...lit her face...[which] was suddenly very beautiful, truly beautiful, exquisitely grave and yet full of an inner, as well as outer, light.

—John Fowles, 1969

The Life that I have chosen gives me my full hours of enjoyment for the balance of my life.

The sun will not rise or set without my notice and thanks.

Winslow Homer
1836–1910

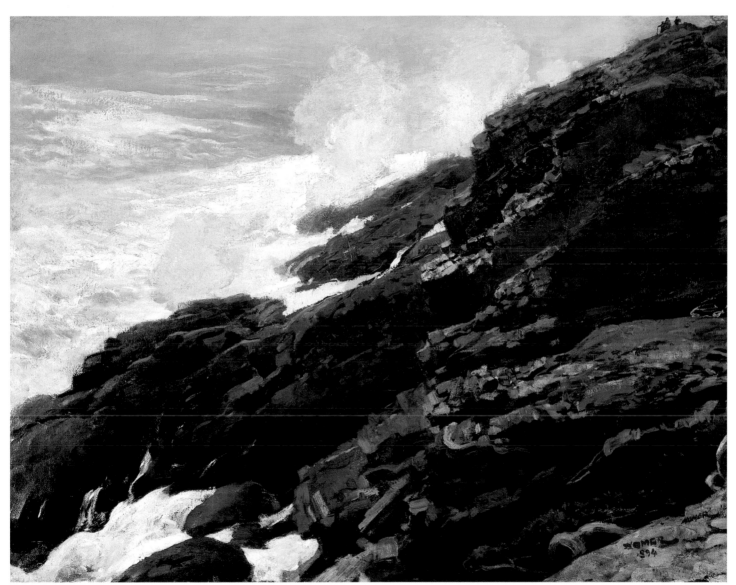

High Cliffs, Coast of Maine, 1894, oil on canvas, 76.5 x 97 cm (30 1/8 x 38 1/4 in.). Gift of William T. Evans

Homer's late seascapes no longer depicted what people did on the sea, or at it, but the elemental dynamics of the sea itself. The small figures in the upper right represent the marginal and impotent passivity of humanity in relation to this elemental natural process.

—Nicolai Cikovsky, Jr., 1990

Ocean, clouds, rain, and rivers are the elements of a gigantic circulation on which the life of the world depends. The ocean is the mighty heart—the clouds and vapors driven by the wind are the conducting arteries.

—George Chaplin Child, 1871

My decorations belong to the poetic and imaginative world where a few choice spirits live.

Thomas Wilmer Dewing
1851–1938

During Dewing's own heyday...an idealized womanhood...had come to personify the cultural values of the young nation. Dewing's works are the quintessence of this type of expression, his artfully posed figures and subtly related color harmonies evoking a dream world of beauty in which time and logic play no role. They demonstrate his saying, moreover, that "the purpose of the artist [is] to see beautifully."

— Susan Hobbs, 1981

The Spinet, ca. 1902, oil on wood, 39.5 x 50.7 cm (15 1/2 x 20 in.). Gift of John Gellatly

Throughout his long life...[Dewing] had one transcendent conviction, that the mission of the painter was to evoke beauty.... I think of him as the consummate craftsman, dedicated to the creation of fine things.... In my youth, when I first visited him in his studio, then on North Washington Square, I used to be charmed by the harp on the door which gave forth delicate music as the door was opened and shut. That is what characterizes his art, an exquisite music. And he, like his art, was endearing.

— Royal Cortissoz, 1939

If one would realize the powerful appeal that flowers make to art let them bind themselves to a long apprenticeship in a garden.

Maria Oakey Dewing
1845–1927

Garden in May, 1895, oil on canvas, 60.1 x 82.5 cm (15 1/2 x 20 in.). Gift of John Gellatly

The salient trait of Maria Oakey Dewing, through whose death last week a peculiarly distinguished figure was lost to American art, was the strain of originality that characterized her deep feeling for beauty.... She knew how to interpret the soul of a flower—but her principal aim was to make it a work of art, a piece of good painting.... [S]ave for La Farge we have no one who could work with flowers the magic that was hers.

—Royal Cortissoz, 1927

See where the summer comes with heat of days
And garlanded with lily and with rose,
Down the bright garden's fragrant, sheltered ways,
With rhythmic footsteps dreamily she goes.

—Maria Oakey Dewing, 1883

TRADITION

While Hassam's French connection was recognized so early in his career that any reference to Claude Monet became an annoyance to him, impressionism was but one of three strong currents flowing through his art. Two others surged up earlier: popular culture made familiar through Hassam's work as an illustrator; and lessons of early nineteenth-century British landscape painting, reinforced by the artistic leanings of Boston during the 1860s and 1870s, and furthered by Hassam's travels to England in the 1880s.

—David Park Curry, 1990

In the Garden (Celia Thaxter in Her Garden), 1892, oil on canvas, 56.5 x 45.7 cm (22 1/4 x 18 in.). Gift of John Gellatly

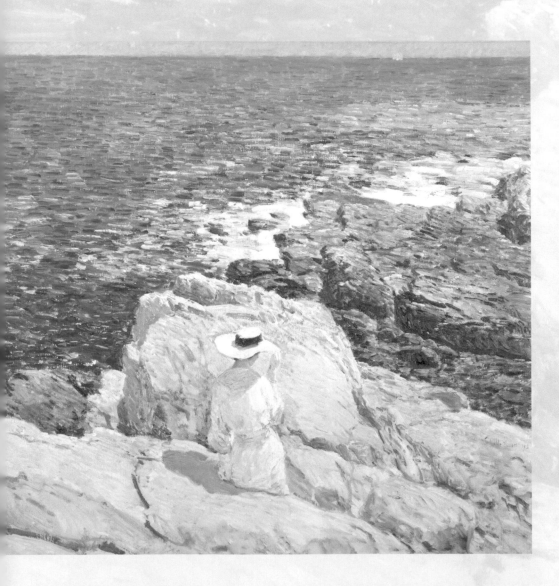

He has a way of taking his own where he finds it, and thus he leaves the stamp of his personality on localities where he has worked.... The schooners beating in and out, the wharves, the sea, the sky, these belong to Hassam....

There are many other fields that he has invaded and made his. Flowers in gardens, flowers in still life, flowers as accessories to portraits. These are painted with great tenderness, great restraint of color yet very colorfully, always part of the picture, never jumping out in forced contrast. Interiors are his,—interiors that are renderings of space with a magic play of light, the light that instinctively seems to be the heritage of Hassam.

—Ernest Haskell, 1922

The South Ledges, Appledore, 1913, oil on canvas, 87 x 91.6 cm (34 1/4 x 36 1/8 in.). Gift of John Gellatly

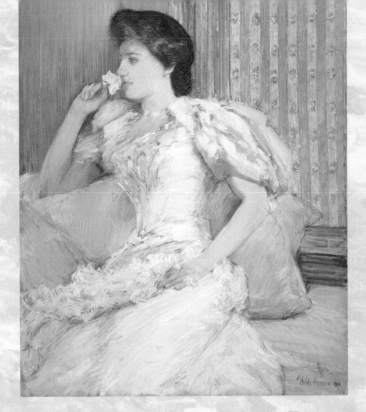

Lillie (Lillie Langtry), ca. 1898, watercolor and pencil, 61.7 x 50.2 cm (24 5/16 x 19 3/4 in.). Gift of John Gellatly

Childe Hassam

1859–1935

In a series of paintings begun in 1907, Hassam showed a solitary woman standing by a window—the individual placed in relation to the broader world. His women embody the finest of Western and Eastern traditions, evoked in this painting by the Hellenistic figurine and oriental screen. They are well bred, like the hybrid roses on the table. Hassam's generation was preoccupied by evolutionary theory, and to him, the modern American woman represented a refinement of nature and culture that had been long in the making.

The key to the picture, however, is found in the sliver of the "outside world" glimpsed through the window, where laborers are seen building a skyscraper. While these men are creating the visible edifices of the modern American age, the new American woman is coming to maturity as a guardian of civilization.

—Elizabeth Broun, 1994

Tanagra (The Builders, New York), 1918, oil on canvas, 149.2 x 149 cm (59 3/4 x 58 3/4 in.). Gift of John Gellatly

His art was alternately of the most delicate, far-sought "nuance" and of the most refreshing spontaneity—giving a sense of musical improvisation.

—Duncan Phillips, 1991

John Henry Twachtman

1853–1902

Round Top Road, ca. 1890–1900, oil on canvas, 76.8 x 76.2 cm (30 1/4 x 30 in.). Gift of William T. Evans

One of his students remembered that Twachtman, after having requested breakfast one morning when he was staying at the Holly House in Cos Cob [Connecticut], "sauntered towards the window and stood silent there for a few moments. Turning he said, 'But Nature is fine this morning,' and went out of the room. The maid brought his breakfast and set it down. It grew cold, and somebody went to find Mr. Twachtman. They found him standing outside in the snow, painting like mad, utterly forgetful of the breakfast, ordered but never eaten."

—Deborah Chotner, 1989

I feel more and more contented with the isolation of country life. To be isolated is a fine thing and we are all then nearer to nature. I can see how necessary it is to live always in the country—at all seasons of the year.

We must have snow and lots of it. Never is nature more lively than when it is snowing. Everything is so quiet and the whole earth seems wrapped in a mantle. That feeling of quiet and all nature is hushed to silence.

—John Henry Twachtman, 1891

To say to the painter, that Nature is to be taken as she is, is to say

to the player, that he may sit on the piano.

James A. M. Whistler
1834–1903

I found myself in Valparaiso, and in Santiago [Chile], and I called on the President, or whoever the person in authority was. After that came the bombardment. There was the beautiful bay with its curving shores, the town of Valparaiso on one side, on the other, the long line of hills. And there, just at the entrance of the bay, was the Spanish fleet, and, in between, the English fleet, and the French fleet, and the American fleet...and all the other fleets. And when the morning came, with great circles and sweeps, one after another sailed out into the open sea, until the Spanish fleet alone remained. It drew up right in front of the town, and bang went a shell, and the bombardment began.... And then I knew what a panic was. I and the officials turned and rode as hard as we could, anyhow, anywhere.... By noon, the performance was over.

—James A. M. Whistler

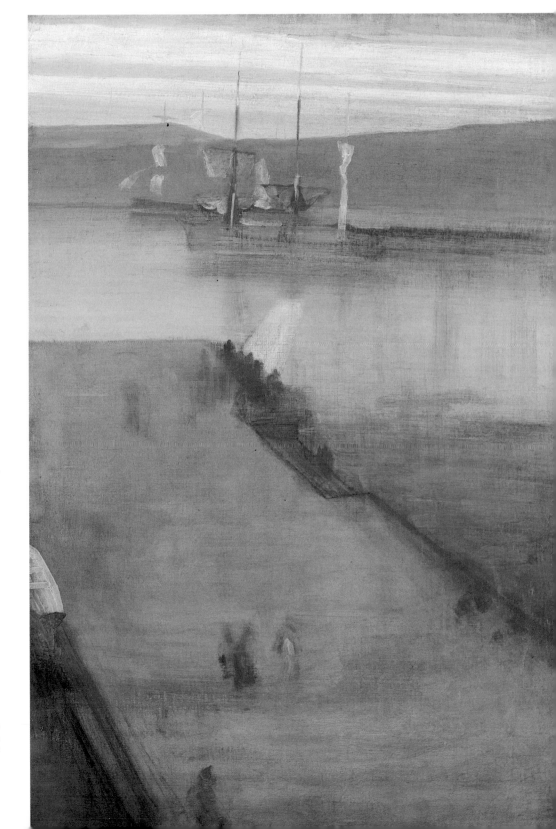

Valparaiso Harbor, 1866, oil on canvas, 76.6 x 51.1 cm (30 1/4 x 20 1/8 in.). Gift of John Gellatly

20TH CENTURY *Life*

Art is the great stimulus of life—I find it year by year more rich, more desirable, and more mysterious.

Maurice Prendergast
1859–1924

An amusing story is told about a studio party in New York after [Prendergast's] second return from Europe. Glackens, Shinn, Sloan, Henri, Fitzgerald, and others were there. Prendergast was talking to all, of Cézanne; and the high point of the evening was a stentorian demand [attributed to Sloan], loud above the noise of conversation: "Prendergast, who is this man, Cézanne?"
—William Milliken, 1926

Summer, New England, 1912, oil on canvas, 48.9 x 69.9 cm (19 1/4 x 27 1/2 in.).
Gift of Mrs. Charles Prendergast

I have just seen the Champs de Mars exhibition [Société Nationale des Beaux-Arts] and it was worth travelling 100,000 miles to see and to spend all [the] money one could afford.... One thing [that] made a great impression on me were the beautiful colors which they got, and in wonderful taste—all have that, whatever color they are. There is a beautiful quality of grey in them.... I got in at eight in the morning and I happened to look at my watch and it was four o'clock in the afternoon. I forgot [hunger?], I forgot I was in Paris, I was so absorbed. Of course there is a lot of rot and so many and many charming and delightful, so much, so much in my own temperament. I never got such a shake-up and it made me feel glad I have that quality. And there are so many others [it] made Paris feel so homelike. It is the real home of the artist. There is no thinking of yourself like alas—Boston....

You ought to see the Luxembourg Garden now, it is in full swing—the Band playing and the children romping about and women talking, sewing, and embroidering. I see pictures in every direction.
—Maurice Prendergast, 1907

I am not interested in any one school or movement, nor do I care for art as art.

I am interested in life.

Robert Henri
1865–1929

Cumulus Clouds, East River, 1901–02, oil on canvas, 63.1 x 79.3 cm (25 1/4 x 31 3/4 in.). Partial and promised gift of Mrs. Daniel Fraad in memory of her husband

There are great things in the world to paint, night, day, brilliant moments, sunrise, a people in the joy of freedom; and there are sad times, halftones in the expression of humanity, so there must be an infinite variety in one's language. But language can be of no value for its own sake, it is so only as it expresses the infinite moods and growth of humanity. An artist must...be filled with emotion toward the subject and...make his technique so sincere, so translucent that it may be forgotten, the value of the subject shining through it. To my mind a fanciful, eccentric technique only hides the matter to be presented and for that reason is not only out of place, but dangerous, wrong.

—Robert Henri, 1915

Desert, the monotonous ocean, the unbroken snowfields of the North, all solitudes, no matter how forlorn, are the only abiding-place on earth of liberty.

Rockwell Kent
1882–1971

Snow Fields, 1909, oil on canvas mounted on linen, 96.5 x 111.7 cm (38 x 44 in.). Gift of William T. Evans

In 1929, Kent saw Greenland for the first time, appropriately enough as a ship-wrecked sailor. He and his two companions had successfully maneuvered a small boat there, all the way across from Nova Scotia, only to have it dashed against the rocks in Karajak Fiord. His friends left for home on the next ship, but Kent stayed on for two months; after all, he had gone there to paint! Early in the summer of 1931 he returned, and at Igdlorssuit, a small settlement about 225 miles north of the Arctic Circle, he built himself a house and prepared to stay for an entire year. That year, he later wrote, was "perhaps the happiest and certainly the most productive of my life."

—Fridolf Johnson, 1985

The beauty of those Northern winter days is more remote and passionless, more nearly absolute, than any other beauty that I know. Blue sky, white world, and the golden light of the sun to tune the whiteness to the sun-illumined blue. If we personify the sun and feel for it in its incessant toil of making varicolored things to harmonize...what vast delight we must believe it to experience in shining down on snow. "I who am nothing," whispers that prone whiteness, "partake of you, dear sun, and of the blue heaven in which you shine, and become beautiful." In Greenland one discovers, "as though for the first time," what beauty is. God must forgive me that I tried to paint it.

—Rockwell Kent, 1935

Art must of necessity be the artist's own reaction to nature and his personal style is governed by his own temperament, rather than by a style molded through his intellect.

Ernest Martin Hennings
1886–1956

Riders at Sunset, 1935–45, oil on canvas, 76.2 x 91.7 cm (30 x 36 1/8 in.). Gift of Arvin Gottlieb

Landscape plays so important a part of my work, and subjects of sage, mountain and sky. Nothing thrills me more, when in the fall, the aspen and cottonwoods are in color and with the sunlight playing across them—all the poetry and drama, all the moods and changes of nature are there to inspire one to greater accomplishments from year to year.

In figure subjects I think I find my greatest inspiration—subjects which you have grown to know from experience and subjects which the imagination brings forth.

—Ernest Martin Hennings

20TH CENTURY *Life*

Raymond Jonson (1891–1982), *Arroyo (2)*, 1922, oil on paperboa
52.7 x 68.6 cm (20 3/4 x 27 in.). Gift of Arvin Gottlieb

Leon Trousset (active 1870s–80s),
Old Mesilla Plaza ca. 1885-86, oil on
canvas, 75.1 x 123.2 cm (29 9/16 x 48 1/2
in.). Transfer from the Bureau of American
Ethnology, Smithsonian Institution

**The Arvin Gottlieb Collection, bequeathed to the National Museum
of American Art in 1992, includes twenty-two paintings by most of
the original founders of the Taos Society of Artists who worked in
New Mexico between 1900 and the 1940s, including Eanger Irving
Couse, Ernest Martin Hennings, and Walter Ufer.**

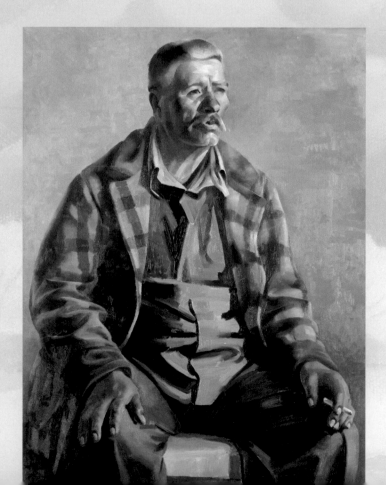

Kenneth M. Adams (1897–1981),
Juan Duran, ca. 1933–34, oil on canvas,
101.9 x 76.6 cm (40 1/8 x 30 1/8 in.).
Transfer from the U.S. Department of Labor

Perhaps because the appeal of Taos and Santa Fe
has long been taken for granted, contemporary
audiences have almost forgotten why the area of-
fered such dramatic possibilities to a restless group
of American artists at the turn of the century. Yet
artists (and writers) of that era made no secret of
their enthusiasm for New Mexico; they saw it as a
brave new world, far from urban conveniences and
conventions and replete with soul-stirring attrac-
tions. His initial view of the Taos valley caused the
painter Ernest Blumenschein to exclaim, "No artist
had ever recorded the New Mexico I was now
seeing. No writer had ever written down the smell of
this air or the feel of the morning's sky."

The brilliant atmosphere and the spacious, arid
landscapes were indeed compelling; the artists,
however, at first took greater notice of the indig-
enous population of Indians and Hispanics.... The
lives of both unchanged by progress, untested by
another artistic eye, conformed perfectly to an
"American" perspective Anglo painters sought in the
Southwest.

—**Charles C. Eldredge and
William H. Truettner, 1986**

This strong primitive appeal [of New Mexico] calls out the side of art that is not derivative; it urges the painter to get his subjects, his coloring, his tone from real life about him, not from the wisdom of the studios.

Coupled with this impressive simplicity, the country makes its inhabitants daring and lovers of the "chance." In the cities men are careful, doing what others have done, bound by conventions, ringed round by tradition. The very air of the Taos country, its nearness to works of nature, drives caution from man's brain. He takes a chance.

—Victor Higgins, 1917

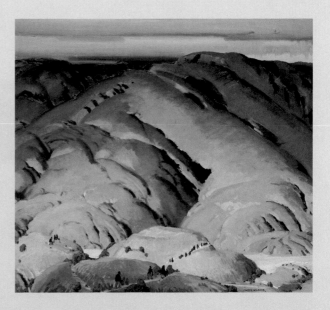

Victor Higgins (1884–1949), *Mountain Forms #2*, ca. 1925-27, oil on canvas, 102.9 x 109.4 cm (40 1/2 x 43 1/16 in.). Gift of Arvin Gottlieb

The Southwest

I think New Mexico was the greatest experience from the outside world that I have ever had. It certainly changed me for ever. Curious as it may sound, it was New Mexico that liberated me from the present era of civilization, the great era of material and mechanical development.

—D. H. Lawrence, 1931

Gene Kloss (born 1903), *Midwinter in the Sangre de Cristos*, ca. 1919–36, oil on canvas, 50.8 x 76.8 cm (20 x 30 1/4 in.). Transfer from the U.S. Department of Labor

It is a fact that admits of no question that Eastern people have formed their conceptions of what the Far-West life is like, more from what they have seen in Mr. Remington's pictures than from any other source.

—William A. Coffin, 1892

Frederic Remington
1861–1909

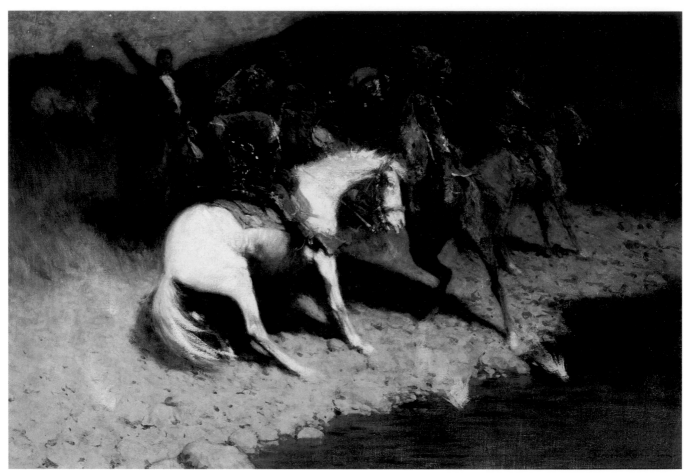

Fired On, 1907, oil on canvas, 68.8 x 101.6 cm (27 1/8 x 40 in.). Gift of William T. Evans

What came to interest Remington was not "the West" but the "no more"—that great Romantic theme that determined, more than any cowboy or Indian, his way of thinking. And Remington's most eloquent statement of this "no more," this Romantic distance, was his sustained unconscious expression of his paintings as, in his own words, "merely paint." For at no time was something further away for Remington than at just that moment when he wanted to bring it close.

—Alex Nemerov, 1991

I knew the railroad was coming—I saw men already swarming into the land.... I knew the wild riders and the vacant land were about to vanish forever, and the more I considered the subject the bigger the Forever loomed.

Without knowing exactly how to do it, I began to try to record some facts around me, and the more I looked the more the panorama unfolded.... I saw the living, breathing end of three American centuries of smoke and dust and sweat, and I now see quite another thing where it all took place, but it does not appeal to me.

—Frederic Remington, 1905

I paint the Indian as he is. In the garden digging—in the field working.... [The Indian] is not a fantastic figure. He resents being regarded as a curiosity.

Walter Ufer
1876–1936

One of the most prominent painters of the first generation who settled in Taos, Ufer's work in the Southwest was characterized by a dash and bravura that set him almost immediately apart from his more conservative colleagues, Joseph Henry Sharp, Eanger Irving Couse, and Bert Phillips. Ufer had received thorough training in Munich from 1911 to 1913 and came to Taos (through Chicago) a mature painter. He immediately shed his dark palette, painting his figures in full sunlight, with strong, vibrant color that became his personal variety of Southwest Impressionism....

Often (as in *Callers*) a psychological tension is evident in the subject. The meaning is never clear; the message that comes through is that understanding an alien culture is not as easy as portraying its colorful surroundings.

—William H. Truettner, 1984

Callers, ca. 1926, oil on canvas, 128.4 x 128.4 cm (50 1/2 x 50 1/2 in.). Gift of Mr. and Mrs. R. Crosby Kemper

20TH CENTURY *Life*

In art, the cult of the city was often closely allied with tendencies that sought to avoid all sentimentality and spontaneous personal expressiveness in favor of a disciplined order and a detachment that sometimes was manifested in a studied irony.... Once the horrors of World War I were passed, a new day did indeed seem to be dawning, and in the minds of artists and intellectuals the new cultural mentors were science and technology. The new psychology, too, in the writings of Freud and Jung, was helpful in making what had been thought private and personal quite public, breaking down the confines of the individual to allow for a consideration of man in terms of communal characteristics and the racial mind. To those who believed in it, the new impersonality meant emancipation.... There was a passionate need for that which was ruthlessly impersonal, hermetic, and mocking of self. What better image could there be than the modern, mechanized American city?

—Joshua C. Taylor, 1976

Max Weber (1881–1961), *Foundry in Baltimore*, 1915, pastel, 61.9 x 47.6 cm (24 3/8 x 18 3/4 in.). Museum purchase

The dominant trend in America of today, beneath all the apparent chaos and confusion is towards order and organization which find their outward sign and symbol in the rigid geometry of the American city: in the verticals of its smoke stacks, in the parallels of its car tracks, the squares of its streets, the cubes of its factories, the arc of its bridges, the cylinders of its gas tanks.

—Louis Lozowick, 1927

Louis Lozowick (1892–1973), *New York*, ca. 1925, lithograph, 29.2 x 22.9 cm (11 1/2 x 9 in.). Museum purchase

Their very suffering brings them together and, with shoulders that are habitually stooped and rounded from the burdens they are forced to bear, they collect in little knots—groups so eloquent in attitude that you can't help but paint them, because they represent New York.

—Everett Shinn, 1911

Everett Shinn (1876–1953), *Eviction (Lower East Side)*, 1904, gouache on paper mounted on paperboard, 21.3 x 33.3 cm (8 3/8 x 13 1/8 in.). Bequest of Henry Ward Ranger through the National Academy of Design

Urban Views

Werner Drewes (1899–1985), *Grain Elevator III*, 1926, drypoint on paper, 32.5 x 21.2 cm (12 13/16 x 8 3/8 in.). Gift of the artist

Howard Cook (1901–1980), *George Washington Bridge*, 1931, lithograph, 35 x 24.9 cm (13 13/16 x 9 13/16 in.). Gift of Barbara Latham

I have little interest, really none, in making the kind of pictures I know how to make.

In such a procedure there is for me no enlightenment.

Ralston Crawford
1906–1978

Buffalo Grain Elevators, 1937, oil on canvas, 102.1 x 127.6 cm (40 1/4 x 50 1/4 in.). Museum purchase

The personality of Mr. Crawford—I don't mean of the gentleman on two legs who has gone about to see the scenes presented on these canvases, I mean the personality that seems to look out at you, as if through a mirror, from behind the colours—that personality, then, is male, vigorous, honest, perceptive. It would make a good friend to have in the house.

—Ford Madox Ford, 1937

I belong to the twentieth century. To me, it is very important to belong to the century in which one lives. I have observed and considered at great length contemporary activities with a further consideration of appropriate pictorial procedure. It is clear to me that the forms of the Italian Renaissance as well as the Victorian viewpoint, for example, are not adequate for modern visual comment.

—Ralston Crawford, 1947

There is nothing particularly new in this modern art. It is based upon the same cosmic principles of harmonious balance and relation of lines, forms, colors, volumes as is all true art.

William Zorach
1889–1966

Zorach seems to have found his direction almost by instinct. He was not, of course, unaware of what other sculptors were doing, and from the beginning he showed a natural antipathy for the Rodin tradition of impressionist modeling. Writing in *The Arts* in 1925 and 1926, he criticized severely the bronzes of Degas for their lack of sculptural quality and praised the carvings of Brancusi. Like the latter, Zorach allied himself naturally with the growing number of modern sculptors who believed in the esthetic necessity of carving their own designs directly in the block of stone or wood rather than modeling them in clay to be copied by professional cutters in the harder material. Indeed Zorach was one of the first exponents of direct carving in this country.

—John I. H. Baur, 1959

In New York in order to free myself from my academic way of seeing the world about me, I reset my course. Instead of drawing with my right hand, I tried to draw with my untrained left. My right hand was too clever and patterned. The left hand had no habits to overcome; it was clumsy but free.... Instead of looking straight at a landscape I'd lie on my back and look up at the trees; I was seeing a new world, new forms and movement unfolded....

My place in the art world did not come easily to me.... It was my innate belief in myself and in the importance of art in life that sustained me through the long years of struggle.

—William Zorach, 1967

Victory, 1944, French marble, 107.7 x 38.1 x 30.8 cm (42 3/8 x 15 x 12 1/8 in.). Gift of Mrs. Susan Morse Hilles

Transition, among other things, implies a degree of change which for me is a sufficient shift to constitute an end and a beginning.

Theodore Roszak
1907–1981

Recording Sound, 1932, plaster and oil on wood, 81.3 x 121.9 x 17.1 cm (32 x 48 x 6 3/4 in.). Museum purchase

Recording Sound combines painting and sculpture in a way that is unique in Roszak's oeuvre and quite possibly unique in all American art. A three-dimensional plaster stage projects forward and backward from the canvas plane to a total depth of about three inches—a miniaturized opera performed for the modern miracle of the gramophone. Just as new technology transcribed live music into recorded sound, the painter transcribed the fully experienced world into an abstracted, flattened plane. From this concept Roszak developed an image brimming with personal and social meaning.

—Elizabeth Broun, 1989

For [Roszak] a construction can never be a purely non-objective arrangement of lines, shapes, and masses. It must be a machine.
—H. H. Arnason, 1956

The boundaries of nations are not the boundaries of Art.

Yasuo Kuniyoshi
1889–1953

In 1922 Kuniyoshi embarked on a new kind of subject—children.... His children with their big heads and almond eyes have a decided Oriental character and at the same time a strong early American flavor. These were the days of the discovery of American folk art, a discovery due largely to the artists of the modern movement and those close to them. His friends were scouring the countryside for early paintings and furniture. Kuniyoshi remembers that the furniture impressed him even more than the paintings. His pictures of the early 1920's show an unmistakable early American influence. It is curious how the Oriental, the early American and the modernist elements came together in them and harmonized.
—Lloyd Goodrich, 1948

The age-old controversy, environment versus inheritance, is not within my province, but certainly there has been sufficient proof established that cultural assimilation does take place. If the individual lives and works in a given locale for a length of time, regardless of nationality, work produced there becomes indigenous to that country. The results may not coincide with those already established forms, but what is it that makes for vitalization and progress if not new sources of inspiration from other civilizations.
—Yasuo Kuniyoshi

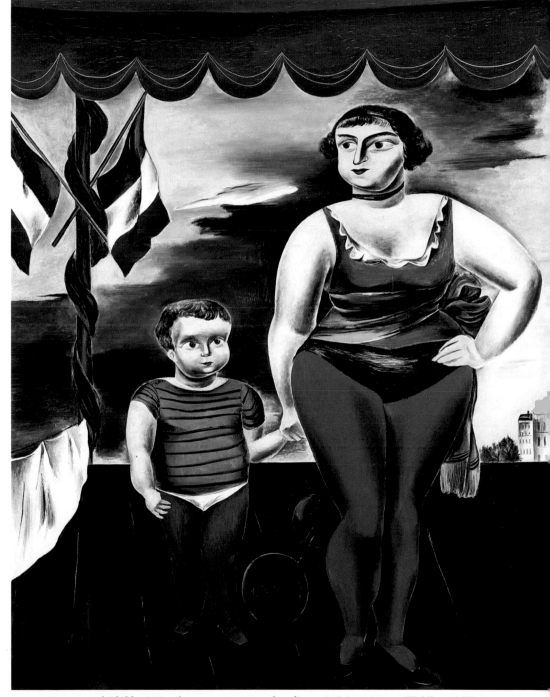

Strong Woman and Child, 1925, oil on canvas mounted on linen, 145.4 x 114 cm (57 3/8 x 44 7/8 in.). Gift of the Sara Roby Foundation

20TH CENTURY *Life*

What the government's experiments... actually did, was to work a sort of cultural revolution in America. They brought the American audience and the American artist face to face for the first time in their respective lives. And the result was an astonishment needled with excitement such as neither the American audience nor the American artist had ever felt before.

—Archibald MacLeish, 1937

Millard Sheets (1907–1989), *Tenement Flats (Family Flats)*, ca. 1934, oil on canvas, 102.1 x 127.6 cm (40 1/4 x 50 1/4 in.). Transfer from the U.S. Department of the Interior, National Park Service

Speaking for myself, I can say that without the financial benefit of the Project, it would have been impossible for me to have continued to work and grow in stature. The collective output of the past year has clearly revealed the enormous amount of young talent that, under less fortunate circumstances, would have been crushed on the wheels of poverty. It is of the greatest importance to the culture of our nation that the Project be maintained on a permanent basis, free from the offensive stigma of relief.

—O. Louis Guglielmi, 1936

Moses Soyer (1899–1974), *Artists on WPA*, 1935, oil on canvas, 91.7 x 107 cm (36 1/8 x 42 1/8 in.). Gift of Mr. and Mrs. Moses Soyer

Francis Criss (1901–1973), *Sixth Avenue "l"* (mural, Williamsburg Housing Project, New York), 1937, oil on canvas, 182.9 x 213.4 cm (72 x 84 1/8 in.). Transfer from the Newark Museum

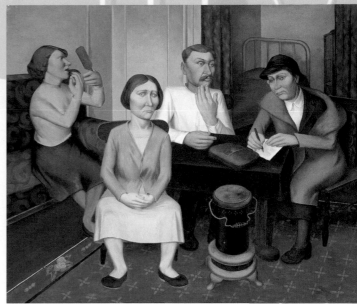

O. Louis Guglielmi (1906–1956), *Relief Blues*, ca. 1938, 61.1 x 76.2 cm (24 x 29 7/8 in.). Transfer from the Museum of Modern Art

The New Deal

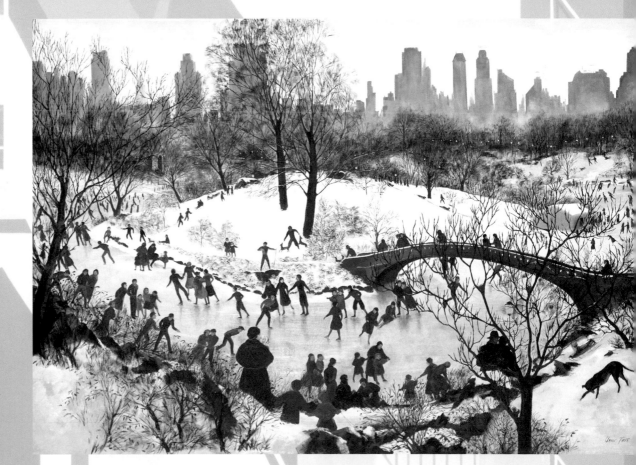

Agnes Tait (1894–1981), *Skating in Central Park*, 1934, oil on canvas, 85.8 x 121.8 cm (33 7/8 x 48 1/8 in.). Transfer from the U.S. Department of Labor

Photography can never grow up if it imitates some other medium.

It has to walk alone; it has to be itself.

Berenice Abbott
1898–1991

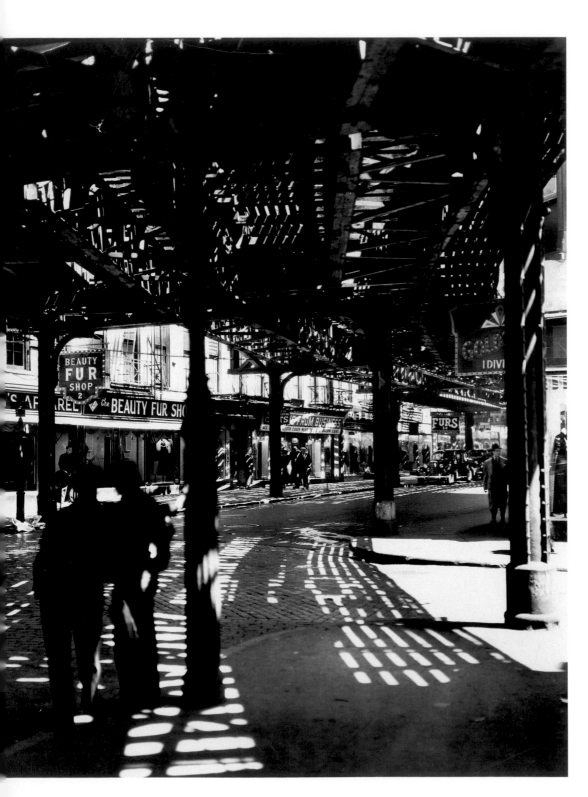

It is important that [the city] should be photographed today, not tomorrow; for tomorrow may see many of these exciting and important mementos of eighteenth- and nineteenth-century New York swept away to make room for new colossi. Already many an amazing and incredible building which was, or could have been, photographed five years ago has disappeared. The tempo of the metropolis is not of eternity, or even time, but of the vanishing instant. Especially then has such a record a peculiarly documentary, as well as artistic, significance. All work that can salvage from oblivion the memorials of the metropolis will have value.

—Berenice Abbott, 1935

"El" Second and Third Avenue Lines; Bowery and Division Street, Manhattan (from series, "Changing New York"), 1936, gelatin-silver print, 24.4 x 19.9 cm (9 9/16 x 7 7/8 in.). Gift of George McNeil

If I have achieved a degree of success as a creative artist, it is mainly due to the black experience which is our heritage—an experience which gives inspiration, motivation, and stimulation.

Jacob Lawrence
born 1917

Maybe...humanity to you has been reduced to the sterility of the line, the cube, the circle, and the square; devoid of all feeling, cold and highly esoteric. If this is so, I can well under- stand why you cannot portray the true America. It is because you have lost all feeling for man. And the art of those that are devoid of feeling themselves can- not reflect the vital, strong, and pulsating beat that has always been humanity. And your work shall remain without depth for as long as you can only see and respect the beauty of the cube, and not see and respect the beauty of man—every man.
—Jacob Lawrence, ca. 1953

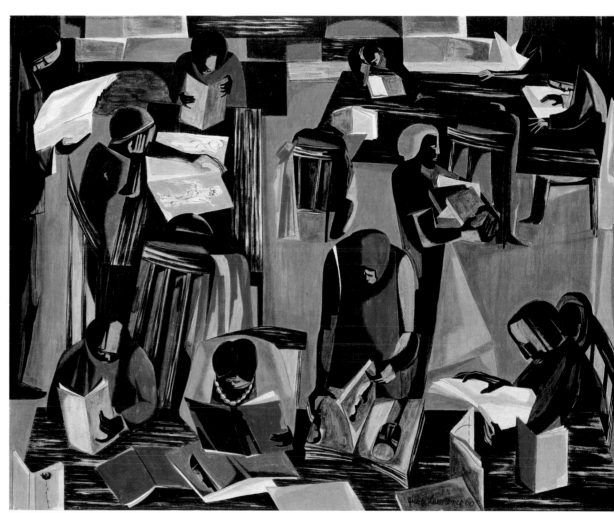

The Library, 1960, tempera on fiberboard, 60.9 x 75.8 cm (24 x 29 7/8 in.). Gift of S. C. Johnson & Son, Inc.

The constants that move through Jacob Lawrence's art from the mid-1930s to the present are a collage cubist style, a format of narrative and often serial imagery, and a subject matter of black American history or contemporary life. These constants seem quite straightforward, almost formulaic. And on one level they are, because a kind of simplicity resides in the instant comprehensibility of the art: in its subject matter—everyday life in the black community and the historic struggles of oppressed people—and in the nonillusionistic shapes and colors. The simplicity, however, does not preclude the complex aesthetic decisions that Lawrence, even in the beginning of his career, made in composing the paintings, nor the richness of the results.

—Patricia Hills, 1986

20TH CENTURY *Life*

A visit to [Johnson in Harlem] on a rainy day recently found him working in a very large room covering the entire top floor of [a] garage building and its walls lined with his Modern paintings. Rain was leaking through the roof in several places and water stood on the floor nearly everywhere.... He had just completed a self-portrait which stood on the easel. The room was entirely without electric lights, although empty sockets hung from the ceiling here and there. As the darkness approached, Mr. Johnson lighted a candle which stood in the neck of a bottle.... The place was clean and orderly and while the furnishings were most modest...Mr. Johnson's self-possession and joy at finding someone interested in what he was doing made one forget these things and feel that he was a real genius and in the finest surroundings.

—Unsigned, Harmon Foundation Papers, ca. 1929

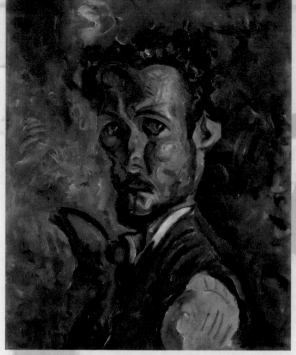

Self-Portrait, 1929, oil on canvas, 59 x 46.3 cm (23 1/4 x 18 1/4 in.). Gift of the Harmon Foundation

William H.

In all my years of painting, I have had one absorbing and inspiring idea, and have worked towards it with unyielding zeal: to give—in simple and stark form—the story of the Negro as he has existed.

—William H. Johnson, 1946

Li'l Sis, 1944, oil on paperboard, 66.1 x 54 cm (26 x 21 1/4 in.). Gift of the Harmon Foundation

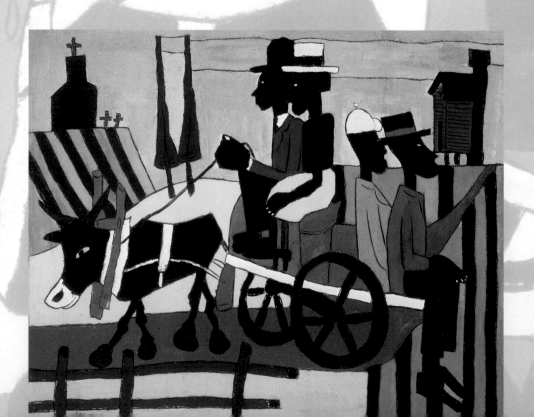

Going to Church, ca. 1940-41, oil on burlap, 96.8 x 115.4 cm (38 1/8 x 45 1/2 in.). Gift of the Harmon Foundation

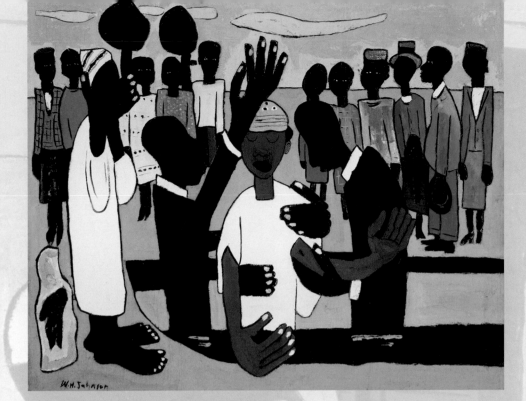

I Baptize Thee, ca. 1940, oil on burlap, 96.9 x 115.6 cm (38 1/4 x 45 1/2 in.). Gift of the Harmon Foundation

Johnson

1901–1970

Throughout most of his career Johnson sought to capture the soul and spirit rather than simply the appearance of his subjects. An expressionist, he valued instinct over intellect and acknowledged that his vision as an artist was as important in making paintings as was depicting the observable world. In his earlier paintings of picturesque towns and dramatic landscapes, as well as in the images with African-American themes, the "world" he chose to paint was a down-to-earth place, inhabited by people who, like him, believed in community. He summed up his personal philosophy of art...in 1932: "My aim is to express in a natural way what I feel, what is in me, both rhythmically and spiritually, all that which in time has been saved up in my family of primitiveness and tradition, and which is now concentrated in me." In this context, "primitivism" refers to Johnson's sense of racial/cultural belonging to the "folk," and the way this kinship with people who are bound to nature resulted in an art that expressed the tradition, essence, and spirituality of a greater, more generic "family."

—**Richard J. Powell, 1991**

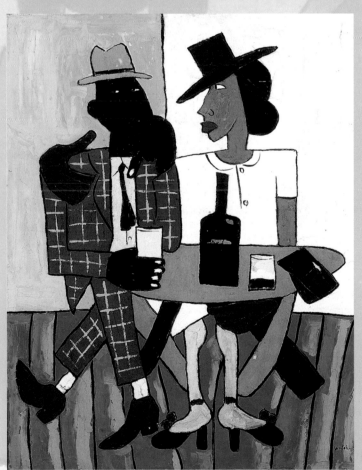

Cafe, ca.1939–40, oil on paperboard, 92.7 x 72.2 cm (36 1/2 x 28 3/8 in.). Gift of the Harmon Foundation

The only way an artist can personally fail is to quit work.

Thomas Hart Benton
1889–1975

Achelous and Hercules, 1947, tempera and oil on canvas mounted on plywood, 159.6 x 671 cm (62 7/8 x 264 1/8 in.). Gift of Allied Stores Corporation, and museum purchase through the Smithsonian Institution Collections Acquisition Program

Benton's major mural painting, *Achelous and Hercules,* is a splendid example of the artist's ability to raise the American experience to the level of myth. As a youth, Benton spent many hours studying classical murals in the then-new Library of Congress in Washington—his father served as a congressman from Missouri from 1897 to 1904—and his interest in mythology was shared by the abstract artists of his generation.

In this work, Hercules wrestles Achelous, a river god who assumes the form of a giant bull, for the favors of Deianeira. Hercules breaks off one horn, which then is miraculously transformed into a cornucopia or horn of plenty. Throughout the mural, America is presented as a land of abundance and opportunity.

—Elizabeth Broun, 1985

Benton's idiom was essentially political and rhetorical, the painterly equivalent of the country stump speeches that were a Benton family tradition. The artist vividly recalled accompanying his father, Maecenas E. Benton—a four-term U.S. congressman, on campaigns through rural Missouri. Young Tom Benton grew up with an instinct for constituencies that led him to assess art on the basis of its audience appeal. His own art, after the experiments with abstraction, was high-spirited entertainment designed to catch and hold an audience with a political message neatly bracketed between humor and local color.

—Elizabeth Broun, 1987

I believe that art is not only more true but also more living and vital if it derives its immediate inspiration and its outward form from contemporary life.

Paul Cadmus

born 1904

The color in the picture was used symbolically—related to the Seven Deadly Sins. The soldier is in red light (Lust), the woman is in golden-yellow light (Money, Avarice), the traveler is in a green light (Envy). Auden once said sometime somewhere that "homo–sexuality is a form of Envy," it is a desire for the maleness of the male.
—Paul Cadmus, 1981

Cadmus's neglect by critics is notorious. He has been a true rebel in a revolution trivialized by fashionable rebelliousness that long ago forgot (and sometimes never knew) what the revolution was about. In a wonderful irony of history, he is the *enfant terrible* who turned out to be, after all, the keeper of the flame in a time of confusion and darkness. Whatever our allegiances or our taste, we cannot deny that having a draftsman among us who can draw like Pisanello is a miracle, and one which the Age of Andy Warhol scarcely deserves.
—Guy Davenport, 1989

Night in Bologna, 1958, egg tempera on fiberboard, 129 x 89 cm (50 1/2 x 35 1/8 in.). Gift of the Sara Roby Foundation

I like Coney Island because of the sea, the open air,

and the crowds—crowds of people in all directions, in all positions, without clothing,

moving—like the great compositions of Michelangelo and Rubens.

Reginald Marsh
1898–1954

George Tilyou's Steeplechase, 1932, oil and egg tempera on linen mounted on fiberboard, 76.5 x 101.8 cm (30 1/8 x 40 in.).
Gift of the Sara Roby Foundation

Once upon a time when an artist dared not study the human body, he tried nevertheless to paint it; now when we know the body better than we ever did, we try not to paint it. We have all the learning but don't use it? I begin to be afraid the art of drawing man may be destroyed.

—Reginald Marsh

20TH CENTURY *Life*

American artists using Surrealism often found no compulsion to create new environments for fantasy; the local scene served perfectly well.... In a sense, the tie to reality can be perceived even in the automatist-derived art of the Americans. The generation of Americans who experienced Surrealist aesthetics directly, when the European Surrealists arrived here during World War II, generally did not involve themselves with the rather abstruse and purely psychic qualities of the style. Though an indefinable romantic sensibility may have been part of their nature, the artistic liberation of Surrealism was funneled directly toward the problem of picture-making.

—Jeffrey Wechsler, 1976

Lorser Feitelson (1898–1978), *Genesis #2*, 1934, oil on fiberboard, 102.1 x 121.8 cm (40 1/4 x 47 7/8 in.). Museum purchase

Surreal

My central position is one of extreme romanticism—the concept of "reality" as being, innately, mystery and magic; the intuitive awareness of the power of the "unknown"—which human beings are afraid to realize, and which none of their religious and intellectual systems can really take into account. This romanticism revolves upon the feeling that the world is far stranger than we think; that the "reality" we think we know is only a small part of a "total reality"; and that the human imagination is the key to this hidden, and more inclusive "reality."

—Clarence John Laughlin, 1973

Clarence John Laughlin (1905–1985), *Figment of Desire*, 1941, gelatin-silver print on paper mounted on paperboard, 34.3 x 26.7 cm (13 1/2 x 10 1/2 in.). Museum purchase through the Director's Discretionary Fund and the General Acquisitions Fund

George Tooker (born 1920),
The Waiting Room, 1959, egg tempera
on wood, 61 x 76.2 cm (24 x 30 in.).
Gift of S. C. Johnson & Son, Inc.

Connections

Jan Matulka (1890–1972), *Surrealist Figures in Landscape*, ca. 1935,
watercolor, ink, and pencil on paper, 51.2 x 57.8 cm (20 3/16 x 22 3/4in.).
Museum purchase

Ralph Eugene Meatyard (1925–1972),
Untitled, 1954, gelatin-silver print on
paper mounted on paperboard,
22.5 x 9.3 cm (8 7/8 x 3 5/8 in.).
Museum purchase

20TH CENTURY *L*IFE

In 1969 Joseph Cornell wrote: "Anyone who has shown any...concern...with my work & [who] has not been moved or inspired to become involved somehow or other with the humanities in a down-to-earth context...has not understood its basic import." "Down to earth"—a quality rarely ascribed to a man characterized as reclusive and eccentric or to a body of work associated with the realms of poetry and dreams. Yet the expression, as used by Cornell to connote an unpretentious, compassionate engagement with life, bears directly on his pursuit of knowledge and the manner in which he lived and worked.

—Lynda Roscoe Hartigan, 1980

Americana: Natural Philosophy (What Makes the Weather?), ca. 1955, masonite, paper, paint, colored pencil, graphite, and ink, unframed, 30.5 x 22.8 cm (12 x 9 in.). Gift of Robert Lehrman in honor of Lynda Roscoe Hartigan

Joseph

At night, [Cornell's] cellar studio became a luminous sanctuary. Stains, splashes, streams of colored dyes had left phosphorescent patterns on the floor there.... An effect of hibernation and sequestration had been created around the objects in this uniformly whitewashed low-ceilinged room. Objects, too diversified to catalog, along with the random order of various cardboard boxes, large and small, purely functional, also whitewashed, crudely shelved, and hurriedly identified with Prussian blue poster-paint: *Medici slot material, Best white boxes, Tinfoil, Old-fashioned marbles, Habitat birds, Watch parts, Love Letters, Cupid (Miscellaneous), Jennifer Jones, Cherubino, Caravaggio, Nostalgia of the Sea.* Old newspapers (bone-colored), ready to crumble, leaves, small stones, rain-soaked oddments of wood, even a bird's nest on a weather-worn plank with two (fractured) pale-beige speckled eggs inside it.

—Howard Hussey, 1974

Colombier (Dovecote #2), ca. 1950, tempera and ink on newsprint, wood, and glass, 48.4 x 32.7 x 10.2 cm (19 1/16 x 12 7/8 x 4 in.). Gift of Mr. and Mrs. John A. Benton

"Ideals Are Like Stars; You Will Not Succeed in Touching Them with Your Hands..." (Great Ideas of Western Man Series), ca. 1957–58, painted and stained wood, glass, shells, etc., 44.2 x 32.7 x 8.9 cm (17 3/8 x 12 7/8 x 3 1/2 in.). Gift of the Container Corporation of America

Creative filing
Creative arranging
as poetics
as joyous creation
—Joseph Cornell, 1959

Cornell
1903–1972

Jouet Surréaliste, ca. 1932, steel line engravings, paper, paint, and ink on paperboard, 2.3 x 10.6 x 9.9 cm (7/8 x 4 1/8 x 3 7/8 in.). Gift of Mr. and Mrs. John A. Benton

Helen Levitt's extraordinary gift is to perceive in a transient split second, and in the most ordinary of places—the common city street—the richly imaginative, various, and tragically tender moments of ordinary human existence.

—Sandra S. Phillips

Helen Levitt
born 1918

New York (Children with Masks), ca. 1942, gelatin silver print, 18.1 x 26.6 cm (7 1/8 x 10 1/2 in.). Museum purchase

Limited and specialized as her world is, it seems to me that Miss Levitt has worked in it in such a way that it stands for much more than itself; that it is, in fact, a whole and round image of existence. These are pastoral people, persisting like wild vines upon the intricacies of a great city, a phantasmagoria of all that is most contemporary in hardness of material and of appetite. In my opinion they embody with great beauty and fullness not only their own personal and historic selves but another self also which I presume to be warm-blooded, and pastoral, and, as a rule, from its first conscious instant onward, as fantastically misplanted in the urgent metropolis of the body as the body in its world.

—James Agee, 1965

Helen Levitt's pictures remind viewers of the redemptive possibilities within a community, even one down on its luck: boys and girls who don't have much nevertheless have one another, and with great exuberance seize each day for all it is worth. The viewer is asked for no sorrow, no act of condescending pity, no highfalutin "policy paper" with various social and political recommendations— only to marvel at and enjoy, in Flannery O'Connor's phrase, the "mystery and manners" of childhood.

—Robert Coles, 1992

My pictures are immediate and yet at the same time, they're forever.

They present a moment so profoundly a moment that it becomes an eternity.

Roy DeCarava
born 1919

At first, in the mid-forties, DeCarava used photography to create resource material for his paintings. However, he became increasingly interested in photography for its own sake, and by 1947 it had become his principal medium.

DeCarava's first photographic project was an emotionally powerful study of the people of Harlem, which he continued when he became the first black Guggenheim Fellow in 1952....
His interest in promoting exhibitions of photography prompted DeCarava to found and direct (1954-56) A Photographer's Gallery in New York, one of the first post-World War II galleries to show photography as a fine art.
—**John Bloom and Diana C. Du Pont, 1986**

Untitled (Five Young Girls), ca. 1954, gelatin silver print mounted on paperboard, 24.7 x 34.3 cm (9 3/4 x 13 1/2 in.). Museum purchase

Roy DeCarava's focus on life in the city is personal rather than panoramic. Many photographers interpret the city as an abundance of structure, people, and movement, and the rapid course of city life is accurately delineated in their works. DeCarava, in contrast, penetrates this surface frenetic action of urban existence and concentrates his attention upon the single image, the single interaction. Thus, clarity and quietude emerge from his work as valid aspects of urban reality which one seldom recognizes.... DeCarava's unerring sense of grace renders human pain visually bearable and makes manifest the beauty lying dormant within the mundane passages of life.

—**Alvia Wardlaw Short, 1975**

20TH CENTURY *Life*

My intention in the neighborhood paintings and some drawings was to show aspects of life in the city with special reference to the use of the terminology "black" people and to present them in an ordinary light, persons enjoying the usual pleasures of life with its mixture of both sorrow and joys.

—Allan Rohan Crite

Allan Rohan Crite (born 1910), *School's Out*, 1936, oil on canvas, 76.9 x 91.8 cm (30 1/4 x 36 1/8 in.). Transfer from The Museum of Modern Art

African-American

During the Harlem Renaissance Alain Locke observed that African sculpture had been for contemporary European painting and sculpture "a mine of fresh motifs...a lesson in simplicity and originality of expression." He went on to prophesize that "surely, once known and appreciated, this art can scarcely have less influence upon the blood descendants, bound to it by tradition only".... Travel, military service, rising political consciousness and increased flow of information would all contribute to the experience of young African-American artists, encouraging them to reclaim their past.

—Alvia J. Wardlaw, 1989

Lois Mailou Jones (born 1905), *Les Fétiches*, 1938, oil on canvas, 64.7 x 54 cm (25 1/2 x 21 1/4 in.). Museum purchase made possible by Mrs. N. H. Green, Dr. R. Harlan, and Francis Musgrave

Artists should work to the end that love, peace, justice, and equal opportunity prevail all over the world; to the end that all people take joy in full participation in the rich material, intellectual, and spiritual resources of this world's lands, peoples, and goods.
—Elizabeth Catlett, 1984

Elizabeth Catlett (born 1919), *Singing Head*, 1980, black Mexican marble, 40.7 x 24.2 x 30.5 cm (16 x 9 1/2 x 12 in.). Museum purchase

Experience

Hughie Lee-Smith (born 1915), *The Stranger*, ca. 1957–58, oil on canvas, 66 x 91.4 cm (26 x 36 in.). Museum purchase

Eldzier Cortor (born 1916), *Southern Gate*, 1942–43, oil on canvas, 117.5 x 55.8 cm (46 1/4 x 22 in.). Gift of Mr. and Mrs. David K. Anderson, Martha Jackson Memorial Collection

My aim in painting has always been the most exact transcription possible of

my most intimate impressions of nature.

Edward Hopper
1882–1967

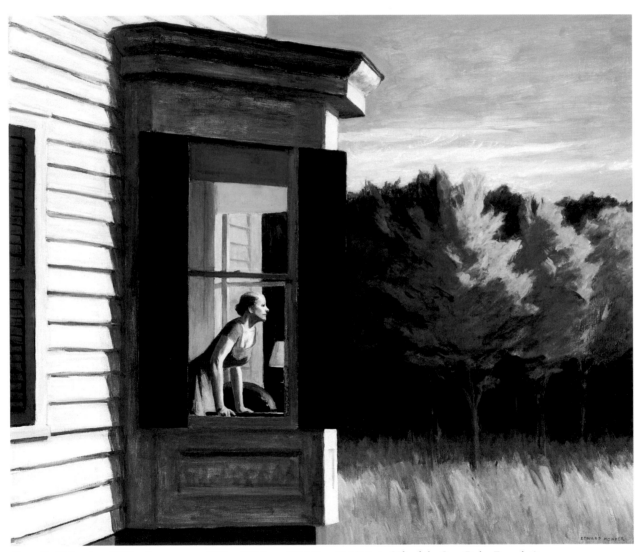

Cape Cod Morning, 1950, oil on canvas, 86.7 x 102.3 cm (34 1/8 x 40 1/4 in.). Gift of the Sara Roby Foundation

Part of the mystery of Hopper's impact is that in his paintings nothing very much happens. Neutralized by anonymity, people gaze out windows, gather on a porch, at a restaurant, a hot-dog stand. They never speak, or run, or attract attention. All the things in his pictures—the hoardings, empty streets, buildings, people—would take on a natural unity with some happening or action. But the psychological strings of overt motivation remain unconnected, reminding one of Robert Lowell's phrase, "a wilderness of lost connections."

Yet his power of concentration makes the absence an event. A non-event becomes one almost against one's will. That is what gives his work its great power to hold one through the sheer curiosity felt before such laconic indifference.

—Brian O'Doherty, 1964

Pathos motivated me in the past. It doesn't motivate me anymore. I'm interested in the natural grace, the tremendous strength and simple beauty that have preserved the Black people through all these years of trauma.

John Biggers born 1924

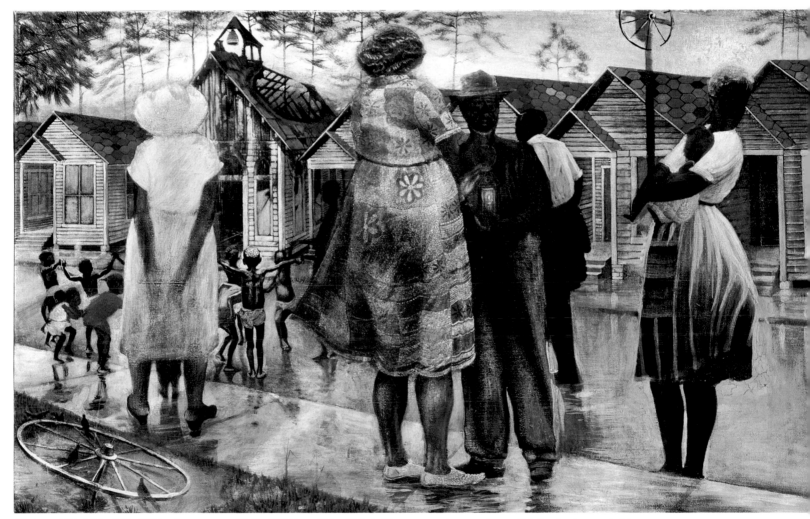

Shotgun, Third Ward #1, 1966, oil on canvas, 76.2 x 121.9 cm (30 x 48 in.). Museum purchase made possible by the Anacostia Museum, Smithsonian Institution

Shotgun, *Third Ward #1* depicts a scene from Houston's predominantly African-American Third Ward community where Biggers lived.... A pivotal painting in the artist's career, it is one of his earliest to employ three motifs that became ubiquitous symbols in his later works: the wheel, shotgun houses, and a lighted candle. This excerpt of Third Ward life depicts a church that burned in the neighborhood among a row of neatly arranged shotgun houses, and the reactions of some of the residents to that event....

Immediately behind the central female figure is an elderly African-American man holding a lighted candle in a glass [symbolizing] a ray of hope for the burned church, which will be restored and continue to serve as a source of light and inspiration for the community. Characteristically, a group of small children who play and dance in the middle ground, seemingly oblivious to the recent tragedy, represent the next generation of Third Ward leaders.

—Regenia A. Perry, 1992

20TH CENTURY *Life*

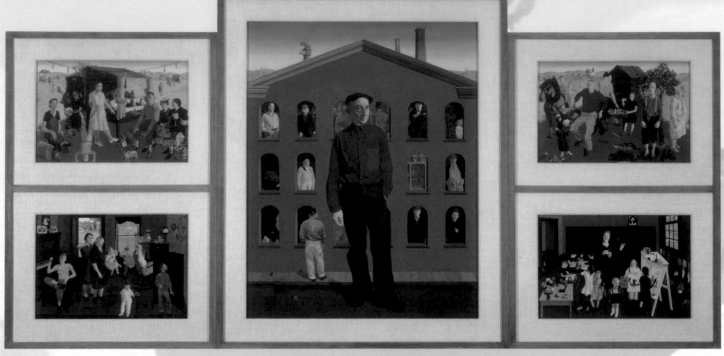

Honoré Sharrer (born 1920), *Tribute to the American Working People*, 1951, oil on composition board, 98.5 x 196.2 cm (38 1/4 x 77 1/4 in.). Gift of the Sara Roby Foundation

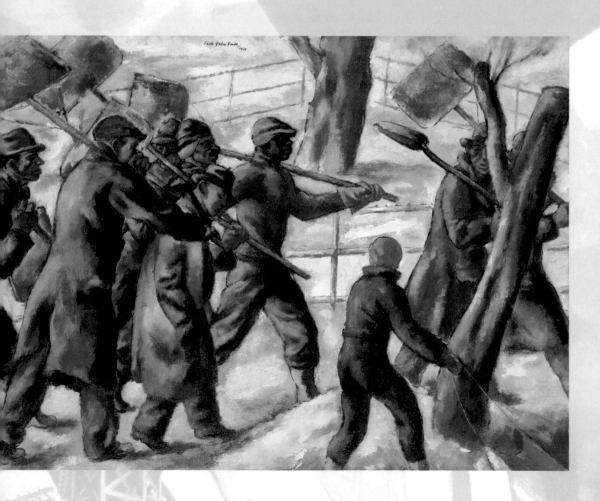

In my painting gamut I give preference to the toiler and his station in life, to the miner with his coal-blackened face, the hunch-backed little street he lives on and never sees in daylight; landscape and still life of social meaning are also my themes.

My approach to art is social realism as are my convictions and general conception of life.

I prefer the ethical to the esthetic and refuse to sacrifice truth.

—Frank Cohen Kirk

Jacob Getlar Smith (1898–1958), *Snow Shovellers*, 1934, oil on canvas, 76 x 101.9 cm (29 7/8 x 40 1/8 in.). Transfer from the U.S. Department of Labor

Frank Cohen Kirk (1889–1963), *Homeward*,
oil on canvas, 122.4 x 97.2 cm (48 1/8 x 38 3/8 in.).
Gift of Mrs. Frank Cohen Kirk

In Europe there is, from the nineteenth century, a definable pattern of artists' concern with expressing...the contemporary circumstances and problems of workers' lives.... In America, which had not known the violent revolutions of the 1840s and 1870s in Europe, and did not have Europe's heritage of a sharply defined and immobilized class structure, recognition of the workers' existence and role in society could be post-poned until the 1930s.... It was the rare American painter before the twentieth century who was a social activist through his work.

Yet the American worker entered American painting obliquely: as imaginative portrait, as enlivening detail in landscape, as part of the drama of an exotic interior, as character actor in narrative genre. At last, in the twentieth century he became central to American expression in the visual arts.

—Abigail Booth Gerdts, 1979

Labor

William Gropper (1897–1977), *Construction of the Dam*, 1937, oil on canvas, left: 68.8 x 57.3 cm (27 1/8 x 22 5/8 in.), center: 68.9 x 106.7 cm (27 1/8 x 42 in.), right: 68.8 x 57.3 cm (27 1/8 x 22 5/8 in.). Transfer from the U.S. Department of the Interior, National Park Service

[Gropper's] earliest schooling in life was in a great American institution—the sweatshop, on New York's lower East side and there he became a part of the people for his life and ours. There he learned the hard way about their sufferings and about their fight and became a battering ram in that fight.

Some aesthete one day asked Gropper why the color in his paintings of the East side was so subdued—why he didn't splash and revel in the full orchestration of a luscious palette. Gropper replied that when he worked in the sweatshop the cloth seemed grey—the light was poor—his back was tired and there was an awful stink in the place. He could not paint these struggling people's lives in roseate hues.

—Philip Evergood, 1944

20TH CENTURY *Life*

Jay Jaffee (born 1921), *Chair and Window Frame, Queens, New York*, 1950, gelatin silver print, 18.1 x 16.3 cm (7 1/8 x 6 1/2 in.). Museum purchase

Sid Grossman (1914–1955), *Coney Island*, 1947–48, gelatin silver print, 20.3 x 25.1 cm (8 x 9 7/8 in.). Museum purchase

Just to photograph the event? No, not just that, but to tell the story of what is happening through the people who are involved, either as participants or bystanders—to photograph them at the split moment in which all that they are thinking and feeling is intensely mirrored in their faces.
—Paul Strand, 1945

Weegee (1899–1968), *Untitled (In the Movie House Watching "Haunting of Hill House")*, ca. 1950, gelatin silver print, 27.9 x 32.4 cm (11 x 12 3/4 in.). Museum purchase

Rebecca Lepkoff (born 1916), *Untitled (Family on Street)*, 1948, gelatin silver print, 18.4 x 24.8 cm (7 1/4 x 9 3/4 in.). Museum purchase made possible by Howland Chase, James Harlan, Lucie Fery, B. Giradet, and George McClellan

The morning sun picks out an apartment house, a cigar store, streams through the dusty window of a loft. The racket swells with the light. These shoes are killing me, she said, taking the cover off the typewriter. Main Central is up to forty-six. Did you read about the earthquake? Looms, shears, jackhammers, trolley cars, voices, add to the din. And in the quieter streets the hawkers with the pushcart moves slowly by.

—The WPA Guide to New York City, 1939

City Lives

Photography has always been to me a passionate way of interpreting the world around me. Human beings (whether they are in the photograph or not) have always been the central theme of my work.

—Louis Stettner, 1988

Louis Stettner (born 1922), *Promenade, Brooklyn*, 1954, gelatin silver print, 26 x 34.6 cm (10 1/4 x 13 5/8 in.). Museum purchase made possible by Howland Chase, James Harlan, Lucie Fery, B. Giradet, and George McClellan

I don't care about being realistic. In other words, I don't put in little rust spots or bolts that show. I'm not looking for that kind of realism. I'm just using the subjects as the stepping-off points to compose the paintings.

Robert Cottingham
born 1935

The shabby commercial areas of any downtown area are rich in what Cottingham is looking for.... For all the paintings, drawings, and graphics that Cottingham does, the primary step is the photographing of the image and this requires a strategically planned trip at least once a year. The atlas is spread out and areas marked to set up a chain of cities and towns that correspond to the Greyhound bus routes. Cottingham's enthusiasm for bus travel is understandable: "Bus terminals are in the grubbiest part of town...exactly where my subject matter is."
—Jane Cottingham, 1980

Candy, 1979, oil on canvas, 198.4 x 198.4 cm (78 1/8 x 78 1/8 in.). Museum purchase made possible by the Luisita L. and Franz H. Denghausen Endowment

Commercial signs are amazing. Here are these elaborate, monumental structures designed solely to tell you that this is where you can buy a hamburger or a pack of cigarettes. You can see these signs as hilarious or pathetic. All that effort, all that pomposity just to sell you something. And yet they are an heroic attempt by someone to leave his mark.

—Robert Cottingham, 1980

Numbers fill my life. They fill my life even more than love. We are immersed in numbers from the day we are born. Love? Love is like the cherry on top of the whipped cream.

Robert Indiana

born 1928

My favorite American painting in the Metropolitan Museum of Art is Charles Demuth's I Saw the Figure Five In Gold painted in 1928, the year I was born. It was inspired by a William Carlos Williams poem, The Great Figure, and that's an interesting story in itself. One hot summer's day in New York, Williams was on his way to visit the studio of a friend, Marsden Hartley, on 15th Street, when he heard "a great clatter of bells and the roar of a fire engine passing." He turned in time to see a golden figure 5 on a red background flash by and it moved him to scribble the following poem on the spot:

Among the rain
and lights
I saw the figure 5
in gold
on a red
firetruck
moving
tense
unheeded
to gong clangs
siren howls
and wheels rumbling
through the dark city.
—Robert Indiana, 1982

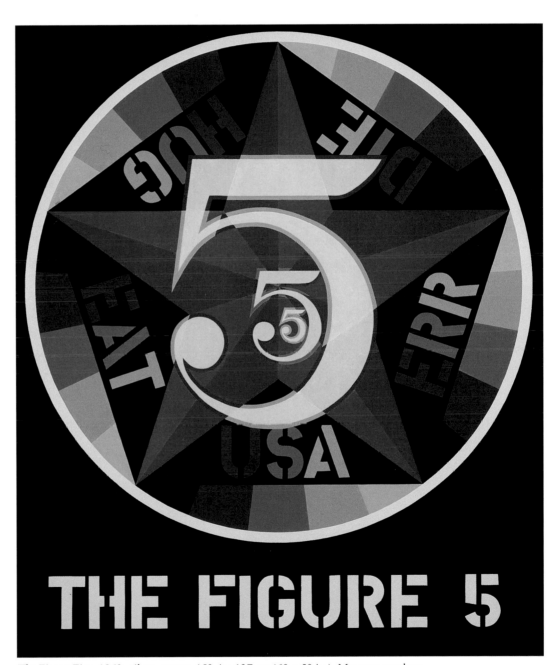

The Figure Five, 1963, oil on canvas, 152.4 x 127 cm (60 x 50 in.). Museum purchase

20TH CENTURY *Life*

Roger Brown, (born 1941), *World's Tallest Building Disaster*, 1972, oil and Magna on canvas, 183.1 x 122 cm (72 1/8 x 48 in.). Museum purchase

The Imagists' use of the vernacular is always filtered through a strongly personal response. Commercial and popular sources are never used "straight" but are catalysts for the artists' emotionally charged transformations.... Nutt's [figures evolve] through jagged and then more fluid distortions, and Nilsson's in an organic profusion.... Brown transforms his figures and the other elements of his land- and cityscapes into stylized emblems of the things they represent. This transformation of the everyday into personalized variations also occurs in the work of...Yoshida and others. A catalogue of the Imagists' methods of expressive transformation, then, would include the distortions of expressionism, the juxtapositions of Surrealism and the stylization of primitive and folk art.

—Russell Bowman, 1980

For me, Chicago epitomizes the American experience in that it is constantly changing—vital. In Chicago, even our architectural masterpieces are sacrificed; old buildings are torn down to make way for the new. In Europe, artists are surrounded by past architecture and art. All this must be inhibiting. In America—in Chicago—we are living in a constantly growing and changing environment, one that is to a large extent devoid of masterpieces of older art. In a strange way this is good, because not having the great works of European art as constant reference points gives us the opportunity to make fresh art—art that derives from our own experience.

—Roger Brown, 1978

Ray Yoshida, (born 1930), *Partial Evidences II*, 1973, acrylic on canvas, 126.3 x 116.5 cm (49 3/4 x 45 7/8 in.). Gift of the S. W. and B. M. Koffler Foundation

It is in the nature of Chicago art that it is anti-traditional and anti-idealistic to the core, and this means that it is as likely to turn its back on its own tradition as on others. Just as soon as any given ideal is recognized, Chicago art yearns to split from it.... That's a rather dadaist thought, and Jean Dubuffet—long a special favorite among Chicago artists and collectors—once remarked that Chicago is the place where dada *should* have been born.

—Franz Schulze, 1972

Jim Nutt (born 1928), *It's a Long Way Down*, acrylic on wood, 86 x 62.9 cm (33 7/8 x 24 3/4 in.). Gift of the S. W. and B. M. Koffler Foundation

Chicago Style

Gladys Nilsson (born 1940), *Arytystic Pairanoiya*, 1978, watercolor and pencil on paper, 63.9 x 102.4 cm (25 1/4 x 40 3/8 in.). Gift of the S. W. and B. M. Koffler Foundation

I like to think that my work is about all kinds of pleasure.

Tom Wesselmann

born 1931

Still Life #12, 1962, acrylic and collage of fabric, photogravure, metal, etc., on fiberboard, 122 x 122 cm (48 x 48 in.). Museum purchase

Some of the worst things I've read about Pop Art have come from its admirers. They begin to sound like some nostalgia cult— they really worship Marilyn Monroe or Coca-Cola. The importance people attach to things the artist uses is irrelevant. My use of elements from advertising came about gradually. One day I used a tiny bottle picture on a table in one of my little nude collages. It was a logical extension of what I was doing. I use a billboard picture because it is a real, special representation of something, not because it is from a billboard. Advertising images excite me because of what I can make from them. Also I use real objects because I need to use objects.... But [they] remain part of a painting because I don't make environments. My rug is not to be walked on.

—Tom Wesselmann, 1992

I was my own first model. I wrapped myself in the bandages and my wife put on the plaster.

I had a hell of a time getting the pieces off and reassembled.... I had found my medium.

George Segal
born 1924

George Segal's reality is a tragic one, in which the human and the artifact are alone and immobile, but as though consecrated to this state by some interior directive, to endure forever.

—Allan Kaprow, 1984

The first thing you learn in art school is that the conception of a Renaissance painting is that of a window on the world.... If you're born now and you're going to consider what kind of artwork you're going to make, [you ask] is the flatness of your canvas plane the wall or is it a window?

—George Segal, 1977

The Curtain, 1974, plaster, glass, and painted wood, 214.6 x 99.7 x 90.2 cm (84 1/2 x 39 1/4 x 35 1/2 in.). Museum purchase

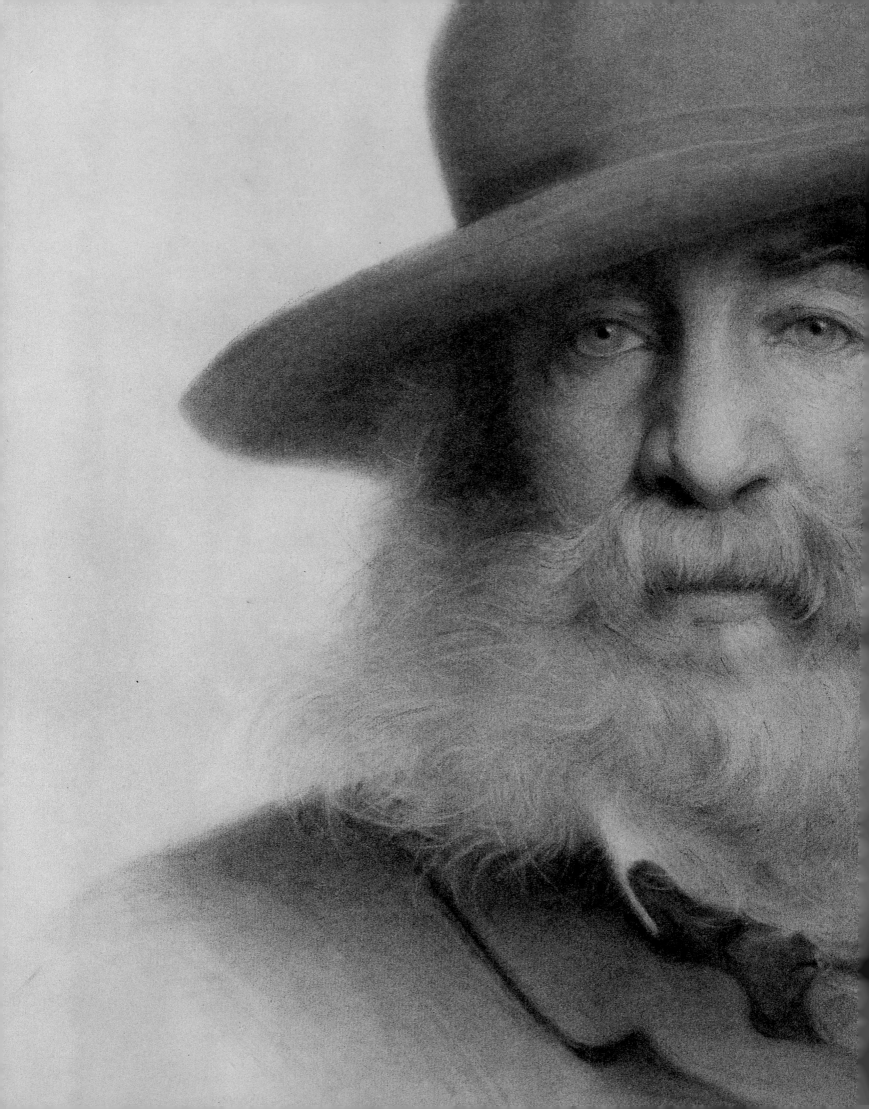

PEOPLE

I love the art of painting, but the greatest merit of execution on subjects that have

not a virtuous tendency lose all their value in my estimation.

Charles Willson Peale
1741–1827

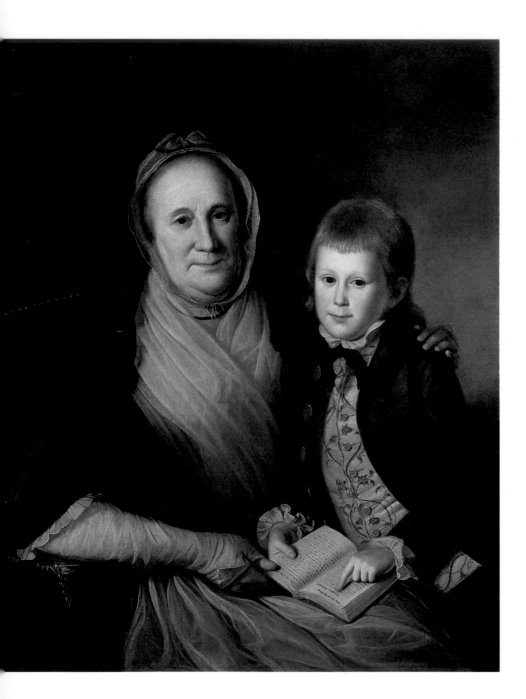

A good painter of either portrait or History must be well acquainted with the Greesian and Roman Statues, to be able to draw them at pleasure by memory, and account for every beauty.... These are more than I shall ever have time or opportunity to know, but as I have variety of Characters to paint I must as Rembrandt did make these my Anticks, and improve myself as well as I can while I am providing for my support.
—Charles Willson Peale, 1772

MR. PEALE'S MUSEUM, CONTAINING the Portraits of Illustrious Personages, distinguished in the late Revolution of America, and other paintings—Also, a Collection of preserved Beasts, Birds, Fish, Reptiles, Insects, Fossils, Minerals, Petrifactions, and other curious objects, natural and artificial.

Intended to be an easy and pleasant Instruction in Natural History. As this *Museum* is in its Infancy, Mr. *Peale* will thankfully receive the Assistance of the Curious. N.B. To pay for Attendance, &c. Admittance *One Shilling*, or *One Dollar* for a free Ticket for one Year.
—*Pennsylvania Packet*, 1788

Mrs. James Smith and Grandson, 1776, oil on canvas, 92.4 x 74.3 cm (36 3/8 x 29 1/4 in.). Gift of Mr. and Mrs. Wilson Levering Smith, Jr. and museum purchase

No man ever painted if he could obtain employment in portraits.

Gilbert Stuart
1755–1828

It was his habit to throw his subject off guard, and then by his wonderful powers of conversation he would call up different emotions in the face he was studying.
—Josiah Quincy

Speaking generally, no penance is like having one's picture done. You must sit in a constrained and unnatural position, which is a trial to the temper. But I should like to sit to Stuart from the first of January to the last of December, for he lets me do just what I please, and keeps me constantly amused by his conversation.
—John Adams, 1825

John Adams, 1826, oil on canvas, 76.2 x 63.6 cm (30 x 25 1/8 in.). Gift of Mary Louisa Adams Clement in memory of her mother, Louisa Catherine Adams Clement

Couse's art...was not about documenting culture or artifacts but expressing an American vision of the Indian spirit.

—J. Gray Sweeney, 1991

Eanger Irving Couse
1866–1936

Elk-Foot of the Taos Tribe, 1909, oil on canvas, 198.6 x 92.4 cm (78 1/4 x 36 3/8 in.). Gift of William T. Evans

Couse chose his models carefully, and Elkfoot, who began to pose for Couse in 1907, appeared in more of [his] paintings than any other model.... Although Couse's Indians may appear idealized, they are accurate and recognizable portraits, a fact easily demonstrated by comparing the proud and noble bearing of [the subject] as he appears in *Elkfoot of the Taos Tribe* with the model's equally aristocratic image as recorded in Couse's many photographs of him. The heroic portrait of Elk-Foot surpasses mere portraiture, and its symbolism makes it academic in conception. The princely Elk-Foot, holding a coupstick that signals his valour, appears implacable—the American policy of Manifest Destiny usurped the homeland of the Native American but never conquered his spirit.

—Virginia Couse Leavitt, 1991

Ultimately, Interior with Portraits *questions the nature of reality and the reality of illusion.*

—Karol Ann Lawson, 1989

Thomas LeClear

1818–1882

Interior with Portraits, ca. 1865, oil on canvas, 65.7 x 102.9 cm (25 7/8 x 40 1/2 in.). Museum purchase made possible by the Pauline Edwards Bequest

Several themes and aesthetic issues intertwine in this seemingly simple portrayal of children anxiously posed before a photographer. While the children are exemplars of mid nineteenth-century dress and demeanor and the studio provides a glimpse into the lifestyle of a successful painter of the period, the invasion of the artist's studio by a camera—a mechanical means of image-making—is of particular interest. Technology obscures and pushes aside the traditional accoutrements of an artist's retreat. Paintings are covered by the backdrop, and the easel is carelessly placed out of the way. The camera seems an intrusion here, only grudgingly accepted as tool and competitor.

—Karol Ann Lawson, 1989

PEOPLE

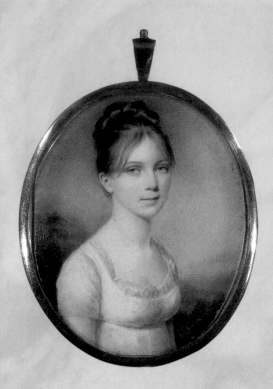

Edward Greene Malbone (1777–1807), *Henry B. Bounetheau's Aunt*, ca. 1804, watercolor on ivory, 8.6 x 6.8 cm (3 3/8 x 2 11/16 in.). Gift of Mrs. Henry Du Pré Bounetheau

Unlike oil portraits that hung in the formal rooms of a house, miniatures celebrated a more intimate sentiment and were fashioned to be set in a piece of jewelry, or secreted in a drawer for private viewing. The gift of one's miniature was the traditional means of marking an important family event or special relationship, such as an engagement, a marriage, a long separation, or a memorial....

The original technique for painting miniatures, gouache on vellum, was lifted directly from the pages of the medieval manuscript. In the eighteenth century it was modified. A less opaque watercolor was applied to a translucent piece of ivory in thin coats of paint, judiciously layered to gradually build up the image. Light passing through the ivory in the pale, painted areas, like the flesh and filmy fabrics, lent life to the portrait.

—Robin Bolton-Smith, 1991

Tokens

While in London, [Charles Willson] Peale became a member of the Society of Artists, and entered three miniatures in its 1768 exhibition, including [a] double portrait of John Beale Bordley's sons. Thomas and Matthias had just arrived in England on their way to study at Eton, and are seen dutifully improving themselves with the classics. They stand between a bust of Minerva, goddess of wisdom, and the dome of St. Paul's, symbol of religious faith.

—Edgar P. Richardson, 1982

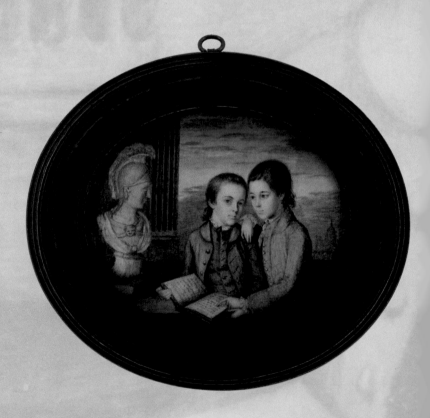

Charles Willson Peale (1741–1827), *Matthias and Thomas Bordley*, 1767, watercolor on ivory, 9.2 x 10.5 cm (3 5/8 x 4 1/8 in.). Museum purchase and gift of Mr. and Mrs. Murray Lloyd Goldsborough, Jr.

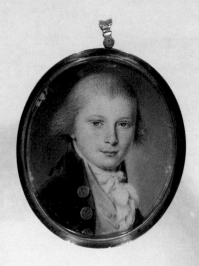

James Peale (1749–1831), *Josiah Hewes Anthony*, 1790, watercolor on ivory, 4.6 x 3.7 cm (1 13/16 x 1 7/16 in.). Gift of Mr. and Mrs. Ruel P. Tolman

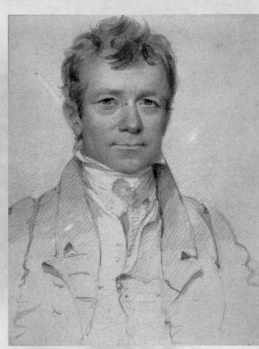

Attributed to Henry Inman (1801–1846), *John Wesley Jarvis*, ca. 1822, watercolor and pencil on paper, 9.5 x 7.6 cm (3 3/4 x 3 in.). Museum purchase

of Affection

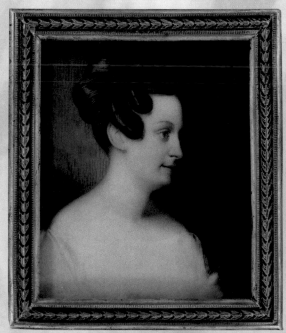

George Catlin (1796–1872), *Mary Catlin*, ca. 1827, watercolor on ivory, 7.6 x 6.2 cm (3 x 2 3/8 in.). Gift of Mr. David Morse (Rooney Pace Inc.)

John Wood Dodge (1807–1893), *Colonel Elija Rice*, ca. 1840, watercolor on ivory, 9.4 x 5.1 cm (2 1/2 x 2 in.). Gift of Mr. and Mrs. Robert A. Blackford

The point on which we differ is one which a long experience of portrait painting has made me perfectly familiar—I have very often been reproached with giving a hard expression to ladies portraits, especially when I have retained some look of intelligence in a face.

John Singer Sargent
1856–1925

At one of my sittings during which Mr. Sargent painted my hands I sat motionless for two hours. A certain way in which I had unconsciously put my hands together pleased him very much because the posture, he said, was clearly natural to me. He implored me not to move. We worked very hard—he with his magical brush, I with my determination to control fidgets and the restless instincts to which most sitters are prone when forced to remain still for any length of time, for the most part we were silent. Occasionally I heard him muttering to himself. Once I caught: "Gainsborough would have done it!... Gainsborough would have done it!"

—Unidentified Sitter, 1902

Elizabeth Winthrop Chanler, 1893, oil on canvas, 125.4 x 102.9 cm (49 3/8 x 40 1/2 in.). Gift of Chanler A. Chapman

To get along I was obliged to paint at hazzard what I thought would be likely to please or what I happened to fancy very much, and if it happened to hit the fancy I would get an offer for it.

Lilly Martin Spencer
1822–1902

Although a number of American women gained prominence as sculptors in the mid-nineteenth century, Lilly Martin Spencer was apparently the first woman painter to be ranked with her male colleagues in this country. In an age that mistrusted women in the arts and other professions, Mrs. Spencer seems to have been lauded in part *because* "the hand that rocked the cradle held the brush." Having had almost no formal training, she nevertheless developed considerable skill in the detailed rendering of various materials, as seen here in the satin and lace. The popularity of this painting with her contemporaries, however, must be traced to a timely blend of sentiment and mood. Remarkably ambitious in size and detail, *We Both Must Fade* clearly benefits from its implicit *vanitas* theme.

—William Kloss, 1985

We Both Must Fade (Mrs. Fithian), 1869, oil on canvas, 182.8 x 136.3 cm (72 x 53 3/4 in.). Museum purchase

There is such a thing as style, but it can easily become a vice. Only when it comes naturally as a result of real mastery is it delightful.

William Robinson Leigh
1866–1955

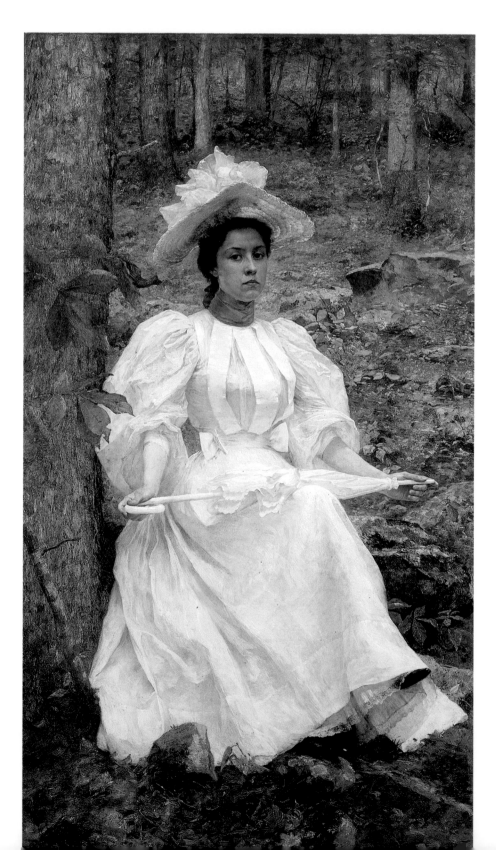

William Robinson Leigh painted this portrait of his cousin, Sophie Hunter Colston, while on a visit home to West Virginia in the summer of 1896. Having just returned from twelve years' study in Munich, the artist stood on the brink of his professional career....

Even after his return to America, he was quick to proclaim his allegiance to the techniques he had learned in Munich and to deny all French influence on his work. But his portrait of Sophie Hunter Colston tells us otherwise.... [It] ends as an intriguing hybrid: no French painter would have flattered his subject so little; no Munich realist disciple would have invented such telling surface patterns; and none but an American would have chosen the setting of a West Virginia forest for a formal portrait.

For the next ten years Leigh worked in New York as a magazine illustrator. After a trip to the West in 1906, however, he became enamoured of frontier life and devoted the remainder of his long career to lively, nostalgic representations of cowboys, Indians, and wild animals.

—William H. Truettner, 1983

Sophie Hunter Colston,
1896, oil on canvas, 183.8
x 103.9 cm (72 3/8 x 40 7/8
in.). Museum purchase

Art is not born of beauty. It is born of life—and in one form or another, vigorous, developed life always turns toward beauty.

Cecilia Beaux
1855–1942

[Cecilia Beaux's portrait of her brother-in-law, Henry Sturgis Drinker,] is a tour de force in color, paint texture and fluid brushwork and, at the same time, a striking portrait laden with expressive content. Beaux often talked about a strong head being a matter of "dimensions," which is taken to mean strong individual features that harmonize together in the face. She was always very selective in whom she chose to paint, and frequently turned down lucrative commissions when confronted with a face she didn't judge strong.

—Frank H. Goodyear, Jr., 1974

Man with the Cat (Henry Sturgis Drinker), 1898, oil on canvas, 121.9 x 87.8 cm (48 x 34 5/8 in.). Bequest of Henry Ward Ranger through the National Academy of Design

His work is the only thing he's interested in all the time, his one passionate interest....

At his studio by half-past eight, he sits there for ten months of the year every day

as long as the light lasts.

—Unidentified author

Thomas Wilmer Dewing

1851–1938

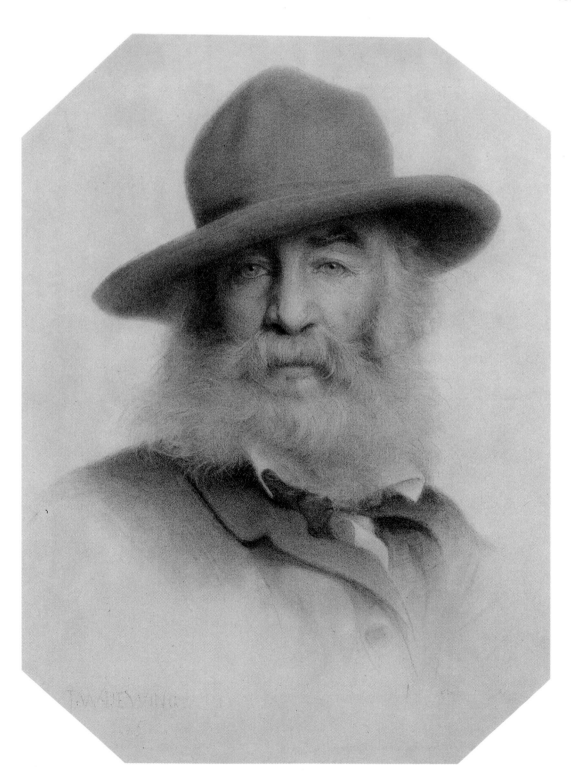

The virtuosity of Dewing's portrait *Walt Whitman* is also astonishing in view of the paucity of training then available to the young artist in Boston. The charcoal is applied so precisely that upon first glance the expertly modeled work appears to be a lithograph.... One of the era's most painted and photographed figures, Whitman was then living in Camden, New Jersey. As the pose and clothing in Dewing's drawing is extremely close to a woodcut reproduction of another portrait of Whitman after one R. Piquel that appeared in the *New York Daily Graphic* in 1873 and there is no evidence that the poet was in Boston at that time or that Dewing was ever in Camden—it is likely that Dewing drew it after this image, possibly for commercial purposes.

—Susan Hobbs, 1981

Walt Whitman, 1875, charcoal on paper, 62.2 x 45.7 cm (24 1/2 x 18 in.). Museum purchase

The artist is an active dreamer; his dreams are ever seeking their affinity to the outer world....

It is quite evident that I belong to this artist order of human beings, for in the course of my life

I have never done what is commonly called a wise thing.

Romaine Brooks
1874–1970

[In] Romaine's harshly penetrating self-portrait...we see the strongly isolated form of this lonely woman in her late forties whose face expresses a temperate calm and a strength that defies the habitual twilight of color and the ruined landscape behind her. This is a powerful expression of the "lapidé" [outcast]. It is handsome in design, controlled in its composition, brilliant in its pervasive insight into personality, and altogether a triumph both of introspection and perception.
—Adelyn D. Breeskin, 1971

Self-Portrait, 1923, oil on canvas, 117.5 x 68.3 cm (46 1/4 x 26 7/8 in.). Gift of the artist

These images above all should entertain — the only sure road to appreciation.

Man Ray
1890–1976

Man Ray was part of a pragmatic, American tradition in that he used whatever was available—everyday materials from a hardware store or his studio workbench—to construct works that were both personal and independent.... His self-portrait of 1933 consisted of a bronze cast of his bust, which he fitted with a pair of his own spectacles and placed in a wooden box. Just like any paper-stuffed shipping crate the "package" of Man Ray was packed and ready for delivery. A reference to the death masks made of prominent figures, here surrounded by the ephemera of everyday news, the object is both a witty and profound statement on the artist's "entombment" in his work.

—Merry A. Foresta, 1988

Autoportrait, 1933, cast bronze, glass, wood, etc., 35.6 x 21.1 x 13.7 cm (14 x 8 1/4 x 5 3/8 in.). Gift of Juliet Man Ray

My conscious intention, in all my work, has been to wield inextricably

its objective and subjective aspects.

Helen Lundeberg
born 1908

[L]orser] Feitelson, that influential teacher and Lundeberg's husband, was a pioneer American Modernist who had lived in Paris, known the Dada, Surreal and so-called Metaphysical artists like de Chirico and also studied the Italian Renaissance masters. Back in California, beginning in 1933, he and Lundeberg would invent and propagate their own version of Surrealism.

Works by both Lundeberg and Feitelson of this period locate fragmentary gatherings of objects in cool, articulated space—instead of the shifting perspectives and ambiguous space of East Coast Surrealism—in a deliberate effort to achieve a tranquil and elevated effect.

—Eleanor C. Munro, 1979

In "Double Portrait in Time" I used a photograph I still have for the portrait of myself as a child. I also used the clock to show that it was a quarter past two which corresponded to the child's age if translated into years. And instead of presenting myself as an adult before a painting of myself as a child, I reversed the situation so that the child casts an adult shadow on the portrait on the wall, which is a self-portrait I painted somewhat earlier.

—Helen Lundeberg, 1972

Double Portrait of the Artist in Time, 1935, oil on fiberboard, 121.3 x 101.6 cm (47 3/4 x 40 in.). Museum purchase

Every sincere artist knows that there is no band wagon that goes all the way; no seeming success of the moment that will atone for the thing he knows in his heart he has...left undone.

John Steuart Curry
1897–1946

This *Self Portrait* documents a moment of unusual assertiveness in the life of this naturally shy man who was often given to self-doubt. Poised on the brink of a promising future, he levels a steady gaze that seems almost a challenge to the viewer. Subsequent self-portraits show a more genial and less accommodating artist, less given to concealing his vulnerabilities. Like the great self-portraitists before him, Curry made his own image both a mirror and a mask.

— *Antiques and Arts Weekly*, 1986

The artist ought to paint people doing things, or if he paints a portrait, to show the personality and inner meaning of the life before him. The use of life as an excuse for clever arrangements of color or other pictorial elements ends where it begins. It is well, if you would make a dramatic design, to think of the life before you. If you feel the significance of the life, the design builds itself. The feeling inherent in the life of the world cannot be ignored or trifled with for the sake of a theory.

— John Steuart Curry, 1935

Self Portrait, 1928, charcoal, conté crayon, and pencil on paper, 64.3 x 49.1 cm (25 5/16 x 19 3/8 in.). Museum purchase

I want to build powerful, aggressive images.

Like massive cathedrals, you've got to build them one brick at a time.

Chuck Close

born 1940

Close's absorption with [composer Phil] Glass's image seems thoroughly appropriate, for an analogy may be drawn between their work. As Robert Rosenblum has noted, Glass's music is composed of what at first may seem monotonous, repetitive tones, electronically amplified in a way that nearly conceals personal style. Yet the experience becomes a kind of slow immersion in a sonic sea, where the structural anchors of the score tend to be washed away by the mounting sensuous force of the cumulative sound. By a similar means of almost mechanical repetition of predetermined forms, Close also creates works in which simple components combine to produce images that are visually astounding in their infinite detail.

—Lisa Lyons, 1980

Phil III, 1982, cast paper pulp, 72.7 x 33.3 cm (68 x 52 1/2 in.). Gift of Barbara Krakow Gallery

The regular, run-of-the-mill work, I hate. The novelty, the idea of making something, is what I really enjoy.

Irving Dominick
born 1916

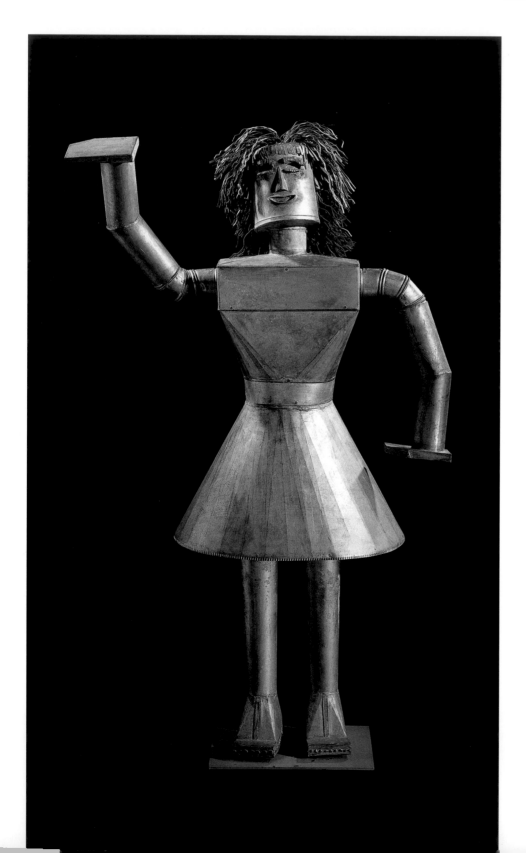

Dominick began working in the sheet-metal trade with his father after school and on Saturdays when he was fourteen, and soon thereafter entered into a formal apprenticeship with a firm in Brooklyn. As an advertising attraction, his father crowned the roof of his shop in the Bronx with a larger-than-life figure called "Tiny Tin," a self-portrait by the shop foreman. After his father's death, Dominick and his brother moved the family business and its mascot, "Tiny Tin," to Spring Valley, a suburb of New York. Dominick, pleased to have a reason to create nonfunctional, imaginative forms, made two replacement "Tiny Tin" figures after collectors bought previous versions. A collector who owned one figure asked Dominick to produce a female companion for "Tiny Tin." Dominick used his ten-year-old granddaughter, Marla, as his model.

—Andrew Connors, 1990

Marla, 1982, cut, bent, soldered, and riveted galvanized iron, 149.9 x 89.5 x 37.3 cm (59 x 35 1/4 x 14 3/4 in.). Gift of Herbert Waide Hemphill, Jr.

Like a lot of Chicano artists at that time, I was interested in my roots. I experimented with a lot of different materials and styles while I was in college, but finally decided to paint what was around me—what I had grown up with.

Jesse Treviño
born 1946

Mis Hermanos (My Brothers), 1976, acrylic on canvas, 121.2 x 175.6 cm (48 1/2 x 70 1/4 in.). Gift of Lionel Sosa, Ernest Bromley, Adolfo Aguilar of Sosa, Bromley, Aguilar and Associates, San Antonio

The Chicano community is an integral part of the family structure and a social organization providing a point of reference for my work. The images are a natural outgrowth of interrelating my environment with the family structure. These very personal portraits are also visual representations of the diverse aspects of the Chicano culture.

—Jesse Treviño, 1984

SPIRIT AND RELIGION

Doubtless my lifelong passion for birds has helped to incline me to work wings into my pictures; but primarily I have put on wings probably more to symbolize an exalted atmosphere...where one need not explain the action of the figures.

Abbott Handerson Thayer
1849–1921

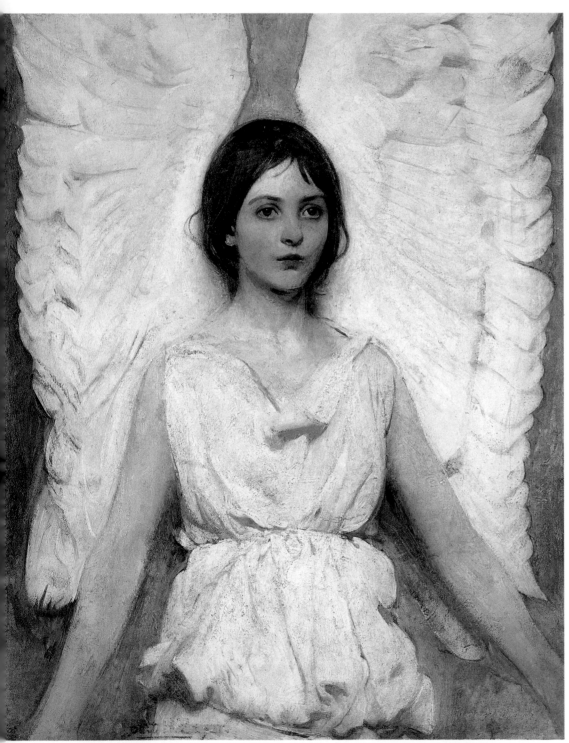

Angel, ca. 1888, oil on canvas, 92 x 71.5 cm (36 1/4 x 28 1/8 in.). Gift of John Gellatly

After speaking of St. Gaudens in sculpture, it is natural to turn to Abbott H. Thayer in painting, whose work called An Angel, has this year been given the place of honor in the exhibition of the Society of American Artists. This picture is so remarkable that one hesitates to express his thoughts about it fully, lest enthusiastic admiration should seem to run away with him. Some critics in New York think and freely say that it marks an epoch in American art....

Thayer in his picture has followed to some extent the pre-Raphaelite teaching. He has the spirituality and refinement of this school and also a good deal of their love of symbols, but he is not affected in anyway whatsoever, nor does imitate anybody. Joined with these qualities is a most deep and exquisite expression of character, and also a scientific, realistic, modelling and coloring which a portrait painter might envy. This rare union of the ideas of opposing schools is what makes the picture so unique, and entitles it to a place in American art that is thought by many to be easily the very highest.

—Unsigned review, 1888

If art survives at all I am certain that realism will outlast all the other isms.

Raphael Soyer
1899–1987

I hope that the realists of today will follow the precept of Courbet, the first to call himself a realist. He said: "My aim is to render the customs, the ideas, and the appearance of my age, according to my own feelings, in short, to create a living art."

Great realism consists of many elements—the abstract, the physical, the literary, the poetic, the metaphysical, the psychological.

—Raphael Soyer, 1972

You don't have the feeling of repetition [in Soyer's work]. You get the feeling of a man of character, of a man who knows both his power and his limitations. You know people who run after vogues and fashion changes.... A real artist remains himself.

I admire my good friend Raphael Soyer for many things, but mostly for his integrity as an artist.... He has been faithful to himself and to his notions about art for fifty years or perhaps longer....

Raphael Soyer is a realist, but he is also an artist who believes in the soul, which is the essence of all art.

—Isaac Bashevis Singer, 1982

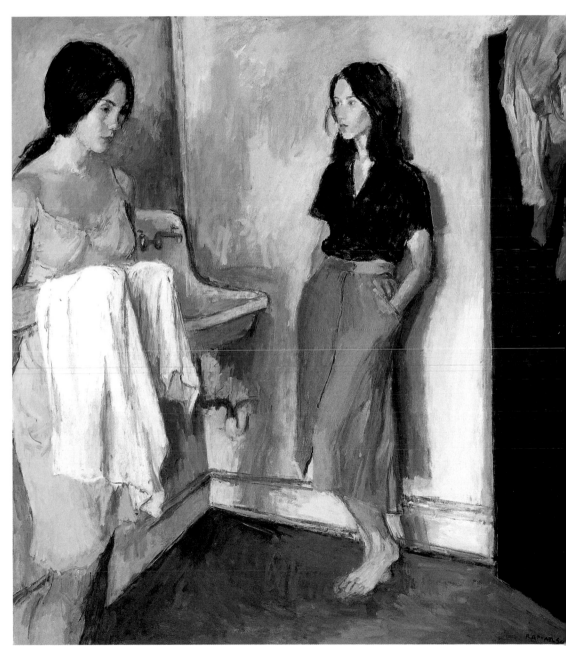

Annunciation, 1980, oil on linen, 142.5 x 127.3 cm (56 x 50 1/8 in.). Gift of the Sara Roby Foundation

SPIRIT AND *R*ELIGION

It has very often seemed to me that many painters of religious subjects...seem to forget that their pictures should be as much works of art...as are other paintings with less holy subjects. To suppose that the fact of the religious painter having a more elevated subject than his brother artist makes it unnecessary for him to consider his pictures as artistic production, or that he can be less thoughtful about a color harmony...than he who selects any other subject, simply proves that he is less of an artist than he who gives the subject his best attention.

— Henry Ossawa Tanner, 1909

Salome, ca. 1900, oil on canvas, 116.5 x 89.4 cm (46 x 35 1/4 in.). Gift of Jesse O. Tanner

Henry

The Savior, ca. 1900–05, oil on wood, 73.9 x 55.3 cm (29 1/8 x 21 7/8 in.). Gift of Mr. and Mrs. Norman B. Robbins

When the *Banjo Lesson* appeared many of the friends of the race sincerely hoped that a portrayer of Negro life by a Negro artist had risen indeed. They hoped, too, that the treatment of race subjects by him would serve to counterbalance so much that has made the race only a laughing-stock subject for those artists who see nothing in it but the most extravagantly absurd and grotesque. But this was not to be. The fact had not been taken into consideration that his early home atmosphere had always been strongly religious, neither was it generally known that it had long been the wish of his father's heart that his son should paint Biblical subjects — turn his genius into religious channels and thus make his art serve religion, since neither his pen nor voice was to be employed in such service. So Mr. Tanner turned, at this point in his career, to what promises to be his life work.

— W. S. Scarborough, 1902

Angels Appearing Before the Shepherds, ca. 1910, oil on canvas, 65.3 x 81.1 cm (25 5/8 x 32 in.). Gift of Mr. and Mrs. Norman B. Robbins

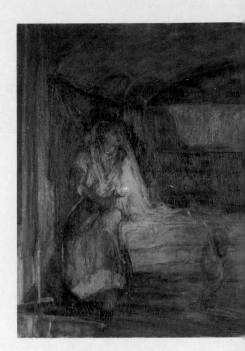

Mary, ca. 1914, oil on canvas, 115.5 x 88.2 cm (45 1/2 x 34 3/4 in.). Gift of Mrs. Dorothy M. McGuire

Ossawa Tanner

1859–1937

Abraham's Oak, 1905, oil on canvas, 54.4 x 72.8 cm (21 5/8 x 28 5/8 in.). Gift of Mr. and Mrs. Norman B. Robbins

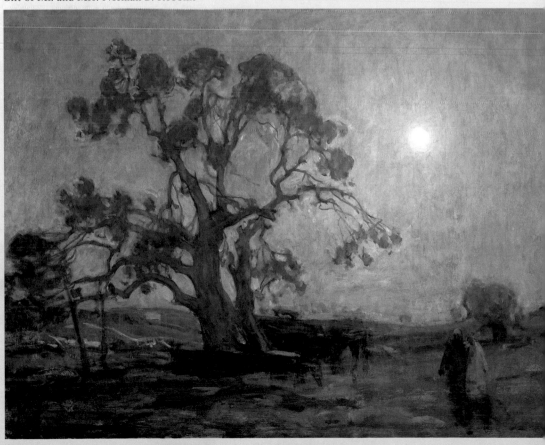

My effort has been to not only put the Biblical incident in the original setting...but at the same time give the human touch "which makes the whole world kin" and which ever remains the same. While giving truth of detail not to lose sight of more important matters, by this I mean that of color and design should be carefully thought out as if the subject had only these qualities. To me it seems no handicap to have a subject of nobility worthy of one's best continued effort. There is but one thing more important than these qualities and that is to try to convey to your public the reverence and elevation these subjects impart to you, which is the primary cause of their choice.

— Henry O. Tanner, 1924

I call it the Mystery of the Hereafter.... It is beyond pain and beyond joy.

Augustus Saint-Gaudens

1848–1907

Nirvana

Yea, I have lived! Pass on
And trouble me with questions nevermore.
I suffered. I have won
A solemn peace—my peace forevermore.
Leave me in silence here.
I have no hope, no care,
I know no fear:
For I have borne—but now no longer bear....
—Hildegarde Hawthorne

John Hay...writes me that he has been to Rock Creek [Cemetery in Washington, D.C.] to see the figure. "The work [in memory of Mrs. Henry Adams] is indescribably noble and imposing. It is to my mind St.-Gaudens' masterpiece. It is full of poetry and suggestion, infinite wisdom, a past without beginning, and a future without end, a repose after limitless experience, a peace to which nothing matters—all are embodied in this austere and beautiful face and form."

Certainly I could not have expressed my own wishes so exactly, and, if your work approaches Hay's description, you cannot fear criticism from me.

—Henry Adams, 1891

Adams Memorial, modeled 1886–91/ cast 1969, bronze, 177.4 x 101.4 x 112.9 cm (69 7/8 x 40 x 44 3/8 in.). Museum purchase

I must confess with a sense of relief, to the solid ground of common sense;

and yet it delights me to tamper and potter with the unknowable, and I have a strong

tendency to see in things more than meets the eye.

Elihu Vedder
1836–1923

[V]edder] reflect[s] a late version of the shift in the image of death that took place at the end of the eighteenth and the beginning of the nineteenth century. The long tradition of fearful skeletons and cadavers common from the late medieval period and still inhabiting the art of Breughel and Holbein, gave way to an idealized human personification reminiscent of the winged figures who escort the departed souls into Hades in late classical reliefs.

—Jane Dillenberger, 1979

So when the Angel of the darker Drink
At last shall find you by the river-brink,
And, offering his Cup, invite your Soul
Forth to your Lips to quaff—you shall
not shrink.

—from *Rubáiyát of Omar Khayyám,* 1886

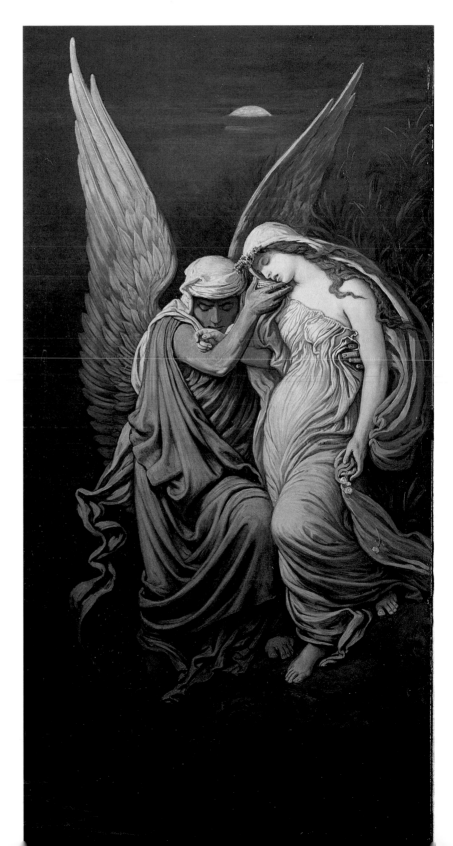

The Cup of Death, 1885–1911,
oil on canvas, 113.9 x 57 cm
(44 7/8 x 22 1/2 in.).
Gift of William T. Evans

SPIRIT AND *R*ELIGION

God called me into the minister's work to...get acquainted with the Earth people from this world.... Then I was in my last church, and I'd been there fifteen years and three months. And I asked them that night what I preached on that mornin', and there wasn't but one man in that church that could tell me my text from one service to another. And I thinks to myself, my God, they ain't listenin' to me. And that's why I retired from preachin'. I tried to think of Billy Graham's messages, and I been hearin' 'em for years, and I couldn't even think of one of his messages. And I said to myself, I'm like that, they're like that, and everybody's like that. Now I've gotta reach the people, so God called me to sacred art. Now when I write a message, that message not goin' away with the wind. And the people not gonna forget it from one service to another. And that's why I'm in folk art. I'm preachin' in thousands of homes alayin' here on my bed.

—Howard Finster, 1992

Howard Finster (born 1916), *VISION OF A GREAT GULF ON PLANET HELL*, 1980, enamel on plywood with painted frame, 50.8 x 16.9 x 19.4 cm (20 x 6 5/8 x 7 5/8 in.). Gift of Herbert Waide Hemphill, Jr. and museum purchase made possible by Ralph Cross Johnson

William Edmondson (ca. 1870–1951), *Crucifixion*, ca. 1932-37, carved limestone, 46.1 x 30.5 x 15.5 cm (18 x 11 7/8 x 6 1/4 in.). Gift of Elizabeth Gibbons-Hanson

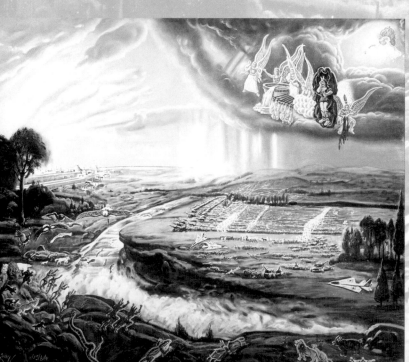

Rev. McKendree Robbins Long, Sr. (1888–1976), *Vision from Book of Revelation*, 1966, oil on canvas, 112.1 x 132.1 cm (44 1/8 x 52 in.). Museum purchase

[W]orking as a house painter] inspired Patrick Sullivan to try his hand at art on wrapping paper or window blinds, but World War I interrupted this interest. After the war he was once again a house painter, and once more began painting on his own.... In his various letters [to art dealer Sidney Janis] he stated: "I never run out of ideas to paint. I don't care for some, or should I say, most of so-called modern art. If one must paint pictures I say paint them so that they can be viewed from any angle or distance and look clean and plain. I never took an art lesson in my life. I just like to paint and from now on I shall paint things that come to mind—powerful stuff that will make people think."

—Herbert W. Hemphill, Jr. and Julia Weissman, 1974

Patrick J. Sullivan (1894–after 1967), *The First Law of Nature—not Self-Preservation but Love*, 1939, oil on canvas, 69.2 x 87.2 cm (27 1/4 x 34 5/8 in.). Museum purchase

Folk Sermons

Jesus is my air
Plane, you hold
the world in your hand, you
Guide me through the land
Jesus is my air Plane I
say Jesus is my air
Plane We're striving for
that Promise Land. Come
on, Join our Band let's make
it in that Kingdom land.

—Sister Gertrude Morgan, ca. 1970

Sister Gertrude Morgan (1900–1980), *Jesus Is My Airplane*, ca. 1970, tempera, ballpoint pen and ink, and pencil on paper, 45.7 x 67 cm (18 x 26 3/8 in.). Gift of Herbert Waide Hemphill, Jr. and museum purchase made possible by Ralph Cross Johnson

This romantic land of the imagination, the mysterious North that has haunted me since I was a boy—it does not really exist, but how did it come into being?

Charles Burchfield

1893–1967

The other night I lay awake, tortured by a multitude of thoughts; outside the sky was blanketed with soft strangely luminous clouds, in which now and then appeared ragged holes thru which glowed the deep indigo sky—black star-studded caves that moved majestically toward the south. In one I saw two brilliant stars, and wondered what they were; the hole advanced revealing suddenly three stars in a row, and I realized I was looking at Orion. A feeling of peace and comfort came over me at the sight of this beautiful group, like some Being saying "All is well."

—Charles Burchfield, 1933

Orion in December, 1959, watercolor and pencil on paper, 101.2 x 83.4 cm (39 7/8 x 32 7/8 in.). Gift of S. C. Johnson & Son, Inc.

The mystical sense of earth [existed] beneath the surface of what the eye sees....

It is not a deity but a presence.

Marsden Hartley
1877–1943

In *Yliaster (Paracelsus)*...Hartley employed the arcane, cabalistic imagery of the sixteenth-century physician-mystic to represent an erupting crater disgorging a stream of lava into a blazing cone of radiant light that emanates from above, hinting at a hidden order, a cosmic energy, lodged deep within the earth. Like Paracelsus, then, Hartley was bent on revealing the covert, occult forces vested in the earth itself.
—Jeanne Hokin, 1993

Yliaster (Paracelsus), 1932, oil on paper board mounted on particle board, 64.1 x 72.4 cm (25 1/4 x 28 1/2 in.). Museum purchase made possible by the Smithsonian Institution Collections Acquisition Program and by George Frederick Watts and Mrs. James Lowndes

I...am deep in the astonishing wisdom and insight of Paracelsus—who gives me more of...what I want to know than any other.
—Marsden Hartley, 1932

SPIRIT AND *R*ELIGION

Ortega is known for the flattened, simplified figures he frequently carved from boards discarded by lumbermills. These works were sold to private chapels, local churches, or families for use in their homes. The small size of this Christ figure and the supporting wood slats at his waist indicate that it, like many similar figures by Ortega, was carried in processions, probably by members of the Penitente brotherhood of the Roman Catholic church during Holy Week. Because of its moveable arms, this figure can be dressed and posed to represent several different stages of the Passion.

—Andrew Connors, 1991

José Benito Ortega (1858–1941), *Our Father Jesus of Nazareth*, ca. 1885, carved and painted wood, painted cloth, and leather with metal, 76.2 x 23.8 x 23.8 cm (30 x 9 3/8 x 9 3/8 in.). Gift of Herbert Waide Hemphill, Jr. and museum purchase made possible by Ralph Cross Johnson

In the Hispanic

Santos carving in northern New Mexico dates back more than 200 years to early days of Spanish settlement, when local artisans began crafting brightly painted devotional images for use in Hispanic homes and Roman Catholic churches in this isolated mountain region northeast of Santa Fe. By the turn of this century the once vital art had all but vanished; handmade images were replaced by mass-produced religious goods.

José Dolores López helped revive the art in the 1920s, but he shaped a new style out of his ancestors' tradition by making saints of unpainted cottonwood and cedar.... George López has kept his father's art alive. "It's in the blood," he says. "It's part of my name."

—Marjorie Hunt and Boris Weintraub, 1991

Attributed to Pedro Antonio Fresquís (1749–1831), *Our Lady of Guadalupe*, ca. 1780–1830, water-based paint on wood, 47.3 x 27.3 x 2.2 cm (18 5/8 x 10 3/4 x 7/8 in.). Gift of Herbert Waide Hemphill, Jr. and museum purchase made possible by Ralph Cross Johnson

Ester Hernández (born 1933),
La Ofrenda, 1988, serigraph,
95.9 x 63.5 cm (37 3/4 x 25 in.).
Gift of the Wight Gallery,
University of California,
Los Angeles

Tradition

George López (1900–1993), *Saint Michael
the Archangel and the Devil*, ca. 1955–56,
carved, incised, and inlaid aspen and palo
duro (mountain mahogany), pencil and iron
nails, 122 x 83.8 x 100.3 cm (48 x 33 x 39
1/2 in.). Gift of Herbert Waide Hemphill, Jr.
and museum purchase made possible by
Ralph Cross Johnson

Maine to me is almost like going on the surface of the moon. I feel things are just hanging on the surface and that it's all going to blow away.

Andrew Wyeth
born 1917

Dodge's Ridge, 1947, egg tempera on fiberboard, 104.2 x 122 cm (41 x 48 in.). Gift of S. C. Johnson & Son, Inc.

The tilted wooden stake with crossbar and tattered cloth are probably the skeleton of a farmer's scarecrow. Their obvious religious symbolism cannot be ignored, however, and it is probable that the painting commemorates the accidental death of the artist's father, the noted illustrator N. C. Wyeth, in late 1945. Wyeth has often spoken of the loss of his father as the turning point in his life and his career as an artist. The resemblance of the composition to the 1946 tempera *Winter*, which Wyeth has described as a "portrait" of his father, reinforces this interpretation.

—William Kloss, 1985

Dodge's Ridge is one of the numerous works Andrew Wyeth has painted in the Port Clyde area of the Maine coast.

Maine has opened certain secret passages to you which are vital, and you will never permanently lose, or forsake, her magic appeal. The work you have already done is wrought with too deep an understanding to ever be called superficial, and it will continue to grow and expand.

—N. C. Wyeth, 1938

It is a hybrid, yes but an inimitable one. It is something unique, exciting, something that says the Cuban spirit will live forever.

—Wayne S. Smith

Humberto Dionisio
1950–1987

Dionisio graduated from the National School of Design in Havana and later studied industrial design, scene and lighting design, and cinematography.... When Cuba temporarily eased emigration restrictions that led to the Mariel boatlift in 1980, Dionisio immigrated to the United States, and his work began to reflect a diversity of cultural influences.

In 1983 Dionisio began a series of constructions as a personal preparation for and contemplation of his imminent death [from AIDS]. In these large assemblages he combined Baroque symbols of Christianity, using discarded wood, shells, construction-site rubble, costume jewelry, and other found objects. With repeated motifs of floating acrobats/spirits and the refuse of society, he created contemporary icons for a ravaged, complex world.

—Andrew Connors, 1991

Untitled, 1986, painted wood, plastic doll, shells, etc., 147.3 x 109.2 x 20.3 cm (58 x 43 x 8 in.). Gift of Jim Kitchens in honor of Michael Ford

SPIRIT AND *R*ELIGION

Where there is no vision the People Perish

—inscribed on *The Throne*

The Throne of the Third Heaven of the Nations Millennium General Assembly, ca. 1950–64, gold and silver aluminum foil, colored kraft paper, and plastic sheets over wood furniture, paperboard, and glass; 180 pieces in overall configuration (see details on opposite page), 315 x 810 x 435 cm (10 1/2 x 27 x 14 1/2 ft.). Gift of anonymous donors

James Hampton had a calling that gave him a secret life. Employed as a janitor, he swept, he mopped, and emptied the trash. Dumpsters and neighborhood streets were goldmines from which he collected the discards that became his medium. After work, he would bring his finds back to a rented garage, where, for more than twenty years, he constructed a variety of magical objects.... The works became larger and more elaborate. Plaques distinguished the walls, chairs became thrones, tables transformed into altars, and stacked forms evolved into pedestals to hold crowns and books. His imagination, his vision, his creations filled the garage to capacity.

—Betye Saar, 1994

James Hampton

1909–1964

In 1964, the museum's installation designer (and later deputy director), Harry Lowe, read an unusual newspaper story about James Hampton, a black veteran who worked as a janitor cleaning government buildings for the General Services Administration in Washington, D.C. Hampton had recently died, leaving a rented garage full of handmade ecclesiastical objects. Altars, bishop's chairs, offertory tables, crowns, plaques of scripture, and lecterns fashioned from cast-off furniture and government property, all covered with silver and gold foil, were found behind the garage doors—the private lifework of a soft-spoken man who would probably never have described himself as an artist, though in his writings he sometimes referred to himself as "St. James".... Lowe, whose knowledge of Southern folk art had taught him to love the inventions of inspired people, was an eager advocate for the work. Shortly after Hampton's death, his lifework was purchased and placed on loan at the museum until its donation to the collection in 1970.

—Elizabeth Broun, 1992

FOLK *A*RT

162

I would have done the carving whether or not I got famous. A person has to have some work to do, so I carve and play the fiddle.

S. L. Jones
born 1901

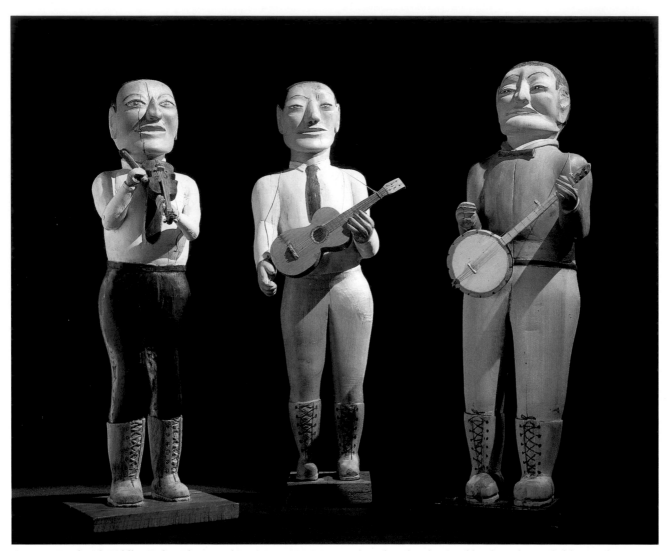

Country Band with Fiddler, Dobro Player, and Banjoist, 1975–76, carved, rouletted and painted hardwood, pencil, felt-tipped pen, string, and metal; fiddler: 59 x 20 x 19.4 cm (23 1/4 x 7 7/8 x 7 5/8 in.), dobro player: 63.5 x 20 x 18.7 cm (25 x 7 7/8 x 7 3/8 in.), banjoist: 64.1 x 21.6 x 22.5 cm (25 1/4 x 8 1/2 x 8 7/8 in.). Gift of Herbert Waide Hemphill, Jr. and museum purchase made possible by Ralph Cross Johnson

In 1967 S. L. Jones turned to his youthful hobby of whittling after his first wife's death and his retirement from forty-five years with the Chesapeake and Ohio Railroad. Using his Bowie knife, Jones first carved miniature figures and animals from the local yellow poplar, walnut, and maple he gathered in the woods. Wood chisels proved more practical when he began to carve life-size busts of people and heads of animals from hardwood logs. Tabletop freestanding figures, singly or in groups, began to appear in the mid-1970s. A similar evolution marks his surfaces—from unpainted early carvings in the late 1960s to the introduction of paint, stain, and penciling around 1972. By the mid 1970s, Jones used opaque paint to embellish his sculptures.

—Lynda Roscoe Hartigan, 1990

On a fine spring day I went by and [Traylor] was drawing a man plowing. He said, "I wanted to be plowing so bad today, I draw'd me a man plowing."

—Charles Shannon

Bill Traylor
1855–1947

One Saturday morning, in the early summer of 1939, an old black man was sitting on a box by the fence in front of the blacksmith shop. He had a white beard and was hunched over like he might be drawing. Walking closer, I could see that he held a stub of a pencil and was ruling clean straight lines on a piece of cardboard, using a short stick for a straightedge. He was deeply engrossed in what he was doing and I later discovered he was experiencing making marks on paper for the first time.

The next day I found him there again. The ruled lines had given way to objects: rats, cats, cups, tea kettles, and other silhouetted shapes neatly distributed across the rectangle. In the days that followed he drew a version of the blacksmith shop.... Along the fence now his drawings were hung by loops of string for passersby to enjoy. I took him some poster board and show card colors and brushes and pencils. I bought a few of his drawings. Others came to buy. He was amused. "Sometimes they buy them when they don't even need them," he said.

—Charles Shannon, 1988

Dancing Man, Woman and Dog, ca. 1939–42, crayon and pencil on paperboard, 55.9 x 35.4 cm (22 x 14 in.). Gift of Herbert Waide Hemphill, Jr. and museum purchase made possible by Ralph Cross Johnson

There's something in there, under the surface of every piece of wood. You don't need a design 'cause it's right there, you just take the bark off and if you do it good you can find something.

Miles Carpenter

1889–1985

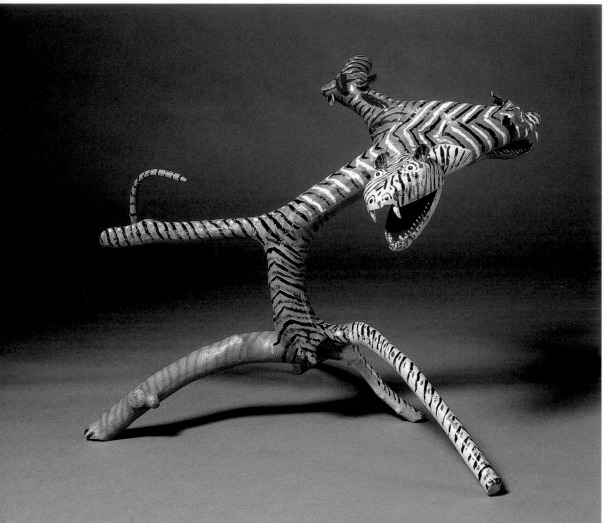

Root Monster, 1968, carved and painted tree roots, rubber, metal, and string, 57.5 x 72.7 x 71.6 cm (22 5/8 x 28 5/8 x 28 1/4 in.). Gift of Herbert Waide Hemphill, Jr. and museum purchase made possible by Ralph Cross Johnson

Miles B. Carpenter is living proof of my thesis that there is a continuum in the folk art tradition of material culture well into the latter half of the twentieth century. Many people believe that there are no more folk artists because there are no more "folk." This is a prejudicial attitude to rationalize the theory that mass production and mass media absorption by all of us has negated the basic desire in people to create practical, visually instructive, and esthetic art that hopefully contains all three qualities. Carpenter is a prime, and not isolated, example of a person who embodies the inherited traditions of our earlier forebears and continues to practice them.
—Herbert W. Hemphill, Jr., 1982

In the countryside around Waverly, Virginia, [Carpenter] collected fallen branches and exposed roots and also cut trees into thick planks as the raw material for his carvings (made primarily after 1966). Poplar is indigenous to the area, and like many carvers and furniture makers, Carpenter found the wood's soft yet solid, rather grainless qualities easy to work with. He detected a dynamic creature in this straddle-legged root, complete with its hint of a tail. Snappily painted stripes, pert rubber ears, and separately carved jaws and teeth define Carpenter's insight. His sense of humor animates many of his sculptures, at times literally. "Clackety-clack" go the articulated jaws of this *Root Monster* when someone manipulates the lengths of string and rubber bands attached to its three heads.

—Lynda Roscoe Hartigan, 1990

A Mr. Caspari of Calvert Street, the oldest tobacconist in Baltimore...stated that a carved Indian

was considered a necessary adjunct to the early tobacco business.... When he started in

business his stock cost only thirty dollars, but he had an Indian out front that cost forty.

—Jean Lipman, 1948

Unidentified Artist

The cigar-store Indian was among the trade signs that originated in Europe. Sixteenth-century English explorers introduced Europeans to the tobacco first cultivated by Native Americans; in the early seventeenth century, English tobacco shops adapted the exotic "red man" as their commercial symbol. Colonial artisans continued the tradition, and by the mid-nineteenth century, the cigar-store Indian was the principal character carved or cast in metal as "show" figures for American business.

Within this genre, *Indian Trapper* and *Indian Squaw*...depart considerably from the highly decorative cigar-store Indians usually made along the eastern seaboard by shipcarvers who adapted their skills as the country's call for wooden ships declined. The male figure does not conform to the conventional depictions of Indian braves, scouts, or chiefs—often bare-chested, draped in tunics or blankets, and adorned with feathered headdresses.... True to the show-figure tradition, the carver worked from a single softwood log (probably pine), anchored the figures on bases, and hollowed their hands—no doubt to hold an object chosen by a shopkeeper.

—Lynda Roscoe Hartigan, 1990

Indian Trapper, ca. 1850–90, carved softwood with traces of paint and stain and metal, 153.7 x 50.9 x 48.3 cm (60 1/2 x 20 x 19 in.). Gift of Herbert Waide Hemphill, Jr.

Indian Squaw, ca. 1850–90, carved softwood with traces of paint and stain and metal, 123.8 x 42.5 x 41.3 cm (48 3/4 x 16 3/4 x 16 1/4 in.). Gift of Herbert Waide Hemphill, Jr. and museum purchase made possible by Ralph Cross Johnson

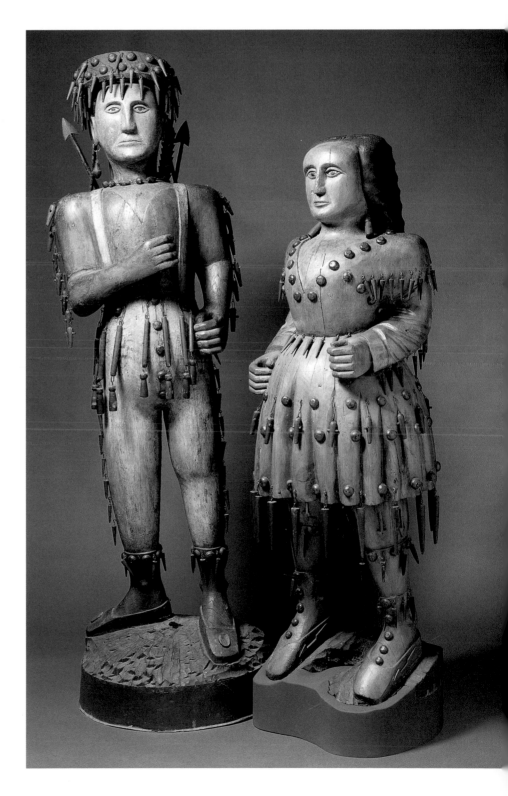

Everything can always be something else.

—Charles Jencks and Nathan Silver

Unidentified Artist

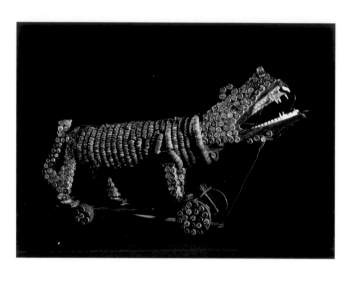

Bottlecap Lion, completed after 1966, carved and painted wood, bottlecaps, flashcubes, fiberboard, and plastic, 74.3 x 125.8 x 38.1 cm (29 1/4 x 49 1/2 x 15 in.). Gift of Herbert Waide Hemphill, Jr. and museum purchase made possible by Ralph Cross Johnson

Retrieved from the American landscape since the 1890s, bottlecaps have inspired many arts and crafts projects.... [The] concept has assumed unexpectedly monumental proportions in this Giraffe [and Lion], a recycler's consummate study in texture, pattern, and obsessiveness.

—Lynda Roscoe Hartigan, 1992

Bottlecap Giraffe, completed after 1966, carved and painted wood, bottlecaps, rubber, glass, animal hair, and fur, 184.2 x 137.2 x 44.5 cm (72 1/2 x 54 x 17 1/2 in.). Gift of Herbert Waide Hemphill, Jr. and museum purchase made possible by Ralph Cross Johnson

I don't like TV because it's just ideas from other people.

Felipe Benito Archuleta
1910–1991

I was a carpenter for 30 years. I was in the union—the carpenter's union. I joined in 1943. I did rough carpentry and finish, but mostly I did rough. But it was not very good. There was no work sometimes.... I just sit around and sit around and wait for carpenter work. But you have to do something. So one time I was bringing my grocery and I ask in God for some kind of a miracle...to give me something to make my life with—some kind of a thing that I can make. So...for about three days I started carvings after that. And they just come out of my mind after that.

—Felipe Archuleta, 1977

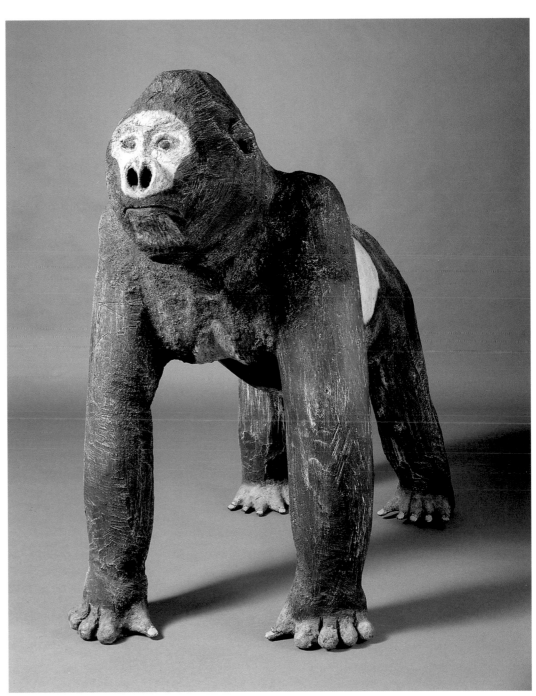

Gorilla, 1976, carved and painted cottonwood, 101.6 x 69.2 x 106.7 cm (40 x 27 1/4 x 42 in.).
Gift of Herbert Waide Hemphill, Jr. and museum purchase made possible by Ralph Cross Johnson

FOLK *A*RT

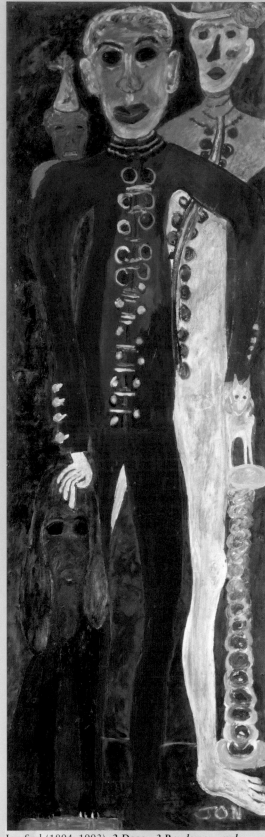

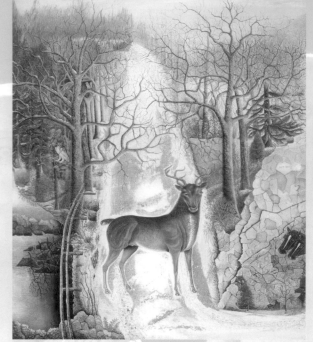

Unidentified Artist, *Stag at Echo Rock*, late 19th century, metallic paint and pencil on muslin, 127 x 175.3 cm (50 x 69 in.). Gift of Herbert Waide Hemphill, Jr. and museum purchase made possible by Ralph Cross Johnson

Made with

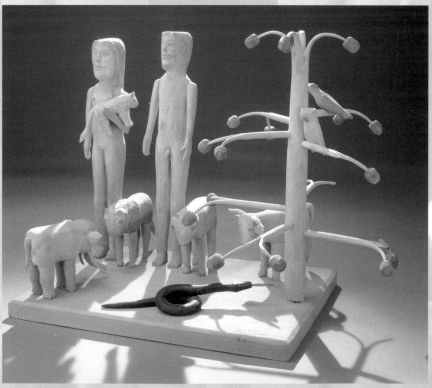

Jon Serl (1894–1993), *2 Dogs—3 Bandsmen; and Camera*, 1963, oil on fiberboard, 176 x 55.9 cm (69 1/2 x 22 in.). Gift of Herbert Waide Hemphill, Jr. and museum purchase made possible by Ralph Cross Johnson

Edgar Tolson (1904–1984), *Paradise*, 1968, carved and painted white elm with pencil, 32.7 x 43.2 x 25.5 cm (12 7/8 x 17 x 10 in.). Gift of Herbert Waide Hemphill, Jr. and museum purchase made possible by Ralph Cross Johnson

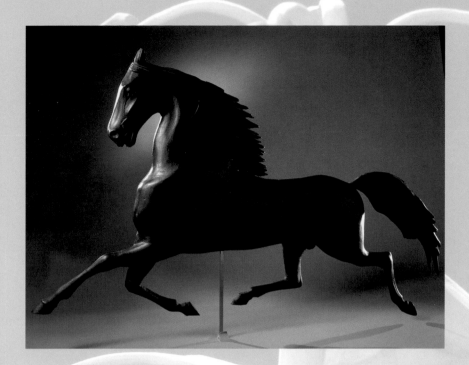

In 1986 the National Museum of American Art acquired through gift and purchase a major collection of more than four hundred objects from Herbert Waide Hemphill, Jr., who has been acknowledged as *"Mr. American Folk Art."* Four years later museum curator Lynda Roscoe Hartigan organized the exhibition *"Made with Passion: The Hemphill Folk Art Collection,"* which was accompanied by a fully illustrated catalogue.

Attrib. to Henry Leach (birth date unknown-1872), *Black Hawk Horse Weathervane Pattern*, 1871–72, carved and painted wood, 55.9 x 87.6 x 9.3 cm (22 x 34 1/2 x 3 5/8 in.). Gift of Herbert Waide Hemphill, Jr. and museum purchase made possible by Ralph Cross Johnson

Passion

While not personally political or religious, [Herbert Waide Hemphill, Jr.] has collected objects that incorporate social commentary or express a sense of spirituality. These strong expressions of conviction connect the objects to their own time and place yet often lend them universality. Many are intended to be read, whether elements of language appear or not.... Rather than an act of insular simplification, folk art, the collection reveals, is just the opposite — an elaboration, a metamorphosis of social and personal expression, from decorating a functional object to reinterpreting popular idioms, contemporary mores, or discarded objects.

—Lynda Roscoe Hartigan, 1990

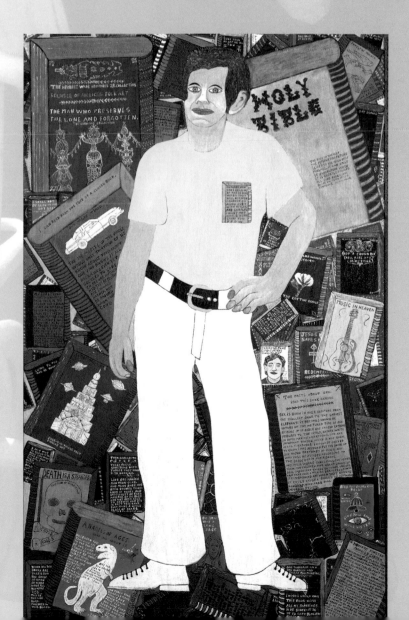

Howard Finster (born 1916), *THE HERBERT WADE HEMPHILL J.R. COLLECTION FOUNDER OF AMERICAN FOLK ART THE MAN WHO PRESERVES THE LONE AND FORGOTTEN. THE UNKNOWN COLLECTION*, 1978, enamel on plywood, 201.9 x 126.9 cm (79 1/2 x 50 in.). Gift of Herbert Waide Hemphill, Jr. and museum purchase made possible by Ralph Cross Johnson

[Peter Charlie] has an important place among those artists who cut themselves off from the world and, in lonely isolation, hide their work from the public while creating fantastic universes that express their hopes and fears.

—Jay Johnson and William C. Ketchum , Jr.

Peter Charlie Besharo
Birth date unknown –1962

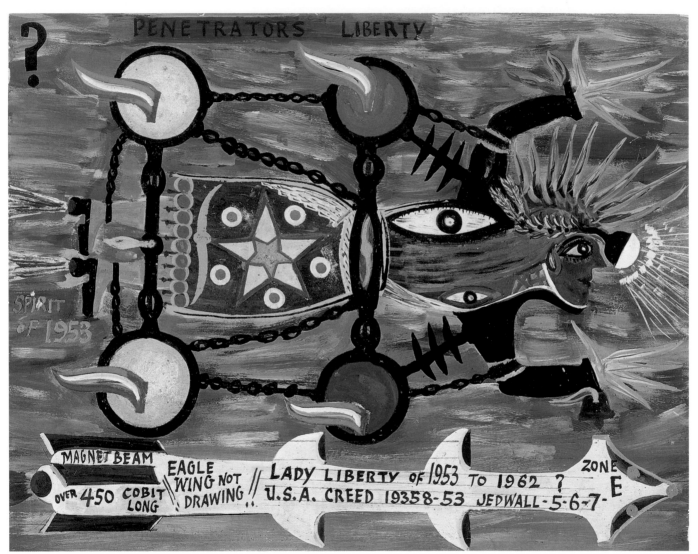

LADY LIBERY of 1953 to 1962?, ca. 1962, house paint and metallic paint on paperboard with pencil, 56.6 x 71.2 cm (22 5/8 x 28 1/2 in.). Gift of Herbert Waide Hemphill, Jr. and museum purchase made possible by Ralph Cross Johnson

Often called just Peter Charlie, [Besharo] was a handyman and house painter in Leechburg, Pennsylvania. He lived a solitary life, and his activities as an artist remained undiscovered until his death in 1962. At that time, sixty-nine paintings were found in a garage he had rented behind a hardware store. His work reflects many themes—space, religion, Armenian folk motifs, American history, and demons, as well as other ideas from his subconscious. Here a chained, peasant-dressed version of Lady Liberty blasts across a blue void. A headlamp guides her on a mission that [Besharo's] inscriptions and images do not clarify. One can speculate, however, that he may have been inspired by events such as the death of Stalin in 1953, the Cuban missile crisis, or John Glenn's orbit of the earth in 1962.

—Elizabeth Tisdel Holmstead, 1990

When you see someone like Ramírez...striding out on [his] own, it makes you feel more comfortable with doing that yourself.

—Jim Nutt

Martin Ramírez

1885–1960

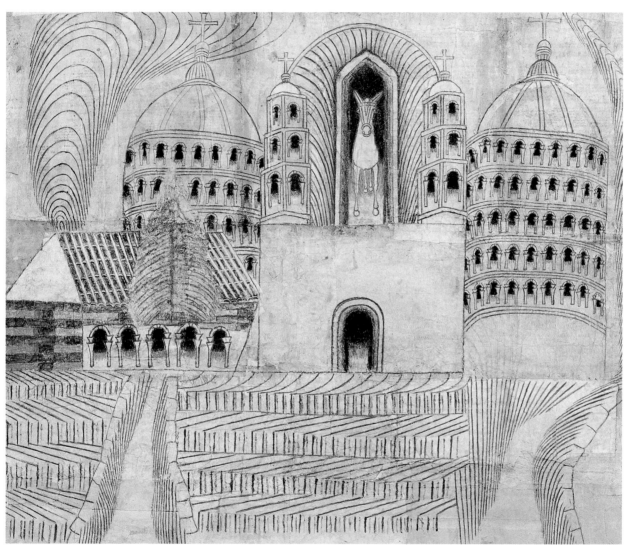

Untitled (Church), ca. 1950, crayon, pencil, and watercolor on joined papers, 80.8 x 94.2 cm (31 7/8 x 37 1/8 in.).
Gift of Herbert Waide Hemphill, Jr. and museum purchase made possible by Ralph Cross Johnson

The art of Martin Ramírez presents a world of patterns and repetitions based on cultural iconography and personal, idiosyncratic symbols. In this drawing, the symmetrical structures of a Baroque church recall buildings undoubtedly familiar to him from his native Mexico....

Ramírez left Mexico as a young man to seek employment in the United States. He worked for a short time with railway construction crews, but was soon unable to cope with the pressures of his new life in California and was diagnosed as paranoid schizophrenic. Ramírez spent the remainder of his life in California mental hospitals. After 1940...he assembled his memories on pieces of scrap paper, pasted together with improvised adhesives, and drew his precise, dense, and repetitive marks and shapes with scavenged pencils, crayons, and markers.

—Andrew Connors, 1991

I never took a lesson. Figured everything—mixing paint, glazing with varnish—myself.

Jack Savitsky
1910–1991

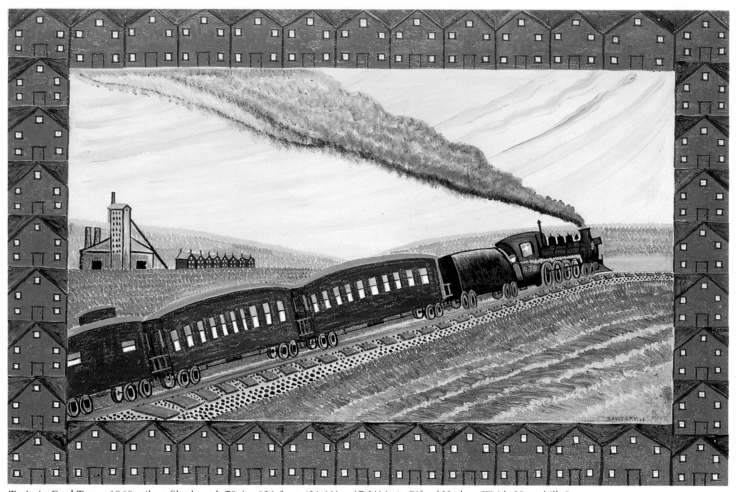

Train in Coal Town, 1968, oil on fiberboard, 79.4 x 121.3 cm (31 1/4 x 47 3/4 in.). Gift of Herbert Waide Hemphill, Jr. and museum purchase made possible by Ralph Cross Johnson

Jack Savitsky worked in Pennsylvania's coal mines for almost forty years before [he was] forced to retire in 1959. His earliest paintings, other than some sign painting and other commercial work, were murals commissioned by a speakeasy during the late 1920s and early 1930s. When Savitsky could no longer work in the mines, he returned to painting as a hobby.

This painting depicts a coal-fired passenger train bringing miners from Pottsville to the mines of Silver Creek. The gray building housing the coal breaker and a row of company-built employee houses in the distance represent Silver Creek, Savitsky's "Coal Town," where the artist grew up and first worked the mines. The lively border pattern is based on the bright red Philadelphia and Reading Coal and Iron Company-owned houses. Savitsky's father reared his family in a similar house, where, Savitsky recalls, "We paid seven dollars per month for a six-room house...every one of them was the same, all in rows, and you couldn't tell them apart."

—Andrew Connors, 1990

The folk artists of our time link hands and minds with those of previous times and peoples.
—Herbert W. Hemphill, Jr. and Julia Weissman

Charlie Willeto
(ca. 1900/05–1965)

A traditional Navajo sheep-herder, Charlie Willeto began carving in the early 1960s, only a few years before his death. He used his works as barter—a standard form of trade on the reservation—for groceries at the Mauzy Trading Post near Lybrook [New Mexico]. Jim Mauzy accepted Willeto's carvings, although they differed from the more conventional Navajo crafts of weaving and silverwork. Only one other life-size carving exists; most of Willeto's four hundred figures range in size from twelve to thirty inches. Originally brightly painted, these male and female figures, their hair bound in Navajo style, stood outside the front of Mauzy's trading post, an ironic twist on the "cigar store Indian" advertising tradition.
—Tonia L. Horton, 1990

Male and Female Navajo Figures, ca. 1962–64, carved and painted wood, male: 165.6 x 41.2 x 25.6 cm (66 1/4 x 16 1/2 x 10 1/4 in.), female: 166.2 x 40.6 x 35.6 cm (66 1/2 x 16 1/4 x 14 1/4 in.). Gift of Herbert Waide Hemphill, Jr. and museum purchase made possible by Ralph Cross Johnson

FOLK ART

And more than a dozen times I've seen the most beautiful cities in the sky. Just beautiful cities of rainbow colors. Now we dream, we talk of heaven, we think every-thing is going to be white. But I believe that we're going to have the beautiful rainbow colors. That's my belief.
— Minnie Evans, 1960s

Minnie Evans (1892–1987), *Design Made at Airlie Gardens*, 1967, oil and mixed media on canvas, 50.5 x 60.6 cm (19 7/8 x 23 7/8 in.). Gift of the artist

W hat impresses me about the work of visionary artists is that it moves beyond formal art structures and freely into the realm of imagination. Visionary artists who create environments seem to have an obsession to build unique domains. These artists are often seen as eccentric by their families and neighbors. Many are recyclers who begin to collect objects and then transform them. They rely on their feelings and intuition.... Certain images and materials come together, as though of their own accord, and the artist begins to sense emerging patterns.

—Betye Saar, 1994

Frank Jones (ca. 1900–1969), *Indian House*, ca. 1968–69, colored pencil on paper, 57.5 x 57.5 cm (22 5/8 x 22 5/8 in.). Gift of Herbert Waide Hemphill, Jr. and museum purchase made possible by Ralph Cross Johnson

Art is the joy we find in work, surely; it is the record of our bodies bumping through the world, our wits at war with the un-knowable. It is the story of our fumbling toward collaboration and our union with the power that moves the universe.
Art is the best that can be done.

— Henry Glassie, 1989

Alexander A. Maldonado (1901–1989),
San Francisco to New York in One Hour, 1969,
oil on canvas, 54.6 x 69.9 cm (21 1/2 x 27 1/2 in.).
Gift of Herbert Waide Hemphill, Jr. and museum
purchase made possible by Ralph Cross Johnson

Personal Visions

Joseph E. Yoakum (1886–1972), *Imperial Valley in Imperial County near Karboul Mounds, California*, 1966, colored pencil and ballpoint pen on wove paper, 30.3 x 45.3 cm (11 7/8 x 17 7/8 in.). Gift of Herbert Waide Hemphill, Jr. and museum purchase made possible by Ralph Cross Johnson

Unidentified Artist, *Button Coverlet, Cincinnati, Ohio*, 1965, plastic, metal, wood, and shell on cotton, 225.1 x 168.9 cm (88 5/8 x 66 1/2 in.). Museum purchase made possible by Ralph Cross Johnson

MODERN *Art*

The building is the architect, the picture is the artist, the symphony is the composer, the poem the poet.

Max Weber
1881–1961

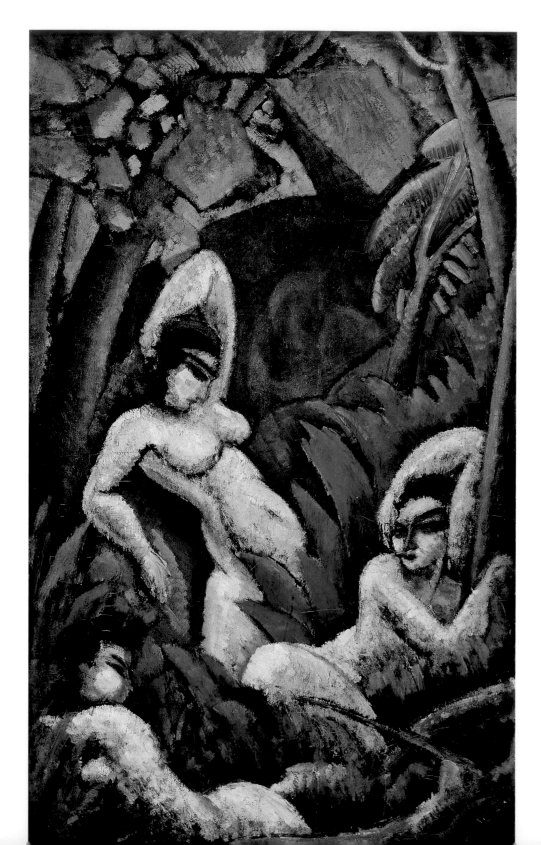

By the time he returned to the United States [1909], Weber was free of the conventions of nineteenth-century art, and the nudes he produced in the next few years were boldly experimental and extremely erotic. More broadly and vividly painted than before, the simplified, slightly distorted figures became increasingly abstract in form. Like his progressive teacher in Paris [Matisse], Weber was rarely concerned with the model's face or extremities and concentrated his full attention on articulating anatomical structure as mass.

—Percy North, 1982

Summer, 1909, oil on canvas, 102.2 x 60.6 cm (40 1/4 x 23 7/8 in.). Museum purchase made possible by the Luisita L. and Franz H. Denghausen Endowment

The credo of the artist must be the result of his education and environment. He cannot depart from his age, and its spiritual and material influences.

Paul Manship
1885–1966

On Herod's birthday the daughter of Herodias danced for them and pleased Herod so much that he promised with an oath to give her whatever she asked.... "Give me here on a platter the head of John the Baptist."

—Matthew 14:6-8

Contemporary critics were taken by Manship's treatment of *Salome*. She disports herself in an attitude dictated by sweeping design; her composed draperies were arranged for the mere love of line. Rather than biblical solemnity, Manship—ever invigorating the past—injected a charming line and a verve seldom encountered in representations of this gruesome and barbaric subject.

—Harry Rand, 1989

Salome, 1915, bronze,
47 x 34.6 x 26.4 cm
(18 1/2 x 13 5/8 x 10 3/8 in.).
Bequest of Paul Manship

To paint today is to make a beautiful object. Just as this chair is an object. It is the making of reality, not the representation of it.

H. Lyman Säyen
1875–1918

THE THUNDERSHOWER
LYMAN SAYEN

Having been with Matisse at the time the latter launched his quest for a unique and lucid style, Säyen knew what it meant to seek personal expression. He recognized the importance of maintaining an affirmative attitude, serenity, harmony, and a constant striving for refinement.
—**Adelyn D. Breeskin, 1970**

The Thundershower, ca. 1917–18, tempera on wood, 91.4 x 116.8 cm (36 x 46 in.).
Gift of H. Lyman Säyen to his nation

Could a man now-a-days believe in the ancient myth of a flat earth on the back of a turtle? In the face of modern evidence of the rotundity of the world could he act on such a belief? That is precisely the sort of thing that is going on in matters of art....

At present, of course, these new ways of looking at pictures seem abstract and technical and confined to a few, but there is little doubt in my mind, that it will become more and more understood and what is popularly taken as a decadence is no more than a renaissance of the true spirit of the art of antiquity.

—**H. Lyman Säyen, 1914**

The abstract, as we consider it in painting today, is an organization of color, whether the color is expressed in planes, or in forms, or in volume—isn't music the organization of sound?

Blanche Lazzell

1878–1957

Between 1916 and 1956 Lazzell created more than 138 blocks and countless impressions through a process that seems to have held a continual fascination for her. Her block prints were technically distinguished by fine cutting and meticulous, sensitive printing. The cutting was made almost exclusively by knife, following a design drawn directly on the block. If the pressures were increased, the paper was forced more deeply into the cut grooves, producing an embossed white line. Watercolors were used for printing (French watercolors were preferred), and Chinese white was occasionally added for opaque pastel tones.
—**Janet Altic Flint, 1983**

Non-Objective (B), 1926, color woodblock on paper, 35.5 x 31 cm (14 x 12 1/4 in.). Museum purchase

MODERN *Art*

Oh our Mother the Earth, oh our Father the Sky,
Your children are we, and with tired backs
We bring you the gifts that you love.
Then weave for us a garment of brightness;
May the warp be the white light of morning,
May the weft be the red light of evening,
May the fringes be the falling rain,
May the border be the standing rainbow.

—Tewa Pueblo song

Tse Ye Mu (1902–1972), *Deer Dancers*, ca. 1925–30, watercolor, gouache, and pencil on paper, 20 x 28.8 cm (8 x 11 9/16 in.). Corbin-Henderson Collection, gift of Alice H. Rossin

Pueblo

Awa Tsireh (1895–1955), *Black Mountain Lion and Black Fox*, ca. 1925–30, watercolor, ink, and pencil on paper, 28.1 x 35.6 cm (11 1/4 x 14 1/4 in.). Corbin-Henderson Collection, gift of Alice H. Rossin

Awa Tsireh (1895–1955), *Animal Designs*, ca. 1917–20, watercolor on paper, 50 x 65.3 cm (20 1/16 x 26 1/8 in.). Corbin-Henderson Collection, gift of Alice H. Rossin

Velino Shije Herrera (1902–1973),
Calf Roping, ca. 1925–35,
gouache on paperboard, 35.5
x 54.9 cm (14 x 21 5/8 in.).
Corbin-Henderson Collection,
gift of Alice H. Rossin

Modernism

By 1915 artists of San Ildefonso Pueblo...had developed a style of painting in watercolor on paper that focused on figures and geometric designs. These artists were encouraged and influenced not only by scientists such as [Jesse Walter] Fewkes and [Edgar L.] Hewett, but by art teachers such as Dorothy Dunn of the Federal Santa Fe Indian School, and non-Indian artists such as John Sloan of New York. By the early 1930s this new style, which eventually came to be considered a "traditional" form of Indian painting, was adopted by artists in neighboring pueblos in the Rio Grande valley. The movement...has continued to influence succeeding generations of Native painters.

—Andrew Connors, 1993

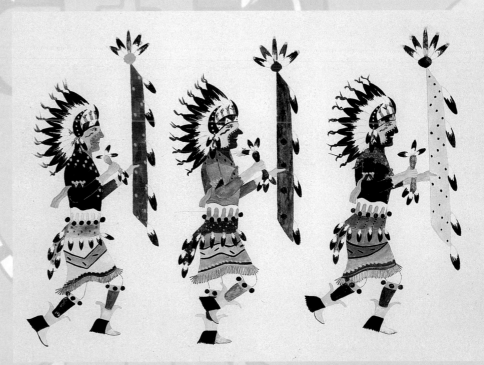

Josefa Roybal (life dates unknown), *Comanche Dancers*, 1930–39, watercolor, ink, and pencil on paper, 28.7 x 35.7 cm (11 1/2 x 14 5/16 in.). Corbin-Henderson Collection, gift of Alice H. Rossin

MODERN *Art*

When Patricia and Phillip Frost began collecting work by members of the American Abstract Artists, they brought a unique perspective and dedication to their search.... From the beginning their commitment was to members of the American Abstract Artists, although occasionally they acquired work by unaffiliated artists...who explored similar paths or exerted significant influence on the directions abstract artists pursued during the 1930s and early 1940s. Dr. and Mrs. Frost also sought works that offered some special insight into the experimental nature of abstraction during the 1930s, and in some cases bought paintings that represented an artist's "alternative side" — expressionistic, figurative-based compositions that did not dovetail with the geometric approach usually associated with the American Abstract Artists.

— Virginia Mecklenburg, 1989

Gertrude Glass Greene (1904–1956), *Construction 1946*, 1946, oil on wood and fiberboard glued to wood panel, 101.9 x 76.5 cm (40 1/8 x 30 1/8 in.). Gift of Patricia and Phillip Frost

Abstract

Irene Rice Pereira (1905–1971), *Machine Composition #2*, 1937, oil on canvas, 122.5 x 152.4 cm (48 1/4 x 60 in.). Gift of Patricia and Phillip Frost

Carl Robert Holty (1900–1973), *Gridiron*, 1937, oil on fiberboard, 122 x 91.5 cm (48 x 36 in.). Gift of Patricia and Phillip Frost

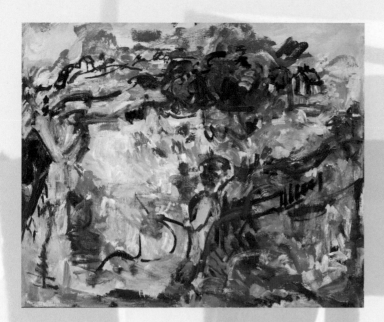

Hans Hofmann (1880–1966), *Afterglow*, 1938, oil on fiberboard, 76.2 x 91.5 cm (30 x 36 in.). Gift of Patricia and Phillip Frost

Inventions

It is actually the artist, and only he, who is equipped for approaching the individual directly. The abstract artist can approach man through the most immediate of aesthetic experiences, touching below consciousness and the veneer of attitudes, contacting the whole ego rather than the ego on the defensive. There is nothing in his amorphous and geometric forms, and nothing within the unconscious or within memory from which he improvises, which is deceptive. The experience is under its own auspices. To whatever extent it helps reconstruct the individual by enabling him to relive important experiences in his past — to that extent it prevents any outward retrogression.

— Balcomb Greene, 1938

Ad Reinhardt (1913–1967), *Untitled*, 1940, oil on fiberboard, 116.8 x 61 cm (46 x 24 in.). Gift of Patricia and Phillip Frost

MODERN *Art*

As with other artists of his generation, Davis's encounter with European modernist painting in the Armory Show of 1913 had a decisive effect on his development. His initial training with the realist Robert Henri had encouraged an acute sensitivity to his environment, and direct visual stimuli would always be fundamental to his method of painting. Conversion to modernism did not result in Davis's repudiation of his realist heritage, but it made him aware of the autonomous character of a work of art.

—Diane Kelder, 1991

International Surface No. 1, 1960, oil on canvas, 145.2 x 114.6 cm (57 1/8 x 45 1/8 in.). Gift of S. C. Johnson & Son, Inc.

I regret that [my paintings] have long been "type-cast" as "Abstract," because my interest in Abstractions is practically zero.

—Stuart Davis, 1951

Abstraction, 1937, watercolor and gouache on paper, 25.7 x 37.2 cm (17 7/8 x 23 3/8 in.). Transfer from General Services Administration

An artist who has traveled on a steam train, driven an automobile, or flown in an airplane doesn't feel the same way about form and space as one who has not. An artist who has used telegraph, telephone, and radio doesn't feel the same way about light and color as one who has not. An artist who has lived in a democratic society has a different view of what a human being really is than one who has not. These new experiences, emotions, and ideas are reflected in modern art, but not as a copy of them.

—Stuart Davis, 1940

Memo, 1956, oil on linen, 91.5 x 71.7 cm (36 x 28 1/4 in.). Gift of the Sara Roby Foundation

Stuart Davis

1894–1964

Composition, 1935, oil on canvas, 56.4 x 76.5 cm (22 1/4 x 30 1/8 in.). Transfer from General Services Administration through Evander Childs High School

Babe La Tour, 1912, watercolor and pencil on paper, 38 x 28 cm (15 x 11 1/16 in.). Gift of Henry H. Ploch

If the alphabet is A to Z, I want to move with it all the way, not only from A to C.

For me, all the doors are open.... I have never been able to understand

the artist whose image never changes.

Lee Krasner
1908–1984

Composition, 1943, oil on canvas, 76.5 x 61.6 cm (30 1/8 x 24 1/4 in.). Museum purchase made possible by Mrs. Otto L. Spaeth, David S. Purvis, and anonymous donors and through the Director's Discretionary Fund

Krasner's *Composition* is one of her few paintings to survive from the important early years of her relationship with Jackson Pollock. Krasner met Pollock in 1942, by which time she had already developed as a proficient draftsman and able painter in the international modern idiom. It was she who introduced him to the Greenwich Village avant-garde through her contacts with Willem de Kooning, John Graham, and her teacher, Hans Hofmann. As a stern critic of her own work, and as an artist interested in experimentation, she scraped down most of her paintings from this early period to salvage the canvas for herself and Pollock. She painted *Composition* in a style for which Graham coined the term "Minimalism," a process of refining, through simplification, the elements of still life into blocks of color and an almost calligraphic use of bold, black line in a manner that was to be so evident in later works of abstract expressionism by such artists as Franz Kline and de Kooning.

—**Harry Rand, 1987**

The extraordinary object...is one which is subjectively and tyrannically there: it can no more be ignored than being stared at can.

Richard Stankiewicz
1922–1983

Stankiewicz was born in Philadelphia and brought up in Detroit during the depression. Here the family lived next to a huge field...which was an industrial dump for French sand (used for casting), slag and some broken machinery. As they could not afford to buy toys, the boys constructed their own from whatever they could pick up.
— **Fairfield Porter, 1955**

The spade began hitting old hunks of metal which I tossed against the building.... I sat down to catch my breath and my glance happened to fall on the rusty iron things lying where I had thrown them, in the slanting sunlight at the base of the wall. I felt, with a real shock— not of fear but of recognition— that they were staring at me. Their sense of presence, of life, was almost overpowering.
— **Richard Stankiewicz, ca. 1960**

Untitled, ca. 1959, iron and steel, 73.6 x 35.6 x 37.5 cm (29 x 14 x 15 in.). Made possible in part by the Julia B. Strong Endowment Fund

MODERN *Art*

Irving Penn (born 1917), *Nude No. 58*, 1949-50, platinum-palladium print, 47.3 x 48.1 cm (18 5/8 x 19 in.). Gift of the artist

Photography's wonderful because you can start with one idea but get lost on something else, and that's where the big thing happens. It's in the drifting off that you find something unique. It's not just to be unique for the sake of being unique, but because it's you. You're different and you're showing something different to another person. I think that's what I'm interested in.
—Harry Callahan, 1981

Harry Callahan (born 1912), *Eleanor, Chicago, 1949*, 1949, gelatin silver print, 19.2 x 15.7 cm (7 5/8 x 6 1/4 in.). Museum purchase

I must stress that my own interest is immediate and in the picture. What I am conscious of and what I feel is the picture I am making, the relation of that picture to others I have made and, more generally, its relation to others I have experienced.
—Aaron Siskind, 1956

Aaron Siskind (1903–1991), *Rome 145* (from "Homage to Franz Kline" series), 1973, gelatin silver print, 24 x 24.9 cm (9 1/2 x 9 7/8 in.). Transfer from the National Endowment for the Arts

Picture Perfect

I experiment with forms and probe for experience. Form cannot live without experience nor can experience communicate without form. There is the magic of forms and the mystery of our lives. Where they come together is where I have a photograph that is vital.
—Ray K. Metzker, 1983

Ray K. Metzker (born 1931), *Philadelphia*, 1963, gelatin silver print, 15.4 x 22.3 cm (6 1/8 x 8 3/4 in.). Museum purchase

Hell, half of the world wants to be like Thoreau at Walden worrying

about the noise of traffic on the way to Boston; the other half use up their lives

being part of that noise. I like the second half.

Franz Kline
1901–1962

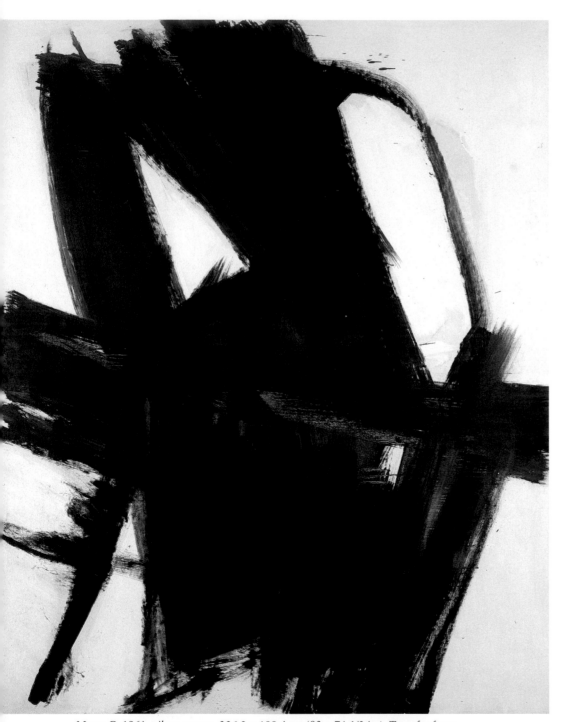

Merce C, 1961, oil on canvas, 236.2 x 189.4 cm (93 x 74 1/2 in.). Transfer from U.S. Department of Labor

One day in '49, Kline dropped in on a friend who was enlarging some of his own small sketches in a Bell-Opticon. "Do you have any of those little drawings in your pocket?" the friend asked. Franz always did and supplied a handful. Both he and his friend were astonished at the change in scale and dimension when they saw the drawings magnified bodilessly against the wall. A 4 by 5-inch brush drawing of the rocking chair...loomed in gigantic black strokes which eradicated the image, the strokes expanding as entities in themselves, unrelated to any reality but that of their own existence.
—Elaine de Kooning, 1962

Everybody likes calligraphy. You don't have to be an artist to like it, or go to Japan. Mine came out of drawing, and light. When I look out the window — I've always lived in the city — I don't see trees in bloom or mountain laurel. What I do see — or rather, not what I see but the feelings aroused in me by looking is what I paint.

—Franz Kline, 1957

The attitude that nature is chaotic and that the artist puts order into it is a very absurd point of view, I think. All that we can hope for is to put some order into ourselves.

Willem de Kooning
born 1904

A notoriously harsh critic of his own work, de Kooning destroyed more than he kept. According to Elaine [de Kooning], paintings from this period [1938–44] were saved only if someone literally bought them off the easel…. De Kooning later regretted all of the lost work: "I destroyed almost all those paintings. I wish I hadn't. I was so modest then that I was vain. Some of them were good. Just as Van Gogh's 'Potato Eaters' is good, as good as anything he painted later in the 'true' Van Gogh style."
—**Marla Prather, 1994**

The Wave, ca. 1942–44, oil on fiberboard, 121.9 x 121.9 cm (48 x 48 in.). Gift of the Vincent Melzac Collection

The game is not what things "look like." The game is organizing, as accurately and with as deep discrimination as one can, states of feeling.

Robert Motherwell
1915–1991

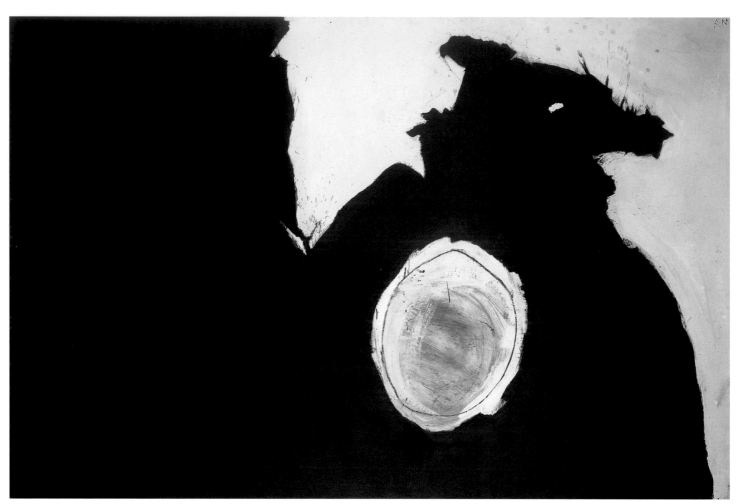

Monster (for Charles Ives), 1959, oil on canvas, 198.8 x 300.4 cm (78 1/4 x 118 1/4 in.). Gift of S. C. Johnson & Son, Inc.

The demonic visits modern artists through many openings in the net of modern culture.... One of the worst circles in Dante's inferno is reserved for those whose presumption has condemned them to metamorphosis. Their shapes became monstrous—a hellish, deeply disturbing condition for the symmetrical human. That is how the demonic is represented in one vein of Motherwell's characterization.... In its very fullness this shape is frightful, as is the endless extension of *Monster (for Charles Ives)*.

—Dore Ashton, 1983

I never think of my pictures as "abstract," nor do those who live with them day by day.... I happen to think primarily in paint—this is the nature of a painter—just as musicians think in music. And nothing can be more concrete to a man than his own felt thought, his own thought feeling. I feel most real to myself in the studio, and resent any description of what transpires there as "abstract"—which nowadays no longer signifies "to select," but, instead, something remote from reality. From whose reality? And on what level?

—Robert Motherwell, 1955

I never wanted color to be color. I never wanted texture to be texture, or images to become shapes. I wanted them all to fuse into a living spirit.

Clyfford Still
1904–1980

No less than caverns and waterfalls, Still's paintings seem the product of eons of change; and their flaking surfaces, parched like bark or slate, almost promise that his natural process will continue, as unsusceptible to human order as the immeasurable patterns of ocean, sky, earth, or water. And not the least awesome thing about Still's work is the paradox that the more elemental and monolithic its vocabulary becomes, the more complex and mysterious are its effects.
— Robert Rosenblum, 1961

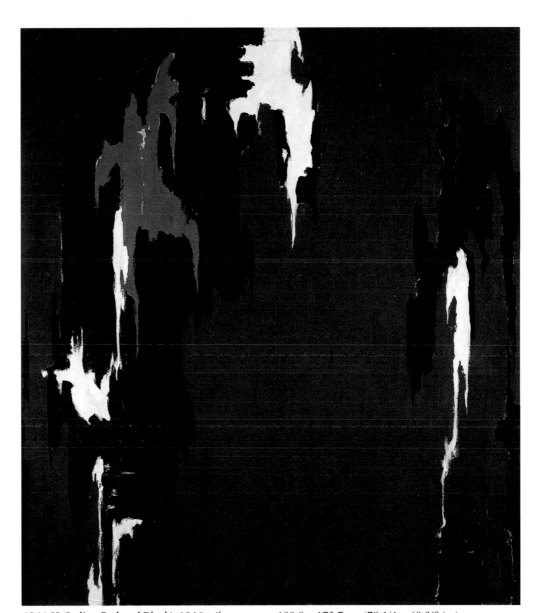

Everywhere in his work there are underlying rhythms surging back and forth like ocean tides or cadenced rivers. At times internal activity intensifies and one thinks of molten lava, but the paintings are never specific representations. Having nothing to do with landscape or any recognizable subject, they frankly exploit all possible means to make the painting itself the entire experience. The painting *is* the sum total and to search beyond that is to invalidate the meaning of the work.
—Katharine Kuh, 1979

1946-H (Indian Red and Black), 1946, oil on canvas, 198.8 x 173.7 cm (78 1/4 x 68 3/8 in.).
Museum purchase from the Vincent Melzac Collection through the Smithsonian Institution Collections Acquisition Program

Painting relates to both art and life. Neither can be made.

(I try to act in that gap between the two.)

Robert Rauschenberg
born 1925

Reservoir was made while Rauschenberg was closely involved with dancer Merce Cunningham and performance art. Created in 1961, it represents a high point in his "combine paintings," works in which found objects are attached to flat surfaces in seemingly accidental relationships and then united through the application of paint. His interest in art as an ongoing process...is apparent in the inclusion of two electric clocks. The clock at the upper left was set to record the hour when Rauschenberg began this combine painting, while that at the lower left was set when it was finished. Continuing to run, the clocks are typical of the multiple references of Rauschenberg's objects. They record a time interval directly pertinent to the painting as a work of art; they function as normal clocks; and they serve as pictorial elements within a larger design.
—Virginia Mecklenburg, 1980

Reservoir, 1961, oil, wood, graphite, fabric, metal, and rubber on canvas, 217.2 x 158.7 x 39.4 cm (85 1/2 x 62 1/2 x 15 1/2 in.). Gift of S. C. Johnson & Son, Inc.

I want to be serious, but at the same time...I cannot be serious without expressing some irony. There is always that dualism in my work.

Larry Rivers
born 1923

Identification Manual, 1964, mixed media and collage on fiberboard, 187 x 214.3 x 48.3 cm (73 5/8 x 84 3/8 x 19 in.). Gift of the Container Corporation of America

This work is subtitled *"The most certain test by which we judge whether a country is really free is the amount of security enjoyed by minorities." Lord Acton, 1877.* It is part of the collection of the Container Corporation of America, a gift to the National Museum of American Art. The collection originated in the "Great Ideas" series of designs (1950–80) that were commissioned by the corporation for reproduction in national magazines.

[Larry Rivers] established a more complex subject matter as the basis of his art, although not necessarily its most critical aspect. In 1961 he listed four crucial elements: the choice and placement of color, its application and—tellingly—Life, the environment beyond the artist's control, noting that "only for the primitive and the semantically misinformed can enthusiasm for subject matter be the major inspiration for a painting."

—Sam Hunter, 1989

All my paintings start out of a mood, out of a relationship with things or people,

out of a complete visual impression.

Richard Diebenkorn
1922–1993

Visiting his studio in Venice [California], where he made the "Ocean Park" series, was always lovely, but strange. It was a cinder-block house that he had built, with little pieces of the landscape all around—right angles of freeways and abutments, not at all pastoral. He took a long time looking before he started to work anywhere. He moved north again toward the end of his life, and his wife, Phyllis, wanted to plant flowers out front after they had been there for a month or two. Dick wouldn't let her. He had just begun to grasp what was there, and he didn't want to have to distill a new element, even a lovely one. Especially a lovely one.

—Wayne Thiebaud, 1993

Ocean Park #6, 1968, oil on canvas, 233.7 x 182.9 cm (92 x 72 in.). Promised gift

It was through reading Proust, years back, that I came to feel that an artist is doing most when he is projecting his own humanness and doing this with utmost intimacy, candor and precision.

Elmer Bischoff
1916–1991

[B]ischoff] places a figure in a landscape. But he carries over the long, broad stroke of previous abstractions—the squiggles, curlicues and loose brushwork. The technique by its very nature is designed to suggest flux, a soft drifting continuum. And that is just what happens. Everything about the landscape and the figure is soft. A tree melts liquidly into the liquid sky. The figure blends with the rocks. There is no hardness in the terrain and no contrasting fleshliness in the human body.
—Dore Ashton, 1960

Two Bathers, 1960, oil on canvas, 172.7 x 164.2 cm (68 x 64 5/8 in.). Gift of S. C. Johnson & Son, Inc.

My aim has been to have the paint on the canvas play a double role—one as an alive, sensual thing in itself, and the other conveying a response to the subject. Between the two is this tightrope.

—Elmer Bischoff, 1985

Art ought to be a troublesome thing, and one of my reasons for painting representationally is that this makes for much more troublesome pictures.

David Park
1911–1960

Woman with Red Mouth, 1954–55, oil on canvas, 60.9 x 52 cm (24 x 20 1/2 in.). Promised gift

Park was a very important influence. The influence was of the total person and what he stood for, and the demands he made of himself, but this is not the whole story; if I didn't like the painting I wouldn't have responded to the person. Whenever I visited Dave, seeing his painting was a stimulating and enlivening experience for me.
—Elmer Bischoff, ca. 1961

He wanted very potent, very demanding subject matter; he wanted to bite. He wanted very much for the subject matter to be bringing up the shape; he wanted something to make these colors come out sharp and hard—so he tapped this area of his reaction to people.
—Richard Diebenkorn, ca. 1961

My concern for the figure is primarily a formal one, growing out of the problems of painting itself. The implications are unconscious, for I have no desire to illustrate stories.

Nathan Oliveira
born 1928

Oliveira's work, more than that of other Bay Area Figurative painters, belonged to a classical strain of agonized expressionism that seemed to reflect an existentialist view of man—battered, tragic, but enduring.
—Thomas Albright, 1985

I am not the avant-garde. I am the artist who comes after the advance guard. I am more concerned with continuity of ideas and tradition than in inventing a unique imagery. I can reprocess all my experiences, create my own world, be faithful to the materials I use—and then let them speak about themselves.
—Nathan Oliveira, 1983

Hat, Gloves, and Stick, 1961, oil on canvas, 130 x 120 cm (52 x 48 in.). Promised gift

I believe you should be able to enter a painting like a promenade—that you should be able to walk in anywhere and walk out anywhere.

Grace Hartigan

born 1922

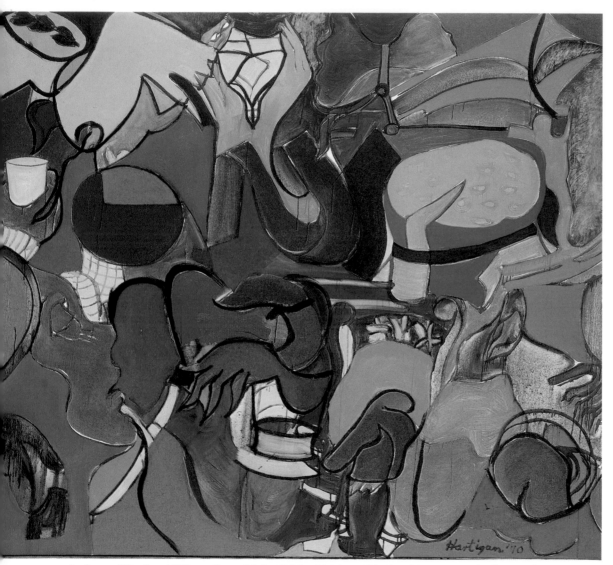

The years after World War II, the heyday of Abstract Expressionism, saw America at its most macho. And the artists involved in the movement fit the bill perfectly....

[Hartigan] says, "Helen [Frankenthaler] was in most of the shows I was in and so was Joan Mitchell. Lee Krasner gave up painting for a while because Jackson told her to. In my generation it was just Helen and Joan and me. That's what it is to be a pioneer. I never even thought about it until the feminist movement came along—those distinctions woman, man, and so forth."

—Mary Gabriel, 1990

Inclement Weather, 1970, acrylic on fabric, 198.8 x 224.2 cm (78 1/4 x 88 1/4 in.). Gift of Mr. and Mrs. David K. Anderson, Martha Jackson Memorial Collection

The human and the monumental are contradictory, but I want to put them together.

Lester Johnson

born 1919

The figure alone is relatively unimportant. Johnson's urge to abstraction is too pressing for that. What he sees from up close and what he renders is the strangeness of man in light of his special environment.

—**Dore Ashton, 1963**

Broadway Street Scene, 1962, oil on canvs, 153 x 198.7 cm (60 1/4 x 78 1/4 in.). Gift of Mr. and Mrs. David K. Anderson, Martha Jackson Memorial Collection

Johnson was an abstract painter until 1954 when he started to capture the essence of the city. He painted the quick tempo of those who lived out impersonal careers amid skyscrapers and never looked up, the slouched gait of the inured urbanite, and aggressively beautiful women....

The same menacing and looming figures of his early work continued to appear in pictures like *Broadway Street Scene*, with its scrawled message. An opaque screen of three men, shoulder to shoulder, blocks the foreground of the picture; nothing about the hats, indistinct faces, thick necks, and wide-shouldered bodies individuates these figures. They serve as the most forceful and impenetrable contrast to the immaterial script—"blue"—that's scrawled across the central surface.

—**Harry Rand, 1985**

A beautiful print is a thing in itself, not just a halfway house on the way to the page.

Irving Penn
born 1924

Rejecting elaborate settings for fashion, Penn instead placed his models against plain backdrops, destroying any sense of space or scale, leaving the subject of fashion to speak for itself.... Perhaps, as in his photograph of a Rochas dress modeled by Lisa Fonssagrives-Penn, [he] even allows a provocative—because restricted—glimpse of the studio, its starkness suggested by bare floorboards and empty walls. Confined to the impractical beauty of her dress, so Penn controls his model's awkward place, visually pinning her—in the legless mermaid dress, could she possibly stand alone?—onto the shallow ground of the canvas backdrop. Such artistic dominance jars us out of our usual immersion in the fashion pitch.
—Merry A. Foresta, 1990

Rochas Mermaid Dress (Lisa Fonssagrives-Penn), 1950, platinum-palladium print, 49.8 x 50 cm (19 5/8 x 19 11/16 in.). Gift of the artist

I found marble to be a stable medium, too beautiful perhaps. The nature of its stability is crystalline, like the beauty. It must be approached in terms of absolutes; it can be broken, but not otherwise changed.

Isamu Noguchi
1904–1988

I once took a stroll with Noguchi in his museum garden in Queens. As we paused to consider the various sculptures, he mused about his creative life: "I have come to no conclusions—no beginning or ending." When I thought about it, I saw the elliptical aspect of his life—all the circling back, the connecting up of disparate sources. There could be no division of his work into this period or that, this phase or that, although there were certainly prolonged moments of intensified interest. Noguchi, like all artists who have sought to surpass even themselves, felt himself drawn on and knew instinctively that there was some unique course taking shape as he moved through his life.
—**Dore Ashton, 1992**

Grey Sun, 1967, Arni marble, 102.5 x 100 x 42.8 cm (40 7/8 x 39 1/2 x 16 7/8 in.). Gift of the artist

The form of my painting is the content.

Ellsworth Kelly
born 1923

All the art since the Renaissance seemed too man-oriented. I liked (the) object quality. An Egyptian pyramid, a Sung vase, the Romanesque church appealed to me. The forms found in the vaulting of a cathedral or even a splatter of tar on the road seemed more valid and instructive and a more voluptuous experience than either geometric or action painting.
—Ellsworth Kelly, 1969

Blue on White, 1961, oil on canvas, 217.5 x 172.1 cm (85 5/8 x 67 3/4 in.). Gift of S. C. Johnson & Son, Inc.

However abstract the forms and colors seem, they should somehow give off an aura of human experience, particularly that of the lonely Faustian thinker combining wisdom and magic. The images should seem serene at first glance, then troubled, then serene again.

Jacob Kainen
born 1909

Dabrowsky V, 1986, oil on canvas, 203.2 x 254 cm (80 x 100 in.). Gift in honor of Adelyn Dohme Breeskin from her friends

Even at this late date, the panorama of American modernism is still unfolding, and we continue to discover unknown riches. Jacob Kainen is part of that panorama. He has been a serious artist for more than sixty-five years. His artistic longevity has been remarkable. It surpasses even that achieved by Stuart Davis (1892–1964), his old friend and mentor in the 1930s, and Hans Hofmann (1880–1966), another artist Kainen has long admired. Even more remarkable has been his staying power as an artist. His painting has reached and maintained a steady, high level of accomplishment that is as rare as it is admirable.

—**William C. Agee, 1994**

I thought to myself, why can't I make a monument that is not connected to a specific time, a specific place, a specific event? Why not make a monument that would transcend time, that would celebrate all time?

Beverly Pepper
born 1924

The abstract language of form that I have chosen has become a way to explore an interior life of feeling.... I wish to make an object that has a powerful presence, but is at the same time inwardly turned, seeming capable of intense self-absorption.
—Beverly Pepper, 1971

Ternana Altar II, 1980/cast 1991, cast iron with fabricated steel base, 234.6 x 120 x 67.6 cm (92 3/8 x 47 1/4 x 26 5/8 in.). Gift of the artist and museum purchase made possible by J. B. Chadwick

Color doesn't work unless it works in space. Color alone is just decoration—you might

as well be making a shower curtain.

Helen Frankenthaler
born 1928

Small's Paradise, at Seventh Avenue and 135th Street, was from the mid-nineteen-twenties through the early fifties the center of Harlem nightlife.... Small's attracted blacks and whites alike as the community grew famous for its poets, writers, artists, entertainers and athletes. And many of them were familiar figures at Small's.... Outside, on Seventh Avenue—one of the community's wide boulevards—the flashy cars belonging to those the local press called "Harlem sportsmen" and "Harlem socialites" triple-parked—as they do today.
— C. Gerald Fraser, 1974

Small's Paradise,
1964, acrylic on canvas, 254
x 237.7 cm (100 x 93 5/8 in.).
Gift of George L. Erion

I usually name them for an image that seems to come out of the pictures....
A picture like Small's Paradise *had a Persian shape in it; also I'd been to that night-club recently.*

— Helen Frankenthaler, 1965

Paintings should produce a delicious pain in the eye — make the viewer gasp —

knock him down and seduce him.

Morris Louis
1912–1962

Faces, 1959, acrylic on canvas, 231.8 x 345.5 cm (91 1/4 x 136 in.). Museum purchase from the Vincent Melzac Collection through the Smithsonian Institution Collections Acquisition Program

Louis spills his paint on unsized and unprimed cotton duck canvas, leaving the pigment almost everywhere thin enough, no matter how many different veils of it are superimposed, for the eye to sense the threadedness and wovenness of the fabric underneath. But "underneath" is the wrong word. The fabric, being soaked in paint rather than merely covered by it, becomes paint in itself, color in itself, like dyed cloth.

— Clement Greenberg, 1960

My new teacher [Louis] did not use any subject-matter, such as a still-life, as a starting point of a painting, we simply worked directly in color. He had no set-pieces or set ideas which he handed out to his students as the gospel. He said A PAINTING CAN BE ANYTHING, BUT IT HAS TO BE SOMETHING.

— Helen Jacobson, 1970

It is notable, perhaps, that during the 1960s, I often regarded myself as

a kind of Rococo pariah in a minimal wilderness.

Gene Davis
1920–1985

While critics have labeled me a color painter, I seldom think about color. I take it for granted. Color theories are boring. Sometimes, I simply use the color I have the most of and worry about getting out of trouble later. I never plan my color more than five stripes ahead and often change my mind before I reach the third stripe. I like to think I am the jazz musician who does not read music but plays by ear. I paint by eye.

—Gene Davis, 1971

Hot Beat, 1964, acrylic on canvas, 115.9 x 127.6 cm (45 5/8 x 50 1/4 in.). Gift of the Woodward Foundation

MODERN *Art*

Joan Mitchell (1926–1992),
My Landscape II, 1967, oil on canvas,
261.6 x 181.6 cm (103 x 71 1/2 in.).
Gift of Patricia and Phillip Frost

The desire for "purity" works, as I have indicated, to put an even higher premium on sheer visibility and an even lower one on the tactile and its associations, which include that of weight as well as of impermeability. One of the most fundamental and unifying emphases of the new common style is on the continuity and neutrality of a space which light alone inflects, without regard to the laws of gravity. There is an attempt to overcome the distinctions between foreground and background; between formed space and space at large; between inside and outside; between up and down.

—Clement Greenberg, 1958

Color

These variations in color and accent are like variations on a theme in music. The possibilities are endless. In some paintings I use harmonious colors to create a balanced theme; in others, I try for resonance; in still others, I try for a dissonant note. I often deliberately try for sweet effects, for lyrical expressions of color, just because they are a challenge. It is hard to paint pretty colors without getting too sweet. I like unexpected effects; lavender with orange, like a sudden discord in music. Color creates mood, sometimes thin, sometimes weighty.

—Howard Mehring, 1960

Howard Mehring (1931–1978),
Banner, 1957, acrylic on canvas,
133.4 x 166.4 cm (52 1/2 x 65 1/2 in.).
Gift of the Vincent Melzac Collection

Considering the preeminence that [Alma Thomas] gave to color, it is not surprising that she decided to study color theory during the 1960s. She was particularly attracted to the recently translated ideas of Johannes Itten, a Swiss artist who had taught at the Bauhaus, and often quoted his dictum: "Color is life; for a world without color appears to us as dead. Colors are primordial ideas, the children of light."

—Merry A. Foresta, 1981

Alma Thomas (1891–1978),
Wind and Crepe Myrtle Concerto,
1973, oil on canvas, 81.6 x 142.3 cm
(32 1/8 x 56 in.). Gift of Vincent Melzac

Abstraction

Sam Gilliam (born 1933), *April 4*, 1969, acrylic on canvas, 179.4 x 256 cm (110 x 179 3/4 in.). Museum purchase

Anne Truitt (born 1921), *17th Summer*, 1974, painted wood, 242.8 x 39.8 x 20.7 cm (95 5/8 x 15 5/8 x 8 1/8 in.). Gift of Kenneth Noland

The photograph was like a Bach exercise for me because I knew that red

was the most difficult color to work with.

William Eggleston
born 1939

Untitled (The Red Room), 1973, dye transfer print on paper, 40.6 x 51 cm (16 x 20 1/16 in.). Gift of Julian Hohenberg

Indeed, Mr. Eggleston's masterly photographs of places draw their strength and their significance from his never losing his own very acute sight of the human factor. The human being — the perpetrator or the victim or the abandoner of what we see before us — is the reason why these photographs of place have their power to move and disturb us; they always let us know that the human being is the reason they were made.

—Eudora Welty, 1989

I wanted color to be the origin of the painting.

Kenneth Noland
born 1924

The circle, Noland discovered, was an almost perfect pictorial conduit for color. It is a single format, but with infinite variations. It is set, but with the potential for constant spatial movement. The circle provided a given format, but not an obvious or intrusive structure. Neither color nor structure predominate; the two are equal. It provided the basic principle to organize the picture, which is after all a primary problem of painting. It was a way to get the color down, to let color work as a free and independent language. The Concentric Circles were the paintings that allowed Noland's gift for color to bloom.
—William C. Agee, 1993

Split, 1959, acrylic on canvas, 237.8 x 238.5 cm (94 x 94 1/4 in.). Gift of the Vincent Melzac Collection

The thing is color, the thing in painting is to find a way to get the color down, to float it without bogging the painting down in surrealism, cubism, or systems of structure.... Structure is an element profoundly to be respected, but too open an engagement with it leaves one in the back waters of what are basically cubist concerns.

—Kenneth Noland, 1968

MODERN ᴀRT

All art media are at least partly about their own process. When we look at a given work, we see it not simply as an idea but as a thing, full of information about itself. We experience the hand and brush through the marks they leave, marks which chart the course of the picture. Understanding the process gives us an insight into images, much as maps allow us to understand topography. But the impact of the image is more than process. It is an alchemy of the material into a spiritual substance.... Like a work one revisits before leaving an exhibition—a picture that must be remembered—it epitomizes the spirit of working with this medium. It sends me back into the studio wanting to make monotypes, wanting to continue the process, the dialogue, wanting to transcend the material.

—Michael Mazur, 1981

Michael Mazur (born 1935), *Palette Still Life #53*, 1982, color monotype, 119.3 x 78.7 cm (47 x 31 in.). Museum purchase

Jazz has shown me the ways of achieving artistic structures that are personal to me; but it also provides me continuing finger-snapping, head-shaking enjoyment of this unique, wonderful music.

—Romare Bearden

Romare Bearden (1914–1988), *Untitled*, n.d., monotype with watercolor additions, 76.2 x 104.1 cm (30 x 41 in.). Museum purchase

Eric Fischl (born 1948), *Untitled (Group in Water)*, 1992, color monotype, 163.6 x 332.8 cm (36 x 73 1/8 in.). Museum purchase

Monotypes

The monotype has been defined as a hybrid printmaking process in which a drawing or painting executed on a flat, unworked printing plate or other surface is transferred through pressure to a sheet of paper. Because most of the image is transferred in the printing process, only one strong impression can be taken. Additional impressions of the residual image are sometimes taken (called cognates or ghosts), or else the remaining image can be reworked with additional ink or paint to create an additional impression related to, but different from, the original image.

—Joann Moser, 1994

Nathan Oliveira (born 1928), *London Sites 6*, 1984, monotype, 50.8 x 45.4 cm (20 x 17 7/8 in.). Museum purchase made possible by Mrs. Henry Bonnetheace, Cardine Henry, John Lodge, and Venice Workshop Artists

I began imagining what a work of art could be if it were made to pull vision apart rather than focus it.

Mel Bochner

born 1940

Skeleton (Skew), 1979–81, charcoal on paper, 76.2 x 127 cm (30 x 50 in.). Museum purchase

The *Skeleton* drawings, which accompanied the wall paintings beginning in 1978, first revealed the changes in Bochner's aesthetic evolution. These are important works because they provide vital information about his method of compositional organization and thinking. The drawings for *Skew* (1979), *Syncline* (1979–80), and *Secant* (1979) depict complex successive phases of the dialectic which formed the final configurations.... In the *Skeletons*, multiple components meld, revealing that Bochner, at the onset of 1980, had arrived at his own abstract vocabulary.

—Elaine A. King, 1985

Drawing can present conclusions. It can record the spontaneous appearance of a thought. It can contain the results of an investigation into the nature of relationships. Or, it can be the clear declaration of a complex idea.

—Mel Bochner, 1981

Art is not about finding out who you are, it is about finding out what it is.

Pat Steir
born 1940

In *Looking for the Mountain*, Steir examines one by one the visual systems we have invented for recording a mountain: elevation charts, calibration, silhouettes, diagrams, maps. She rejects the traditional idea that an illusionistic painting of a mountain is more "real," recognizing that the illusion itself is as much an abstraction as any diagram.
—Elizabeth Broun, 1980

The urge to make anything, to make a poem, to make a sculpture, a painting, no matter how mundane the doer is, has to do with awe. There's a tree; I think I'll draw a bigger tree right next to it. To add to the general chaos of the universe. To make one more thing that is not a part of you.
—Pat Steir, 1983

Looking for the Mountain, 1971, oil, pencil, crayon, and ink on canvas, 234.7 x 191.1 cm (92 3/8 x 75 1/4 in.). Gift of Richard M. Hollander in honor of Jean S. Lighton

I always thought, "I'm a very spiritual man, not interested in paint," and now I discover myself to be very physical, and very involved with matter.

Philip Guston
1913–1980

Transition, 1975, oil on canvas, 167.6 x 204.5 cm (66 x 80 1/2 in.). Bequest of Musa Guston

"I got sick and tired of all that purity," [Guston] said. "I wanted to tell stories." And so he did. In 1969 he painted six comments on the art world in cartoon-strip format. When his new paintings were unveiled they caused a furor in the art world. Many people had seen him erroneously as a gentle, lyrical painter, and these crude images of abandoned boots, Krazy Kat bricks, and black-eyed Klansmen wielding whips were taken as a personal affront, a shoe lobbed in the face of good taste. Undaunted by the negative critical response..., he painted in a fury for the rest of the seventies, unable to keep up with "all the images and situations...flooding in on me. I'm in a place where I literally can't do anything else," he said in 1974.
—**April Kingsley, 1980**

Now that he was painting "recognizable" things again, Guston's membrane should have been expected to vibrate more emphatically than ever. If shoes, clocks, books and hands were the subject, odds were that they would be as achingly subtle as any earlier hue or tone.

In fact, they were the opposite. Guston had boldly welded shut his chief escape hatch: his elegance. Elegance is, finally, what certifies possibility, while *impossibility* has always been Guston's most meditated concern. He expected out of figurative work nothing less than the same mix of perplexity the abstract work provided: image as both archer and target.

—**Ross Feld, 1980**

My hypothesis is that there is this monumental event in reality, and what I want to do is to reduce it to the point where conceptually it's monumental and yet it has a figurative presence. It's still large, but it alludes to something much larger, in that translation from reality.

Bryan Hunt

born 1947

Nature in landscape becomes the figure.... [T]he figure is never obvious. There were times when I would see it and follow that passage, and others when I would just let it go because I was more interested in the dynamics of the shape and the landscape, and how the landscape can turn space and volume into a narrow line.

—Bryan Hunt, 1983

Stillscape I, 1984, bronze, 396.2 x 142.9 x 55.2 cm (156 x 56 1/4 x 21 3/4 in.). Museum purchase

Stillscape II, 1984, bronze, 386.1 x 75 x 172.4 cm (152 x 29 1/2 x 67 7/8 in.). Gift of Nan Tucker McEvoy

CRAFT OBJECTS

It's almost like dancing, you know. Clay is just a big blob, but the minute you touch a piece of clay it moves. It's plastic. So you have to respond.

Peter Voulkos
born 1924

Rocking Pot, 1956, wheel-thrown and slab-constructed stoneware with colemanite wash, 34.6 x 53.3 x 44.6 cm (13 3/4 x 21 x 17 1/2 in.). Gift of the James Renwick Alliance and various donors and museum purchase

[*Rocking Pot's*] strength comes from its intense mix of ambiguity and ambivalence. Its form is perplexing because it seems familiar, a relative of the domestic pot. Yet its penetration of volume and its strange base, made up of two curved feet or "rockers," sows confusion and challenges its claim to vesselness. It presents itself simultaneously as a pot, a sculpture, and a demented birdfeeder. But Voulkos has no such confusion about the piece. Unequivocally he has stated, "I claim this as a Pot."

—Garth Clark, 1992

God gave me that hand, but not for myself, for all my people.

—Maria Martinez

Maria and Julian Martinez
1886–1980 **1879–1943**

Maria Montoya Martinez [was] a member of the pueblo of San Ildefonso, a small Tewa village in the northern Rio Grande Valley of New Mexico. She grew up with the traditional pottery of her pueblo and learned more about it shortly after her marriage in 1904 to Julian Martinez, when the two became acquainted with archaeologists from the Museum of New Mexico in Santa Fe and other specialists working in 1907–9 on the excavations at Tyuonyi and Frijoles on the Parjaritos plateau.... From the beginning of their marriage, Julian assisted Maria with her pottery making, painting her pieces with his imaginative designs. In 1910 Maria and Julian revived an old procedure for smudging clay and, working in collaboration, developed the stunning black pottery now known throughout the world as "San Ildefonso blackware."

—Susan Peterson, 1978

Blackware Plate, ca. 1930s, blackware, 37.2 cm (14 5/8 in.) diam. Gift of the IBM Corporation

I myself start on little pots, and my mother used to say, "Don't go over and bother your aunt; you just make little things here!"... My aunt Nicolasa...used to make those water [jars], to carry water, and to mix the dough, and to wash the hair.

"If you want to learn that, go ahead and learn slowly, you learn it slowly without bothering anybody. Just go ahead and watch her, how she mix the clay, and then you can make it yourself." ...I learn it with my whole heart.... First we made the cooking pots, usually, and I was the one that made those water jars, but in the black.... We mostly made it for our own use, for we wash clothes, and we wash our heads, and then the cooking pots.

—Maria Martinez, 1979

Beatrice Wood combines her colors like a painter, makes them vibrate like a musician. They have strength even while iridescent and transparent. They have rhythm and the luster both of jewels and of human eyes. Water poured from one of her jars would taste like wine.

—Anaïs Nin

Beatrice Wood
born 1893

Most painters are too clever. They are concerned with methods and form, and reveal little of birth and true freshness of approach. So much of art is from the mind, and not the heart. I do not refer to Marcel [Duchamp], Picasso, the few great, but to the many very talented who are so clever. Marcel is an intellectual painter, yet he has "birth" and feels the pain of true creation. I wonder if art should not be anonymous, then a lot of the nonsense of collectors would be done away with. It is the objet d'art, and not the artist that matters.

—Beatrice Wood , 1937

In this age when so much of living and thought is mechanized, it is good that a few still love objects the hands touch. They breathe a magic life of their own. To know the earth, to create form, to bring forth a glaze that delights is to tune up into heavenly chords.

—Beatrice Wood, 1951

Gold Lustre Teapot, 1988, earthenware with lustres, 35.6 x 29.2 cm (14 x 11 1/2 in.).
Museum purchase

There was never any question of doing anything else once I had touched clay.

Betty Woodman
born 1939

Kimono Vases: Evening, 1990, glazed earthenware, Part A 78.7 x 57.1 x 21.6 cm (31 x 22 1/2 x 8 1/2 in.), Part B 78.7 x 60 x 21.6 cm (31 x 23 1/2 x 8 1/2 in.). Gift of the James Renwick Alliance and museum purchase

Among the vessels of Betty Woodman there is a din of conversation.... Lured into these discussions by means as various as the artist's colors and shapes, the viewer is soon caught up in the rollicking debate of a serious question: What is art? A dry subject, but the vessels are far from dry. Products of a learned respect for the history of the medium, they break every boundary and push against all limits. They cannot be still.

—Linda Schmidt, 1989

CRAFT OBJECTS

The potter's dismissal of function as a governing premise in the construction of vessels is analogous to the painter's and sculptor's abandonment of realism early in the twentieth century. In each case industrialism and technology left their mark: photography created cheap perfect images and mass factory production created cheap perfect forms. This allowed for a separation between traditional craftsmanship and the expression of ideas and feelings in both ceramics and the fine arts.

—Vicki Halper, 1987

Vessel

Richard Devore (born 1933), *Untitled (#403) Vessel*, 1983, multi-glazed stoneware, 40.6 x 31.2 cm (16 x 12 1/2 in.). Museum purchase

Bruce Mitchell (born 1908), *Star Chamber*, 1987, burl, walnut, 31.2 x 68 x 61 cm (12 1/4 x 26 3/4 x 24 in.). Gift of Jane and Arthur K. Mason

A vessel of baked clay: do not put it in a glass case alongside rare precious objects. It would look quite out of place. Its beauty is related to the liquid that it contains and to the thirst that it quenches. Its beauty is corporal: I see it, I touch it, I smell it, I hear it. If it is empty, it must be filled; if it is full, it must be emptied. I take it by the shaped handle as I would take a woman by the arm, I lift it up, I tip it over a pitcher into which I pour milk or pulque—lunar liquids that open and close the doors of dawn and dark, waking and sleeping. Not an object to contemplate: an object to use.

—Octavio Paz, 1974

Wayne Higby (born 1945), *White Table Canyon Bowl*, 1981, raku-fired earthenware, 26.2 x 39 x 40 cm (10 1/2 x 15 5/8 x 16 in.). Museum purchase and gift of the James Renwick Alliance

and Containment

Fritz Dreisbach (born 1941), *Ruby Wet Foot Mongo*, 1990, glass, 48.9 x 48.3 x 39.4 cm (19 1/4 x 19 x 15 1/2 in.). Gift of the James Renwick Alliance and museum purchase made possible by the Smithsonian Institution Collections Acquisition Program

Mary Adams (born 1920s), *Wedding Cake Basket*, 1986, woven sweet grass and ash splints, 63.7 x 39.3 cm (25 1/2 x 15 3/4 in.). Gift of Herbert Waide Hemphill, Jr.

I find pleasure in fooling people.

John Cederquist
born 1947

In *Ghostboy* John Cederquist has faithfully represented a high chest of the type made by 17th-century Rhode Island cabinetmaker John Townsend.... Since many people have commented on the Cubist character of his furniture, Cederquist decided to make this piece of crafted furniture take on the appearance—or lack of appearance—of a ghost.... Seven secret parallelogram drawers slide on an angle that follows the point of view. The placement of the drawers, and of the one cabinet door, combined with the deliberate fragmentation of the illusion, creates a multi-layered reality that continually engages the eye and mind of the viewer.

—Michael W. Monroe, 1993

[René Magritte] talked a lot about the relationship between image and object, reality and illusion and how we have a tendency to mix them up. To some degree that is what I am saying here.... In one way, [it is] a chest of drawers in terms of the fact that it works. You can pull the drawers out. In another way, it's an image of a chest of drawers. And being able to separate the two has allowed me to do some things that you just can't normally do with furniture.

—John Cederquist, 1992

Ghostboy, 1992, birch plywood, sitka spruce, poplar, copper leaf, epoxy resin inlay, and aniline dyes, 224.2 x 113 x 38.2 cm (88 x 44 x 15 in.). Gift of the James Renwick Alliance, Ronald and Anne Abramson and museum purchase

Art cannot come from art. Art must come from life.

John McQueen
born 1943

Untitled #192, 1989, burdock (burrs) and applewood, 58.42 x 48.26 x 50.8 cm (23 x 19 x 20 in.). Gift of the James Renwick Alliance

In 1988 when McQueen gave a lecture in Oakland, California, he began by speaking about his rural experiences—chopping firewood, working his garden, waiting for water to boil on a wood stove, living without electricity....

I asked him whether he always begins his lectures by describing his lifestyle. He said that he does. He wants his lectures to show the connection that exists between his life and his art....

McQueen feels that calling his work baskets rather than sculpture gives him a real advantage: "There's no limitation. I think sculpture, because of its place in the hierarchy of fine arts, has more rules, requirements, and preconceptions. The advantage of having baskets ignored by modern western culture is that baskets are allowed to be whatever I want—the rules haven't been determined."

—Ed Rossbach, 1991

People still argue about whether or not I'm an artist because I work with clay!

Robert Arneson
1930–1992

The things that I'm really interested in as an artist are the things you can't do—and that's really to mix humor and fine art. I'm not being silly about it, I'm serious about the combination. Humor is generally considered low art but I think humor is very serious—it points out the fallacies of our existence.

—Robert Arneson, 1981

Arneson's theme now is Arneson—portrait busts, comic satires of classical themes—Arneson as Bacchus, Arneson as a heroic channel swimmer, Arneson as a *cordon bleu* chef. If all that seems to be glorifying the ego, Arneson enjoys it immensely. He doesn't care to belong to the precious ethos of the "potter's life"—not in the tea-mug genre anyway. However, he does have great reverence for a transcending classical heritage, and he teaches himself anatomy for these big new busts from Albrecht Dürer's drawings.

—Fred Ball, 1974

35-Year Portrait, 1986–88, glazed ceramic, 194.3 x 59.7 x 63.5 cm (76 1/2 x 23 1/2 x 25 in.). Promised gift

With Game Fish, I have endeavored to "play" with my audience, bombarding their senses and tickling their sensibilities, to create a feeling of frivolous fun and excitement, while extracting an aesthetic integrity from the chaos of our cultural images and artifacts.

Larry Fuente
born 1947

Game Fish, 1988, mixed media, 130.8 x 285.6 x 27.3 cm (51 1/2 x 112 1/2 x 10 3/4 in.). Gift of the James Renwick Alliance and museum purchase through the Smithsonian Institution Collections Acquisition Program

Larry Fuente is a California artist who transforms banal, commercial products into objects of wonder and mystery.... Using a mounted sailfish trophy, Fuente created a flamboyant work that is itself a punning play on words, for the actual "game fish" is covered with a wide variety of commercial, game-related artifacts—dice, miniature pinball games, poker chips, ping-pong balls, yo-yos, domino and Scrabble tiles—even badminton birdies.... The sheer excess of the thousands of colored ornaments that emphasize yet transform the underlying found object is the essence of Fuente's delightfully obsessive decorative aesthetic.
—Michael W. Monroe, 1991

In the realm of taste, to be rasquache is to be unfettered and unrestrained, to favor the elaborate over the simple, the flamboyant over the severe. Bright colors (chillantes) are preferred to sombre, high intensity to low, the shimmering and sparkling to the muted and subdued. The rasquache inclination piles pattern on pattern, filling all available space with bold display. Ornamentation and elaboration prevail, joined to a delight for texture and sensuous surface.
—Tomas Ybarra-Frausto, 1991

Right now, I'm saying I might not make any more furniture,

I'm making sculpture now.

Wendell Castle
born 1932

Ghost Clock, 1985, bleached Honduras mahogany,
219 x 62.2 x 38.1 cm (86 1/4 x 24 1/2 x 14 in.).
Museum purchase made possible by the Smithsonian
Institution Collections Acquisition Program

Ghost Clock is a masterwork of trompe l'oeil, or
"fool the eye" illusionism. It is definitely not what
it appears to be — a grandfather clock covered
with a white sheet. Rather, it is a remarkable
wood sculpture.

The entire piece was handcarved in 1985 from
a single block of laminated mahogany. With
astonishing accuracy, Wendell Castle replicated
every protrusion and every drapery fold down to
the smallest detail. To complete the visual decep-
tion, he bleached the wooden "sheet" white and
stained the "clock" dark brown.

But *Ghost Clock* is more than a virtuoso
sculptural illusion: it is haunted with poetic
meaning. With no inner mechanism, the clock
clearly cannot tell time. Instead, it symbolizes the
end of time—the mystery of death.

—Jeremy Adamson, 1992

[Wood is] as capable of self-expression as any of the other traditional fine-arts media are.

Michael Hurwitz
born 1955

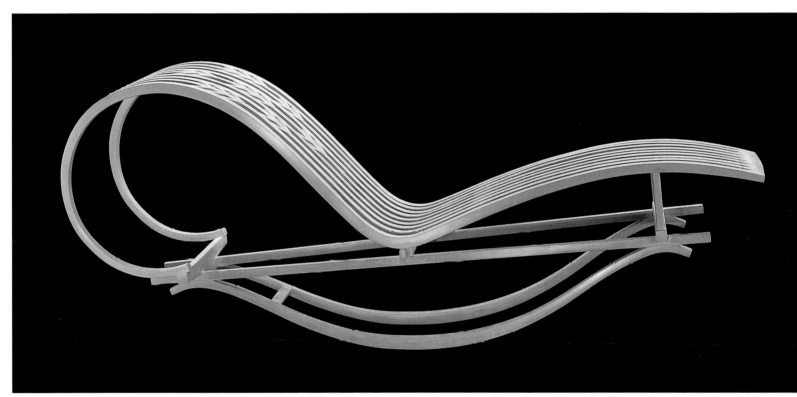

Rocking Chaise, 1989, laminated mahogany, steel pipe, and yellow ochre milk paint, 91.4 x 228.6 x 61 cm (36 x 90 x 24 in.). Gift of Anne and Roland Abramson, the James Renwick Alliance, and museum purchase made possible by the Smithsonian Institution Collections Acquisition Program

Michael Hurwitz's *Rocking Chaise* was part of the exhibition "New American Furniture" organized by the Museum of Fine Arts, Boston, in 1989. The task of each participating artist was to choose a historic piece of furniture and create a contemporary interpretation....

Hurwitz played off of the compositional aspects of a Fancy Chair by Samuel Gragg (1772–1855)—the scale, strength of line, relationship of positive to negative space, interplay of paint and detail and especially the sense of invention. Rather than recasting these elements, the artist stretched out the line and placed it on a rocking structure. In so doing, Hurwitz created a furniture form which evokes an image of a magic carpet for the fantasy of the viewer and user.

— Michael W. Monroe, 1990

I respond to a certain quality in ancient and primitive art which I perceive as originating from genuine creative necessity. Efforts born out of this need reflect an honesty and directness that I don't always see in work resulting from more deliberate action. Also of interest to me in these works is the "roundness," the sense of repleteness, that a piece develops as it matures through time and use. In my own work I try to be sensitive to the nature of wood, allowing it to help determine the form and content that ultimately emerge.

—Michael Hurwitz, 1986

CRAFT OBJECTS

The art of fine furniture making is a subject abstruse to most Americans; it requires explanation. Popular culture presents furniture as consumer merchandise. Fine furniture is different: it derives from the same aesthetic impulses that produce fine paintings, sculpture, and architecture. There is no basic difference between fine arts and fine crafts. Profound appreciation of any art work requires time, thought, and a developed taste.

—Jonathan L. Fairbanks, 1983

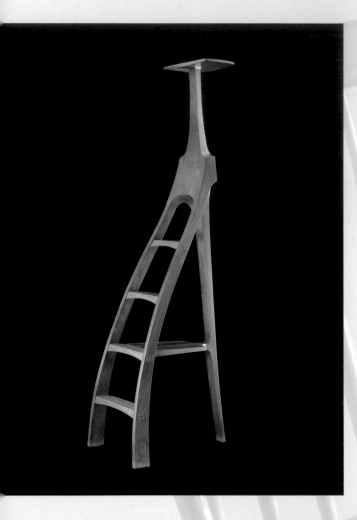

Daniel Jackson (born 1938), *Four Step Library Ladder*, 1965, black walnut and oak, 199.4 x 52.1 x 65.4 cm (78 1/2 x 20 1/2 x 25 3/4 in.). Gift of the James Renwick Alliance and museum purchase made possible by the Smithsonian Institution Collections Acquisition Program

Emerson wrote, "I look on the man as happy who, when there is a question of success, looks into his work for a reply."

—Sam Maloof, 1983

Sam Maloof (born 1916), *Double Rocking Chair*, 1992, fiddleback maple and ebony, 108.3 x 106.7 x 113 cm (42 5/8 x 42 x 44 1/2 in.). Gift of the Hafif Family Foundation, the James Renwick Alliance, and museum purchase made possible by the Smithsonian Institution Collections Acquisition Program

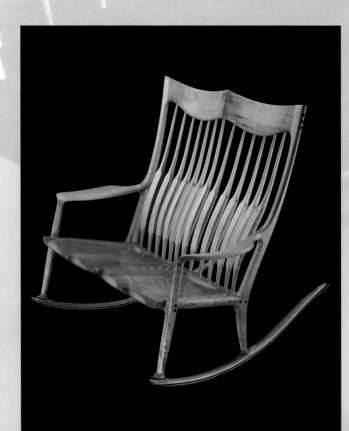

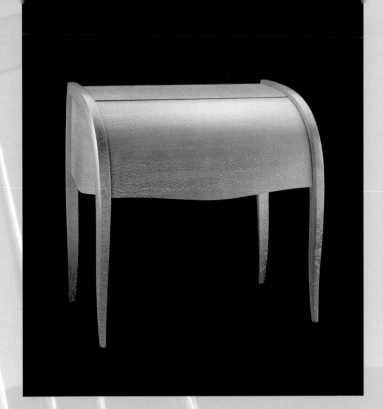

Quite often the shape, size, texture and the extravagances of graining dictate the design and function of an object. Here the relationship of man to timber prevails as the two live comfortably together day after day, without tiring of each other.
—George Nakashima, 1981

Jere Osgood (born 1936), *Cylinder-Front Desk*, 1989, 116.5 x 109.9 x 73.7 cm (45 7/8 x 43 1/4 x 29 in.). Gift of the James Renwick Alliance and museum purchase made possible by the Smithsonian Institution Collections Acquisition Program

Furniture as Art

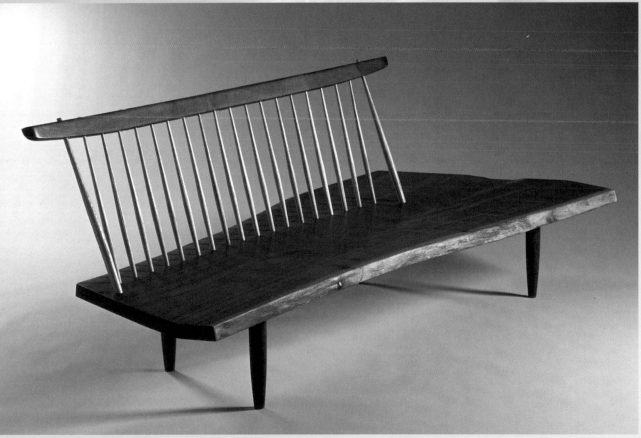

George Nakashima (1905–1990), *Conoid Bench*, 1977, walnut and hickory, 79.1 x 214.6 x 90.5 cm (31 1/8 x 84 1/2 x 35 5/8 in.). Gift of Dr. and Mrs. Warren D. Brill

There's a fine line between reverence and irreverence toward the material. Tradition can dictate its use in a certain way, or the artist may discover the material's malleability allows going in many directions.

John Roloff
born 1947

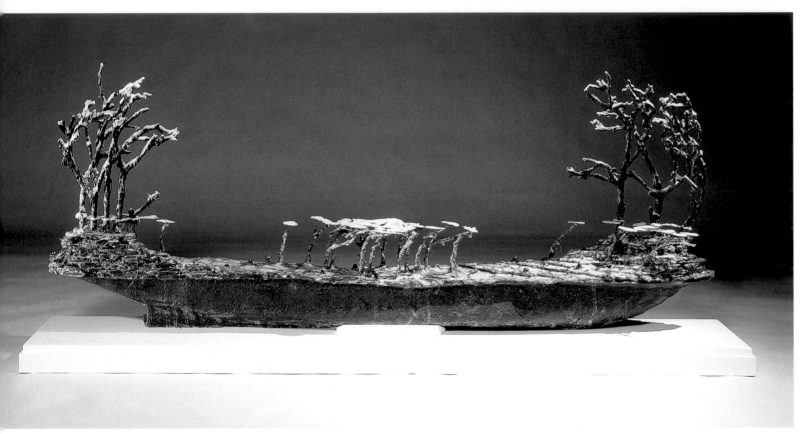

Night Ship/Submerged Channel/The Frozen Sea, 1986, ceramic, 54.3 x 135.9 x 19.1 cm (21 3/8 x 53 1/2 x 7 1/2 in.). Museum purchase made possible in part by Mr. and Mrs. Fortunato Parotto and John Lodge

The provocative ships of John Roloff serve as allegorical devices to explore the unknown through an association of poetic images. *Night Ships/Submerged Channel/The Frozen Sea* transforms itself into an isolated island, a magic aqueous winter garden in miniature. This work suggests ancient underwater wrecks, ghostly ships that have sunk to abyssal depths.

Roloff spent his childhood on the Oregon coast and, for him, the boat conveys the intrigue, loneliness and vulnerability of an exploration at sea.

—Jeremy Adamson, 1988

When considering all my work over time and as a whole, certain themes become apparent. The occurrence and reoccurrence of a number of images represent and embody a personal connection with forces of nature and comment on the human interface with those forces. The ship, among others—when activated in isolation, complexity or temperature—exists as emotional and romantic evidence of something that is both known and unknown.

—John Roloff, 1988

In glass blowing, if the necessary risk is taken, the outcome must always be in doubt.

Artistic creation must occur in crisis; it cannot be planned or divided up.

Harvey Littleton
born 1922

It has to do with an aesthetic sense, with the ability to create something that is not part and parcel of an accepted form. I think this is often where you find the difference between the artist and the craftsman, in that the craftsman uses the medium essentially for functional purposes. The artist is not going to be satisfied doing the traditional form—like the ceramic vessels that Littleton had done earlier in his career. Although they are of excellent quality, they are not really different from a whole lot of other ceramics. He needed the glass medium to really express himself, to take full advantage of his personal vision of what form should be about.

—Gudmund Vigtel, 1984

Form comes not from inspiration; it is born of work. Artists do not imagine forms and then execute them. It is naive to suppose that in art forms are transferred, as if they were templates, from mind to matter.

—Harvey Littleton, 1971

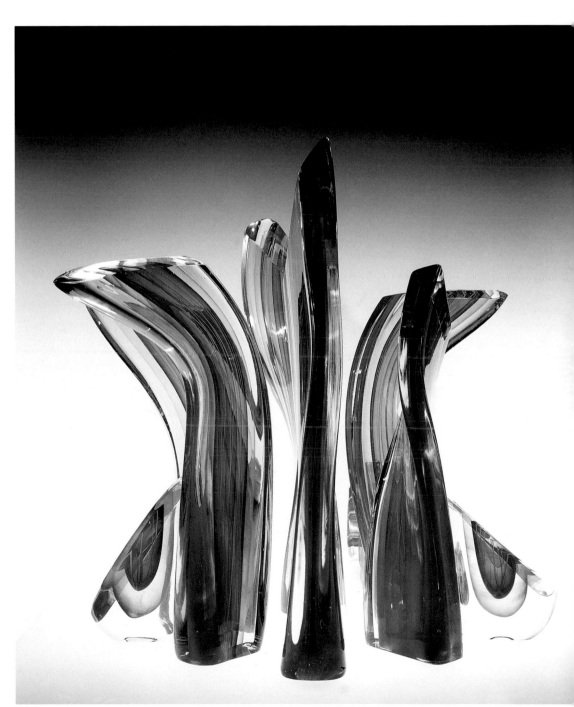

Opalescent Red Crown, 1983, barium, potash glass with multiple cased overlays of Kugler colors, 70 x 75 x 57 1/2 cm (28 x 30 x 23 in.). Museum purchase with funds donated by Mr. and Mrs. R. Philip Hanes, Jr., Victor Cross, Joseph Davenport, Jr., John Hauberg, Mr. and Mrs. Robert Judelson, Samuel Johnson, and Edward Elson

I have learned that jewelry, whether large or small, can be sumptuous, bold, aggressive and be a symbol of man's relationship to his society.

Richard Mawdsley
born 1945

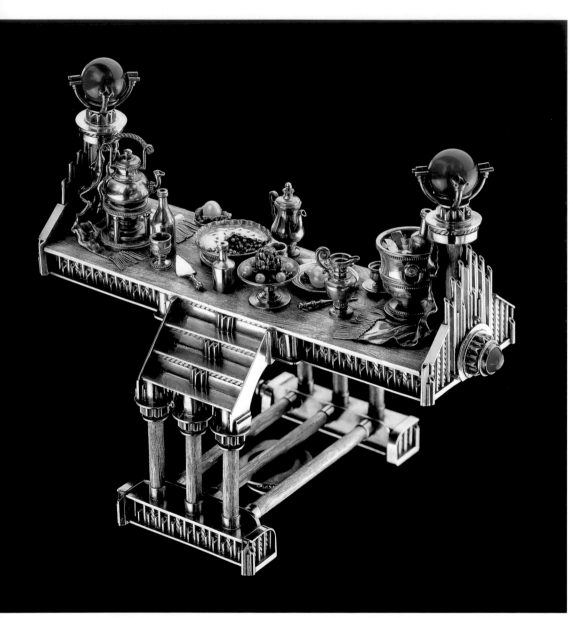

Feast Bracelet, 1974, sterling silver, jade, and pearls, 9.6 x 7 x 11.5 cm (3 3/4 x 2 3/4 x 4 1/2 in.). Gift of the James Renwick Alliance

[Mawdsley's] metalwork, from as far back as graduate school, has had a unity of image and character that can be attributed to a single idea. Yet that nugget is so rich in meaning and in visual possibilities that he could spend his life on it without exhausting the lode.

The dominant imagery is mechanical, and Mawdsley's means of expressing it is metal tubing.... He uses the tubing structurally and also applies it as embellishment. The forms are abstract, anatomical, figural, representational and even organic, but all make a reference to the system, logic and efficiency of the machine....

The slowness of working with tubing agrees with Richard Mawdsley. "I feel more and more like a dinosaur," he says, adding that he has been called "insanely self-indulgent" for his work habits. He notes wryly that people seeing his jewelry, and concluding from the quantity of detail that he must be extraordinarily patient, usually assume that he is an older man. "Actually they thought I was a retired watchmaker. Now, I've finally gotten old enough for my work."

—Janet Koplos, 1983

At first, when I realized I was a romantic, I was sort of shocked and shamed.

But it is true...that the material I work most with is emotion.

Albert Paley
born 1944

In June 1972 five American metalsmiths were invited to submit drawings for a commission to design and fabricate a pair of symmetrical wrought iron and brass gates to adorn the entrance to the Renwick Gallery's museum shop. The commission was awarded to Albert Paley, a young goldsmith from Rochester, New York, who had already gained renown for onc-of-a-kind pieces of jewelry fabricated in gold, silver, and copper. The Renwick commission marked a turning point in Paley's career, and his *Portal Gates* has been hailed as one of the masterworks of contemporary ironsmithing.

—Michael W. Monroe, 1990

Portal Gates, 1974, forged steel, brass, copper, and bronze, 230.5 x 182.9 x 10.3 cm (90 3/4 x 72 x 4 in.). Commissioned for the Renwick Gallery

My work is a means of exploration and the development of form. Rather than having an image in mind and then coercing or informing material into that, usually the imagery or the development of form is through the direct manipulation and involvement with structure.

—Albert Paley, 1976

CRAFT OBJECTS

When I learned to work in fiber there were conditions of utility and appropriateness. We didn't feel we had to be innovative at all. The work you were doing was in relation to someone else's. Drapes were done in relation to architecture. Everything was in relation to something else. Nobody ever seemed to think about these other things as being in relation to fiber. That's wrong, isn't it?.... Decorative arts, crafts—whatever these things are called—are always put into these relations, and I would like them to be, I want fiber to be, in relation to me.

—Ed Rossbach, 1983

Ed Rossbach (born 1914), *Linen Doublecloth Wallhanging*, 1966, linen, 165.1 x 165.1 cm (65 x 65 in.). Gift of the artist

We touch things to assure ourselves of reality. We touch the objects of our love. We touch the things we form. Our tactile experiences are elemental....

Concrete substances and also color per se, words, tones, volume, space, motion—these constitute raw material; and here we still have to add that to which our sense of touch responds—the surface quality of matter and its consistency and structure.

—Anni Albers, 1965

Anni Albers (1899–1994), *Ancient Writing*, 1936, tapestry, 112.4 x 124.5 cm (49 x 44 1/4 in.). Gift of John Young

In the chaotic and depressing time immediately following the First World War, handmade textiles began to regain their importance. Several European art schools, notably the Bauhaus in Germany, began to explore the creative potential of fiber as an art medium.... The aim of the Bauhaus was to bring together the artist and the craftsman and to make no distinction between the two....

These textile or fiber artists were few in number but they brought their ideas with them to the United States as they fled the tyranny of World War II.... [T]heir ideas for using textiles as an art medium began to take root in this country and by the end of the 1950s had many adherents.

—Rebecca A. T. Stevens, 1981

Fiber

Lenore Tawney (born 1907), *In the Dark Forest*, wool and silk, 321.3 x 137.8 x 5 cm (126 1/2 x 54 1/4 x 2 in.). Gift of the James Renwick Alliance and museum purchase made possible by the Smithsonian Institution Collections Acquisition Program

Cynthia Schira (born 1934), *Reflections*, 1982, cotton and linen wrap, dyed rayon, bound-resist dyed cotton, 241.3 x 383.5 cm (95 x 151 in.). Museum purchase made possible in part by the James Renwick Alliance and Roberta Golding

CONTEMPORARY *Voices*

I like being part of the real world. So the question was, how could

I relate that world to my work.

Luis Jiménez
born 1940

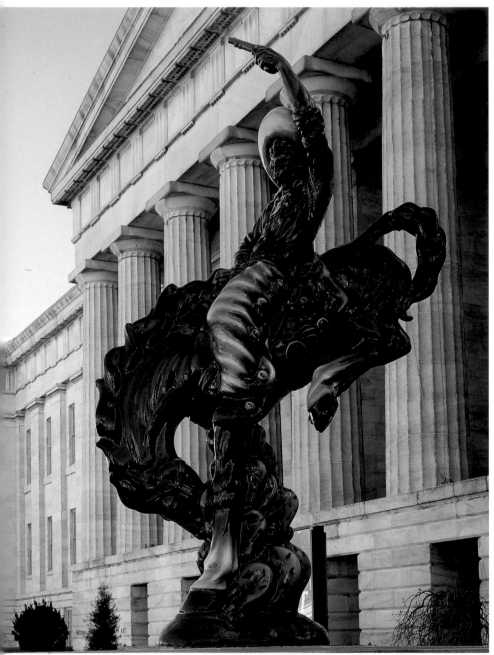

Vaquero, modeled 1980/cast 1990, acrylic urethane, fiberglass, steel armature, 505.5 x 289.6 x 170.2 cm (199 x 114 x 67 in.). Gift of Judith and Wilbur L. Ross, Jr., Anne and Ronald Abramson, Thelma and Melvin Lenkin

[Luis Jiménez's] subject matter utilizes the popular images of the *cultura del norte* [U.S. culture], and a large part of it is depicted and transformed in the rough and tumble world of *la frontera* [the frontier]. He is also a son of *el norte* [the North of the U.S.], and so he uses its materials and explores its emerging, popular myths. The tension, and attraction, of Jiménez's work is that he always creates within the space of his two worlds, the Mexicano and the Americano. He constantly shows us the irony of the two forces which repel, while showing us glimpses of the synthesis he seeks.
—Rudolfo Anaya, 1994

My initial idea was to do the piece [Vaquero] with a cowboy because I saw the Cowboy and the Indian as being really American images. My feeling was that if somebody from Europe came to the U.S., what they really thought of the U.S. was the Cowboys and Indians. But as I began researching it, thinking about it, I was struck with the irony that our concept of the American cowboy was this John Wayne type image, this blond cowboy coming out of Hollywood, where in fact the original cowboys were Mexican. It was a Mexican invention. All of the terminology connected with the American cowboy is drawn from Spanish: corral, lariat, remuda....The American cowboy saddle is derived from the Mexican saddle; the cowboy hat, from the Mexican hat. Somehow we'd lost sight of that.

—Luis Jiménez, 1994

They're all toys.

David Levinthal
born 1949

I think the Western work was heavily influenced by my age, because I grew up in the 50s. I loved cowboys as a young child. My mother has told me that I had a favorite shirt and she would stay up late and wash it so that I could wear it the next day. And I wouldn't go out without my Red Ryder gloves. I remember going to the movies with my father on Saturday and seeing bad Westerns. (I knew they were bad; they must have been God-awful to him.).... All those had a great influence. You absorb everything in your life. If you're an artist, part of your life is synthesizing these elements. But you don't want to know too much about your own past. Subconsciously it's stronger; if you're consciously trying to relive your life, it looks too programmed.

—David Levinthal, 1993

Untitled (from "Wild West" series), 1988, Polaroid Polacolor, 74.3 x 55.9 cm (29 1/4 x 22 in.). Museum purchase

See, when you are an artist, you got to study all these things to make your pictures and drawings over all those other men. You have to do something wonderful, so people know who you are! There are a million paintings to do, to think about!

William Hawkins
1895–1990

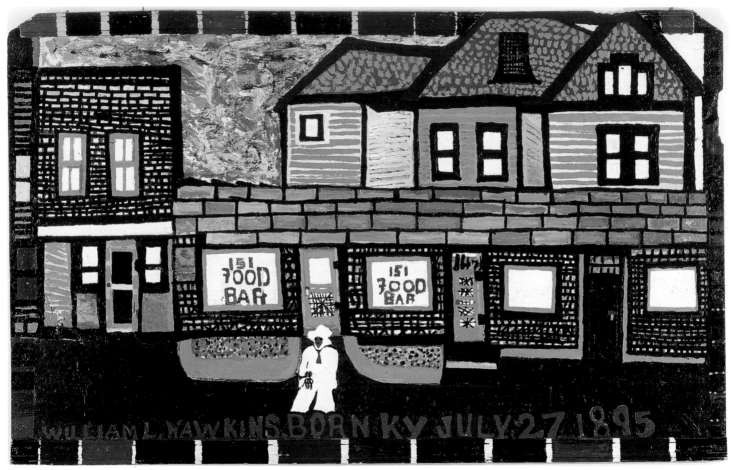

Food Bar, late 1980s, oil on canvas, 121.92 x 190.5 cm (48 x 75 in.). Gift of Herbert Waide Hemphill, Jr.

African-American artist William Hawkins was reared on a Kentucky farm and learned to draw by copying illustrations from horse-auction advertisements and calendar pictures. When he was twenty-one, he moved to Columbus, Ohio, where he painted cityscapes and fantastic animals for which he is best known.

Food Bar depicts neighborhood shops and houses clustered under a sky that is a jumble of overlapping colors. The strong geometric shapes of his urban landscape are painted in bold, rich colors of gloss enamel in startling juxtapositions and patterns. Hawkins painted on scavenged plywood boards and created his frames from found pieces of molding that he nailed directly to the plywood. By completely filling the surfaces of his large paintings, Hawkins directs the viewer to see events as he does—bigger than life with all the remembered details of many years of observation.

—Lynda Roscoe Hartigan, 1989







What makes anything a viable alternative is the integrity of your approach to it.... It doesn't have anything to do with the materials, or the style...it is a kind of energy that comes into the particular sequence of events.

William T. Wiley

born 1937

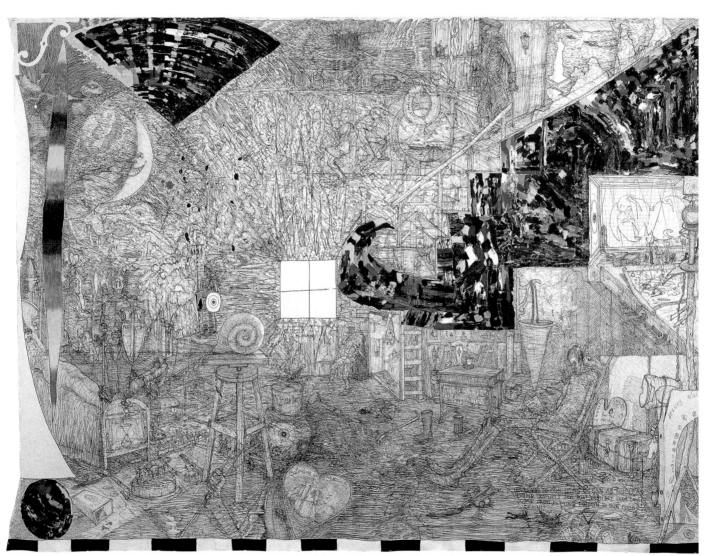

In the Name Of (Not to Worry It's Juxtaposition), 1982, acrylic, felt-tipped pen and ink, and charcoal on canvas, 245.1 x 322.6 cm (96 1/2 x 127 in.). Museum purchase

During the 1960s the Bay Area became the center for an important visual and contextual shift in contemporary art. William T. Wiley [among others] began exploring the realm of idiosyncratic, content-laden art. Wiley particularly developed conceptual affinities with Dada, and by the mid-1960s he had evolved an offbeat, yet lyrical style often punctuated with visual and verbal puns, *double entendre*, and riddles. Although elements are shared with Pop art of the 1960s, Wiley, along with many of his Bay Area colleagues, more profoundly transforms his sources and themes than did most purely Pop artists, often injecting notes of humanistic and ecological concerns through provocative, if enigmatic, juxtapositions.

A three-part work, *In the Name Of (Not to Worry It's Juxtaposition)* combines a large-scale painting/drawing (shown above) with a constructed assemblage and a smaller-scale drawing and watercolor.

—Virginia Mecklenburg, 1983

My work is about the underbelly of the beauty of nature, and the dark side of nature is its indifference.

April Gornik
born 1953

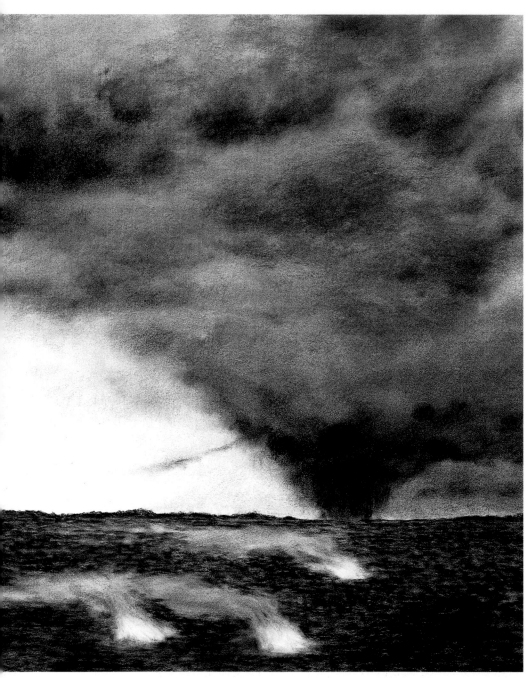

Storm and Fires, 1990, charcoal and pastel on paper, 119.8 x 97.2 cm (47 1/8 x 38 1/4 in.). Museum purchase through the friends of Philip Desind

Gornik's landscapes are...contrived settings that suggest perceived conditions rather than temporal events. Her intention is to create an architectural sense of space that the viewer can enter and move about in, metaphorically and poetically. "In [my] landscapes...it is often difficult to tell if you are standing on land, in water, or hovering above water. I don't want you to look at what I've painted in the same way that you would look at an actual vista—I want you to have a different kind of psychological experience."
—Lucinda Barnes, 1988

A leading proponent of the revival of landscape themes in contemporary American art, Gornik has become particularly well known for eerie vistas devoid of human presence that both allure and repulse the viewer. She sees in her work affinities with 19th-century Romantic painters such as Caspar David Friedrich and with the supernatural clarity of American Luminists such as Martin Johnson Heade. The ominous power and sense of mystery inherent in the swirling clouds and mysterious smoke of "Storm and Fires" typifies her interest in scenes that simultaneously convey both a primal thrill and a sense of dread. She has noted of similar works, "I love imminent storms—the charge in the air is incredibly exciting just before a storm erupts."
—*Journal of the Print World*, 1991

The escape from traditional descriptive photography to a photography of invention offers

insights into the larger sense of unreality experienced by all of us.

—Joshua P. Smith

Susan Rankaitis
born 1949

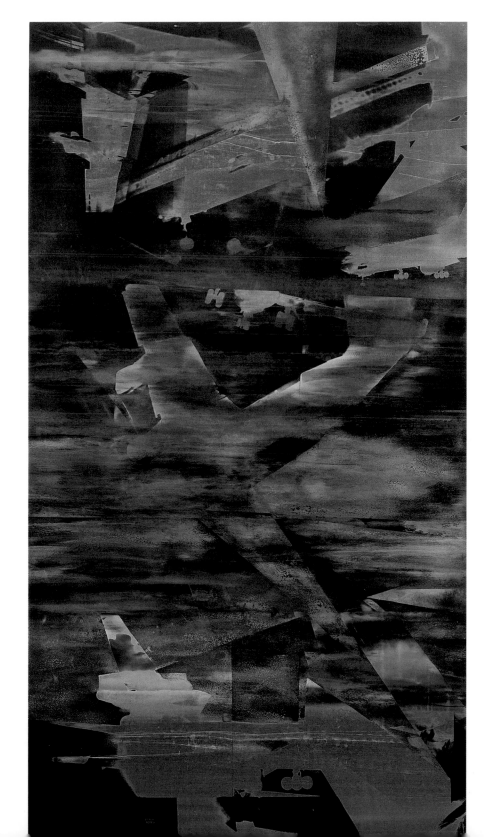

Like a number of women artists in Los Angeles using photography, Rankaitis has never had an interest in the traditional, more documentary uses of the medium and has always made her work within the studio. Concerned more with abstraction, she uses the photographic negative as a component rather than the essence of the final print. Unwilling to relinquish her interest in painting, she experimentally applies various photographic emulsions, brushed or sprayed onto the paper, incorporating imagery at various levels.

—Kathleen McCarthy Gauss, 1985

An airplane, fragmented and shorn of its tail, weaving in and out of a black and gold colorfield, is not just an airplane: it takes its place, as do all our technological artifacts, among the most elemental figures that haunt our consciousness: the flight of a bird just over the horizon, logs floating downstream, the flotsam and jetsam of our threatening yet oddly enticing late twentieth-century landscape.

—Marjorie Perloff, 1988

Marvel, 1986, mixed photographic media on paper, 128.6 x 21.9 cm (90 x 48 in.). Museum purchase

CONTEMPORARY *Voices*

Lois Conner (born 1951), *St. George's Hotel, Brooklyn, New York*, 1991, platinum-palladium print, 16.7 x 42.1 cm (6 9/16 x 16 9/16 in.). Gift of the Consolidated Natural Gas Company Foundation

My aim has been to photograph in a way that denies specific time and undermines conventional ideas about space. Photography can be beautifully articulate about what we consider to be reality, but the tables can be turned. Although one cannot refute the existence of what one sees in a photograph, a seeming over-abundance of information can make it seem strangely poised on the edge of myth.

—Lois Conner, 1992

Between Home

A collection of more than 300 landscapes by contemporary artists was acquired through the generosity of the Consolidated Natural Gas Company Foundation. This collection provided the basis for a major touring exhibition and accompanying book titled *Between Home and Heaven: Contemporary American Landscape Photography,* produced in 1992.

John Pfahl (born 1939), *Goodyear #5, Niagara Falls, New York* (from the series "Smokestacks"), 1989, Ektacolor Plus print, 46.9 x 46.9 cm (18 1/2 x 18 1/2 in.). Gift of the Consolidated Natural Gas Company Foundation

Mark Klett (born 1952), *Around Toroweap Point, Just Before Sundown, Beginning and Ending with Views Used by J. K. Hillers, Over 100 Years Ago, Grand Canyon*, 1986, gelatin silver prints, each 50.5 x 40.6 cm (19 7/8 x 16 in.). Gift of the Consolidated Natural Gas Company Foundation

The landscape is not so much a paradise to long for...as it is a mirror that reflects our own cultural image. We now view landscape photographs, both past and present, much like the shadows on the walls of Plato's cave. They are artifacts of what we think we know about the land, and how we have come to know it—the language of an individual's experience in his or her time, and at their best a form of commentary.

—Mark Klett, 1990

and Heaven

Karen Halverson (born 1941), *Mulholland at the Hollywood Overlook, August 28, 1992*, 1992, chromogenic print, 41.1 x 127 cm (16 3/16 x 50 in.). Gift of the Consolidated Natural Gas Company Foundation

In the late twentieth century, landscape—whether "as close as your own back-yard," or "paradise on earth"—lies somewhere between the ideals of home and heaven. Echoing the older traditions of Arcadia and Utopia, this double vision of landscape promises either a return to an edenic past or innovation that will make us a paradise in the future. Photographers today chart the territory somewhere between: between society's need to make its home on earth and the hope that such a home can be heaven on earth.... [Their pictures] speak for a view of landscape as it moves away from awed response to a wary, respectful look at the land.

—Merry A. Foresta, 1992

There's a spiritual element that enters in when you work a sign into a sculpture. Somehow it has to be the right sign, from the right place, the one that's meant for the piece.

William Christenberry
born 1936

Alabama Wall, 1985, metal and tempera on wood, 115.3 x 128.3 cm (45 3/8 x 50 1/2 in.). Museum purchase

I am genuinely fascinated with the passage of time. I am fascinated by how things change, how one of these signs, for example—it was once in mint condition, an object put there to sell, advertise a product—takes on a wonderful character, an aesthetic quality through the effect of the elements and the passage of time.
—William Christenberry, 1990

I had a hammer and I had to hold on to it with both hands. I had to wear ear plugs, goggles, a mask for the dust, a scarf, a hat.... I couldn't hear anything. I couldn't see anything. You're in there by yourself with that stone.

Jesús Bautista Moroles
born 1950

While working a piece of granite in the devouring Texas sun, in a frenzy of physical exertion that seemed to get nowhere against the hard surface of the stone, he suddenly realized that he was feeling a deep respect for the stone's toughness; its unyielding presence, its density and hardness as itself overcame him with admiration. This would be his work, to attack this stone and attempt to release the energies he sensed inside it. In an animistic statement of a type reminiscent of the expression theory of art, Moroles says that he didn't choose the stone, the stone chose him. It was because the stone fought him so hard that it won him as its acolyte.
—Thomas McEvilley, 1990

The legacy of Moroles' background may provide a clue; like other Mexican-American artists, Moroles was reared in a culture mined with visual signification and a strong visual identity. Although it is simplistic to impute a Jungian pre-Columbian memory to Moroles' granite sculptures, it is equally simplistic to ignore the powerful antecedent of ancient Mexico.... This relationship adds a level of signification, of historical allusion, to Moroles' work that allows it to function on many levels.
—Mel McCombie, 1988

Granite Weaving, 1988, Georgia gray granite, 245.1 x 193 x 25.4 cm (96 1/2 x 76 x 10 in.). Promised gift of Frank Ribelin

The basis of my work, the humor and seriousness of two cultures—East and West—clashing, is provided by my own life experiences.... In my work I take the best and worst of both cultures and juxtapose them in a coherent statement that is visually exhilarating.

Masami Teraoka
born 1936

Oiran and Mirror, 1988, watercolor on paper, 38.1 x 56.5 cm (15 x 22 1/4 in.). Museum purchase made possible by Eugene Vail, Martha Loomis, Mrs. Rhinelander Stewart, and Mrs. E. N. Vanderpoel

In 1986 the artist met an old friend with a newborn baby who had become infected with AIDS as a result of a blood transfusion. By focusing on this disease in an extended series of [works], Teraoka sought to draw attention to the social and health issues raised by this modern plague. The Japanese writing in the background of *Oiran and Mirror* translates as follows: "Pretty soon my boyfriend will be here. I wonder if he is prepared with a condom. Even if I have visited Anzenji Shrine [Geishas often go to shrines to pray for safety], maybe I should use a woman's condom. Oh, the telephone is ringing." Her boyfriend is calling. He tells her, "I have to work late again tonight." Shown in the mirror, he is tearing open a condom packet with his teeth when he later arrives at her house. By imitating the traditional style of *Ukiyo-e*, "the floating world" of nineteenth-century Japanese painting and woodblock prints, [Teraoka] transforms the anxiety of contemporary life into a kind of visual Kabuki theater, full of drama, elegance, and pop irony.

—Joann Moser, 1991

If we assume that the city is a body, graffiti tells us where it hurts, and the thing is not to cut out the bad part, but to make the body healthy through dialogue and art.

Charles "Chaz" Bojórquez
born 1949

Placa/Rollcall, 1980, acrylic on canvas, 173.4 x 211 cm (68 1/4 x 83 1/8 in.). Gift of the artist

Chaz Bojórquez grew up in East Los Angeles. His work employs Chicano graffiti brushwork style in a very expressionistic manner. He remains faithful to his street graffiti roots but has cleaned up the often coarse calligraphic style of street "writing." *Placa/Rollcall* is a list of his friends, his gang, in an elegant script that appears to be abstract patterns until one learns to identify the letters.

—Andrew Connors, 1993

The Mexican American movement of the late 1960s was a cultural bomb with a slow fuse. With a cause, we artists and activists created an artistic visual record of who we were: Americans with a Mexican Heritage. Chicano was our new name. I painted a representation of that common cause, a "Rollcall" of allegiance, an endless list of human identity.

—Chaz Bojórquez, 1990

CONTEMPORARY *V*OICES

George LeGrady (born 1950), *Fire in the Ashes*, 1989, ink-jet print on paper, 58.4 x 73 cm (23 x 28 3/4 in.). Museum purchase

George LeGrady (born 1950), *Ashes in the Wind*, 1989, ink-jet print on paper, 58.4 x 73 cm (23 x 28 3/4 in.). Museum purchase

Golub saw the United States government—his own national government—even after its nightmarish experiences of subjugating Native Americans and African Americans, inscribing yet another racist genocide into its history. The still fresh memory of the Holocaust was agonizingly stirred. The analogy was made explicit in Golub's work when the "Burning Man" paintings, which had originated from photographs of Holocaust victims, modulated into the "Napalm" pictures.

—Thomas McEvilley, 1992

*We are left
with one final resolution
in our own predestined way,
we are going forward.
There is no going back.*
—Ana Castillo, 1988

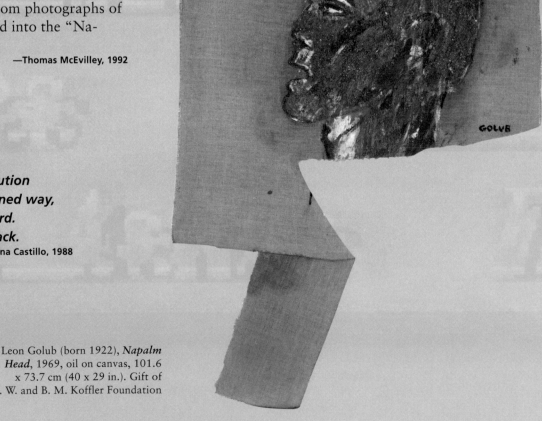

Leon Golub (born 1922), *Napalm Head*, 1969, oil on canvas, 101.6 x 73.7 cm (40 x 29 in.). Gift of S. W. and B. M. Koffler Foundation

The art of the Chicano movement serves as a shield to preserve and protect our cultural values from the mechanical shark of this society that has been chewing and spitting out our beautiful language, music, literature and art for over a hundred years. The artists use their own media in their own way to strengthen the unity of our people and they help educate us about ourselves since the educational system has failed to do so.
—Emanuel Martinez, 1969

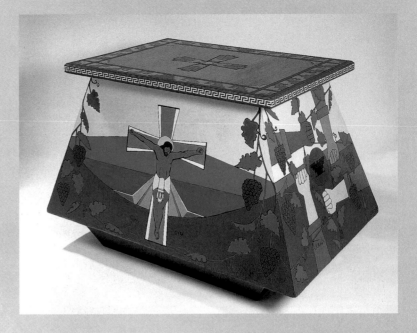

Emanuel Martinez (born 1947), *Farm Workers' Altar*, 1967, acrylic on mahogany and plywood, 96.9 x 138.5 x 91.4 cm (38 1/8 x 54 1/2 x 36 in.). Gift of the International Bank of Commerce in honor of Antonio R. Sanchez, Sr.

Voices of Protest

An analysis of the Los Angeles riots of 1992, *Top of the Line* ascribes some of the mob's behavior to its hunger for material equality.... The title alludes to this violent desperation to improve one's lot by upgrading one's possessions.
—Paul Arnett and William Arnett, 1993

Thornton Dial (born 1928), *Top of the Line*, 1992, enamel, rope, and metal on plywood, 151.8 x 202.5 x 13.7 cm (60 3/4 x 81 x 5 1/2 in.). Gift from the collection of Ron and June Shelp

I work with pictures and words because they have the ability to determine who we are, what we want to be, and what we become.

Barbara Kruger
born 1945

Typically large, [Kruger's] works incorporate photographs taken from different media sources that she has cropped, enlarged, and juxtaposed with strident verbal statements or phrases. Art historically, these works belong to the realm of montage, but they resist the smooth coherence associated with that genre. For there is no complacency to her art, which is assertive, aggressive, and argumentative.

—Kate Linker, 1990

We Will No Longer Be Seen and Not Heard, 1985, photo-offset lithograph and serigraph, 9 pieces, each 52 x 52 cm (20 1/2 x 20 1/2 in.). Museum purchase

Most of the time, I approach a composite in terms of discovering a piece

of information, an answer to a question.

Nancy Burson
born 1948

Burson has sidestepped into the venerable art photography club by a thoroughly up-to-date route: using computer technology to manipulate digitized images.
In the early 1980s, she and her husband, David Kramlick, concocted software that allowed Burson to isolate individual features from photographic portraits and mix them in a seamless way to create new faces, faces with a gloss of realism but an uncanny peculiarity about them....

Since the blends somehow always ended up as a recognizable human face, the odd progeny of digital interbreeding, the message seemed obvious: Political differences are less important than behavioral similarities.

—Owen Edwards, 1989

Presidents, 1988, Polaroid print, 62.8 x 49.5 cm (24 3/4 x 19 1/2 in.). Museum purchase through the Smithsonian Institution Special Exhibition Fund

I have to make these statements about how I feel about the political situation.

Frank Romero

born 1941

The Death of Rubén Salazar, 1985–86, oil on canvas, 180 x 300 cm (72 x 120 in.). Museum purchase made possible in part by the Luisita L. and Franz H. Denghausen Endowment

The Death of Rubén Salazar commemorates the death of a prominent journalist for the *Los Angeles Times* who had written with passion about the difficulties experienced by the Chicano community. On August 29, 1970, Salazar was one of three Chicanos killed in an altercation that ended a peaceful march protesting the Vietnam War and the high percentage of Chicano soldiers who had lost their lives in it. For Chicanos, Salazar's death symbolized personal sacrifice in the cause of social justice and emphasized the need for them to be better represented in government and social programs.

—Andrew Connors, 1992

I came to prominence as a member of a Chicano art collective called Los Four. Although I was not well known as an individual artist, I was able to exhibit widely as a member of that group. The work of Carlos Almaraz reflected the political issues of the farmworkers and other causes, and Gilbert Luján's work celebrated the Chicano life style. My work and that of "Beto" de la Rocha were more concerned with art issues. Ten years or more passed before I did my first political painting, The Closing of Whittier Boulevard, *in 1984. I have been dealing with barrio issues and, recently, with Central American issues ever since."*

—Frank Romero, 1990

To me the Blues is the litmus test by which to judge all other creative endeavors; it represents the purest form of human emotion and expression.

Frederick Brown

born 1945

I grew up in Chicago. South Chicago, right across from the steel mills where a lot of people had migrated from Mississippi, Tennessee and the south to work. And the blues just came right on up the Illinois Central Railroad from the city of New Orleans. Chicago became the real repository of a southern culture, especially among the Black community. And they brought their music with them. People would work in the mills on the swing shift, and I grew up hearing the music.

—Frederick Brown, 1991

Stagger Lee, 1983, oil on canvas, 228.6 x 355.6 cm (90 x 140 in.). Museum purchase

The story of Stagger Lee is well known in African-American folklore and is immortalized in a Blues song in which Stagger Lee murders a man accused of stealing his hat. Although the story has many versions, Stagger Lee always emerges as a folk hero who is both feared and admired. In Brown's interpretation, Stagger Lee...is accompanied by his personal entourage, including a pilgrim, Native American Squanto, and a steelworker.... In the background are images including a crucified Christ, several small empty crosses, television sets, airplanes, a group of skyscrapers, and a New York tavern. The result is a tapestry that weaves legend and fact and alludes to the complex and perhaps violent nature of American society.

—Regenia A. Perry, 1992

Sometimes the most poignant things can be said in a very humorous way, and there's almost a reaction time between when you laugh at something and when you suddenly realize it's really not funny.

Roger Shimomura
born 1939

Shimomura's "Diary Series" of paintings was inspired by the daily journal kept by his grandmother, Toku Shimomura, who immigrated to this country from Japan in 1912. The artist gives visual form to events that deeply affected the Japanese community in the United States during World War II.

Roger Shimomura, *Diary: December 12, 1941*, 1980, acrylic on canvas, 127.6 x 152.4 cm (50 1/4 x 60 in.). Gift of the artist

"I spent all day at home. Starting from today we were permitted to withdraw $100 from the bank. This was our sustenance of life, we who are enemy to them. I deeply felt America's largeheartedness in dealing with us."

Written five days after the Japanese bombing of Pearl Harbor, this entry is the subject of *Diary, December 12, 1941....* The painting depicts a woman seated in the confined space of a Japanese-style room; appearing as a shadow across the back wall is the figure of Superman, the great American symbol of protection. In conflating the Japanese *Ukiyoe* print of the eighteenth and nineteenth centuries with the modern American comic book, Shimomura creates a unique, hybrid style that encompasses the traditional sensibilities of his grandmother and his own ironic, and sensitive, response to them.

— Noriko Gamblin, 1992

I began to think seriously about all the people who came before me—the people who had a hand in shaping who I am and who I will become. The spirits of these people, whether living or long gone, are with me in everything I do.

Renée Stout
born 1958

Renée Stout uses the adventurer as a way of reclaiming history and identity. The wooden chair, Oriental rug, and curio cabinet that comprise her installation tableau *Colonel's Cabinet* (1991) evoke the den of a gentleman adventurer in the tradition of Theodore Roosevelt. The tableau in fact belongs to Stout's elaborately constructed alter ego, Colonel Frank, an African-American in search of his own history.... The objects in the cabinet represent aspects of this [African, Caribbean, and Native American] heritage, forming a collection of personal fetishes.... *Colonel's Cabinet* symbolizes Stout's attempt to construct an identity and sense of ancestry often lost among Americans of African descent.
—Pamela Lee, 1991

The Colonel's Cabinet, 1991–94, carpet, painting, chair, and cabinet, with found and hand-made objects, overall: 171.5 x 152.4 x 28.3 cm (67 1/2 x 60 x 50 1/2 in.). Museum purchase made possible by Ralph Cross Johnson

I took the pieces you threw away and put them together by night and day,

washed by rain, dried by day, a million pieces all in one.

Howard Finster
born 1916

I don't even consider bein' an artist, I don't consider bein' an artist at all. My art is visions from God. Like a fellow at this big university wanted to know how'd I'd do all this. I said, "Do you have a computer?" He said, "Yeah." I said, "Well, God computerizes my brain and it comes right out as God computerizes it." I do my art direct from God.

—Howard Finster, 1994

Finster began building his everchanging environmental sculpture, *Paradise Garden*, on swampy land behind his house in the early 1960s. Composed of walkways and constructions made from cast-off pieces of technology, the *Garden* assembles individual monuments to human inventors into an all-encompassing "Memorial to God." Much of the building material in the garden was accumulated from Finster's television and bicycle repair businesses and his twenty-one other trades.

Eager to deliver sermons, Finster hopes that objects in his *Paradise Garden* will inspire visitors to ask questions. This model of a super power plant, an assemblage of discarded parts from television sets, echoes the large constructions in the *Garden*.

—Lynda Roscoe Hartigan, 1990

THE MODEL OF SUPER POWER PLANT (FOLK ART MADE FROM OLD T.V. PARTS), 1979, painted plastic and metal electronic television parts, glitter, mirror, wood, and metal, 50 x 16.5 x 19 cm (20 x 6 5/8 x 7 5/8 in.). Gift of Herbert Waide Hemphill, Jr. and museum purchase made possible by Ralph Cross Johnson

When we can hang TV—within five years—we will not only compete with great painters—we may be better than them because we can mass produce…. A plastic card will hold one thousand paintings easily with today's technology.

Nam June Paik
born 1932

Since I make machine-based art, everybody thinks I am a machine freak. I don't drive a car. I'm a very clumsy guy, and although I like music, I can barely play an LP or a CD player. But since I have a very clumsy hand and a very anti-machine mentality, I struggle to create something that is related to the machine. I ended up creating something unforeseen; maybe that is the secret of my "success."
—Nam June Paik, 1994

Neat and substantial, [*Technology*] shows Paik's genius for treating us to unexpected and unanticipated relationships. Who else would use a quatrefoil window to frame a TV set? Neither assemblage nor a surrealist work, the combination constitutes a new invention, an autonomous entity that can be viewed as a kind of microcosmic, technicolor summary of our civilization in both its glory and its ambivalence. As Paik put it, "One must know technology very well in order to be able to overcome it." Few in the art world would dispute his understanding or the way in which he has turned it into an aesthetic triumph. *Technology* is our very own testimony to this triumph.
—Jacquelyn D. Serwer, 1994

Technology, 1991, 25 video monitors in steel and plywood cabinet with aluminum sheeting and details of copper, bronze, plastic, and other materials, approx. 3.6 x 1.4 x 1.3 m (11 x 5 x 4 ft.). Museum purchase

TEXT CREDITS

The original spelling and punctuation have been retained in all of the quotations used in this book. Unless otherwise noted, a quotation from the artist is given in an epigraph at the top of most of the pages and is the first citation for each of those pages in the following list.

EARLY AMERICA

Page 16. John Singleton Copley, ca. 1767, *Letters & Papers of John Singleton Copley and Henry Pelham*, Da Capo Press, 1970, pp. 65–66; John Singleton Copley, 1762, letter to Jean-Etienne Liotard, quoted in *John Singleton Copley*, vol. 1, National Gallery of Art, 1966, p. 37; Richard N. Murray, National Museum of American Art, 1993

Page 17. Johann Wolfgang von Goethe to Johann Christoph Friedrich von Schiller, August 30, 1797, quoted in Oswaldo Rodriguez Roque, "Trumbull's Portraits," in Helen A. Cooper, *John Trumbull: The Hand and Spirit of a Painter*, exh. cat., Yale University Art Gallery, 1982, p. 94; Karol Ann Lawson, National Museum of American Art, 1988; John Trumbull, quoted in John Durand, "John Trumbull: First Article," *American Art Review*, Sept. 1881, p. 182

Page 18. Edward Nygren, *Views and Visions: American Landscape before 1830*, exh. cat., Corcoran Gallery of Art, 1986, p. 25; ibid., pp. 233–34

Page 19. Thomas Sully, *Hints to Young Painters*, 1873, reprinted by Reinhold, 1965; William H. Truettner, National Museum of American Art, 1983

Page 20. John James Audubon, in Maria R. Audubon, ed.,

Audubon and His Journals, Dover Publications, 1960, p. 525; John James Audubon, "The Lost Portfolio," in J. J. Audubon, *Ornithological Biography*, Edinburgh, 1831–39, reprinted in *Audubon and His Journals*, vol. 2, p. 253; John James Audubon, "Myself," *Scribner's Magazine*, March 1833, reprinted in *Audubon and His Journals*, vol. 1, p. 38

Page 21. "A Letter from Alvan Fisher," ca. 1832, quoted in *Art in America*, July 1944, p. 126; Jeremy Adamson, "Nature's Grandest Scene in Art," *Niagara: Two Centuries of Changing Attitudes, 1697–1901*, exh. cat., Corcoran Gallery of Art, 1985, p. 36

Page 22. Julie Schimmel, "Inventing 'the Indian,'" in William Truettner, ed., *The West as America: Reinterpreting Images of the Frontier*, exh. cat., National Museum of American Art/Smithsonian Institution Press, 1991, p. 151; Joni Louise Kinsey, "Artists' Biographies," in *The West as America*, p. 350

Page 23. Charles Baudelaire, *The Salon of 1846*, 1846, reprinted in *The Mirror of Art: Critical Studies by Charles Baudelaire*, Doubleday Anchor Books, 1956, p. 73

Page 24. Jonathan Elliot, *Historical Sketches of the Ten Miles Square Forming the District of Columbia*, 1830, pp. 165–66, quoted in Andrew F. Cosentino, *The Paintings of Charles Bird King*, exh. cat., National Collection of Fine Arts/Smithsonian Institution Press, 1977, p. 60; John C. Ewers, "Charles Bird King, Painter of Indian Visitors to the Nation's Capital," *Smithsonian Report for 1953*, p. 464; Sharitarish, Pawnee leader, speech delivered at the White

House, Feb. 4, 1822, quoted in Herman J. Viola, "Invitation to Washington—A Bid for Peace," *The American West*, Jan. 1972, p. 25

Page 25. Thomas Cole, 1835, quoted in Marshall Tymn, ed., *Thomas Cole: The Collected Essays and Prose Sketches*, John Colet Press, 1980, p. 131; William Cullen Bryant, *A Funeral Oration, Occasioned by the Death of Thomas Cole, Delivered Before the National Academy of Design, New-York, May 4, 1848*, quoted in Ellwood C. Parry III, *The Art of Thomas Cole: Ambition and Imagination*, University of Delaware Press/Associated University Presses, 1988, pp. 362–63; Alan Wallach, "Thomas Cole: Landscape and the Course of American Empire," *Thomas Cole: Landscape into History*, exh. cat., National Museum of American Art/Yale University Press, 1994 , p. 51

Page 26. Virgil Barker, *Abbott H. Thayer Memorial Exhibition*, exh. cat., Corcoran Gallery of Art, 1922, p. viii, quoted in Richard Murray, *American Art from the Gilded Age: Paintings and Photographs*, 100th Birthday Celebration, The Admiralty House, 1883–1993, Art at the Vice President's House, Washington, D.C., 1993, n.p.; Nicolai Cikovsky, Jr., "Democratic Illusions," *Raphaelle Peale Still Lifes*, exh. cat., National Gallery of Art, 1988, pp. 48–50

Page 27. William H. Gerdts, *Painters of the Humble Truth: Masterpieces of American Still Life 1801–1939*, Philbrook Art Center/University of Missouri Press, 1981, p. 87

Page 28. William H. Truettner, "Ideology and Image: Justifying Westward Expansion," in

Truettner, ed., *The West as America: Reinterpreting Images of the Frontier, 1820–1920*, exh. cat., National Museum of American Art/Smithsonian Institution Press, 1991, p. 30; William H. Truettner, National Museum of American Art, 1983

Page 29. Brian W. Dippie, "The Moving Finger Writes: Western Art and the Dynamics of Change," in *Discovered Lands: Invented Pasts*, exh. cat., Thomas Gilcrease Institute of American History and Art/Yale University Art Gallery, 1992, p. 89

Page 30. Tecumseh, *Weekly Register*, Nov. 6, 1813, quoted in *Dictionary of American Biography*, vol. 9, p. 360; Julie Schimmel, "Inventing the 'Indian,'" in William H. Truettner, ed., *The West as America*, exh. cat., National Museum of American Art/ Smithsonian Institution Press, 1991, pp. 169–70; Benjamin Drake, *Life of Tecumseh and of His Brother The Prophet*, E. Morgan & Co., 1841

Page 31. Joshua Taylor, introd. to *Emanuel Leutze, 1816–1868: Freedom Is the Only King*, exh. cat., National Collection of Fine Arts, 1975, p. 11; Nathaniel Hawthorne, "Chiefly About War Matters," *Atlantic Monthly*, July 1862, p. 46

Page 32. Asher B. Durand, "Letters on Landscape Painting," *The Crayon*, 1855, reprinted in John Durand, *Life and Times of A. B. Durand*, Charles Scribner's Sons, 1894, p. 212; Asher B. Durand, *The Crayon*, Jan. 17, 1855, quoted in Frederick A. Sweet, "Asher B. Durand, Pioneer American Landscape Painter," *Art Quarterly*, Spring 1945, p. 146; William H. Truettner, National Museum of American Art, 1980

Page 33. Robert Scott Duncanson, 1845, quoted in Joseph D. Ketner, *The Emergence of the African-American Artist: Robert S. Duncanson 1821–1872*, University of Missouri Press, 1993, p. 73; Nicholas Longworth, letter to Hiram Powers, 1852, quoted in Romare Bearden and Harry Henderson, *A History of African-American Artists*, Pantheon, 1993, p. 27; Lynda Roscoe Hartigan, "Robert Scott Duncanson," *Sharing Traditions: Five Black Artists in Nineteenth-Century America*, exh. cat., National Museum of American Art/Smithsonian Institution Press, 1985, pp. 51–52

Page 34. Unidentified author, "American Art in Water Colors. The Twelfth Annual Exhibition of the Water Color Society in the National Academy," *New York Evening Post*, March 1, 1879, quoted in Richard J. Powell, "Introduction: Winslow Homer, Afro-Americans, and the New Order of Things," in Peter H. Wood and Karen C. C. Dalton, *Winslow Homer's Images of Blacks: The Civil War and Reconstruction Years*, Menil Collection, exh. cat., University of Texas Press, 1989, p. 9; Henry James, "On Some Pictures Lately Exhibited," *Galaxy*, July 1875, quoted in Ian Crofton, *A Dictionary of Art Quotations*, Schirmer Books, 1988, p. 86; Peter H. Wood and Karen C. C. Dalton, *Winslow Homer's Images of Blacks*, pp. 94–95

Page 35. Jean Jepson Page, letter to Lois Marie Fink, National Museum of American Art, 1980; Jean Jepson Page, "Francis Blackwell Mayer," *Antiques Magazine*, Feb. 1976, pp. 317, 319–21

Page 36. Frederic Edwin Church, May 20, 1844, letter to Thomas Cole, Thomas Cole Papers, New York State Library, Albany, quoted in Elaine Evans Dee, *Frederic E. Church: Under Changing Skies*, exh. cat., Arthur Ross Gallery, University of Pennsylvania, 1992, p. 10; unidentified author, *Leader* (New York), March 21, 1863, quoted in Gerald L. Carr, *Frederic Edwin Church: The Icebergs*, Dallas Museum of Fine Arts, 1980, p. 22; Isaac L. Hayes, *The Open Polar Sea*, 1867, quoted in William H.

Truettner, "The Genesis of Frederic Edwin Church's *Aurora Borealis*," *Art Quarterly*, Autumn 1968, pp. 273–74

Page 37. Albert Bierstadt, letter from the Rocky Mountains published in *The Crayon*, Sept. 1859, quoted in Nancy K. Anderson and Linda S. Ferber, *Albert Bierstadt: Art & Enterprise*, exh. cat., Brooklyn Museum, 1990, p. 157; William H. Truettner, National Museum of American Art, 1980

Page 38. Thomas Moran, quoted in William Kloss, *Treasures from the National Museum of American Art*, Smithsonian Institution Press, 1985, p. 202

Page 39. Howard Russell Butler, "Thomas Moran Memorial Exhibition," Clinton Academy, East Hampton, N.Y., 1928, n.p.; William H. Truettner, National Museum of American Art, 1980

Page 40. Comment of an unidentified contemporary, quoted in William Kloss, *Treasures from the National Museum of American Art*, Smithsonian Institution Press, 1985, p. 24; Kloss, ibid., p. 23

Page 41. J. J. Jarves, "Art in America, Its Condition and Prospects: I," *Fine Arts Quarterly Review I*, 1863, quoted in John K. Howat, *American Paradise: The World of the Hudson River School*, exh. cat., Metropolitan Museum of Art, 1987, p. 304; untitled poem by unidentified nineteenth-century poet, *Knickerbocker Magazine*, quoted in Howat, *The Hudson River and Its Painters*, Viking Press, 1972, p. 161; Paletta, "Art Matters," *American Art Journal*, Jan. 5, 1867, quoted in Howat, *American Paradise*, p. 304

Page 42. Maud Appleton McDowell, in *The Heavenly Guest, with other unpublished writings*, 1935, p. 126, quoted in David Park Curry, *Childe Hassam: An Island Garden Revisited*, exh. cat., Denver Art Museum/W. W. Norton, 1990, pp. 71, 198

Page 43. Winslow Homer, quoted in George W. Sheldon, *Hours with Art and Artists*, 1882, reprinted by Garland Publishing, 1978, p. 38

TRADITION

Page 46. Benjamin West, quoted in William Dunlap, *A History of the Rise and Progress of the Arts of Design in the United States*, 1834, reprinted by Dover Publications, 1969, p. 92; William Kloss, *Treasures from the National Museum of American Art*, Smithsonian Institution Press, 1985, p. 22; Joel Barlow, excerpt from his epic poem *The Columbiad*, 1807, quoted in Ann Uhry Abrams, *The Valiant Hero: Benjamin West and Grand-Style History Painting*, Smithsonian Institution Press, 1985, p. 7

Page 47. Washington Allston, "Sentences written by Mr. Allston on the walls of his studio," quoted in Washington Allston, *Lectures on Art and Poems* and *Monaldi*, Scholars' Facsimiles & Reprints, Gainesville, Florida, 1967, p. 167; William Shakespeare, *A Midsummer Night's Dream*, Act 3, Scene 2, in Stanley Wells and Gary Taylor, eds., *William Shakespeare: The Complete Works*, Clarendon Press, 1986, p. 365

Page 48. George Inness, "Mr. Inness on Art Matters," *Art Journal*, 1879, quoted in Nicolai Cikovsky, Jr., *George Inness*, Praeger, 1971, p. 18; Cikovsky, ibid., pp. 17–18

Page 49. Elliott Daingerfield, "Nature Versus Art," 1911, quoted in *Elliott Daingerfield: Memorial Exhibition*, exh. cat., Grand Central Art Galleries, New York, 1934; Lucile Howard, "An Appreciation," in *Elliott Daingerfield: Memorial Exhibition*, n.p.

Page 50. Albert Pinkham Ryder, "Paragraphs from the Studio of a Recluse," *Broadway Magazine*, Sept. 1905, quoted in Elizabeth Broun, *Albert Pinkham Ryder*, exh. cat., National Museum of American Art, 1989, pp. 10–11

Page 51. Charles Caffin, "International Still Stirs the Public [Review of 1913 Armory Show]," *New York American*, March 1913, p. 8; Elizabeth Broun, *Albert Pinkham Ryder*, exh. cat., National Museum of American Art, 1989, pp. 4–5

Page 52. Edward Mitchell Bannister, letter to George Whitaker, 1895, reprinted in George Whitaker, "Reminiscences of Providence Artists," *Providence Magazine, The Board of Trade Journal*, Feb. 1914, and quoted in Lynda Roscoe Hartigan, *Sharing Traditions: Five Black Artists in Nineteenth-Century America*, exh. cat., National Museum of American Art/Smithsonian Institution Press, 1985, p. 79; Hartigan, ibid., p. 74

Page 53. Elliott Daingerfield, "Ralph Albert Blakelock," *Art in America*, Dec. 1913, p. 60; Frederick W. Morton, "Work of Ralph A. Blakelock," *Brush and Pencil*, Chicago, Feb. 1902, quoted in Lloyd Goodrich, *Ralph Albert Blakelock: Centenary Exhibition*, exh. cat., Whitney Museum of American Art, 1947, p. 264; Harriet Monroe, "Ralph Albert Blakelock," *Chicago Tribune*, Nov. 2, 1913

Page 54. William H. Gerdts, *American Neo-Classic Sculpture: The Marble Resurrection*, Viking Press, 1973, p. 21

Page 55. William Wetmore Story, letter to Charles Eliot Norton, Aug. 15, 1861, reprinted in Henry James, *William Wetmore Story and His Friends*, Houghton Mifflin, 1903, pp. 70–71

Page 56. Hiram Powers, letter to Elizabeth Barrett Browning, 1853, Archives of American Art; Martha Gyllenhaal, "Hiram Powers, 1805–1873," in *New Light: Ten Artists Inspired by Emanuel Swedenborg*, exh. cat., Glencairn Museum, Bryn Athyn, Pa., 1988, p. 11; Bayard Taylor, 1845, first stanza of poem composed after viewing *Eve Tempted* at Hiram Powers's studio, published in Taylor, *Rhymes of Travel, Ballads and Poems*, 1849, quoted in Richard P. Wunder, *Hiram Powers, Vermont Sculptor, 1805–1873*, University of Delaware Press, 1991, p. 191

Page 57. Walt Whitman, quoted in Lloyd Goodrich, *Thomas Eakins*, exh. cat., Whitney Museum of American Art, 1970, p. 29; William H. Truettner, National Museum of American Art, 1986; Thomas Eakins, 1914, quoted in Lloyd Goodrich, *Thomas Eakins*, p. 32

Page 58. Karol Ann Lawson, National Museum of American Art, 1990

Page 59. Lois Marie Fink, "Children as Innocence from Cole to Cassatt," *Nineteenth Century*, Winter 1977, p. 71

Page 60. Henry James, *Italian Hours*, Houghton Mifflin, 1909, quoted in William L. Vance, "Seeing Italy: The Realistic Rediscovery by Twain, Howells, and James," in Theodore E. Stebbins, Jr., *The Lure of Italy: American Artists and the Italian Experience 1760–1914*, exh. cat., Museum of Fine Arts, Boston/Harry N. Abrams, 1992, p. 110; Henry T. Tuckerman, *Book of the Artists: American Artist Life*, F. P. Putnam & Son, 1867, p. 152

Page 62. Edmonia Lewis, "Edmonia Lewis," *The Revolution*, Apr. 20, 1871, quoted in Eleanor M. Tufts, "Edmonia Lewis, Afro-Indian Neo-Classicist," *Art in America*, July/Aug. 1974, p. 72; Lynda Roscoe Hartigan, *Sharing Traditions: Five Black Artists in Nineteenth Century America*, exh. cat., National Museum of American Art/Smithsonian Institution Press, 1985, p. 85; Regenia A. Perry, *Free Within Ourselves: African-American Artists in the Collection of the National Museum of American Art*, exh. cat., National Museum of American Art/Pomegranate Artbooks, 1992, pp. 135–36

Page 63. Old Testament, Book of Exodus 12: 29–30; Elizabeth Broun, National Museum of American Art, 1994

Page 64. Louis Comfort Tiffany, "Color and Its Kinship to Sound," *The Art World*, May 1917, pp. 142–43 (lecture presented by Louis Comfort Tiffany to Rembrandt Club of Brooklyn); Elizabeth Broun, National Museum of American Art, 1989; Louis Comfort Tiffany, quoted in Gary Reynolds, "Louis Comfort Tiffany: Also a Painter," *American Art & Antiques*, Mar./Apr. 1979, pp. 40–41

Page 65. Frederick Arthur Bridgman, *Winters in Algeria*, New York, 1890, quoted in Ilene Susan Fort, *Frederick Arthur Bridgman and the American Fascination with the Exotic Near East*, Ph. D. diss., City University of New York, 1990, p. 307; Richard N. Murray,

National Museum of American Art, 1993

Page 66. Henry La Farge, "Painting with Colored Light: The Stained Glass of John La Farge," in *John La Farge*, exh. cat., Carnegie Museum of Art/National Museum of American Art, 1987, p. 203

Page 67. Russell Lynes, *The Tastemakers*, Harper & Bros., 1954, p. 197

Page 68. Eastman Johnson, letter to Charlotte Child, March 1851, reprinted in John I. H. Baur, *Eastman Johnson: An American Genre Painter 1824–1906*, exh. cat., Brooklyn Museum, 1940, p. 11; Andrew Connors, National Museum of American Art, 1992; John Fowles, *The French Lieutenant's Woman*, Little, Brown and Company, 1969, pp. 11, 16, 147, 148

Page 69. Winslow Homer, quoted in Nicolai Cikovsky, Jr., *Winslow Homer*, National Museum of American Art/Harry N. Abrams, 1990, p. 93; Nicolai Cikovsky, Jr., ibid., p. 117; George Chaplin Child, M.D., *The Great Architect: Benedicite; Illustrations of the Power, Wisdom, and Goodness of God, as Manifested in His Works*, 2 vols., G. P. Putnam, 1871, quoted in Patricia Junker, "Expressions of Art and Life in *The Artist's Studio in an Afternoon Fog*," *Winslow Homer in the 1890s: Prout's Neck Observed*, Hudson Hills Press/Memorial Art Gallery of the University of Rochester, 1990, p. 62

Page 70. Thomas Wilmer Dewing, letter to Charles Lang Freer, Feb. 16, 1901, Archives of American Art, Freer Papers; Susan Hobbs, "Thomas Wilmer Dewing: The Early Years, 1851–1885," *American Art Journal*, Spring 1981, p. 5; Royal Cortissoz, "Thomas Wilmer Dewing," *The Player's Bulletin*, March 1, 1939, n.p.

Page 71. Maria Oakey Dewing, "Flower Painters and What the Flower Offers Art," *Art and Progress*, June 1915, p. 262; Royal Cortissoz, memorial tribute, *New York Herald Tribune*, Dec. 18, 1927, quoted in Jennifer A. Martin, "The Rediscovery of Maria Oakey Dewing," *Feminist Art Journal*, Summer 1976, p. 27; Maria Oakey Dewing, excerpt from "Summer," *Century Magazine*,

June 1883, reprinted in Susan Hobbs, "Thomas Wilmer Dewing: The Early Years," *American Art Journal*, Spring 1981, p. 31

Page 72. David Park Curry, *Childe Hassam: An Island Garden Revisited*, exh. cat., Denver Art Museum/W. W. Norton, 1990, p. 13; Ernest Haskell, introd. to *Childe Hassam* (Distinguished American Artists series), compiled by Nathaniel Pousette-Dart, Frederick A. Stokes, 1922, pp. viii–ix

Page 73. Elizabeth Broun, National Museum of American Art, 1994

Page 74. Duncan Phillips, "Twachtman: An Appreciation," *International Studio*, vol. 72, Feb. 1919; Deborah Chotner, "Twachtman and the American Winter Landscape," in *John Twachtman: Connecticut Landscapes*, exh. cat., National Gallery of Art, 1989, p. 74; John Henry Twachtman, letter to J. Alden Weir, Dec. 16, 1891, quoted in Richard J. Boyle, *John Twachtman*, Watson-Guptill, 1979

Page 75. James A. M. Whistler, 1888, "Ten O'Clock Lecture" reprinted in Whistler, *The Gentle Art of Making Enemies*, William Heinemann, 1907, p. 143; James A. M. Whistler, quoted in E. R. and J. Pennell, *The Life of James McNeill Whistler*, J. B. Lippincott, 1909, pp. 134–35

20TH CENTURY LIFE

Page 78. Maurice Prendergast, quoted in Hedley Howell Rhys, *Maurice Prendergast 1859–1924*, Harvard University Press, 1960, p. 19; William Milliken, "Maurice Prendergast, American Artist," *The Arts*, Apr. 1926, p. 186; Maurice Prendergast, letter to Charles Prendergast, ca. May 31, 1907, quoted in Nancy Mowll Mathews, *Maurice Prendergast*, exh. cat., Williams College Museum of Art, Prestel-Verlag, 1990, p. 23

Page 79. Robert Henri, *The Art Spirit*, J. B. Lippincott, 1923, p. 221; Robert Henri, "My People," *The Craftsman*, Feb. 1915, p. 459

Page 80. Rockwell Kent, quoted in David Traxel, *An American Saga: The Life and Times of Rockwell Kent*, Harper & Row,

1980, p. 157; Fridolf Johnson, in *"An Enkindled Eye": The Paintings of Rockwell Kent*, exh. cat., Santa Barbara Museum of Art, 1985, p. 11; Rockwell Kent, *Salamina*, Harcourt, Brace, 1935, n.p.

Page 81. Ernest Martin Hennings, quoted in Robert Rankin White, "The Life of E. Martin Hennings, 1886-1956," *The Lithographs and Etchings of E. Martin Hennings*, Museum of New Mexico Press, 1978; Ernest Martin Hennings, ibid.

Page 82. Charles C. Eldredge and William H. Truettner, wall text for exhibition "Art in New Mexico, 1900–1945: Paths to Taos and Santa Fe," National Museum of American Art, 1986

Page 83. Victor Higgins, 1917, quoted in Laura M. Bickerstaff, *Pioneer Artists of Taos*, Old West Pub. Co., 1983, p. 181; D. H. Lawrence, "New Mexico," *Survey Graphic*, May 1, 1931, quoted in Keith Sagar, ed., *D. H. Lawrence and New Mexico*, Gibbs M. Smith, 1982, p. 96

Page 84. William A. Coffin, 1892, quoted in Peter H. Hassrick, *Frederic Remington*, exh. cat., Amon Carter Museum, 1973, p. 3; Alex Nemerov, "Frederic Remington: Within and Without the Past," *Smithsonian Studies in American Art*, Spring 1991, p. 58; Frederic Remington, *Collier's Weekly*, Mar. 18, 1905

Page 85. Walter Ufer, quoted in J. Gray Sweeney, *Masterpieces of Western American Art*, M & M Books, 1991, p. 222; William H. Truettner, National Museum of American Art, 1984

Page 86. Joshua C. Taylor, "The Image of Urban Optimism," *America as Art*, Harper & Row, 1976, pp. 189–90; Louis Lozowick, in *Machine Age Exposition*, exh. cat., 1927, quoted in Janet Flint, *The Prints of Louis Lozowick*, Hudson Hills Press, 1982, pp. 18–19

Page 87. Everett Shinn, 1911, quoted in Sylvia L. Yount, "Consuming Drama: Everett Shinn and the Spectacular City," *American Art*, Fall 1992, p. 98

Page 88. Ralston Crawford, statement from untitled manuscript, May 7, 1964,

quoted in William C. Agee, *Ralston Crawford*, Twelve Trees Press, 1983 (fig. 65); Ford Madox Ford, 1937, introd. to catalogue of Crawford's first one-man exhibition, Boyer Gallery, Philadelphia, 1937, reprinted in Richard B. Freeman, *Ralston Crawford*, University of Alabama Press, 1953, p. 42; Ralston Crawford, "Comment on Modern Art by the Artist," *Paradise of the Pacific*, Aug. 1947, pp. 17–19, 32, quoted in William C. Agee, *Ralston Crawford*, Twelve Trees Press, 1983 (fig. 22)

Page 89. William Zorach, "The New Tendencies in Art," *The Arts*, Oct. 1921, p. 12; John I. H. Baur, *William Zorach*, exh. cat., Whitney Museum of American Art, 1959, n.p.; William Zorach, *Art Is My Life*, World Pub. Co., 1967, pp. 33, 188

Page 90. Theodore Roszak, artist's statement, in Dorothy Miller, ed., *Fourteen Americans*, exh. cat., Museum of Modern Art, 1946, p. 58; Elizabeth Broun, National Museum of American Art, 1989; H. H. Arnason, *Theodore Roszak*, exh. cat., Walker Art Center, 1956, p. 25

Page 91. Yasuo Kuniyoshi, n.d.; Lloyd Goodrich, *Yasuo Kuniyoshi*, exh. cat., Whitney Museum of American Art, 1948, p. 17; Yasuo Kuniyoshi, quoted in Donald B. Goodall, introd. to *Yasuo Kuniyoshi*, exh. cat., University Art Museum, University of Texas at Austin, 1975

Page 92. Archibald MacLeish, "Unemployed Artists: WPA's Four Art Projects," *Fortune Magazine*, May 1937, quoted in Harriet W. Fowler, *New Deal Art*, University of Kentucky Art Museum, 1985, p. 11; O. Louis Guglielmi, 1936, quoted in "After the Locusts," *Art for the Millions*, Francis V. O'Connor, ed., New York Graphic Society, 1973, p. 115

Page 94. Berenice Abbott, "It Has to Walk Alone," *Infinity*, 1951, quoted in Alice C. Steinbach, "Berenice Abbott's Point of View," *Art in America*, Nov./Dec. 1976, p. 77; Berenice Abbott, 1935, proposal to Works Progress Administration Federal Art Project, in Brooks Johnson, *Photography Speaks*, Aperture/Chrysler Museum, 1989, p. 66

Page 95. Jacob Lawrence, 1970, speech to National Association for the Advancement of Colored People, quoted in Ellen Harkins Wheat, *Jacob Lawrence, American Painter*, exh. cat., Seattle Art Museum, 1986, p. 142; Jacob Lawrence, speech to a gathering of artists and art students, ca. 1953, quoted in Ellen Harkins Wheat, *Jacob Lawrence*, p. 106; Patricia Hills, "Jacob Lawrence's Expressive Cubism," in Ellen Harkins Wheat, *Jacob Lawrence*, p. 15

Page 96. Unidentified author, *Human Interest Facts on the Artists Receiving Harmon Awards*, ca. Dec. 1929, Harmon Foundation Papers, Library of Congress, quoted in Richard J. Powell, *Homecoming: The Art and Life of William H. Johnson*, exh. cat., National Museum of American Art/Rizzoli, 1991, pp. 41-42; William H. Johnson, 1946, quoted in Powell, *Homecoming*, p. 213

Page 97. Richard J. Powell, wall text for exhibition "Homecoming: William H. Johnson and Afro-America, 1938–1946," National Museum of American Art, 1991

Page 98. Thomas Hart Benton, *An Artist in America*, University of Missouri Press, 4th rev. ed., 1983, p. 369; Elizabeth Broun, National Museum of American Art Newsletter, May 1985

Page 99. Elizabeth Broun, "Thomas Hart Benton: A Politician in Art," *Smithsonian Studies in American Art*, Spring 1987, p. 61

Page 100. Paul Cadmus, "Credo," 1937, quoted in Lincoln Kirstein, *Paul Cadmus*, Chameleon Books, 1992, p. 142; Paul Cadmus, quoted in Philip Eliasoph, *Paul Cadmus— Yesterday and Today*, exh. cat., Miami University Art Museum, 1981, p. 77; Guy Davenport, *The Drawings of Paul Cadmus*, Rizzoli, 1989, p. 7

Page 101. Reginald Marsh, "Let's Get Back to Painting," *Magazine of Art*, 1944, p. 294; Reginald Marsh, quoted in W. G. Rogers, "A Good Artist Must Have Fun with Art, Says Reginald Marsh," Associated Press

Page 102. Jeffrey Wechsler, *Surrealism and American Art, 1931–1947*, exh. cat., Rutgers University Art Gallery, 1976, pp. 62–63; Clarence John Laughlin,

statement in *Clarence John Laughlin: The Personal Eye*, Aperture, 1973, p. 14

Page 104. Lynda Roscoe Hartigan, "Joseph Cornell: A Biography," *Joseph Cornell*, exh. cat., Museum of Modern Art, 1980, p. 91; Howard Hussey, excerpt from an unpublished memoir, "Joseph Cornell," in *Joseph Cornell Portfolio*, exh. cat., published by Leo Castelli Gallery, Richard L. Feigen and Company, New York, and James Corcoran Gallery, Los Angeles, 1976, n.p.

Page 105. Joseph Cornell, Diary, March 9, 1959, quoted in Mary Ann Caws. ed., *Joseph Cornell's Theater of the Mind: Selected Diaries, Letters, and Files*, Thames and Hudson, 1993, p. 163

Page 106. Sandra S. Phillips, "Helen Levitt's New York," in *Helen Levitt*, exh. cat., San Francisco Museum of Modern Art, 1991, p. 39; James Agee, *A Way of Seeing*, Viking Press, 1965, p. 74; Robert Coles, "Children of Poverty Making Do with Ease and Zest," *New York Times*, Apr. 26, 1992

Page 107. Roy DeCarava, quoted in Sherry Turner DeCarava, "Celebration," *Roy DeCarava, Photographs*, ed. James Alinder, Friends of Photography, Inc., 1981, p. 19; artist's biography, by John Bloom and Diana C. Du Pont, in Van Deren Coke with Diana C. Du Pont, *Photography: A Facet of Modernism*, exh. cat., San Francisco Museum of Modern Art, 1986, p. 171; Alvia Wardlaw Short, *Roy DeCarava: Photographs*, exh. cat., Museum of Fine Arts, Houston, 1975, p. 7

Page 108. Allan Rohan Crite, "The Artist Craftsman's Work on the Church," *Commentary on the 1950s*, quoted in Regenia A. Perry, "Allan Rohan Crite," *Free Within Ourselves*, exh. cat., National Museum of American Art/Pomegranate Artbooks, 1992, p. 51; Alvia J. Wardlaw, "Reclamations," *Black Art: Ancestral Legacy, The African Impulse in African-American Art*, exh. cat., Dallas Museum of Art, 1989, p. 191

Page 109. Elizabeth Catlett, 1984, quoted in *Elizabeth Catlett*, exh. cat., Spelman College, Atlanta, 1985, n.p.

Page 110. Edward Hopper, quoted in Alfred H. Barr, Jr., *Edward Hopper: Retrospective Exhibition*, Museum of Modern Art, 1933, p. 17; Brian O'Doherty, "Portrait: Edward Hopper," *Art in America*, Dec. 1964, p. 77

Page 111. John Biggers, quoted in Mae Tate, "John Biggers: The Man and His Art," *International Review of African American Art*, vol. 7, no. 3, 1987, p. 55; Regenia A. Perry, *Free Within Ourselves*, exh. cat., National Museum of American Art, 1992, p. 39

Page 112. Frank Cohen Kirk, from catalogue of *Memorial Exhibition of Paintings*, National Arts Club, New York City, 1964, quoted in Lois Marie Fink and Joshua C. Taylor, *The Academic Tradition in American Art*, exh. cat., National Collection of Fine Arts, 1975, p. 258

Page 113. Abigail Booth Gerdts, preface, *The Working American*, exh. cat., District 1199, National Union of Hospital and Health Care Employees and Smithsonian Institution Traveling Exhibition Service, 1979, p. ix; Philip Evergood, 1944, quoted in David Shapiro, ed., *Social Realism: Art as a Weapon*, Frederick Ungar, 1973, p. 210

Page 114. Paul Strand, review of *Weegee's Naked City*, reprinted in *Photo Notes, February 1938– Spring 1950*, Visual Studies Workshop, Rochester, N.Y., 1977, p. 2

Page 115. *The WPA Guide to New York City*, Random House, 1939, quoted in Sandra S. Phillips, "Helen Levitt's New York," Sandra S. Phillips and Maria Morris Hambourg, *Helen Levitt*, exh. cat., San Francisco Museum of Modern Art, 1991, p. 23; Louis Stettner, 1988, artist's statement in Colin Naylor, ed., *Contemporary Photographers*, St. James Press, 2nd. ed., 1988, p. 990

Page 116. Robert Cottingham, interview with Linda Chase and Ted McBurnett, in "The Photo-Realists: 12 Interviews," *Art in America*, Nov.–Dec. 1972, p. 78; Jane Cottingham, "Techniques of Three Realist Painters," *American Artist*, Feb. 1980, p. 62; Robert Cottingham, quoted in Cottingham, "Techniques," p. 62

Page 117. Robert Indiana, quoted in Martin Dibner, introd. to *Indiana's Indianas: A 20-Year Retrospective of Paintings and Sculpture from the Collection of Robert Indiana*, exh. cat., William A. Farnsworth Library and Art Museum, Rockland, Maine, 1982, p. 7; Robert Indiana, quoted in Dibner, *Indiana's Indianas*, p. 6

Page 118. Russell Bowman, "Chicago Imagism: The Movement and the Style," *Who Chicago?*, exh. cat., Ceolfrith Gallery, Sunderland Arts Centre (England), 1980, p. 25; Roger Brown, quoted in Russell Bowman, "An Interview with Roger Brown," *Art in America*, Jan./Feb. 1978, pp. 109–10

Page 119. Franz Schulze, *Fantastic Images: Chicago Art since 1945*, Follett, 1972, pp. 38–39

Page 120. Tom Wesselmann, quoted in Paul Gardner, "Tom Wesselmann," *ARTnews*, Jan. 1982, p. 67; Tom Wesselmann, quoted in Marco Livingstone, ed., *Pop Art*, Montreal Museum of Fine Arts, 1992, p. 62

Page 121. George Segal, quoted in "The Silent People," *Newsweek*, Oct. 25, 1965, p.107; Allan Kaprow, quoted in Don Hawthorne and Sam Hunter, *George Segal*, Rizzoli, 1984, p. 51; George Segal, Christopher B. Crossman, and Nancy E. Miller, "A Conversation with George Segal," *Gallery Studies 1*, Buffalo Fine Arts Academy, 1977, p. 11

PEOPLE

Page 124. Charles Willson Peale, letter to Thomas Jefferson, July 3, 1820, quoted in Lillian B. Miller, "Charles Willson Peale: A Life of Harmony and Purpose," in Edgar P. Richardson et al., *Charles Willson Peale and His World*, Harry N. Abrams, 1982, p. 188; Charles Willson Peale, letter to John Beale Bordley, 1772, *The Selected Papers of Charles Willson Peale and His Family*, vol. 1, ed. Lillian B. Miller, Yale University Press, 1983; announcement in *Pennsylvania Packet*, July 21, 1788, reprinted in Charles Coleman Sellers, *Charles Willson Peale*, Scribner's, 1969, p. 230

Page 125. Gilbert Stuart, quoted in *Gilbert Stuart: Portrait of the Young Republic, 1755–1828*, exh. cat., National Gallery of Art, 1967, p. 9; Josiah Quincy, quoted in Richard McLanathan, *Gilbert Stuart*, National Museum of American Art/Harry N. Abrams, 1986, p. 148; John Adams, quoted in McLanathan, *Gilbert Stuart*, p. 147

Page 126. J. Gray Sweeney, *Masterpieces of Western American Art*, M & M Books, 1991, p. 213; "Elkfoot of the Taos Tribe," Virginia Couse Leavitt, *Eanger Irving Couse, Image Maker for America*, exh. cat., Albuquerque Museum, 1991, pp. 132–33

Page 127. Karol Ann Lawson, National Museum of American Art, 1989; ibid.

Page 128. Robin Bolton-Smith, *Tokens of Affection*, exh. brochure, Metropolitan Museum of Art/National Museum of American Art, 1991, pp. 1, 2 ; Edgar P. Richardson, "Charles Willson Peale and His World," in Richardson et al., *Charles Willson Peale and His World*, Harry N. Abrams, 1982, p. 30

Page 130. John Singer Sargent, undated letter, quoted in Charles Merrill Mount, *John Singer Sargent: A Biography*, W. W. Norton, 1955, p. 270; unidentified writer, 1902, quoted in Evan Charteris, *John Sargent*, Scribner's, 1927, pp. 157–58

Page 131. Lilly Martin Spencer, letter to her mother, Aug. 11, 1852, quoted in Robin Bolton-Smith and William H. Truettner, *Lilly Martin Spencer: 1822–1902 The Joys of Sentiment*, exh. cat., National Collection of Fine Arts, 1973, p. 48; William Kloss, *Treasures from the National Museum of American Art*, exh. cat., National Museum of American Art/Smithsonian Institution Press, 1985, p. 58

Page 132. William Robinson Leigh, "My America," *Arizona Highways*, Feb. 1948, quoted in June DuBois, *William Robinson Leigh*, Lowell Press, 1977, p. 46; William H. Truettner, National Museum of American Art, 1983

Page 133. Cecilia Beaux, 1907, quoted in Frank H. Goodyear, Jr., introd. to *Cecilia Beaux: Portrait of an Artist*, exh. cat., Pennsylvania Academy of the Fine Arts, 1974, p. 18; ibid., p. 95

Page 134. Undated comment by Dewing's unidentified studio mate, quoted in Susan Hobbs, Yu-tarng Cheng, and Jacqueline S. Olin, "Thomas Willmer Dewing: Look Beneath the Surface," *Smithsonian Studies in American Art*, Summer/Fall 1990, pp. 64–65; Susan Hobbs, "Thomas Wilmer Dewing: The Early Years, 1851–1885," *American Art Journal*, Spring 1981, p. 10

Page 135. Romaine Brooks, "No Pleasant Memories,"unpublished manuscript, 1930s, National Museum of American Art; Adelyn D. Breeskin, *Romaine Brooks, "Thief of Souls,"* exh. cat., National Collection of Fine Arts/Smithsonian Institution Press, 1971, p. 25

Page 136. Man Ray, *Oggetti d'Affezione* (Objects of Affection), Giulio Einaudi (Turin), 1970; Merry A. Foresta, *Perpetual Motif: The Art of Man Ray*, exh. cat., National Museum of American Art, 1988, p. 39

Page 137. Helen Lundeberg, quoted in "Helen Lundeberg," *Source Book*, Nov./Dec. 1974, p. 20, quoted in Jan Butterfield, "Helen Lundeberg: A Poet Among Painters," *Helen Lundeberg Since 1970*, exh. cat., Palm Springs Desert Museum, 1983, p. 10; Eleanor C. Munro, *Originals: American Women Artists*, Simon & Schuster, 1979, p. 172; Helen Lundeberg, quoted in Henry Seldis, introd. to *Helen Lundeberg*, exh. cat., La Jolla Museum of Contemporary Art, 1972, n.p.

Page 138. John Steuart Curry, "What Should the American Artist Paint?" *Art Digest* (Sept. 1935), reprinted in John S. Czestochowski *John Steuart Curry and Grant Wood: A Portrait of Rural America*, University of Missouri Press, 1981, p. 41; John Steuart Curry, ibid., p. 41 ; unidentified author, "National Museum of American Art Acquires John Steuart Curry Drawing," *Antiques and The Arts Weekly*, May 2, 1986, p. 45

Page 139. Chuck Close, quoted in Lisa Lyons and Martin Friedman, *Close Portraits*, exh. cat., Walker Art Center, 1980, p. 16; Lisa Lyons, "Phil: A Case Study," *Close Portraits*, p. 14

Page 140. Irving Dominick, quoted in Cathy Maroney, "From Metal to Works of Art," *Journal News of Rockland and Westchester Counties* (N.Y.);

Andrew Connors, "Irving Dominick," in Lynda Roscoe Hartigan, *Made with Passion: The Hemphill Folk Art Collection*, exh. cat., National Museum of American Art/Smithsonian Institution Press, 1990, p. 92

Page 141. Jesse Treviño, quoted in Dan R. Goddard, *Three Decades of Art by Jesse Treviño*, exh. cat., Instituto Cultural Mexicano, 1993, n.p.; Jesse Treviño, quoted in "The Canadian Club Hispanic Tour," exh. cat., El Museo del Barrio, 1984, n.p.

SPIRIT AND RELIGION

Page 144. Abbott H. Thayer, quoted in Ross Anderson, *Abbott Handerson Thayer*, Everson Museum, 1982, p. 60; unsigned review of "Art in New York," *Chicago Daily News*, 1888

Page 145. Raphael Soyer, 1984, quoted in Patricia Hills, *Raphael Soyer's New York: People & Places*, exh. cat., Cooper Union, New York, 1984, n.p.; Raphael Soyer, 1972, quoted in Hills, *Raphael Soyer's New York*, n.p.; Isaac Bashevis Singer, quoted in Robert Ratner, "Singer on Soyer," *Horizon* July/Aug. 1982, p. 25

Page 146. W. S. Scarborough, "Henry Ossawa Tanner," *Southern Workman*, Dec. 1902, quoted in Dewey F. Mosby, *Henry Ossawa Tanner*, Philadelphia Museum of Art, 1991, p. 125; Henry Ossawa Tanner, "The Story of an Artist's Life II," *The World's Work*, July 1909, vol. 18

Page 147. Henry Ossawa Tanner, "Effort," artist's statement in *Exhibition of Religious Paintings by H. O. Tanner*, exh. cat., Grand Central Art Galleries, New York, 1924, quoted in Lynda Roscoe Hartigan, *Sharing Traditions: Five Black Artists in Nineteenth-Century America*, exh. cat., National Museum of American Art/Smithsonian Institution Press, 1985, pp. 106–07

Page 148. Augustus Saint-Gaudens, quoted in an undated letter from Mrs. Barrett Wendell to Homer Saint-Gaudens, reprinted in Homer Saint-Gaudens, ed., *The Reminiscences of Augustus Saint-Gaudens*, Century

Company, 1913, p. 362; Hildegarde Hawthorne, from undated poem inspired by the *Adams Memorial*, reprinted in *The Reminiscences of Augustus Saint-Gaudens*, p. 363; Henry Adams, letter to Augustus Saint-Gaudens, June 23, 1891, quoted in *The Reminiscences of Augustus Saint-Gaudens*, p. 365

Page 149. Elihu Vedder, *The Digressions of Elihu Vedder*, Houghton Mifflin, 1910, p. 408; Jane Dillenberger, "Between Faith and Doubt: Subjects for Meditation," in *Perceptions and Evocations: The Art of Elihu Vedder*, exh. cat., National Collection of Fine Arts, 1979, p. 142; *Rubáiyát of Omar Khayyám*, trans. Edward Fitzgerald, Houghton Mifflin, 1886, n.p.

Page 150. Howard Finster, interview, 1992, with Norman Girardot and Ricardo Viera, "Howard Finster," *Art Journal*, Spring 1994, p. 48

Page 151. Herbert W. Hemphill, Jr. and Julia Weissman, *Twentieth Century American Folk Art and Artists*, E. P. Dutton, 1974, p. 99; Sister Gertrude Morgan, ca. 1970, in Regenia A. Perry, *Free Within Ourselves*, exh. cat., National Museum of American Art, 1992, p. 145

Page 152. Charles Burchfield, 1954, quoted in J. Benjamin Townsend, ed., *Charles Burchfield's Journals*, State University of New York Press, 1993, p. 122; Charles Burchfield, 1933, quoted in *Charles Burchfield's Journals*, p. 335

Page 153. Marsden Hartley, "Mexican Vignette," unpublished essay, Hartley-Berger Collection, Yale Collection of American Literature, Beinecke Rare Book and Manuscript Library, Yale University, quoted in Townsend Ludington, *Marsden Hartley: The Biography of an American Artist*, Little, Brown and Company, 1992, p. 221; Jeanne Hokin, *Pinnacles and Pyramids: The Art of Marsden Hartley*, University of New Mexico Press, 1993, p. 87; Marsden Hartley, letter to Adelaide Kuntz, July 23, 1932, Archives of American Art

Page 154. Andrew Connors, "José Benito Ortega," in Lynda Roscoe Hartigan, *Made with Passion*, exh. cat., National

Museum of American Art/ Smithsonian Institution Press, 1991, pp. 168–69; Marjorie Hunt and Boris Weintraub, "Masters of Traditional Arts," *National Geographic*, Jan. 1991, p. 77

Page 156. Andrew Wyeth, 1976, quoted in Thomas Hoving, *Two Worlds of Andrew Wyeth: Kuerners and Olsons*, exh. cat., Metropolitan Museum of Art, 1976, p. 181; N. C. Wyeth, 1938, letter to Andrew Wyeth, May 18, 1938, reprinted in Betsy James Wyeth, ed., *The Wyeths: The Letters of N. C. Wyeth, 1901–1945*, Gambit Press, 1971, p. 773; William Kloss, *Treasures from the National Museum of American Art*, Smithsonian Institution Press, 1985, p. 148

Page 157. Wayne S. Smith, "The Transplanted Seed," *Cuba-USA: The First Generation*, exh. cat., Fondo del Sol Visual Arts Center, Washington, D.C., 1991, p. 4; Andrew Connors, National Museum of American Art, 1991

Page 158. Inscription on *The Throne*

Page 159. Elizabeth Broun, in Reginia A. Perry, *Free Within Ourselves*, exh. cat., National Museum of American Art/ Pomegranate Artbooks, 1992, p. 8; Betye Saar, "Personal Selection: Temple for Tomorrow," *American Art*, Fall 1994, p. 132

FOLK ART

Page 162. S. L. Jones, quoted in Charles B. Rosenak, "A Person Has to Have Some Work to Do: S. L. Jones, Wood Carver," *Goldenseal—West Virginia Traditional Life*, Spring 1982; Lynda Roscoe Hartigan, *Made with Passion: The Hemphill Folk Art Collection in the National Museum of American Art*, exh. cat., National Museum of American Art/Smithsonian Institution Press, 1990, p. 211

Page 163. "Remembering Bill Traylor: An Interview with Charles Shannon," in Frank Maresca and Roger Ricco, *Bill Traylor: His Art—His Life*, Alfred A. Knopf, 1991, p. 29; Charles Shannon, "Bill Traylor's Triumph," *Art and Antiques*, Feb. 1988, pp. 61–62

Page 164. Miles Carpenter, quoted in "Fame Came Late in Life for Waverly Folk Artist,"

Richmond Times-Dispatch, May 10, 1982; Lynda Roscoe Hartigan, *Made with Passion*, p. 211; Herbert W. Hemphill, Jr., introd. to *Cutting the Mustard* by Miles B. Carpenter, American Folk Art Company, 1982, p. 1

Page 165. Jean Lipman, *American Folk Art in Wood, Metal and Stone*, Pantheon, 1948, p. 76; Lynda Roscoe Hartigan, *Made with Passion*, pp. 84–85

Page 166. Charles Jencks and Nathan Silver, *ADHOCISM: The Case for Improvisation*, Doubleday Anchor Books, 1973, p. 23, quoted in Tom Patterson, *Reclamation and Transformation: Three Self-Taught Chicago Artists*, exh. cat., Terra Museum of American Art, 1993, p. 11; Lynda Roscoe Hartigan, wall label, National Museum of American Art, 1992

Page 167. Felipe Archuleta, unpublished interview with Davis Mather, Aug. 28, 1978; Felipe Archuleta, in Davis Mather, "Felipe Archuleta—Folk Artist," *The Clarion*, Summer 1977, p. 19

Page 169. Lynda Roscoe Hartigan, *Made with Passion*, pp. 69–70

Page 170. Jay Johnson and William C. Ketchum, Jr., *American Folk Art of the Twentieth Century*, Rizzoli, 1983, p. 27; Elizabeth Tisdel Holmstead, "'Peter Charlie' Boshegan [Besharo]," in Lynda Roscoe Hartigan, *Made with Passion*, p. 141

Page 171. Jim Nutt, quoted in Lynda Roscoe Hartigan, *Made with Passion*, p. 47; Andrew Connors, "Martin Ramírez," in *Made with Passion*, p. 150

Page 172. Jack Savitsky, quoted in Herbert W. Hemphill, Jr. and Julia Weissman, *Twentieth-Century American Folk Art and Artists*, E. P. Dutton, 1974, p. 176; Andrew Connors, "Jack Savitsky," in Lynda Roscoe Hartigan, *Made with Passion*, p. 204

Page 173. Herbert W. Hemphill, Jr. and Julia Weissman, *Twentieth-Century American Folk Art and Artists*, E. P. Dutton, 1974, p. 11; Tonia L. Horton, "Charlie Willeto," in Lynda Roscoe Hartigan, *Made with Passion*, p. 167

Page 174. Minnie Evans, interview with Nina Howell Starr, 1960s, quoted in Mitchell D. Kahan, *Heavenly Visions: The Art of Minnie Evans*, exh. cat., North Carolina Museum of Art, 1986, p. 9; Betye Saar, "Personal Selection: Temple for Tomorrow," *American Art*, Fall 1994, p. 132

Page 175. Henry Glassie, *The Spirit of Folk Art: The Girard Collection at the Museum of International Folk Art*, exh. cat., Harry N. Abrams, 1989, p. 258

MODERN ART

Page 178. Max Weber, *Essays on Art*, 1916, quoted in *Max Weber: Retrospective Exhibition*, Museum of Modern Art, 1930, n.p.; Percy North, *Max Weber: American Modern*, exh. cat., Jewish Museum, New York, 1982, p. 36

Page 179. Paul Manship, quoted in Harry Rand, *Paul Manship*, exh. cat., National Museum of American Art/Smithsonian Institution Press, 1989, p. 71; New Testament, Matthew 14:6–8; Harry Rand, *Paul Manship*, p. 39

Page 180. H. Lyman Säyen, "The United States and Modern Art," speech presented to the Philadelphia Sketch Club, Nov. 1914, quoted in Adelyn D. Breeskin, *H. Lyman Säyen*, exh. cat., National Collection of Fine Arts, 1970, p. 19; Adelyn D. Breeskin, *H. Lyman Säyen*, p. 23; H. Lyman Säyen, letter to Margaretta Achambault, Nov. 24, 1914, quoted in Adelyn D. Breeskin, *H. Lyman Säyen*, p. 20

Page 181. Blanche Lazzell, quoted in John Clarkson, *Blanche Lazzell*, exh. cat., Creative Arts Center of West Virginia University, 1979, p. 10; Janet Altic Flint, *Provincetown Printers: A Woodcut Tradition*, exh. cat., National Museum of American Art, 1983, p. 20

Page 182. Tewa Pueblo Indian song, in Herbert J. Spinden, *Songs of the Tewa*, The Exposition of Indian Tribal Arts, 1933, quoted in Jill D. Sweet, *Dances of the Tewa Pueblo Indians*, School of American Research Press, 1985, p. 26

Page 183. Andrew Connors, *Pueblo Indian Watercolors: Learning by Looking (A Study Guide)*, National Museum of

American Art, 1993, p. 3

Page 184. Virginia Mecklenburg, "Foreword," *The Patricia and Phillip Frost Collection: American Abstraction 1930–1945*, exh. cat., National Museum of American Art/ Smithsonian Institution Press, 1989, p. 7

Page 185. Balcomb Greene, "Expression as Production," *American Abstract Artists Yearbook* Arno Press, 1938, p. 31; Ed Garmen, letter to Virginia Mecklenburg, Feb. 15, 1988, quoted in Virginia Mecklenburg, *The Patricia and Phillip Frost Collection: American Abstraction 1930–1945*, National Museum of American Art/Smithsonian Institution Press, 1989, p. 11

Page 186. Diane Kelder, "Stuart Davis and Modernism: An Overview," in Lowery Stokes Sims, *Stuart Davis: American Painter*, exh. cat., Metropolitan Museum of Art, 1991, p. 17; Stuart Davis, quoted in *40 American Painters, 1940–1950*, exh. cat., University Gallery, University of Minnesota, 1951, p. 18

Page 187. Stuart Davis, "Is There a Revolution in the Arts?" *Bulletin of America's Town Meeting of the Air*, Feb. 19, 1940, quoted in John W. McCoubrey, *American Art 1700–1960, Sources and Documents*, Prentice-Hall, 1965, p. 207

Page 188. Lee Krasner, 1977, quoted in Eleanor Munro, *Originals: American Women Artists*, Touchstone/Simon & Schuster, 1982, p. 119; Harry Rand, National Museum of American Art, 1987

Page 189. Richard Stankiewicz, quoted in Dorothy C. Miller, ed., *Sixteen Americans*, exh. cat., Museum of Modern Art, 1959, p. 70; Richard Stankiewicz, quoted in *Richard Stankiewicz/ Robert Indiana*, exh. cat., Walker Art Center, 1963, n.p.; Fairfield Porter, "Stankiewicz Makes Sculpture," *Art News*, Sept. 1955, p. 36

Page 190. Harry Callahan, "Harry Callahan: A Life in Photography," from video interview by the Center for Creative Photography, in *Harry Callahan Photographs: From the Hallmark Photographic*

Collection, exh. cat., Hallmark Cards, 1981, p. 55

Page 191. Aaron Siskind, "Credo," *Spectrum*, vol. 6, no. 2, 1956, quoted in *Aaron Siskind: Photographs 1932–1978*, exh. cat., Museum of Modern Art, Oxford, England, 1979; Ray K. Metzker, letter to Anne Tucker, July 20, 1983, quoted in Anne Wilkes Tucker, *Unknown Territory: Photographs by Ray K. Metzker*, exh. cat., Aperture/ Museum of Fine Arts, Houston, 1985, p. 18

Page 192. Franz Kline, 1958, quoted in Frank O'Hara, *Art Chronicles*, George Braziller, 1975, p. 52; Franz Kline, quoted in Selden Rodman, *Conversations with Artists*, Devin-Adair, 1957, pp. 109–10; Elaine de Kooning, introd. to *Franz Kline: Memorial Exhibition*, Washington Gallery of Modern Art, 1962, pp. 14–15

Page 193. Willem de Kooning, quoted in Thomas B. Hess, "Ingres," *Art News Annual 22*, 1953, p. 182; Marla Prather, *Willem de Kooning: Paintings*, exh. cat., National Gallery of Art/ Yale University Press, 1994, p. 79

Page 194. Robert Motherwell, "On the Humanism of Abstraction," lecture at St. Paul's School, Concord, N.H., Feb. 6, 1970, quoted in Stephanie Terenzio, ed., *Collected Writings, Robert Motherwell*, Oxford University Press, 1992, p. 1; Robert Motherwell, statement in *The New Decade: Thirty-five American Painters and Sculptors*, exh. cat., Whitney Museum of American Art, 1955, p. 49; Dore Ashton, "On Motherwell," *Robert Motherwell*, exh. cat., Albright-Knox Art Gallery/Abbeville Press, 1983, p. 41

Page 195. Clyfford Still, quoted in Katharine Kuh, "Clyfford Still," in John P. O'Neill, ed., *Clyfford Still*, exh. cat., Metropolitan Museum of Art, 1979, p. 11; Robert Rosenblum, "The Abstract Sublime," *Art News*, Feb. 1961, p. 40; Katharine Kuh, "Clyfford Still," in O'Neill, ed., *Clyfford Still*, p. 11

Page 196. Robert Rauschenberg, quoted in Mary Lynn Kotz, *Rauschenberg/Art and Life*, Harry N. Abrams, 1990, p. 7; Virginia Mecklenburg, National

Museum of American Art, 1980

Page 197. Larry Rivers, interview with Sam Hunter, 1987, quoted in Sam Hunter, *Larry Rivers*, Rizzoli, 1989, p. 51; Sam Hunter, ibid., p. 51

Page 198. Richard Diebenkorn, quoted in Linda Cathcart, "Diebenkorn: Reaction and Response," *Richard Diebenkorn*, exh. cat., Albright-Knox Art Gallery, 1976, p. 58 n. 34; Wayne Thiebaud, quoted in Adam Gopnik, "Diebenkorn Redux," *The New Yorker*, May 24, l993, p. 100

Page 199. Elmer Bischoff, letter to Floyd T. Amsden, Jan. 24, 1976, quoted in *Elmer Bischoff*, exh. cat., Laguna Art Museum, 1985, p. 25; Dore Ashton, "Art: Elmer Bischoff's Paintings at the Staempfli," *New York Times*, Jan. 8, 1960; Elmer Bischoff, quoted in Jan Butterfield, "Walking a Tightrope," *Elmer Bischoff*, exh. cat., Laguna Art Museum, 1985, p. 39

Page 200. David Park, quoted in Paul Mills, *The New Figurative Art of David Park*, Capra Press, 1988, p. 30; Elmer Bischoff, ca. 1961, quoted in Mills, *The New Figurative Art*, p. 88; Richard Diebenkorn, ca. 1961, quoted in Mills, *The New Figurative Art*, p. 77

Page 201. Nathan Oliveira, quoted in Peter Selz, *New Images of Man*, exh. cat., Museum of Modern Art, 1959, p. 113; Thomas Albright, *Art in the San Francisco Bay Area: 1945–1980*, University of California Press, 1985, p. 77; Nathan Oliveira, 1983, quoted in Harvey L. Jones, *Nathan Oliveira: Paintings, 1959–1973*, exh. cat., Oakland Museum, 1973, p. 25

Page 202. Grace Hartigan, quoted in Allen Barber, "Making Some Marks," *Arts Magazine*, June 1974, p. 51, in Joseph D. Ketner, *Hartigan: Thirty Years of Painting 1950–1980*, exh. cat., Fort Wayne Museum of Art, Indiana, 1981, n.p.; Mary Gabriel, "Amazing Grace," *Museums & Art Washington*, Nov./Dec. 1990, p. 65

Page 203. Lester Johnson, quoted in *Lester Johnson*, exh. cat., Martha Jackson Gallery, New York, 1973, n.p.; Harry Rand, *The Martha Jackson Memorial Collection*, exh. cat., National Museum of American

Art, 1985, pp. 42–43; Dore Ashton, "Show at the Martha Jackson Collection," *Arts & Architecture*, Jan. 1963, p. 4

Page 204. Irving Penn, 1964, quoted in John Szarkowski, *Irving Penn*, exh. cat., Museum of Modern Art, 1984, p. 28; Merry A. Foresta, "Irving Penn: The Passion of Certainties," in Merry A. Foresta and William F. Stapp, *Irving Penn: Master Images*, exh. cat., National Museum of American Art/ National Portrait Gallery, 1990, p. 5

Page 205. Isamu Noguchi, *Isamu Noguchi: A Sculptor's World*, Harper & Row, 1968, pp. 27–28; Dore Ashton, *Noguchi East and West*, Alfred A. Knopf, 1992, p. 286

Page 206. Ellsworth Kelly, "Notes from 1969," quoted in Barbara Rose, *Ellsworth Kelly*, exh. cat., Stedelijk Museum, Amsterdam, 1980, p. 3; Ellsworth Kelly, "Notes from 1969," quoted in Barbara Rose, *Ellsworth Kelly*, p. 30

Page 207. Jacob Kainen, unpublished statement, Nov. 16, 1973, Jacob Kainen Archives, quoted in Avis Berman, "Images from a Life," *Jacob Kainen*, exh. cat., National Museum of American Art/Thames and Hudson, 1994, pp. 37–38; William C. Agee, "Jacob Kainen: Poetry in Painting," *Jacob Kainen*, p. 43

Page 208. Beverly Pepper, quoted in Deborah Solomon, "Woman of Steel," *ARTnews*, Dec. 1987, p. 116; Beverly Pepper, quoted in "Statements by Sculptors," *Art Journal*, Winter 1975/76, p. 127

Page 209. Helen Frankenthaler, quoted in Deborah Solomon, "Artful Survivor," *New York Times Magazine*, May 14, 1989, p. 62; Helen Frankenthaler, quoted in Henry Geldzahler, "An Interview with Helen Frankenthaler," *Artforum*, Oct. 1965, p. 38; C. Gerald Fraser, "Ed Smalls, Who Long Owned Harlem's Paradise Nightclub, Dies," *New York Times*, Oct. 18, 1974

Page 210. Morris Louis, quoted in Helen Jacobson, "As I Remember Morris Louis," *Ten Washington Artists: 1950–1970*, exh. cat., Edmonton Art Gallery, Canada, 1970, p. 9; Helen

Jacobson, ibid., p. 8; Clement Greenberg, "Louis and Noland," *Art International*, vol. 4, no. 5, 1960, reprinted in *Morris Louis 1912–1962*, exh. cat., Museum of Fine Arts, Boston, 1967, p. 81

Page 211. Gene Davis, *Art Now: New York*, University Galleries, Inc., 1970; Gene Davis, "Random Thoughts on Art," *Art International*, Nov. 20, 1971, p. 40

Page 212. Clement Greenberg, "Sculpture in Our Time," *Arts Magazine*, June 1958, quoted in John O'Brien, ed., *Clement Greenberg: The Collected Essays and Criticism*, vol. 4, University of Chicago Press, 1993, p. 60; Howard Mehring, unpublished notes from interview with Howard Mehring, 1960, quoted in Jane Livingston, *Howard Mehring: A Retrospective Exhibition*, exh. cat., Corcoran Gallery of Art, 1977, p. 14

Page 213. Merry A. Foresta, *A Life in Art: Alma Thomas 1891–1978*, National Museum of American Art, 1981, p. 24

Page 214. William Eggleston, quoted in Mark Holborn, *William Eggleston: Ancient and Modern*, Random House, 1992, p. 28; Eudora Welty, introd. to *The Democratic Forest*, Doubleday, 1989, p. 11

Page 215. Kenneth Noland, quoted in William C. Agee, *Kenneth Noland: The Circle Paintings 1956–1963*, exh. cat., Museum of Fine Arts, Houston, 1993, p. 33; Kenneth Noland, quoted in Philip Leider, "The Thing in Painting Is Color," *New York Times*, Aug. 25, 1968; William C. Agee, *Kenneth Noland*, p. 33

Page 216. Romare Bearden, quoted in Sharon F. Patton, *Memory and Metaphor: The Art of Romare Bearden, 1940–1987*, Studio Museum in Harlem/Oxford University Press, 1991, p. 65; Michael Mazur, "Monotype: An Artist's View," *The Painterly Print: Monotypes from the Seventeenth to the Twentieth Century*, exh. cat., Metropolitan Museum of Art, 1981, p. 62

Page 217. Joann Moser, National Museum of American Art, 1994

Page 218. Mel Bochner, 1975, quoted in Brenda Richardson,

Mel Bochner: Number and Shape, exh. cat., Baltimore Museum of Art, 1976, p. 43; Elaine A. King, *Mel Bochner: 1973–1985*, exh. cat., Carnegie-Mellon University Art Gallery, 1985, pp. 12–13; Mel Bochner, *Mel Bochner: Twenty-Five Drawings 1973–1980*, exh. cat., University Gallery, Meadows School of the Arts, Southern Methodist University, 1981, p. 5

Page 219. Pat Steir, interview with Elizabeth Broun, *Form Illusion Myth: Prints and Drawings of Pat Steir*, Spencer Museum of Art, University of Kansas, 1983, p. 33; Elizabeth Broun, National Museum of American Art, 1980; Pat Steir, quoted in Frederick Ted Castle, "Conversation with Pat Steir," *Arbitrary Order: Paintings by Pat Steir*, exh. cat., Contemporary Arts Museum, Houston, 1983, p. 18

Page 220. Philip Guston, quoted in *Memorial Exhibition: Alexander Brook, Philip Guston, Clyfford Still*, exh. cat., American Academy and Institute of Arts and Letters, New York, 1980, p. 27; April Kingsley, "Philip Guston's Endgame," *Horizon*, June 1980, p. 39; Ross Feld, "Philip Guston," *Philip Guston*, exh. cat., San Francisco Museum of Modern Art, 1980, p. 22

Page 221. Bryan Hunt, interview with Robin White, *View*, Crown Point Press, 1980, p. 17; Bryan Hunt, interview with Constance W. Glenn, "Artist's Dialogue: A Conversation with Bryan Hunt," *Architectural Digest*, March 1983, p. 72

CRAFT OBJECTS

Page 224. Peter Voulkos, quoted in D. Loercher, *Christian Science Monitor*, p. 16; Garth Clark, "Subversive Majesty," *American Art*, Fall 1992, p. 110

Page 225. Maria Martinez, quoted in Richard Spivey, *Maria*, Northland Press, 1979, p. 137; Maria Martinez, ibid., p. 22; Susan Peterson, *Maria Martinez: Five Generations of Potters*, exh. cat., Renwick Gallery, 1978, p. 7

Page 226. Anaïs Nin, quoted in *Enduring Creativity*, exh. cat., Whitney Museum of American Art, 1988, p. 28; Beatrice Wood, "A Potter's Experiment," *Craft Horizons*, Summer 1951, p. 31;

Beatrice Wood, 1937, *I Shock Myself*, Chronicle Books, 1988

Page 227. Betty Woodman, quoted in Linda Schmidt, "Beyond the Boundaries of History and Form," *American Ceramics*, 1989, p. 24; Linda Schmidt, ibid., p. 20

Page 228. Vicki Halper, *Clay Revisions: Plate, Cup, Vase*, exh. cat., Seattle Art Museum, 1987, pp. 7–8

Page 229. Octavio Paz, "Use and Contemplation," *In Praise of Hands*, New York Graphic Society/World Crafts Council, 1974, p. 17

Page 230. John Cederquist, quoted in Karen Sandra Smith, "The Art of the Illusion," *Art of California*, Nov. 1992, p. 52; John Cederquist, ibid., p. 53; Michael W. Monroe, *Renwick Quarterly*, June–Aug. 1993, n.p.

Page 231. John McQueen, quoted in Ed Rossbach, "Containing and Being Contained," *John McQueen: The Language of Containment*, exh. cat., Renwick Gallery, 1991, p. 13

Page 232. Robert Arneson, quoted in Jo Ann Lewis, "Arneson & His Feats of Clay," *Washington Post*, Apr. 30, 1986, C1; Robert Arneson, conversation with Suzann Boettgen, 1981, quoted in *Robert Arneson*, exh. brochure, Hirshhorn Museum and Sculpture Garden, 1986; Fred Ball, "Arneson," *Craft Horizons*, Feb. 1974, p. 65

Page 233. Larry Fuente, artist's statement, 1994; Tomas Ybarra-Frausto, "Rasquachismo: A Chicano Sensibility," in Richard Griswold del Castillo et al., eds., *Chicano Art: Resistance and Affirmation, 1965–1985*, exh. cat., Wight Art Gallery, University of California, Los Angeles, 1990, p. 157; Michael W. Monroe, *Renwick Quarterly*, March–May 1991

Page 234. Wendell Castle, "A Timely Switch from Furniture to Art," *Washington Home*, May 1, 1986, p. 9; Jeremy Adamson, Renwick Gallery, 1992

Page 235. Michael Hurwitz, quoted in Edward S. Cooke, Jr., *New American Furniture: The Second Generation of Studio Furnituremakers*, exh. cat., Museum of Fine Arts, Boston,

1989, p. 60; Michael W. Monroe, Renwick Gallery, 1990; Michael Hurwitz, Portfolio Section, *American Craft*, Feb./March 1986, p. 41

Page 236. Jonathan L. Fairbanks, introd. to Sam Maloof, *Sam Maloof: Woodworker*, Kodansha International, 1983, p. 14; Sam Maloof, ibid., p. 123

Page 237. George Nakashima, *The Soul of a Tree*, Kodansha International, 1981, p. 128

Page 238. John Roloff, quoted in Elaine Levin, *John Roloff: A Ceramics Monthly Portfolio*, June/July/Aug. 1986, n.p.; John Roloff, quoted in "Renwick Acquires Roloff Sculpture," *Ceramics Monthly*, April 1988; Jeremy Adamson, Renwick Gallery, 1988

Page 239. Harvey Littleton, *Glassblowing: A Search for Form*, Van Nostrand Reinhold, 1971, p. 17; Harvey Littleton, ibid., p. 118; Gudmund Vigtel, interview with Janet Koplos, "Considering the Past," *American Craft*, Aug./Sept. 1984, p. 44

Page 240. Richard Mawdsley, *Jewelers USA*, exh. cat., Dextra Frankel Art Gallery, California State University, 1976, p. 22 ; Janet Koplos, "Richard Mawdsley's Tubular Fantasies," *American Craft*, April/May 1983, pp. 18–21

Page 241. Albert Paley, quoted in Gail P. Zlatnik, *Functional Ornament: The Ironwork of Albert Paley*, exh. cat., University of Iowa Museum of Art, 1983; Albert Paley, quoted in "The Works and Words from Two Metal Artists," *Newporter* (Newport, R.I.), July 1976, p. 23; Michael W. Monroe, Renwick Gallery, 1990

Page 242. Anni Albers, *On Weaving*, Wesleyan University Press, 1965, pp. 62–63; Ed Rossbach, interview with Harriet Nathan, in Charles Edmund, *Rossbach: Artist, Mentor, Professor, Writer*, Regional Oral History, Bancroft Library, University of California, Berkeley, 1983

Page 243. Rebecca A. T. Stevens, introd. to *Old Traditions/New Directions*, exh. cat., Textile Museum, Washington, D.C., 1981, p. 5

CONTEMPORARY VOICES

Page 246. Luis Jiménez, quoted in Lucy Lippard, "Dancing with History: Culture, Class, and Communication," in *Man on Fire: Luis Jiménez*, exh. cat., Albuquerque Museum, 1994, p. 25; Rudolfo Anaya, "Luis Jiménez: A View from La Frontera," in *Man on Fire*, p. 3; Luis Jiménez, quoted in *Man on Fire*, p. 101

Page 247. David Levinthal, quoted in Constance Sullivan, ed., *The Wild West: Photographs by David Levinthal*, Smithsonian Institution Press, 1993, p. 13; David Levinthal, quoted in *The Wild West*, p. 8

Page 248. William Hawkins, quoted in Gary J. Schwindler, *William L. Hawkins: Transformations*, exh. cat., Tarble Arts Center, Eastern Illinois University, 1989; Lynda Roscoe Hartigan, National Museum of American Art Newsletter, 1989

Page 249. William T. Wiley, interview with Robin White, *View*, May 1979; Virginia Mecklenburg, National Museum of American Art, 1984

Page 250. April Gornik, quoted in *Journal of the Print World*, Spring 1991; Lucinda Barnes, *April Gornik*, exh. cat., University Art Museum, California State University, Long Beach, 1988; unsigned article, *Journal of the Print World*, Spring 1991

Page 251. Joshua P. Smith, "The Photography of Invention: American Pictures of the 1980's," *The Photography of Invention*, exh. cat., National Museum of American Art, 1989, p. 14; Kathleen McCarthy Gauss, *New American Photography*, exh. cat., Los Angeles County Museum of Art, 1985, p. 10; Marjorie Perloff, introd. to *Susan Rankaitis*, exh. cat., Gallery Min, Tokyo, 1988

Page 252. Lois Conner, artist's

statement for the exhibition "Between Home and Heaven: Contemporary American Landscape Photography," National Museum of American Art, 1992

Page 253. Merry A. Foresta, "Between Home and Heaven," in *Between Home and Heaven: Contemporary American Landscape Photography*, exh. cat., National Museum of American Art/University of New Mexico Press, 1992, p. 38; Mark Klett, "The Legacy of Ansel Adams: Debts and Burdens," *Aperture*, 1990, quoted in Merry A. Foresta, *Between Home and Heaven*, p. 175

Page 254. William Christenberry, quoted in R. H. Cravens, *William Christenberry: Southern Photographs*, Aperture, 1983, p. 20; William Christenberry, quoted in Thomas W. Southall, *Of Time and Place: Walker Evans and William Christenberry*, Friends of Photography and Amon Carter Museum, exh. cat., 1990, p. 78

Page 255. Jesús Bautista Moroles, quoted in Susan Chadwick, "Texas Sculptor Challenges 'Center of the Universe,'" *Houston Post*, Nov. 1988, F-3; Thomas McEvilley, *Art at the Gateway: Jesús Bautista Moroles*, exh. cat., Davis/McClain Gallery, 1990, n.p.; Mel McCombie, "Jesús Bautista Moroles: A Consideration," *Art Today*, Fall 1988, p. 39

Page 256. Masami Teraoka, quoted in Henry Hopkins, *California Painters: New Work*, Chronicle Books, 1989, p. 125; Joann Moser, National Museum of American Art, 1991

Page 257. Charles "Chaz" Bojórquez, quoted in Zan Dubin, "Putting the Wrong Tags on Graffiti, Rap?" *Los Angeles Times*, April 12, 1994, F3; Andrew Connors, National Museum of American Art, 1993; Charles "Chaz" Bojórquez, artist's statement, in Richard

Griswold del Castillo et al., eds., *Chicano Art: Resistance and Affirmation, 1965–1985*, Wight Art Gallery, University of California, Los Angeles, 1990, p. 346

Page 258. Ana Castillo, "We Would Like You to Know," *My Father Was a Toltec*, West End Press, 1988, p. 68, quoted in Richard Griswold del Castillo et al., eds., *Chicano Art: Resistance and Affirmation*, Wight Art Gallery, University of California, Los Angeles, 1990, p. 201; Thomas McEvilley, *Leon Golub*, exh. cat., Malmö Konsthall, 1992, p. 35

Page 259. Emanuel Martinez, "The Art of the Chicano Movement and the Movement of the Chicano Art," in George J. Garcia, ed., *Selected Reading Materials on the Mexican and Spanish American*, 1969, p. 5; Paul Arnett and William Arnett, in *Thornton Dial: Image of the Tiger*, Harry N. Abrams/Museum of American Folk Art, the New Museum of Contemporary Art, and the American Center, p. 156

Page 260. Barbara Kruger, interview with Jeanne Siegel, "Barbara Kruger: Pictures and Words," *Arts Magazine*, June/Summer 1987, p. 19; Kate Linker, *Love for Sale: The Words and Pictures of Barbara Kruger*, Harry N. Abrams, 1990, p. 12

Page 261. Nancy Burson, quoted in *Composite: Computer Generated Portraits*, Beech Tree Books, 1986, p. 18; Owen Edwards, "Portraits with Bursonality," *American Photographer*, May 1989, p. 26

Page 262. Frank Romero, "A Conversation with Frank Romero," *Artweek*, Sept. 3, 1992; Andrew Connors, National Museum of American Art, 1992; Frank Romero, quoted in Richard Griswold del Castillo et al., eds., *Chicano Art: Resistance and Affirmation, 1965–1985*, exh. cat., Wight Art

Gallery, University of California, Los Angeles, 1990, p. 356

Page 263. Frederick Brown, quoted in "Frederick Brown Paintings on Exhibit," *Washington Sun*, Sept. 19, 1991; Frederick Brown, *Washington Afro-American*, Oct. 26, 1991; Regenia A. Perry, *Free Within Ourselves: African-American Artists in the Collection of the National Museum of American Art*, exh. cat., National Museum of American Art/Pomegranate Artbooks, 1992, p. 45

Page 264. Roger Y. Shimomura, *Relocations and Revisions: The Japanese-American Internment Reconsidered*, exh. cat., Long Beach Museum of Art, 1992, p. 18; Noriko Gamblin, *Relocations and Revisions*, p. 18

Page 265. Renée Stout, artist's statement, B. R. Kornblatt Gallery, Washington, D.C., 1991; Pamela M. Lee, *Site Seeing: Travel and Tourism in Contemporary Art*, Whitney Museum of American Art, 1991, p. 4

Page 266. Howard Finster, signpost in front of Paradise Garden, 1976; Howard Finster, interview, 1992, with Norman Girardot and Ricardo Viera, "Howard Finster," *Art Journal*, Spring 1994, p. 49; Lynda Roscoe Hartigan, *Made with Passion: The Hemphill Folk Art Collection*, exh. cat., National Museum of American Art/Smithsonian Institution Press, 1990, pp. 159–60

Page 267. Nam June Paik, interview with Nancy Miller, in Miller, *The Color of Time: Video Sculpture by Nam June Paik*, Rose Art Museum, Brandeis University, 1984, n.p.; Nam June Paik, quoted in Barbaralee Diamonstein, *Inside the Art World: Conversations with Barbaralee Diamonstein*, Rizzoli, 1994, p. 188; Jacquelyn D. Serwer, "Personal Selection, Nam June Paik: Technology," *American Art*, Spring 1994, p. 91

\mathscr{I} NDEX

PICTURE COPYRIGHTS

First published in the United States of America by the National Museum of American Art, Smithsonian Institution, Washington, D.C. 20560

Project Director: Steve Dietz
Curatorial Project Director: Merry A. Foresta
Editor: Janet Wilson
Designer: Steve Bell
Editorial Assistant: Julie Strubel

Hardcover edition published by Bulfinch Press/Little, Brown and Company

ISBN 0-8212-2216-3 (hardcover)
ISBN 0-937311-25-1 (hardcover with CD-ROM)
ISBN 0-937311-20-0 (paper)
ISBN 0-937311-24-3 (paper with CD-ROM)

The National Museum of American Art, Smithsonian Institution, is dedicated to the preservation, exhibition, and study of the visual arts in America. The museum, whose publications program also includes the scholarly journal *American Art*, has extensive research sources: the databases of the Inventories of American Painting and Sculpture, several image archives, and a variety of fellowships for scholars. The Renwick Gallery, one of the nation's premier craft museums, is part of NMAA. For more information or a catalogue of publications, write to the Office of Publications, National Museum of American Art, MRC-210, Smithsonian Institution, Washington, D.C. 20560.

Front cover (paper): Luis Jiménez,*Vaquero*, 246. Back cover: George Catlin, *Buffalo Bull's Back Fat*, 23; Albert Bierstadt, *Among the Sierra Nevada Mountains, California*, 37; John Singleton Copley, *Mrs. George Watson*, 16; Harvey Littleton, *Opalescent Red Crown*, 240; Edward Hopper, *Cape Cod Morning*, 110; Blanche Lazzell, *Non-Objective (B)*, 181; Thomas Hart Benton, *Achelous and Hercules*, 98, 99; Thomas Wilmer Dewing, *Walt Whitman*, 134; Unidentified Artist, *Bottlecap Lion*, 166; William H. Johnson, *Going to Church*, 96. Contents page: Alexander Calder, *Nenuphar*, 2, 3. Title page: Lincoln Gallery, National Museum of American Art, 4, 5.

Library of Congress Catalog Number 94-37723

Library of Congress Cataloging-in-Publication Data

National Museum of American Art (U.S.)
National Museum of American Art, Smithsonian Institution/foreword by Elizabeth Broun; introduction by William Kloss.
p. cm.
Includes bibliographical references and index.
ISBN 0-8212-2216-3 (hardcover)
ISBN 0-937311-20-0 (paper)
1. Art, American—Catalogs. 2. Art—Washington (D.C.)—Catalogs. 3. National Museum of American Art (U.S.)—Catalogs. I. Title.
N857.A617 1995 94-37723
709'.73'074753—dc20

Front cover (paper): photograph by Gene Young

Bulfinch Press is an imprint and trademark of Little, Brown and Company (Inc.)
Published simultaneously in Canada by Little, Brown & Company (Canada) Limited

Printed and bound in China by Toppan Printing Co., (H.K.) Ltd.